THE DARKROOM BOOK

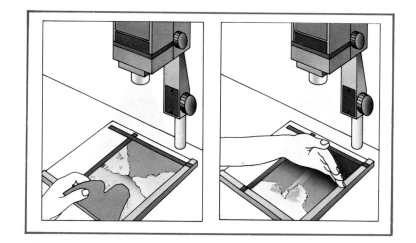

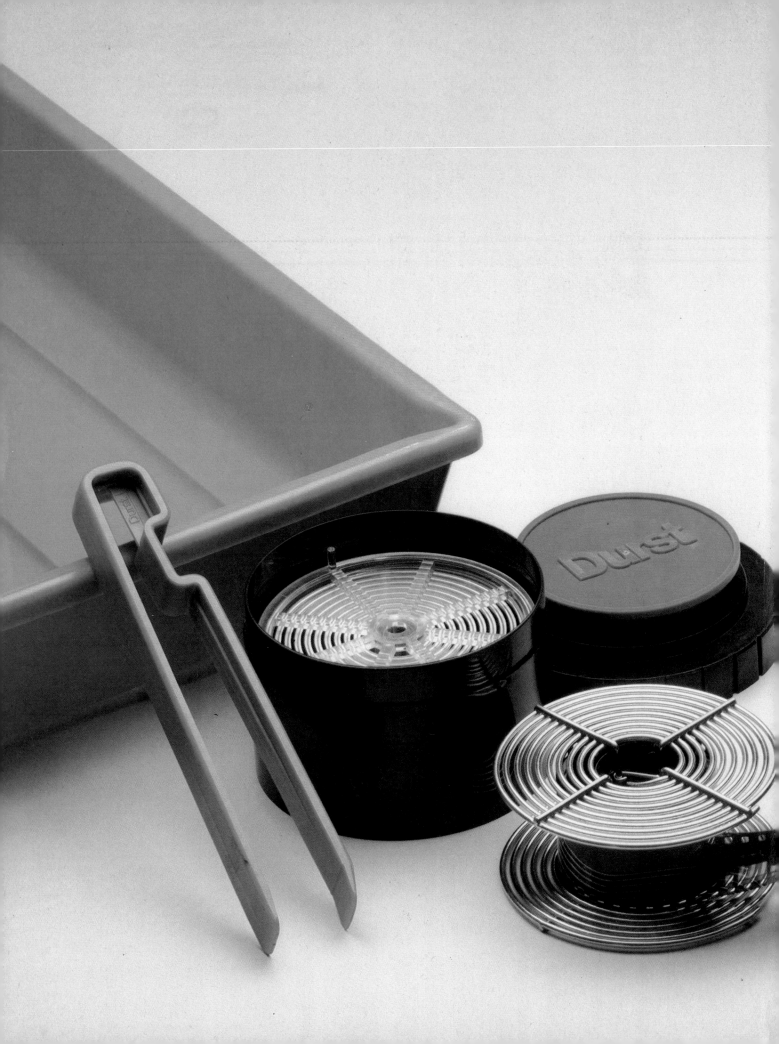

THE DARKROOM BOOK

Consulting Editor Jack Schofield

The comprehensive step-by-step guide
to processing your color or
black-and-white photographs

Popular
Photography
Books

Consultants: Michael Langford, FIIP, FRPS, Fellow
and Senior Tutor in Photography, Royal College of
Art, London; David Kilpatrick; Neville Maude

American technical consultant: Harvey V. Fondiller
Series editor: Alison Louw
Editors: Christopher Angeloglou; Jack Schofield
Copy editors: Stephen Ballantyne; Vanessa Galvin;
David Reed

Contributing editors: Valerie Conway; Amanda Currey;
Roger Darker; Fred Dustin; John Flack; Jim Heise;
David Hodgson, AIIP; Alan Jackson;
Heino Juhanson; David Kilpatrick; Robin Laurance;
Kevin MacDonnell; Neville Maude; Alan Meek;
David Nicholson; David Reed; Anna Roden;
Derek Watkins

Ziff-Davis Publishing Company
One Park Avenue
New York, New York 10016
© 1981 Eaglemoss Publications Limited
87 Elystan Street
London SW3 3PD

Library of Congress Catalog Card No: 80-52794

ISBN 0-87165-106-8

First printing 1981

Printed in Great Britain

CONTENTS

INTRODUCTION

There is little point in owning a good camera and then sending your films to be commercially printed—mass-produced photographs will never do justice either to you or your camera. While you may well be content with the standards of commercial developing, if you are concerned with the quality of your prints it is essential to make your own. The choice of darkroom exposure times, printing papers or filtration is as important as the composition or lighting of the original scene; these factors can make the difference between an average picture and a superb one. The basic steps are easy to learn and produce results far superior to most photographic laboratories.

The Darkroom Book shows you everything you need to know about processing and printing your own positive and negative film. Included are plans for designing your own darkroom and guides to choosing the necessary equipment. The basic processing procedures are explained with photographs and diagrams, step-by-step instructions, together with the theory behind them. Detailed, illustrated sections show potential faults with suggestions on how to avoid them or correct them should they occur.

Printing can be as creative as photography itself and the second part of the book deals with techniques in which the reader's imagination and artistic skills come into play. Inspired examples of techniques such as solarization, sandwiching and posterization reveal the world of darkroom inventiveness and show how the original negative or transparency is but a starting point for further creativity.

The improvised darkroom

Photographers who wish to keep full control over every stage of picture-making will soon find themselves tucked away in some corner at home, engrossed in developing and printing. When space allows, a permanent darkroom is the most satisfactory arrangement but you can still do all kinds of darkroom work in a temporary, improvised set-up. Almost any room can be quickly and easily converted for photographic processing. It must be efficiently blacked out, of course, and there have to be power outlets for the enlarger and safelight, but running water is not essential. Once a film or prints are fixed they can be put in a bucket of water and taken to another room for the important final wash.

Power can be laid on almost anywhere with an appropriate extension cord which can be bought from most electrical or hardware shops. So virtually any room, from garden shed to attic, can become a photographic laboratory. But the most conveniently converted rooms are the bathroom or the kitchen.

Choosing the room

When selecting a room it is helpful to consider these points.
● Can the room be screened easily to shut out light?
● Does the room have a surface long enough to place at least two, and preferably three, trays side by side? The space needed depends on the size of your developing trays. As a guide, 12 x 15in (30 x 37cm) trays need a length of about 4ft (120cm). You must also allow space— not on the same work surface, if possible— for the enlarger.
● Can the room be made, and kept, clean? Dust and dirt mar the results in both developing and printing.
● Can electricity be supplied safely?
● Is there enough ventilation? Very small, poorly ventilated rooms are oppressive for any length of time.

A light-tight room

Windows are usually the chief difficulty and a blackout screen is the best solution. It can be made from hardboard, three-ply wood or stiff card fixed to a secure wooden frame. Glue and tack the material to the frame to prevent light leaking in round the edges and paint the screen black on the window-facing surface. Small clips fixed permanently to the window frame will enable you to secure the screen quickly. Minor light leaks can be stopped with 2in (5cm) wide strips of black adhesive tape, or weather stripping

(draught excluder)—which should be painted black if possible— or strips of black foam rubber.

Alternatively, you may find that you can make a blackout screen out of heavy-duty black PVC sheeting, but it may be difficult to seal the edges effectively. A surprising amount of light seeps around door frames (and even through keyholes), so use 2in (5cm) wide black tape, or draught excluder or a heavy, lightproof curtain.

Other possible sources of light leaks include ventilation points and entry points for pipes. Use a venting hood to make ventilators light-tight, so you don't cut off the ventilation. This is *very* important when working in rooms with gas appliances.

Checking for light-tightness: remain patiently inside for at least 10 minutes until your eyes are used to the dark, to check it really is blacked out. Always check the room each time because light can seep into a seemingly black room. It is also important to have the area behind the enlarger black in case leakages of light from the lamphouse reflect off a white wall on to the paper.

The work area

The workbench itself should be covered with washable material (always wipe up any spilled chemicals immediately). Ideally, the enlarger should sit on a separate work surface which is sturdy enought to prevent shake during printing, away from the chemicals in the processing trays to prevent contamination of the paper and to keep electrical equipment away from water. Always be careful about using electricity near water. Have your enlarger grounded (earthed) if this is what the makers advise and *never* touch any switches or plugs with wet or even damp hands. Cord-pull switches are the safest to use.

When using the bathroom as an improvised darkroom you can wash the prints in the bath and a temporary workbench can be conveniently positioned on the bath itself. To raise the surface to a comfortable working height, build the bench on six 12in (30cm) high legs which can be screwed into three pieces of wood 2 x 2in (50 x 50mm), which sit across the bath to support the bench. It does not need to be the full length of the bath as long as there is enough room to work.

Finally, make sure that the door closes firmly and hang a sign outside on the door handle, to prevent anyone bursting in at the wrong moment.

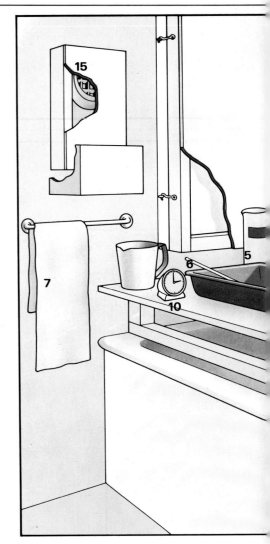

DARKROOM EQUIPMENT
Items marked with an asterisk are useful but not essential.
1 enlarger
2 enlarging easel* (masking frame)
3 printing tongs
4 developing trays
5 graduates
6 thermometer
7 lint-free towel
8 waste-bin
9 safelight
10 timer with large dial
11 blower brush
12 focus finder
13 footswitch for enlarger* or exposure time switch*
14 blackout screen
15 ventilator hood
16 work bench
siphon for washing*, tray warmer*, enlarging meter*,
RC and flatbed print drier (glazer)*, print squeegee*

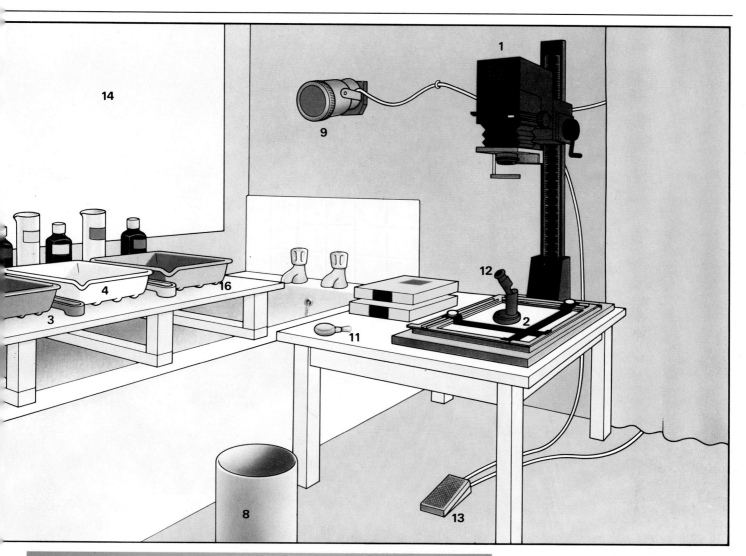

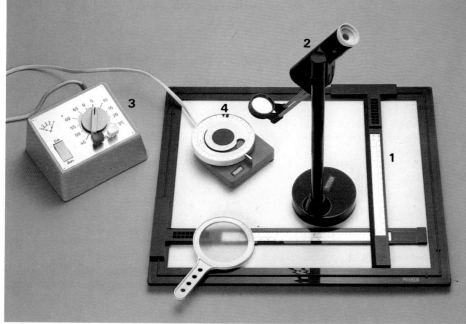

1 An enlarging easel holds the paper flat on the baseboard. It is more economical to buy one that takes a fairly large print—10 x 12in (24 x 30cm). But check that the baseboard is big enough to hold a large enlarging easel, or the easel may not sit evenly on the baseboard.

2 A focus finder is useful to check that the projected image is pin-sharp. Most models let you examine the grain structure of the negative to find the exact focus.

3 An exposure time switch is pre-set. Once switched on it leaves your hands free for techniques such as burning-in or for processing. They can be simple, requiring setting for each exposure or electronic, offering repeats of the same exposure.

4 An enlarger exposure meter works out the correct exposure and saves making test strips.

Creating a permanent darkroom

It is the dream of every photographer doing processing at home to own a permanent darkroom. Often this is impossible because of space restrictions within the home, but, if a free area can be found so that you can leave everything set up, you can get down to work straight away at any time. This means faster results.

Choosing a room

The choice is restricted in most households but you are looking for a room which can be blacked out, kept at a reasonable temperature, and to which you can run electricity and water. Basements and lofts can usually be adapted, although lofts tend to become over-hot in summer and cold in the winter. Sheds and outbuildings suffer the same disadvantages but can still be used. Of course, any spare room indoors can be perfect.

Bear in mind that you will be cramped if the room is small. Anything narrower than 6ft (2m) will prevent you from fitting benches down both sides. The length of the room is less important and 6ft (2m) or more will be adequate. On the other hand an enormous room is tiresome as it involves too much walking about—7 x 8ft (2 x 2.5m) is a comfortable size for a small amateur darkroom, while a room 8 x 10ft (2.5 x 3m) is luxurious.

Excluding the light

The first job is to stop the light coming in. Windows can be covered with hardboard or chipboard, either nailed in place or, better still, held by turn-catches so that the board may be removed if necessary. Cut the board to fit on to the main window frame. If light creeps round the edges you can stick a strip of sponge draught excluder, as used for windows, behind the edge of the board to cut it out. An alternative is to use opaque polythene sheeting, fixed in place with strong masking tape all the way round.

The door has to be checked too. If light leaks round the edge fit draught excluder here as well.

Now stand in the room with the lights off for 10 minutes or until your eyes get accustomed to the dark and if you see any chinks of light cut them out with tape, polythene sheeting or other suitable material.

Ventilation

Blocking up all the holes has probably also prevented the entry of fresh air so it is advisable now to arrange for some ventilation, perhaps through the window or door. The ideal is a powered ventilator fan, suitably light-trapped of course, so that air can be extracted efficiently. Do not have a fan blowing into the room as this blows dust about.

▼ **The most effective way of excluding light from a permanent darkroom is to cut a piece of chipboard exactly to fit the window frame, using turn-catches so that it can be removed easily.**

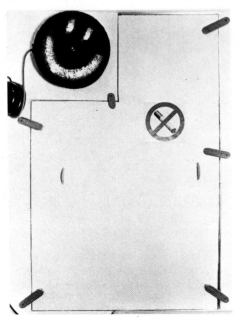

▲ The ideal layout for your darkroom is one which allows you to work efficiently without being constantly on the move. Here the equipment has been carefully arranged. Everything is easily accessible from a central point. The work flows from right to left. All the controls are grouped round the enlarger, the majority being wall-mounted to avoid causing baseboard vibration while printing.

◄ A large fibreglass sink is easier to keep clean than a bench top when processing prints. It also doubles as a water bath to stabilize the temperature of the processing solutions.

▶ A drying rack is easy to make. This one is a series of rectangular frames with a light muslin stretched over each. Ample space between the frames ensures good air circulation.

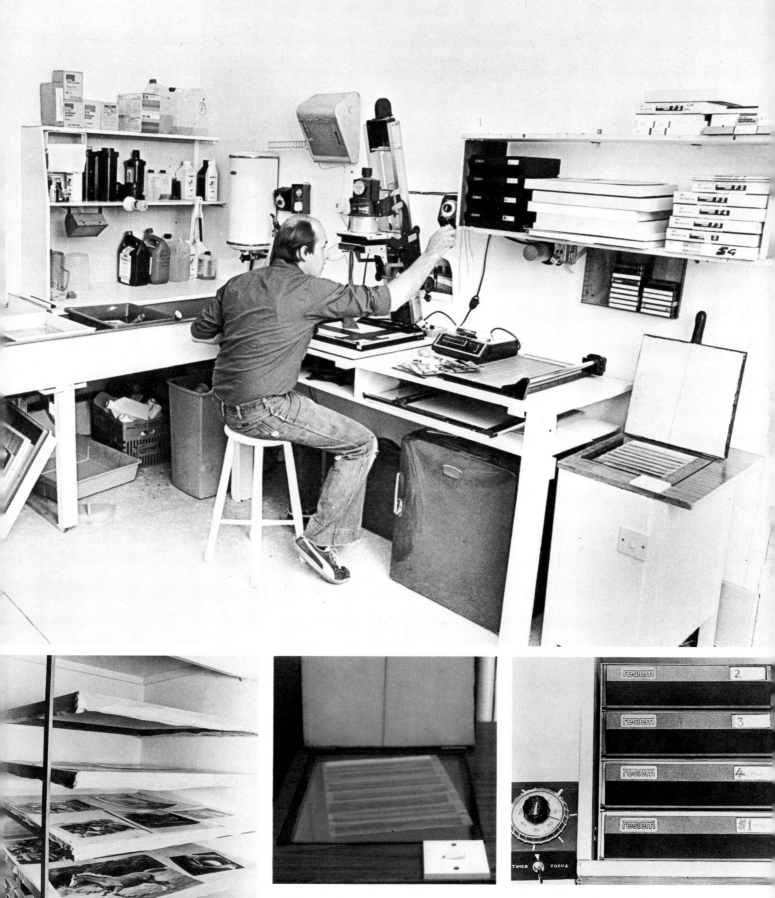

▲ A simple cabinet for making contact sheets. A safelight inside allows the paper and negatives to be positioned. A white light inside is turned on when the lid is down to make the exposure.

▲ Paper safes are more convenient containers than the original packaging when printing. Keeping them on a shelf within easy reach leaves the working bench free for larger items.

▲ Although a darkroom is light-tight it shouldn't be air-tight. This simply constructed air inlet can be set into the door to give adequate ventilation. An exhaust fan set into a far wall causes the air to circulate.

▶ A division between wet and dry areas is essential, although few people have the space to create such a clear separation as in this ideal layout.

which inevitably lands on films and the enlarger. A simple inlet somewhere else in the room can let air in. Ready-made exhaust (extractor) units are commercially available.

A less expensive answer is a box-shaped channel or double louvres painted matt black inside, set into the window, so that air can enter but light cannot. A small darkroom without any form of ventilation becomes uncomfortable quite quickly.

The main requirements

Now consider the basic layout of the room. The possible combinations of bench and sink arrangement are limitless but bear in mind two basic principles. Firstly, dry work such as enlarging, filing, retouching and mounting must be kept away from wet work such as film processing, print developing and washing. If space prevents two separate benches build a partition 20in (50cm) high to prevent splashes reaching the dry side. Secondly, try to arrange a logical flow of work in one direction, to avoid crossing the room unnecessarily. For example, when making black and white prints you will probably take the negative out of the file, operate the enlarger, develop, stop, fix, wash and dry the print. Organizing the room in that order will save a good deal of time when working.

If your conversion to a darkroom

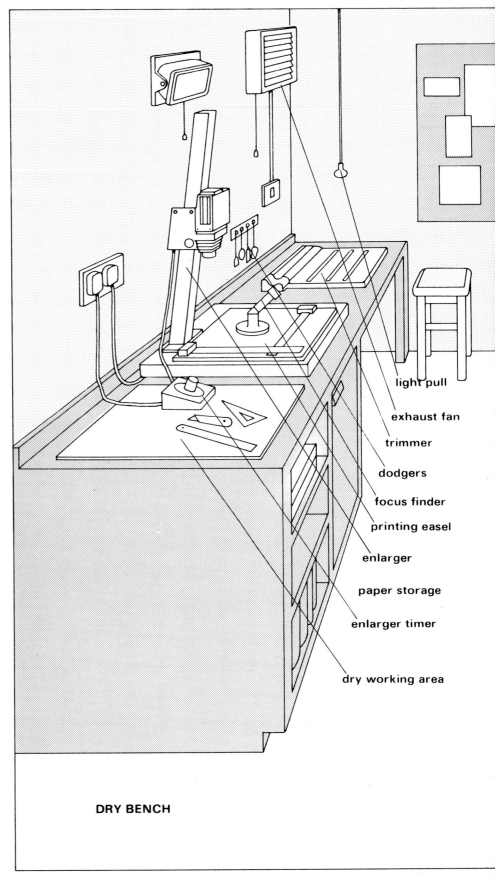

light pull

exhaust fan

trimmer

dodgers

focus finder

printing easel

enlarger

paper storage

enlarger timer

dry working area

DRY BENCH

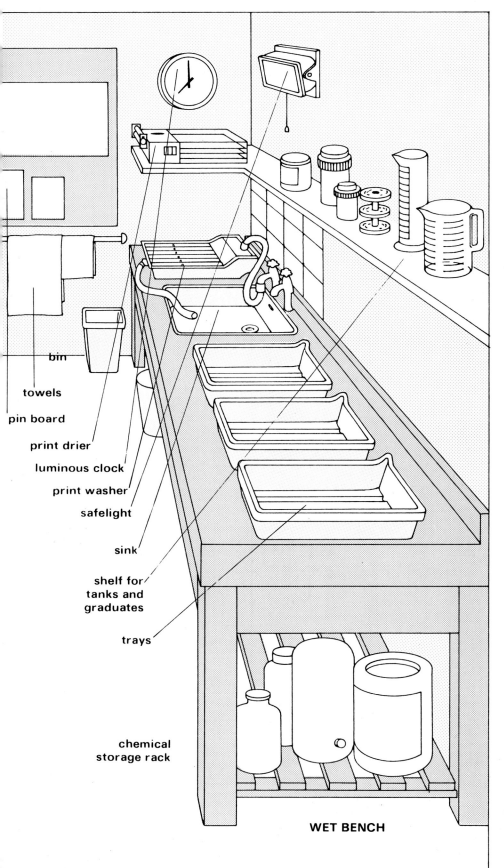

bin

towels

pin board

print drier

luminous clock

print washer

safelight

sink

shelf for
tanks and
graduates

trays

chemical
storage rack

WET BENCH

involves major reconstruction work, such as moving walls, you may need building regulation approval, but if in doubt ask your local authority.

Flooring

Despite the greatest care you will splash water and drip chemicals on to the floor, which must therefore be water-proof. Concrete floors are ideal if properly sealed. Waterproof flooring compounds are available from builders' merchants and are simply painted on. Wood floors are best covered with a complete sheet of flooring material since individual tiles invariably let moisture through the cracks. Choose a flooring which is not slippery when wet. Most kitchen vinyl or linoleum floorings are satisfactory but carpeting is a bad choice because it soaks up water and chemicals. On no account should you have loose mats or rugs in the darkroom as you will almost certainly trip over them.

Walls and ceilings

Despite being called a darkroom it is dreary and uncomfortable to work in dark surroundings. Paint the walls and ceilings with washable paint or emulsion in light colours. White tends to be over-bright on walls but any pale, neutral colour, such as beige, will reflect light from the safelight and improve visibility.

The only place where black paint should be used is on the wall or ceiling near the enlarger since any stray light spilling from the enlarger will not then reflect back on to the printing paper.

Benches and sinks

Dry or wet benches should be at least 20in (50cm) from front to back and preferably 30in (75cm) in order to support an enlarger baseboard. The height of the bench top from the floor would normally be 3ft (1m) or a little more. Measure a few surfaces around the house to find a suitable height, as it is bad for the back as well as uncomfortable to stand bent over all the time. Should you wish to sit while working use a high stool.

Kitchen units are usually fine for a darkroom as long as they are firmly fixed and do not wobble. To make your own bench use 2 x 2in (50 x 50mm) or 1 x 2in (25 x 50mm) wood for the legs and either fit cross-bracing or panel the sides to stop the frame twisting. It is always better to screw the structure firmly to the wall since it is vital that the enlarger does not move or vibrate while

printing. Fit the front of the dry bench with hinged or sliding doors. Provide a small under-cut at floor level to tuck your toes under as this lets you stand upright and closer to the bench.

The length of dry bench needed depends on your scale of operations. As well as the width of your enlarger you need somewhere to rest a negative file, perhaps a timer and the packet of printing paper. Never under-estimate the length—6ft (2m) is a reasonable minimum. The length of the wet bench depends on similar principles. Suppose you intend to make black and white prints up to 16 x 20in (40 x 50cm), you will use three trays, taking up more than 4ft (1.2m) on their own, plus washing facilities.

Cover the tops of the benches with a smooth, waterproof surface such as Formica, which is easy to keep clean. At the back of the wet bench fit a 'splash-back', a small strip running the whole length of the bench to prevent liquids dribbling over the back. For the water supply a small domestic sink is quite adequate, especially stainless steel which is chemical resistant. An enamel sink is fine as long as it is not too chipped or the chemicals will corrode the metal base. An excellent alternative is to fit a sink sufficiently large for all the wet work to be done in the sink itself. You will need to support the sink on a sheet of blockboard about ¾in (20mm) thick or it will flex and crack. Such an arrangement is, however, chemical resistant and easy to keep clean.

Installing water

A permanent darkroom without running water is a feasible proposition but having to take wet prints or films elsewhere for washing is inconvenient. A supply of cold water is more important than hot. One hot tap and two cold is ideal because you can wash film or prints whilst making up other solutions, and so on. A mixer tap may seem a good idea, allowing you to wash films in warm water, but has the danger that when a cold tap is turned on elsewhere in the house it reduces the cold water pressure and the film could then be damaged by the sudden rise in water temperature.

The sink waste must be suitably trapped and should run into the foul water drainage, like the bath for example, not into rainwater or surface water drains. Be sure to install the sink so that water runs down the plug-hole. Near the sink you will need a towel.

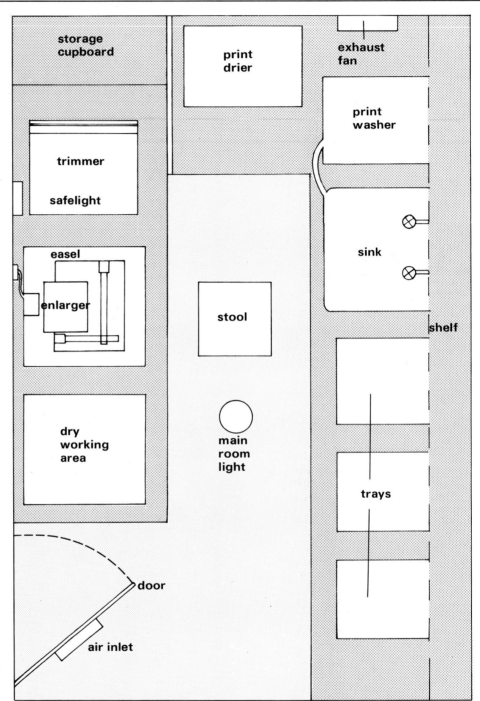

▲ As most people have to make do with a small darkroom, careful planning is essential if the space is to be used to the best advantage.

Smooth linen is preferable to normal terry towels which spread dust and loose fibres.

Illumination

For black-and-white printing you need a safelight, and in a room larger than 6 x 8ft (2 x 2.5m) you may need two. Position a safelight so that it shines well on to the wet bench, making sure it is not closer than the distance recommended by the manufacturer. You will then be able to see clearly what you are doing. Printing papers become much less sensitive to light as soon as they get into the developer so you are unlikely to fog the paper, although you should test it.

It is worth fixing an additional white

Labels in diagram:
dry working area · enlarger · easel · safelight · trimmer · exhaust fan · trays · air inlet · door · room light · shelf · storage cupboard · room light · sink

▲ Some rooms are more difficult to adapt than others. For instance, it isn't always possible to separate the wet and dry areas. The solution is to fit a partition at least 20in (50cm) high that prevents splashes reaching the dry area. However the work flow should still move in one direction.

light near the print washing area so that you can study test strips and final prints in a good light. If so it should have a ceiling pull-switch. Never place an ordinary light switch, or indeed any switch, where you might be tempted to operate it with wet hands.

Other electrics

You will need house power for a number of electrical items: enlarger, film or print drier, print exposure meter and so on. The sockets must be grounded (earthed) and wall-mounted above the bench to avoid fiddling at floor level. Keep them all on the dry side of the room, well away from water. A good number, four or more, of well-placed sockets is a boon. Never be tempted to run an extension cord under the door and then use adapters to plug everything into one socket. It is dangerous. If in any doubt about the electrics ask an electrician.

Heating

Try to maintain the room temperature at a steady and comfortable level, perhaps 59—68°F (15—20°C). Radiators from central heating are perfect. Oil-filled electric radiators are fine, as are other electric heaters which do not give out light or much infra-red. Keep them away from the wet side of the room and cover any lights on them. A thermostat light coming on suddenly while you load a film improves visibility but spoils film. Fan heaters are a nuisance because they spread dust. Oil heaters should not be used because the fumes cannot escape easily from a room with less than perfect ventilation. Also avoid heaters which give out light.

Putting things away

It is difficult to provide too much storage space. Cupboards under the dry bench will store paper, negative files and the bigger pieces of equipment, while drawers are useful for small items. Under the wet bench you will be keeping trays, tanks and other large wet items so it is probably better to leave open shelves or racks—definitely not drawers, which will trap damp. The best place for graduates, small tanks, bottles of chemicals, the clock and so on, is on a shelf above the wet bench or sink.

A 10in (25cm) shelf with a small lip at the front edge to stop things falling off is about right. Further shelves higher up will store the items used less often. If you put up a shelf above the dry bench do not position it in the way of the enlarger.

Cleaning up

After each session you must throw away the exhausted chemicals and pour into storage containers those solutions you wish to keep. Wash out all the wet equipment carefully and put it away tidily so that next time it is clean and ready to use. Unwashed utensils leave chemical deposits which will contaminate subsequent processes and spoil your results. Trays of solution left out days will evaporate, making the solution unusable and the damp will corrode metal equipment. You should occasionally go round the room with a vacuum cleaner to remove dust. For the waste material you produce during printing sessions, the used test strips and the reject prints, a waste-bin will be needed. Get a plastic one. Metal ones rust and wicker ones let water drip through onto the floor.

Once you have done all this you can move all your gear in, spread it out and get to work.

Darkroom accessories: the dry bench

1 All dry bench work is centred on the enlarger.
2 The Paterson Micro Focus finder is designed for low magnification printing.
3 An adjustable enlarging easel allows the width of the print border to be varied.
4 The Paterson Enlarging Meter overcomes the need for test strips each time a print is made.
5 The Saunders Borderless Easel uses sliding metal arms to retain the paper.
6 The Paterson Major Focus Finder is used for high magnification work.
7 An accurate timer ensures that exposures are consistent from print to print.
8 Clear markings on a rotary trimmer and a self-sharpening blade make print trimming easy.
9 This large safelight gives a directional light that can be angled to suit the printer.

Such a large amount of darkroom equipment is available these days that it is difficult for the amateur to decide what will be useful and effective. It is easy to be persuaded by advertisements or salesmen that an expensive item is necessary when its uses are, in fact, limited. Even basic items such as trays or thermometers vary a great deal in quality and design so that a little basic information can be a great help.

Safelights

The first essential for a safelight is that there should be no danger of it fogging your printing paper. The second is that it should let you see what you are doing. Professionals often have a large safelight suspended from the ceiling above their head to give an even lighting to the darkroom, smaller ones being positioned to throw a brighter light over the processing area. The amateur rarely has the space or money for this. One

safelight or at the most two should satisfy his needs.

Though they are not cheap the safelights, such as those made by Kodak, in the form of metal or plastic lamphouses which use flat filters are the best available. They give a fairly directional light and can be positioned so that they do not shine into your eyes. Safelights made in the form of plastic domes give good general illumination but should not come into your field of view since they can dazzle you while printing.

It is a mistake to use a dark green safelight when loading reels with film. Modern materials are very sensitive and will be fogged by even a brief exposure to any form of safelight. Very dark amber or olive green safelights are available for colour printing, but if they give enough light to let you see the darkroom equipment they are almost certainly unsafe.

Provided you follow the manufacturer's instructions you should have no trouble with fogging. Secondhand safelights are a different matter: the filter can easily fade with prolonged use and produce fogging.

If in the slightest doubt, expose a small sheet of paper under the enlarger, giving an exposure that will result in a medium to light grey tone after development. Place the exposed paper emulsion side up at the normal working distance from the safelight, at the same time covering

a quarter of it with a piece of card. After one minute cover half the paper, and after another minute three-quarters of it. Leave the final quarter for two more minutes. Now process the sheet.

The first three steps should all be the same density, though the one that had four minutes will probably have a darker tone of grey. If there is a difference in density between the first three steps the safelight is either too close, is fitted with too powerful a bulb or the filter has faded.

Enlarging easels

These are also known as 'masking frames' or 'printing frames'. There are two basic designs. One produces prints with a white border, the paper being held flat by metal arms that form a frame covering the edges of the paper. Many models have devices for adjusting the width of the margin to suit your particular preference.

The other type of frame produces prints without borders. On some models the corners of the paper are held by friction, using small right-angled metal grips. On others the surface of the frame is permanently sticky. The sticky surface is especially suitable for those RC papers that curl with the emulsion bowed outwards, since such papers are particularly difficult to hold flat with corner grips. Unfortunately the surface gradually loses its stickiness and must be renewed from time to time by spraying with an aerosol adhesive.

When deciding on the size of easel to purchase it is a mistake to buy a very large one for general use as it will prove awkward to handle when making smaller sized prints. An 11 x 14in (25 x 30cm) easel is ideal for making prints up to 8 x 10in (25.4 x 20.3cm). Make sure that the one you buy has a non-slip base, perhaps covered with foam plastic. If it has not, the easel may move slightly as the paper is inserted.

Focusing magnifiers

Some focusing magnifiers use a comparatively low magnification, showing enlarged details of the image. There is no need to bring the eye close to the lens with this type as the image can be viewed from a variety of angles.

Aerial magnifiers greatly enlarge the image of the grain of the negative which snaps in and out of focus and allows the focusing mechanism of the enlarger to be adjusted with great precision. However, to work well the instrument must be placed in the centre of the image on the baseboard and the eye must be close to the magnifying lens. It is difficult to do this when making a big print since you have to stretch up a long way to reach the enlarger's focusing knob. To overcome these difficulties Paterson make two versions, the 'Micro' for normal degrees of enlargement and the 'Major' for big ones. The low-powered focusing magnifiers are rapid and easy to use under any conditions, the more powerful ones are probably more precise.

Print trimmers

The old type of guillotine trimmer, where the paper or card was cut by pulling down a large curved blade, is not readily available today and, unless used with an efficient guard, unsafe. Its advantage was that it could cut very heavy board effectively.

Modern trimmers, such as the one shown here, are usually of the rotary type. The print is positioned on the baseboard and a rotating wheel with a very sharp edge in a protective holder is pulled along a guide bar, cutting through the paper as it moves. The circular blade is self-sharpening and cuts even very thin paper cleanly and accurately, but there is a limit to the thickness of board that can be cut—usually about $\frac{1}{16}$in (1.5mm).

To retain its sharpness the blade must be in contact with the guiding edge all the time. It is, therefore, important that the guide rail, which supports the blade as it moves along, is rigid. If the baseboard is made from plywood it should be thick enough to prevent warping, while if it is metal it must not bend under pressure.

The scale against which the top edge of the print rests should be marked in both inches and millimetres. It is helpful if it also carries indications of the standard print sizes. It is essential that the scale remains at right angles to the guiding edge. If in any doubt about this, check it with a set square.

◀ The most accurate way of focusing is to use a grain magnifier such as the Paterson Micro Focus Finder.

◀ Below: a well made print trimmer with a firm guide bar to support the blade holder is safer and more practical than a craft knife and a ruler.

▶ Although this type of timer is expensive, the initial outlay is more than justified by the consistency gained, which helps to avoid the waste of cruder timing methods.

▼ Once it has been set up, an enlarging meter, such as the Paterson, saves time and paper.

Timers

An inexpensive clockwork-operated timer is suitable for timing the processing of films and paper, provided the dial is large enough and clear enough to be read under safelight conditions. There is no point in buying a luminous type unless you are processing colour or panchromatic material in an open tray. The plastic timers designed for the kitchen are rarely clear or accurate enough for photographic use.

When exposing the paper, an electric timer, that can be preset to switch the enlarger on and off, is to be preferred. The most useful sort are those which it is possible to set to exposures as short as one second or as long as 90 or 100 seconds. For greater accuracy the scale is often spread over two dials, one reading from one to 10 and the other from 10 to 100. The exposure is started by pressing a button. Unfortunately, some of the older types need so much pressure that vibration can be transmitted to the enlarger column. Such timers should be avoided. The lighter the touch needed the better.

The accuracy of electric timers can be affected by long periods in a humid darkroom. Instead of wiring one permanently to the enlarger, plugs should be used so that it can be stored in a dry atmosphere after use.

Enlarging exposure meters

These can be divided into two basic types, both of which can be used for black-and-white and colour. With the first you set the enlarging lens to the stop you prefer and the meter gives the length of exposure needed. With the second the exposure time is set and the meter indicates the aperture needed.

The advantage claimed for the latter is that, when making colour prints, very short or very long exposures cause a shift in colour balance. However, since the aperture of the lens will vary widely with this type of meter it is best used with top quality lenses that will give sharp results with all apertures.

The justification for 'variable time' meters is that all enlarging lenses have one aperture that gives the best result and this is the one that should be used, the exposure being varied to suit.

Both types can give accurate results once you have learnt how to use them and know how to judge the most suitable section of the image to use for the reading. Both are rapid in operation, but remember that an ordinary test strip will probably be as accurate and will give you more information.

Darkroom accessories: the wet bench

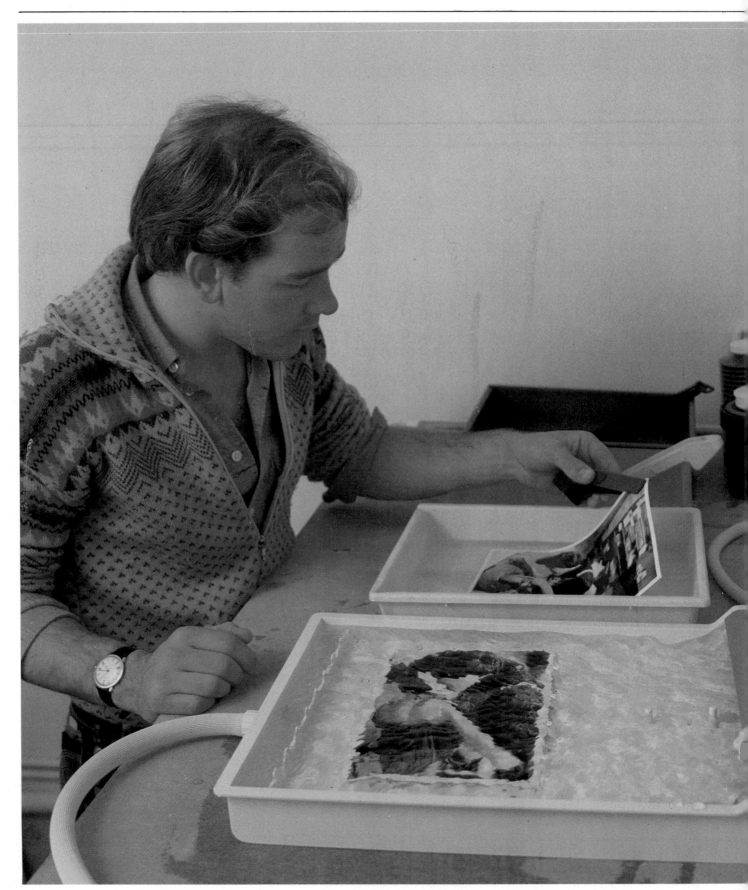

Equipment used in the wet area of the darkroom tends to be subject to quite a lot of wear and tear. The quality of equipment is therefore important, and knowledge of the limitations of each item helps in making wise purchases.

Trays (dishes)

The most practical material is undoubtedly plastic, though it should be of a fairly thick gauge so that it will stand up to hard use and not twist or bend when the tray is rocked. Stainless steel may last a lifetime but it is far too expensive for the average amateur, while enamelled steel tends to chip and crack.

Many photographers prefer to use trays one size larger than the print they are making. This ensures that there is plenty of room for the tongs or fingers to grip the print and lift it out of the solution. Sizes smaller than 8 x 10in (20 x 25cm) are inconvenient to use, even when making very small prints. Unless you intend to process small sheets of film 8 x 10in (20 x 25cm) should be regarded as the minimum size of tray worth buying. To make it easy to identify each solution, it is a good idea to use trays of different colours and always to use the same tray for the same solution. Several manufacturers sell their trays in multi-coloured packs of three with this in mind.

Thermometers

There are three types of photographic thermometers: those with a glass tube filled with mercury or alcohol (a dye being added to the latter to make it visible); those with a metal tube and dial with a pointer on top; and the electronic kind with a digital readout.

Electronic thermometers are very accurate and can be read in the dark, but unfortunately they are expensive. Those with a metal tube and dial are also easy to read but some of the cheaper models are not very accurate. Consequently most amateurs prefer to use the commonly available glass thermometers.

The very cheapest alcohol-filled thermometers can be inaccurate by several degrees, making precision processing

◀ **Organize the wet side of the darkroom so each item is where you use it. To avoid chemical contamination place trays in the order used—developer, stop bath, fix, wash—each with its own print tongs. Wash everything well between sessions. Dirt in the jaws of the print squeegee will scratch prints.**

impossible If you wish to buy one of these it makes sense to pay a little extra for a reputable one certified to within 0.5°F (0.3°C). If you are doing your own colour processing the greater accuracy of a mercury-filled model, which should be certified to within 0.25°F (0.14°C), is essential. The scales on many photographic thermometers only go up to about 86°F (30°C), so if you are going to process modern colour materials check the thermometer scale reaches at least 104°F (40°C) before you buy it.

Once you have bought a thermometer there is a great temptation to use it as an occasional stirring rod. As glass thermometers are very fragile, such misuse should be avoided.

Print washers

The water in an efficient print washer must change constantly and the prints must be separated. It follows that trying to use a sink or bath is rarely successful.

When you buy a print washer it is essential that it is large enough to take the biggest size of paper that you use regularly or are likely to use in the future. Just because you are making 8 x 10in (20 x 25cm) prints now does not necessarily mean you will not make bigger ones as you gain skill and confidence. However, a washing tank for big prints can take up a lot of valuable space and you will need to balance this against the convenience gained when deciding on the size to buy. One of the characteristics of resin-coated printing paper is that it absorbs little of the processing solutions and, therefore, is easily washed. The Paterson High Speed Print Washer takes advantage of this. The water circulation is particularly effective and prints are thoroughly washed in two to four minutes.

Print driers

There are two types of print driers, those meant for traditional fibre-based papers and those for resin-coated papers; they are not interchangeable.

For amateur use the first type comes in the form of a flat metal box with a slightly curved top surface. The prints are pressed into contact with the heated surface by a tensioned cloth. An electric element inside the box heats the surface evenly. Matt prints are placed on the surface emulsion uppermost. Glossy prints can be dried in the same way or squeegeed emulsion down on to a special chromium-plated sheet available at dealers. This is placed on the

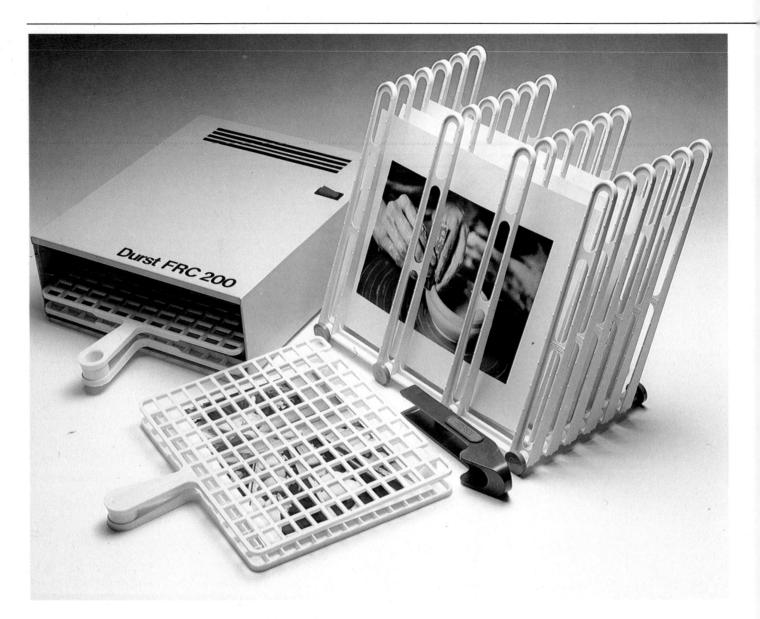

drier, prints uppermost, and the cloth is pulled down over it to keep the prints in contact with the sheet as they dry. The dried prints have a very glossy finish.

If you produce a lot of prints, it might be worth investing in a drier such as the Kaiser 4040 or Arkay Duplex, which has two heated surfaces.

Driers for resin-coated paper are designed in a completely different way. Because the paper does not absorb much fluid, it can be dried in a current of warm air instead of on a heated surface. Expensive professional models work on a continuous flow system in which the prints are fed into the machine through powered rollers. They are transported through the machine automatically and emerge dry in a very short time.

Models for the amateur are designed with wire racks on to which the prints are laid while hot air blows over them. Some amateur models do have rollers, but these are hand-operated and merely remove surplus water from the print surface. If you are producing a large number of prints a relatively sophisticated model such as the Durst FRC400 drier which has four print racks and temperature control of the blower will be useful. But such driers are rather expensive and can only be justified if you do a lot of printing over a long period.

Storage containers

Some people try to save money by storing their chemicals in screw-cap soft drink or beer bottles. This is not only dangerous if children are around,

▲ It is possible to dry modern resin-coated printing materials by hanging them on a line and letting them drip dry. However, that takes up a lot of space and is less efficient than the Paterson Print Drying Rack. The Durst FRC 200 Drier, which blows hot air across the print surface, is quicker but is much more expensive.

but, since the metal cap can react with acid solutions, ineffective. Amber glass bottles or opaque plastic containers, with airtight plastic screw caps, are much safer and give better protection from oxidation while the container is full.

As the contents are used the air space above the liquid in the container increases and if developer is being stored oxidation can easily occur. The chance

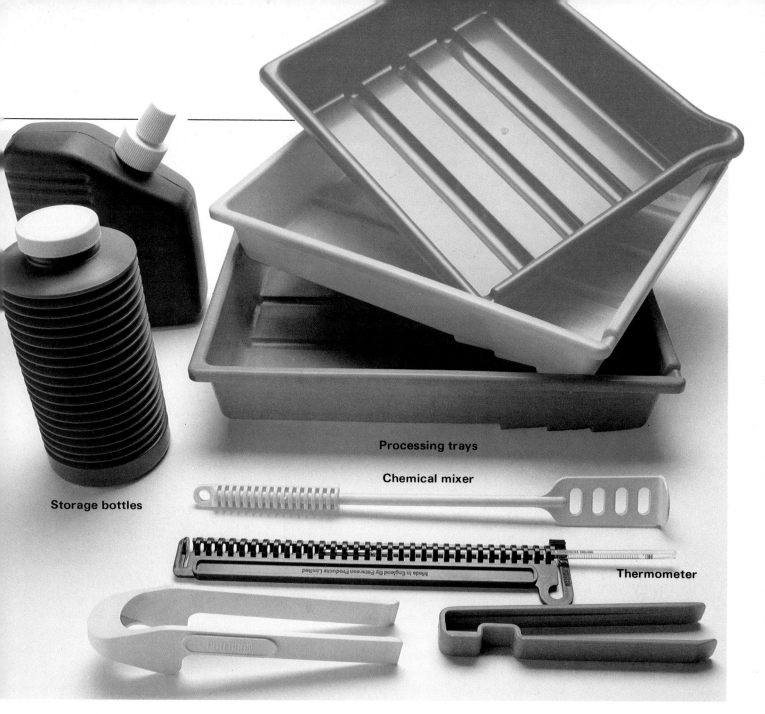

Storage bottles

Processing trays

Chemical mixer

Thermometer

▲ When choosing accessories it is essential to select those that are robust enough to withstand the wear and tear of darkroom use.

▶ The Paterson High Speed Print Washer provides effective water circulation so that residual chemicals are washed from the print very quickly.

of deterioration can be reduced by using a number of small bottles instead of one large one. Alternatively, a crushable container with folding sides, such as the 'Air Evac' bottle, can be used. Every time some of the liquid is decanted, the top of the container is pressed down until the solution comes level with the neck of the bottle. The cap is then screwed on and air excluded until the developer is used again.

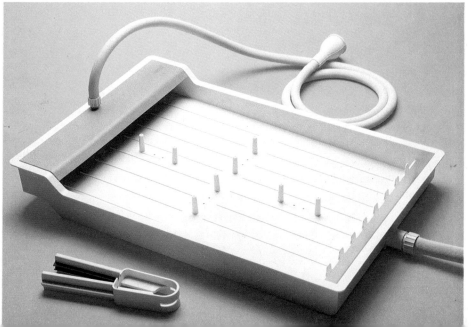

The colour darkroom

These days most amateurs use colour negative film. Unfortunately the prints that are returned to them from the local chemist, photographic dealer or mail order processing house are often of extremely poor quality. Casts that discolour the entire print are far too common.

More often than not the photographer accepts these faults as his or her responsibility. In fact they are much more likely to be that of the processing laboratory. Certainly, if you are given prints that are not satisfactory you should complain.

One way to avoid this and ensure better quality is to print the negatives yourself. Let the professionals do the processing of the film, a standardized sequence to which you can contribute nothing, and then take over the interesting part. Making a good colour print is no more difficult than producing a good black and white one, especially with the equipment that is available today.

The colour darkroom

In planning a darkroom for colour printing, the main object is to arrange the equipment, materials and chemicals so that work can be completed with the minimum of effort, in the shortest time and at the lowest cost. The darkroom is always divided into dry and wet areas but when working in colour, the two need not necessarily be in the same room.

The dry area contains the enlarger, which should stand on a bench slightly larger than the baseboard. This leaves room for the timer and the focus magnifier. You will need a mains power electrical outlet near the enlarger. A shelf or drawer in which to store the packet of paper or the clean processing drum beneath the bench is very useful. Everything else—safelight, dodging tools and other small, light objects—can be hooked on the wall.

The dry area needs to be totally light-tight. To reduce light scatter during exposure the walls near to the enlarger should be painted black to minimize the risk of fogging paper.

The wet area is where the exposed paper is processed. A bathroom is quite suitable since all that is actually needed is a hot and cold water supply, a drain for discarded chemicals and a flat surface on which to position or roll the light-tight processing drum.

If you wish to do more advanced work, larger prints or use the space for long periods then a larger area is required.

Yet, whatever its size, the same separation of wet and dry areas applies. Consistent colour print quality depends on cleanliness, so keep negatives filed away and clean the enlarger lens and baseboard before you begin printing.

Voltage control

Voltage variations in the home, whether slow or sudden, affect both the colour quality and the intensity of the enlarger light. These fluctuations are more common than is generally believed, and, unless dealt with, make consistent quality very difficult to achieve. A variation of only 10 volts changes the light intensity by about 25% and the colour quality by as much as 10 units, usually in the red to cyan range.

The effect of voltage fluctuations can be minimized by printing late at night and adjusting electrical applicances in the home to be either fully on or off.

The problem can be eliminated entirely by using a constant voltage stabilizer. It reacts instantly to sudden or gradual variations before they can affect the enlarger light. If you intend to do a lot of colour printing such a piece of equipment is a sensible investment.

Timers

Exposing colour paper is not that different from the equivalent black and white procedure. However, since colour paper is very sensitive to all but a small fraction of the visible spectrum, any light, other than that coming from the enlarger, has to be eliminated. As accuracy is essential, this means wiring a timer into the electrical circuit of the enlarger so that the light is switched off at a pre-selected time without any need to check a clock face.

Safelights

As colour paper is sensitive to almost all parts of the visible spectrum it follows that no safelight in the colour darkroom will ever give the level of illumination provided by its black and white equivalent. Fortunately colour paper is slightly less sensitive to the yellowish-green part of the spectrum, so a very dim light of this colour can be used so long as the paper manufacturer's instructions regarding darkroom illumination are strictly followed. This means that colour safelights are too dim to use for inspection processing, but it is possible to use them to make out the general features of the equipment.

▶ **Colour print processing is usually carried out in drums. This Paterson Thermo-Drum overcomes the problem of maintaining the temperature of the solutions and the drum by surrounding them with a water bath.**

▼ **A wet print is gently eased out of the processing drum.**

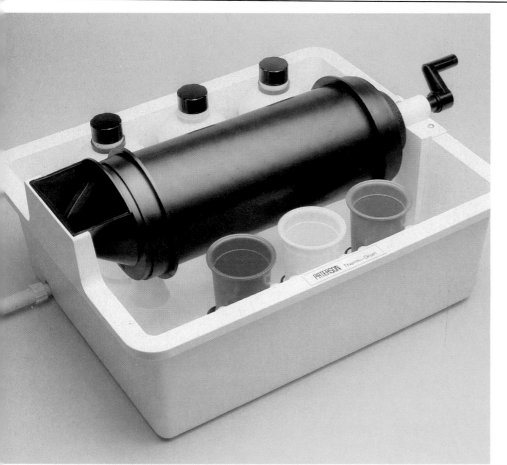

storage bottles, measuring beakers and processing drum all rest in the water. The drum is turned with a handle in the basic unit while an inexpensive, battery operated motor is available separately. The only problem with this unit is the need to keep adding hot water to the bath, but this can be overcome by the addition of a cheap, thermostatically controlled water heater of the type used in tropical fish tanks.

The most sophisticated drums are those made by Jobo or Durst which have motor-drives and thermostatically controlled heaters built into the unit. Obviously, they are rather expensive.

Colour analysers

It is often thought that colour analysers are the complete solution to the problems of getting accurate colour rendition when you are colour printing. However, they need skill to operate properly and a knowledge of colour printing even before you can begin to set up the machine.

When the negative is in the carrier and the enlarger turned on, the analyser interprets the colour and light intensity coming through the negative in terms of its red, green and blue content. This information is converted into numbered filtration values on either a meter similar to a light meter or a digital readout. By adjusting the enlarger filters and the lens apertures in accordance with the information that has been given, the filtration and exposure for every different negative that you produce can be found, given certain conditions.

An analyser can cope with variations in the negative. It cannot deal with changes in the type of film, a change of enlarger or the variations that occur between successive batches of colour paper produced by one manufacturer. If any one of these last three factors change then the analyser must be re-programmed.

A notebook

A colour print is said to be 'balanced' when it appears to represent the original scene accurately. To find this balance tests have to be made that record changes in filtration and exposure. A notebook should be used to record these changes and the final filter combination.

As your records grow you will begin to see a pattern emerge from the information. By taking account of this pattern, you will begin to learn short cuts to the results you want.

The effects of safelight illumination are cumulative. Any time that the paper is exposed the safelight acts on the emulsion. Colour paper fogged in this manner will display a cast that is complementary to the colour of the safelight. With yellow-green safelights the highlights and the border of the print will have a blue-magenta tinge.

This can be avoided by doing without a safelight altogether. If you have difficulty getting your bearings in total darkness, attach strips of luminous tape to buttons and switches.

Tray or drum processing?

It is possible to process colour prints in trays but it is not recommended. Rubber or plastic gloves are necessary to protect your hands but the material tends to absorb the chemicals over a period of time and these residues will eventually contaminate the developer. More important, with so much of the surface of the developer exposed to the air while it is maintained at a temperature perhaps 50°-68°F (10°-20°C) above the surrounding atmosphere, oxidation will be very rapid. Finally the likelihood of chemical carry-over caus-

ing print staining is very high.

Modern drum processors overcome these problems and are much more suitable for home colour printing. All processing stages are carried out in normal room light, which makes solution temperatures and processing times easier to maintain. Drums are designed so that only a minimum quantity of the chemicals is needed for each process and can then be discarded after one use. This eliminates the need to replenish and helps to maintain consistent print quality. Only about 3 US fl oz (90ml) of each processing solution is needed for an 8 x 10in (20 x 25cm) print.

The simplest type of drum is one that is rolled backwards and forwards on a flat surface. These are inexpensive but have the drawback of an additional initial processing stage. Hot water has to be poured in to heat the paper and drum to the processing temperature before the development is begun.

The Paterson Thermo-Drum overcomes this by incorporating a plastic bath into the design of the unit. Hot water is poured into this and topped up at frequent intervals to maintain the processing temperature. The chemical

Darkroom safety

All darkrooms use electricity and water, and are therefore potentially dangerous. But it is not difficult to make your darkroom a safer and more comfortable place to work in.

Planning for safety

The basic layout of your darkroom is dictated by the space you have to spare. When you decide where you will set up your darkroom and what will be in it, you should keep the following points in mind:

Efficiency: A darkroom that is easy to work in is a safer darkroom. Plan the layout of fixtures to cut down on unnecessary movement. By having your wet bench opposite the enlarger rather than alongside it, you simply need to turn around rather than move sideways to process your prints. A small darkroom can be better than a large one if it is carefully planned.

Furniture: Avoid bench heights that produce backache. Store as much as you can at eye level or in drawers. If you never have to bend down to look under a bench, you will never risk knocking your head on a table or open drawer when rising. If you do not have to reach or climb up for stored items, you will be less likely to drop them or to fall over. Standard kitchen cupboard units are designed to give comfortable working for people of average height. Choose units without sharp corners. Whenever you buy anything for the darkroom, make sure that it is rounded, waterproof, and preferably light in colour. A round plastic doorknob is preferable to a metal L-shaped handle.

Let the air in: Ventilation is vital in any work area. Buy or make a light-tight ventilator. A darkroom exhaust fan is even better. If you must work in a small, poorly ventilated darkroom, arrange to wash your prints somewhere else. Leaving the room after every few prints to take them to wherever they will be washed ensures changes of air.

Leave a way out: Darkroom doors should be light-tight, but it must also be possible to open them from the outside. A 'keep out' notice is safer than a lock which may jam. Most rooms have doors that swing inwards, but outward-swinging doors are more suitable for darkrooms. They can be opened more quickly in an emergency, they cannot be jammed shut by people overcome by fumes inside the room, and they do not take up valuable darkroom floor space.

Avoid mixing water and electricity: Keep the water supply as far from electricity points as possible. Never run power cables under water pipes. Pipes and taps can leak.

Electricity safety

The essential requirements of your darkroom's electrical system are that (1) it should be grounded (earthed) and that (2) the maximum load on it should not be greater than the capacity of the wiring or the main supply. Check that the ground connections really are connected to ground, not just to each other.

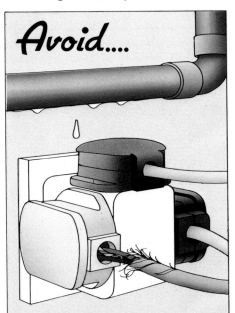

Avoid....

. . . overloading electricity sockets. Also, if you install your own wiring, make sure that there are no pipes or taps nearby that could leak water. Replace all frayed cords.

Power requirements: To work out how much supply capacity you need, you must find out the amperage of the current you will be using. To do this, add up the wattage of each lamp or appliance you will run from a circuit. Then divide the total wattage by the voltage of your electricity supply. The result is the minimum amperage that the circuit must be capable of handling. To be on the safe side, always round the answer up to the next whole number. For example, a 150 Watt enlarger bulb, a 300 Watt print dryer, a 40 Watt safelight, and a 75 Watt tray warmer add up to a total of 565 Watts. If the supply is at 110V, the amperage will be 5.1 amps, and you will need at least a 6 amp circuit to handle this current. (With a 240V supply, the amperage will be 2.3 amps and will need a 3 amp circuit.) Typical household power circuits will

handle 15 or 13 amp currents, but be sure to check with an electrician or your electrical dealer to find out what load you can put on your darkroom wiring. Be careful if your house has ring circuit Wiring. Other appliances may be connected to the same circuit as the darkroom. Never put into any circuit a higher amperage fuse than it is designed to take. Fuses are designed to be the weak link in a circuit that will blow out when there is an overload. If the fuse can handle more current than the circuit, then an overload will cause a failure somewhere else, and may start a fire.

If your local electricity supply is only at 110 volts, do not imagine that you can ignore electrical safety. If your power outlets are not grounded (earthed) you risk electrocution whenever you use an electrical device with a metal casing. Make sure that all your darkroom equipment conforms to local regulations and the Underwriters Laboratories Code. Be careful when inserting or removing two-prong plugs— it is easy to touch the prongs while they are halfway in the socket and still carrying current. Screw-in lamp holders can also become live if they are wrongly connected.

Chemical safety

Try to handle photographic chemicals as little as possible. Even the most apparently harmless chemical can affect

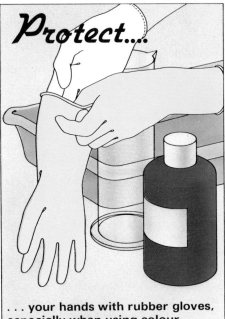

Protect....

. . . your hands with rubber gloves, especially when using colour chemicals. You can wear cotton gloves underneath for greater comfort and to soak up perspiration.

your skin in time. Dermatitis can result from allowing the hands to come into contact with photographic chemicals. Symptoms of dermatitis include discolouring and cracking of the skin. This can be very difficult to get rid of. Some people are prone to Metol dermatitis, which is an unpleasant rash caused by a common developer ingredient. If you develop a rash, try changing to a developer that does not contain Metol.

Wear rubber or thin plastic gloves when mixing and pouring chemicals. Use a funnel whenever possible to pour chemicals from one container to another. Put drip trays under measures and bottles to catch chemical spills. If you don't want to wear rubber gloves when processing your prints, use print tongs instead. This will save the skin of your hands and help to stop your prints from being contaminated by chemicals as well.

Mixing chemicals: When mixing any concentrated chemicals with water, it is best to pour the chemical into the water rather than other way around. This

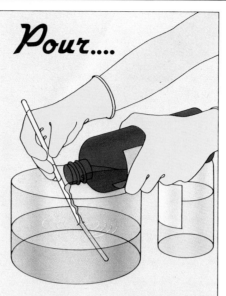

Pour....

... chemicals down a thermometer or a stirring rod if you do not have a suitable funnel. This helps avoid spilling chemicals, but if spills do occur mop them up at once.

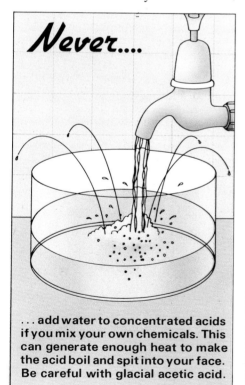

Never....

... add water to concentrated acids if you mix your own chemicals. This can generate enough heat to make the acid boil and spit into your face. Be careful with glacial acetic acid.

applies particularly to concentrated acids, which can boil and splash out of their container when water is added to them. Mix chemicals in a well ventilated room with running water on hand to wash off any accidental spills.
Store chemicals in locked cupboards as an added precaution. Label all bottles as

soon as they are filled. Use waterproof labels and ink. If you should find an unlabelled bottle in your store cupboard, never attempt to identify the contents by smell. The fumes from chemicals such as concentrated acetic acid can cause lung damage. Always read directions which come with packed

Always....

... give yourself plenty of air when mixing chemicals that give off fumes or are composed of very fine powders, but avoid draughts! Aprons, and even face masks can be useful.

chemicals and follow their safety suggestions.

Chemicals spilled on the skin can usually be washed off quickly without harm. If you should get chemicals in your mouth or eyes, or if you should actually swallow any chemical, you must see a doctor as soon as possible. In the mean time, rinse the affected area with plenty of water. If corrosive chemicals have been swallowed, do not try to induce vomiting, as this may result in the chemical getting into your lungs. Drink plenty of milk until help arrives.

Don't....

... allow children into your darkroom without supervision. Never put chemicals in old soft drink bottles, or leave them in unlocked cupboards within reach of a child.

Other points to watch

● Tray warmers may overheat if they are left switched on for too long. They can produce enough heat to melt a plastic tray left standing on them after the solution has evaporated.

● Flat-bed print dryers can also overheat dangerously if left switched on for too long.

● Unguarded guillotines for cutting paper and mounting boards are dangerous and are illegal in some parts of the world. A rotary trimmer is much safer.

● Never use craft knives in the dark or by safelight to cut photographic paper. Blunt-ended scissors are safer.

● Never take the head off a counterbalanced enlarger without locking the mounting in place on the column first. Without any weight on it, the mounting can fly up and hit you.

DANGER IN THE DARKROOM

Does your darkroom look like this? If it does, you are running a serious risk of injury. See how many danger spots you recognise before you check through our list.

1 Water pipe over a power outlet. If the pipe ever leaks, you will be in trouble.

2 Overloaded adaptor—have proper sockets installed by an electrician.

3 Replace frayed wiring immediately.

4 Never leave knives lying around. Use a knife with a retractable blade.

5 An oil heater does not belong in a poorly ventilated room. Do not leave piles of paper where they can create a fire risk.

6 A drawer left open over a cupboard at floor level—an easy way to give yourself a bruised head.

7 It is easy to slip on a loose rug on a smooth floor.

8 The heater on top of the rug is a fire hazard, and the trailing power cord is a potential trip wire.

9 If you leave your prints to wash unattended in a sink, they can block drainage and cause an overflow.

10 The door to your darkroom should open outwards, have a round door knob and should not be locked.

11 Never leave your tray warmer switched on while you are out of the darkroom; another potential fire hazard.

12 Make sure that your shelves will support the weight you put on them.

13 A guillotine without a safety guard is dangerous, especially if you store it on a high shelf.

14 Do not store chemicals in drink bottles—especially if there are children in your house.

15 Never eat in your darkroom—even if you do not put your sandwiches in pools of spilled chemicals, you can still contaminate your food with chemicals on your hands.

16 Never store bottles where you can kick them over accidentally.

17 Do not leave furniture where it can get in your way in the dark.

18 Empty your waste paper bin before it overflows. If you must smoke in the darkroom, use a proper ashtray rather than risk setting fire to the contents of your bin.

Many of the hazards in this picture are made worse by low light levels. Some are dangerous under any sort of light. There are some things that the picture cannot show, such as lack of ventilation. But the major omission is the photographer who should be clearing up the general mess and turning off the overloaded electrical equipment.

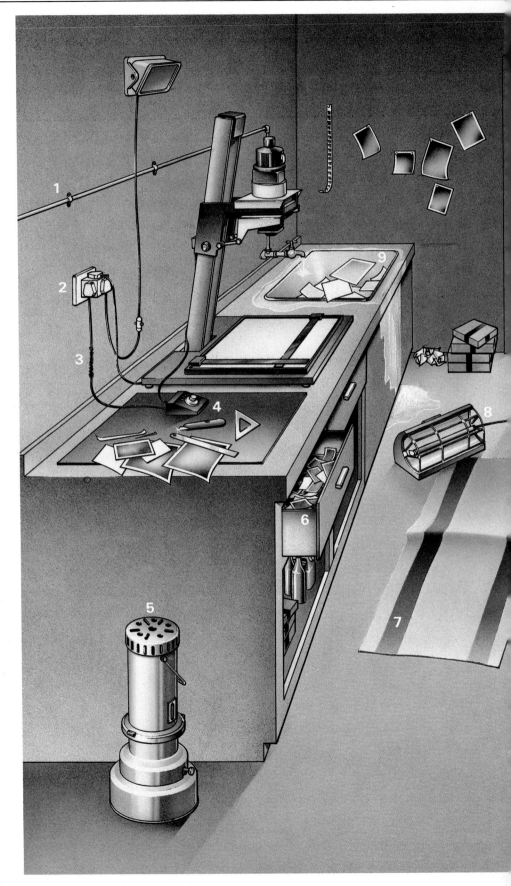

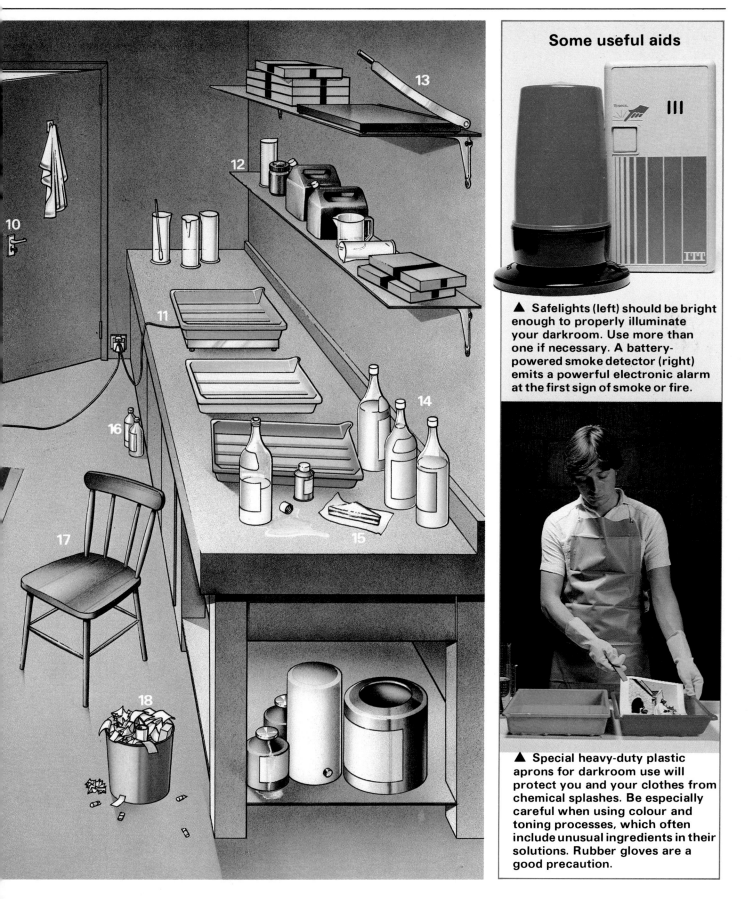

Some useful aids

▲ Safelights (left) should be bright enough to properly illuminate your darkroom. Use more than one if necessary. A battery-powered smoke detector (right) emits a powerful electronic alarm at the first sign of smoke or fire.

▲ Special heavy-duty plastic aprons for darkroom use will protect you and your clothes from chemical splashes. Be especially careful when using colour and toning processes, which often include unusual ingredients in their solutions. Rubber gloves are a good precaution.

Choosing an enlarger

Undoubtedly, the most important piece of darkroom equipment is the enlarger, which is a special type of projector (similar in principle to a slide projector). With it, you can make an enlargement of the whole negative or select a portion of it and print just that area, which makes the enlarger a very creative photographic tool.

A new enlarger will probably be the most expensive item in your darkroom. Knowing how an enlarger works, and what designs are available will help you decide which model is best suited to your needs.

All photographic enlargers do basically the same thing. They project an image on to a sheet of sensitive material to make a print. Every enlarger has a light source, a means of directing the light, a carrier to hold the negative and a lens to focus the illuminated image. These components are integrated into one unit known as the 'enlarger head', which is supported on a rigid column. This is attached to a baseboard, which also acts as a surface on which to place the printing paper or a printing easel. Some models can be wall-mounted for extra stability.

In normal use, the negative carrier, the lens and the baseboard should be kept parallel, although the distances between them can be altered to change the size of the projected image and to focus it.

The main differences among enlargers lie in the light source and whether they are designed primarily for black-and-white or for colour work.

Colour enlargers are similar to those for black-and-white, except that they need facilities for introducing colour filters somewhere between the light source and the negative. This may be a drawer for gelatin filters or a special colour head which incorporates the filters into a mechanism connected to a set of colour coded dials.

Types of enlarger

It is most important that any light source provides even illumination over the whole of the negative area and there are three ways to achieve this. There is the condenser system, the diffuser system, or a happy combination of both, known as a condenser-diffuser or semi-diffused system. Both condenser and condenser-diffuser types are usually only suitable for printing negatives up to 5 x 4in (12.7 x 10.2cm).

Condenser-diffuser enlargers: most amateurs and many professionals use enlargers which have this mixed system.

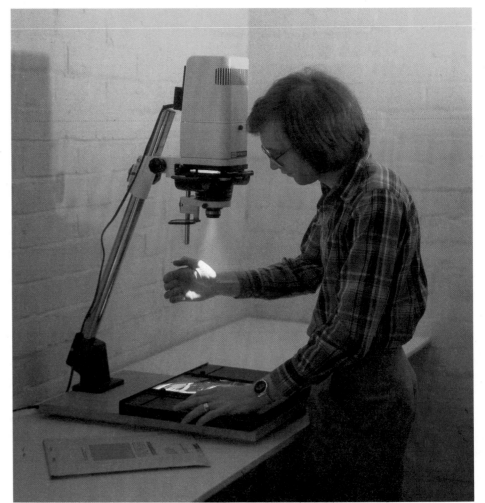

It includes an opal light-bulb to diffuse the light and a pair of condensers (or sometimes just one) to focus the light, after it has passed through the negative, as a brief patch of light on the enlarging lens.

Direct light condenser enlargers: use a point source lamp (bulb) and the condensers focus the light on to the lens as a bright point of light. One of their characteristics is that they give a rather contrasty image, owing to the Callier effect. With this effect, light passing through the negative is partially absorbed and scattered by the silver grains in the emulsion, while in the clear areas light passes through freely.

Diffuser enlargers: since negatives larger than 5 x 4in (12.7 x 10.2cm) need big condensers for even illumination, diffusion lighting is used, especially in professional darkrooms, for enlarging negatives 5 x 4in (12.7 x 10.2cm) and upwards. The light usually comes from a type of fluorescent tube called a cold cathode source behind a diffusing screen

▲ The enlarger is vital equipment in the making of a print, and should be chosen carefully. Check whether the price includes a lens, as not all enlargers are supplied with one.

and, unlike the condenser enlarger, it stays cool all the time.

Most colour enlargers, for any size of negative, use a diffused light system and usually have a halogen lamp.

Lenses

To do justice to a negative you need a first-class enlarging lens. Wide aperture lenses cost more but give a brighter image for easier focusing.

Standard focal length lenses for the most popular negative formats are:

110 — 30mm	6 x 6cm — 80mm
35mm — 50mm	6 x 7cm — 90mm

The magnification you can achieve with any enlarger depends not only on the film-to-baseboard distance, but also on the focal length of the lens in use.

Wide angle lenses enable you to make

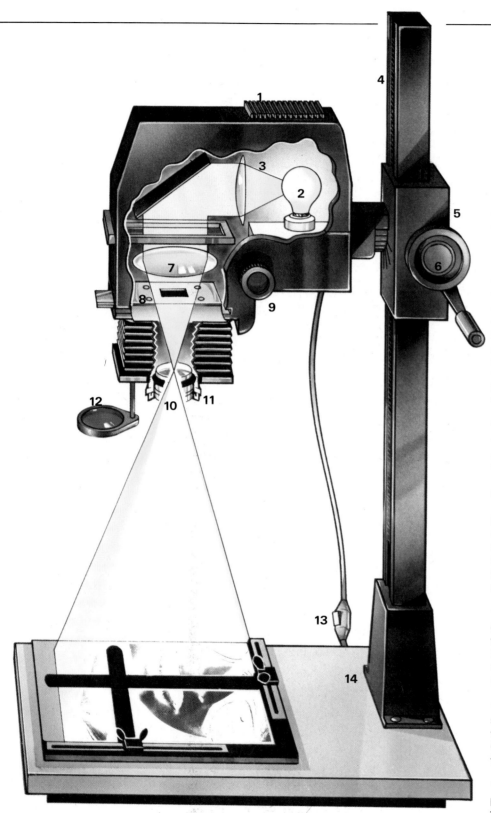

A condenser-diffuser enlarger

1 VENTILATION FOR LAMPHOUSE

2 BULB This must be an enlarger bulb of the correct wattage for that size of lamphouse. The manufacturer or your dealer will advise you if in doubt. An adjuster mechanism focuses the bulb for different negative sizes or very large enlargements.

3 LAMPHOUSE

4 ENLARGER COLUMN Enlargers with heavy heads may have twin or flat columns for additional rigidity.

5 HEAD LINKAGE TO COLUMN Many linkages have a locking wheel for rotating the head through 90° to project on to a wall for giant enlargements.

6 HEAD TRANSPORT This device may simply free the head so that it can be raised (to make the image on the paper bigger) or lowered (to make it smaller), or it may move the head by friction or by rack and pinion drive.

7 CONDENSERS Condensers focus the light sharply on to the negative and must be large enough to cover the whole negative area.

8 NEGATIVE CARRIER

9 LENS FOCUSING WHEEL This device works the lens focusing system which may be bellows or telescopic tubes, altering the distance between the lens and the negative to produce a sharply projected image.

10 LENS Some enlargers take different focal length lenses for use with different negative sizes but a lens which prints 35mm negatives will also print **126, 110,** and portions of larger negatives.

11 f STOPS As on a camera, these stops control the amount of light by varying the aperture of the lens. Click stops are helpful as you can feel each change of f stop.

12 RED FILTER In black-and-white printing this filter is swung in front of the lens to prevent the paper being exposed while it is being positioned under the enlarger.

13 SWITCH for light in lamphouse.

14 BASEBOARD

bigger enlargements without having to increase the film-to-baseboard distance. These are normally 40mm focal length for 35mm negatives, and 60mm for 2¼ x 2¼in (6 x 6cm). Unfortunately, not all enlargers give even illumination with wide angle lenses.

Lens mounts
The lens is usually screwed directly into a threaded plate on the enlarger. On most enlargers this is a standard fitting, the Leica 39mm screw thread. Some enlargers offer faster lens changing and greater versatility by using lens panels which lock or bayonet into place, each lens being mounted in its own panel.

The negative carrier
The negative carrier holds the film flat and should allow it to be moved without being scratched. The carrier must be dust-free, light-tight, and must not overheat. It should not crop negatives too much at the edges.
There are two basic designs.
Glass carriers sandwich the film between two glass plates. The film is held flat but the carrier can scratch, trap dust, leak light and give interference effects caused by partial contact between the film and the glass. Some manufacturers supply anti-Newton ring glasses which minimize interference caused by film/glass contact.
Glassless carriers reduce problems with dust but rarely hold the film completely flat and may scratch the negatives. Some have a mechanism which transports the film, but most open against

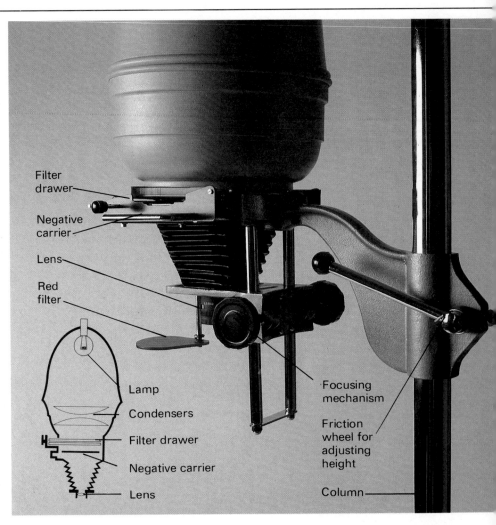

Filter drawer
Negative carrier
Lens
Red filter
Lamp
Condensers
Filter drawer
Negative carrier
Lens
Focusing mechanism
Friction wheel for adjusting height
Column

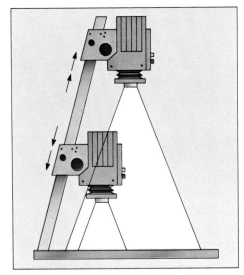

▲ With an inclined column, the enlarger head can be raised without any danger of the projected image overlapping the base of the column.

a spring pressure, allowing you to move the film by hand. With metal carriers, rough edges may scratch negatives; plastic carriers are less prone to this.
A carrier with an upper glass surface and a well finished metal track forming the lower half is a good compromise. There are different sized carriers for different film formats. Some have adjustable masks— useful when printing a negative which is smaller than the size for which the carrier was intended.

The focusing mechanism
There are various forms of focusing mechanisms:
The helical screw, which is precise but limited in the distance through which it can be turned and is usually found only on 35mm enlargers.
Telescopic tubes, which are found on cheaper 6 x 6cm enlargers.
Bellows, which allow a much wider range of movement. They also enable the enlarger head to be tilted to correct, to some extent, 'distortions' created in the camera.

▲ All the dials and levers should be accessible and easy to operate. Can the head be raised and lowered easily? Focusing should be smooth enough to enable fine adjustments to be made.

The column
To produce sharp prints free from blur caused by vibration, the column must hold the enlarger head stable while the exposure is being made.
Single columns are made of plated tube steel, usually about 1½in (3cm) in diameter, and between 26in (65cm) and 36in (1m) high.
Double columns have two steel tubes and are therefore more rigid.
Box columns, rectangular in cross-section, offer greater stability than a single tubular column.
Inclined columns slope about 20° to the vertical with the head set at a compensating angle to keep it parallel to the baseboard. As the head is moved up the inclined column it also moves towards the centre of the baseboard, allowing larger prints to be made.

Reversible columns allow the head to be turned round to project the image on to the floor when making giant enlargements. Some enlargers allow horizontal projection on to a wall.

A particularly convenient feature of some enlargers is automatic focusing: once a negative has been focused, mechanical linkages enable magnification to be changed without the need for manual refocusing.

The head transport system: this is another weak point on many enlargers.

Rack and pinion drives are best because they are very positive. Many friction drives, especially those found on cheaper enlargers, tend to stick and jar when they get older. They only work well on the lightest (that is, 35mm) enlargers.

Care of the enlarger

When not in use the enlarger should be kept covered and checked for cleanliness about twice a year.

To clean the lens use a lens tissue (a clean bit for each surface) or a soft

blower brush but, if it is very dirty, you should have it cleaned professionally. Brush off any dust on the condensers with a soft brush.

Check that the paint on the mounts for the condensers and the masks for the negative carrier is not chipped: touch up with matt black paint if necessary. In time the light bulb may become dirty and can sometimes be cleaned with household abrasive cleaning powder. If the bulb becomes blackened inside, you should change it.

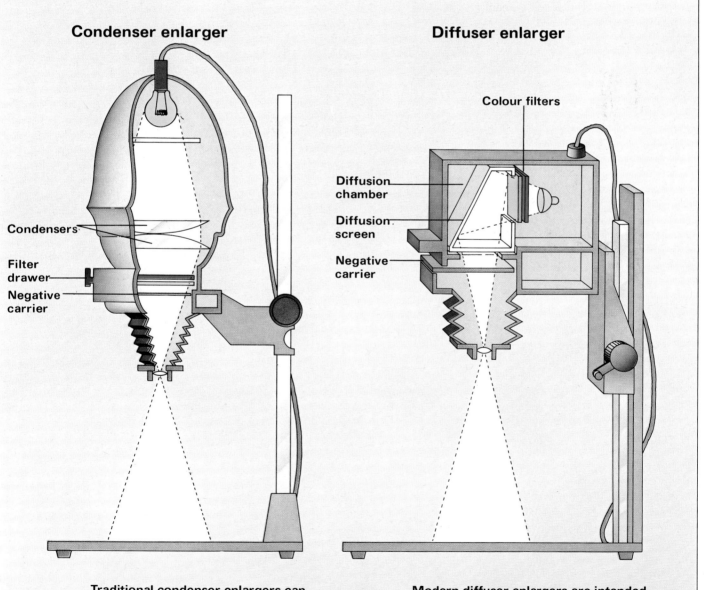

Condenser enlarger

Condensers

Filter drawer

Negative carrier

Diffuser enlarger

Colour filters

Diffusion chamber

Diffusion screen

Negative carrier

Traditional condenser enlargers can be used for colour printing by putting individual filters into a drawer between the condensers and the negative.

Modern diffuser enlargers are intended for colour printing. Variable filtration is dialled in before the light is mixed and reflected through the negative.

Choosing a colour enlarger

If you intend to do a lot of colour printing it makes sense to use an enlarger specially designed for colour work.

A colour enlarger is basically the same as a black-and-white one— it is essentially a movable vertical projector which throws an image on to a baseboard fixed to the lower end of the column which joins the two. The 'projector' component— the enlarger head— includes a light source, a method of focusing or diffusing the light, a negative carrier, a focusing mechanism and a lens. The baseboard acts as a focusing surface and as a support for the light-sensitive photographic paper.

The main mechanical requirement of an enlarger is that the negative carrier, the lens and baseboard are all parallel to each other. The whole enlarger structure must of course be very stable to eliminate vibrations which could cause unsharp prints.

The essential difference between making colour prints and making black-and-white prints is that you need to use special printing filters for the former. These are used to colour the light from the enlarger lamp to suit the require-

ments of the colour printing paper. The amount of colour correction needed depends not only on the paper but on other factors too: the negative (or slide film) used to take the picture; the lighting conditions when you took the picture; the processing of the film; and the processing of the paper. All of these (and more) can alter the colour balance of the finished picture.

To compensate for such variables, enlarger manufacturers produce special 'colour heads' that easily can be adjusted to give different coloured light. These include dichroic colour filters, filter dials, a tungsten-halogen lamp and a mixing box or condensers.

Dichroic colour filters

Dichroic filters are made of glass. They are quite small, about 1in (25mm) square. There are three of these filters in a colour head. One transmits yellow light, one transmits magenta light and the third transmits cyan light. The amount of colour correction required is achieved by progressively inserting the filters into the light path. If the maximum amount of correction available is, say,

130 units, then if half the filter is in the light path it will give 65 units of colour correction.

One of the reasons why colour heads are expensive is that the mechanism that inserts and retracts the filters must be very accurately made to give consistent and repeatable results. Dichroic filters are also expensive to make. They are formed by depositing very thin, transparent layers of non-metallic compounds on to the glass. The coatings are deposited by a vacuum process like the one used in coating camera lenses.

Dichroic filters work in a different way to dyed gelatin filters. The latter absorb specific colours and transmit the rest of the light, while dichroic filters work by reflecting back the unwanted colours. Dichroic filters are therefore more efficient than gelatins. They are fade-free, so their life is far longer. In addition, movable filters provide a continuous range of colour density compared with the fixed steps of gelatins.

Filter dials are used to adjust the amount of filtration introduced into the light path. These have graduated figures included on them so that settings can be repeated. The 'units' chosen are arbitrary, and vary from enlarger to enlarger. In many colour heads the filter dials are backlit so that settings can be adjusted in the dark.

Because the dichroic filters in a colour head are so small, a narrow concentrated beam of light is required to work with them. Most manufacturers have opted for a **quartz-halogen** lamp with an integral reflector to achieve this. These are low-voltage lamps. 12V, 18V and 24V being in common use. A **transformer** is needed to convert the voltage to that of the halogen lamp. (Transformers are usually supplied with colour enlargers.)

After the light has passed through the dichroic filters it must then be thoroughly mixed to produce a homogenized beam of coloured light. Most colour enlargers use a **diffusion box** to achieve this. In it simplest form, a diffusion box can be a white painted chamber with a pair of opal diffusers at the entry and exit points.

Diffusion systems have very useful advantages in colour printing. First, any dust or scratches on negatives or slides are much less obvious on the print than they would be if a condenser enlarger were used. Second, diffusion systems tend to give much more even illumination. Some makers still prefer to use condenser systems, however, and others have evolved unusual systems.

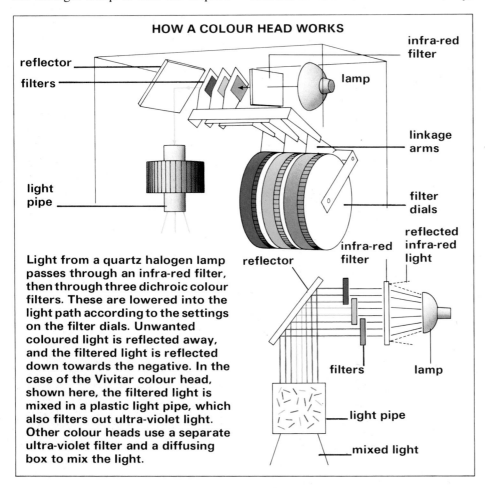

HOW A COLOUR HEAD WORKS

reflector
filters
light pipe
infra-red filter
lamp
linkage arms
filter dials
infra-red filter
reflector
reflected infra-red light
filters
lamp
light pipe
mixed light

Light from a quartz halogen lamp passes through an infra-red filter, then through three dichroic colour filters. These are lowered into the light path according to the settings on the filter dials. Unwanted coloured light is reflected away, and the filtered light is reflected down towards the negative. In the case of the Vivitar colour head, shown here, the filtered light is mixed in a plastic light pipe, which also filters out ultra-violet light. Other colour heads use a separate ultra-violet filter and a diffusing box to mix the light.

(One manufacturer has chosen a 'fibre optic' approach, in which the light colour is mixed in a rod of plastic.)

Some colour heads have additional features. One which is very useful is a **white light lever.** This is used to instantly remove all dichroic filters out of the light path so that focusing and composition can be checked with the brightest possible image on the baseboard. Afterwards, a simple flick of the lever instantly puts back all the filtration exactly as before.

Another feature is a **supplementary filter.** This is usually a pale red dichroic filter which can be switched in or out of the light path (it cannot be progressively inserted—it is either in or out). The supplementary filter is useful should you 'run out' of yellow and magenta filtration when printing from colour negatives, but this is an extremely rare occurrence.

Choosing an enlarger

It is essential to try out something as expensive as a colour enlarger before purchase, so go to a dealer with demonstration facilities. Check these points before you decide:—

● Does the enlarger have a high enough light output? Some colour materials are not very sensitive, and exposure times can become long if the enlarger light is not powerful enough. This can lead to odd colour casts and exposure problems.

● Is the illumination even across the negative? If the corners of the projected image are significantly darker than the centre your prints will show the difference. This is particularly so with contrasty colour slide printing materials.

● Are all controls easy to operate in the dark? Most colour enlargers have illuminated filter dials—a useful aid.

● Is the enlarger built to last? Controls should turn easily and lock positively. The enlarger head and column should be as rigid as possible. A useful comparison test is to balance a glass of water on the enlarger head or column with the machine set for maximum magnification. Tap the enlarger head gently, then time how long it takes for ripples on the water to die away.

● Will the enlarger handle all sizes of film you think you are likely to use in the future?

● Will the enlarger make big enough prints for you?

● Can you fit the enlarger into the space available in your darkroom? If you need to pack your enlarger away between printing sessions, can it be dismantled easily?

▲ **DURST M605K**
This enlarger incorporates a special supplementary red filter for use when printing colour negatives. A light-emitting diode indicates when this filter is in place, while a similar indicator lamp tells the user if the white light lever has removed the dichroic filters.

▼ **VIVITAR V1**
The light emitting end of the light pipe. Light is diffused inside the pipe by internal reflection from the pipe's polished sides. The end of the pipe has a ground matt surface from which the light is radiated. This stays cool even during long printing sessions.

▲ **PHILIPS PCS 150**
This light source fits inside the PCS enlarger. Three lamps behind filters throw their light into the enlarger condenser system by way of a mirror, removed here for clarity. White light focusing is available by turning all three lamps up to their maximum output.

LEITZ FOCOMAT V35

This costs twice as much as most 35mm colour enlargers, but it does have automatic focusing. Also, it comes complete with a 40mm f2.8 wide angle enlarging lens which allows 16 x 20in (40 x 50cm) prints to be made on the baseboard despite the compact dimensions of the enlarger.

The Focomat uses the same kind of illumination as the Durst M605K, reflecting the light through 90° in the colour mixing box. However, the chassis and head-carrying mechanism is completely different. Instead of a column where the head moves up and down, there is a short, thick column base. The head, carefully counterbalanced, is supported by an arm attached to the top of this. The base of the column spreads out into a solid box which houses the transformer and voltage stabilizer for the 100 watts 12 volt bulb. After releasing a single locking knob, the head can be moved effortlessly up and down with the right hand. As the head swings up and down the image changes size but stays in perfect focus.

The V35 is an extremely heavy enlarger, and vibration is low, despite the head-to-baseboard distance. Of the four enlargers it is the quickest to use. But its refinements are probably of most use to the more advanced worker.

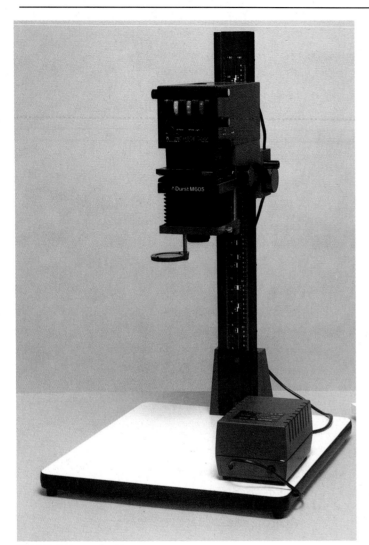

DURST M605K

This colour enlarger is probably the one with which most other amateur machines are compared. It is a very sturdy, excellently designed enlarger. The baseboard is 20 x 22in (50 x 55cm) and the column is 32in (83cm) tall. Prints of up to 16 x 20in (40 x 50cm) can be handled on the baseboard.

The M605K can accept all film sizes from 110 up to 6 x 6cm. The adjustable film carrier is beautifully made and can be used glassless, with one glass, or with two glasses. A huge range of masks for all film sizes, and mounted slides, are available as extras.

A 12 volt, 100 watt lamp is used. The Colitra transformer is very smartly designed.

Filtration is by three dichroics. An integral UV filter is included. The maximum filtration for all three colours is 130 Durst units (roughly equal to 200 Kodak units). A white light lever is included together with a very useful LED warning on the front panel to indicate that it is being used. A supplementary red filter (about 40Y–40M) is also incorporated and this too has an associated warning LED.

The M605K has two integral diffusion boxes, selected by a sliding lever. One is for all sizes up to 35mm, the other for sizes up to 6 x 6cm. This facility shortens printing times for small negatives.

The comprehensive instruction book is excellent.

PHILIPS PCS 130 with PCS 150

The basic PCS 130 enlarger resembles other well-made units but the interesting part is the PCS 150 light source.

Instead of using one lamp and three subtractive (yellow, magenta, cyan) dichroics, the Tri-One light source consists of three lamps each filtered by additive dichroics (blue, green, red). The intensity of each lamp is adjusted, using a special electronic control console, to give differing colour mixes. The electronic console, which includes a timer section, is beautifully made. Instead of a white light lever, the console has a 'focus' setting which instantly gives maximum light intensity with white light from the mixture of colours.

Theoretically, additive filtration should give improved colour saturation. In practice, any differences are quite small.

The three lamps used are 14 or 24 volt, 35 watt types. Philips claim that there is very little likelihood of ever having to replace even a single lamp as they are all run well below their maximum output.

The enlarger is very well made. The 1in (2.5cm) thick baseboard measures 18 x 24in (45 x 60cm) and the carrier takes all sizes from 110 to 6 x 7cm but you have to buy special masks for certain sizes. A double condenser system is utilised and accessory condensers are also needed for certain formats. The instruction leaflets are reasonably good but the one for the PCS 150 does not go into a lot of detail.

VIVITAR VI

The first thing that impresses about this machine is the height of the column— it's all of 48in (122cm) tall. The other immediately noticeable thing is the superb construction. The baseboard measures 18 x 24in (45 x 60cm) and is 1in (3cm) thick. This enlarger, which takes film sizes up to 6 x 7cm, uses a unique method of filtration mixing. Instead of a conventional diffusion box the Vivitar VI incorporates an acrylic light pipe in which the colours are mixed by internal reflection. This approach gives a higher light transmission than is possible with diffusion boxes. It is also a much cooler light source and ensures that films do not buckle, even slightly.

The lamp is a 110V, 75 watt type or a 19V, 80 watt type. The well-made transformer that feeds it is not needed in the US. The filters are the usual yellow, magenta and cyan dichroics. The filtration range for all three filters is 0 to 200 units. The backlit filter dials are very large and extremely easy to read accurately. Infra-red and ultra-violet filters are incorporated. A white light lever is also included.

This enlarger is a little unusual too, in that it uses condenser lenses to focus the light on the negative or slide. This system shows up any dust, hair or scratches in the film so scrupulous cleanliness is essential. Light output is not perfectly even, but an accessory filter is available to correct this.

The instruction manual, supplied in a ring binder, is superb.

Colour analysers

▶ A heavy-duty professional colour analyser. This expensive instrument incorporates advanced features such as digital read-out, matched silicon light cells, compensation for light fall-off at the edge of the projected image, and interchangeable memory modules.

◀ Simple mosaic-type analysers can produce good results for little cost. A diffuser scrambles the light from the enlarger; a test print is made through the filter mosaic and a grey scale helps find the right filtration.

Every year more and more photographs are taken on colour film, and more and more colour prints are made in home darkrooms. Yet some photographers are reluctant to print their own colour, because they feel that the complications of the process are too much of an obstacle. In most respects, colour printing is much the same as black-and-white printing, but there is one very important difference. As well as getting the exposure right to produce a print of the correct density, you also have to get the filter combination right to produce the correct colour balance.

Colour analysers can cut through one of the main complications and make colour printing at home much easier.

How colour analysers work

Colour films and papers have three layers, one for each of the primary colours, that together make up a full colour image. A colour analyser acts like three exposure meters in one, and determines the exposure for each colour layer.

Finding the right exposure and filtration can also be done with test strips, but this can be a lengthy process. You need one test strip to establish the correct exposure and another one, or often two to find the right filtration. You may also need to make more test strips for the other negatives on each roll of film. This takes time and uses costly colour paper and chemicals. An analyser can give you the information you need to print a negative much more quickly.

Simple analysers

The simplest type of colour negative analyser takes the form of a small mosaic made up of yellow, magenta and cyan filters in various densities. You place this mosaic on a piece of colour printing paper, hold a piece of diffusing material under the lens of the enlarger (to mix all the light from the negative together) and give the paper a standard exposure. When the paper is processed you have a print which has many coloured patches on it, one for each filter

of the mosaic. One of these patches should be a neutral grey colour. A chart tells you which combination of filters match this patch, and it is this combination that you put in the enlarger to make the final print.

This type of analyser is simple and usually works well. It is really a way of making many test prints on one small piece of paper. Its main disadvantage is that it uses a sheet of paper for a test before the final print can be made. However, if you only make colour prints occasionally, mosaic-type analysers are adequate and useful.

Electronic analysers

Photographers who make a lot of colour prints will find an electronic analyser more useful. These work by comparing the colours of the negative with those of a standard reference. An analogy with black-and-white printing will explain this. When you judge the exposure needed to make a good print from a black-and-white negative by eye, you

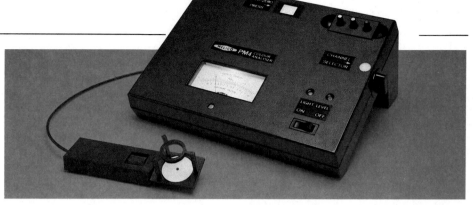

▼ No larger than a pocket calculator, this spot reading analyser is designed for home darkroom use.

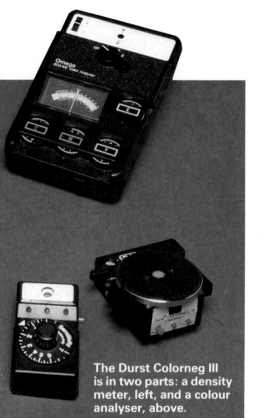

The Durst Colorneg III is in two parts: a density meter, left, and a colour analyser, above.

▲ Colour analysers are available in a variety of designs, and at a range of prices. Shown here are models suitable for all darkroom workers from the home colour print maker to the high-volume laboratory producing top-quality colour prints.

▲ The Melico PM4 has a very sensitive photomultiplier, a fibre optic probe, and plug-in programme modules for different films and papers.

▼ Melico's Mk 3 Linearised analyser compensates for reciprocity law failure (changes in printing paper speed at different exposure times).

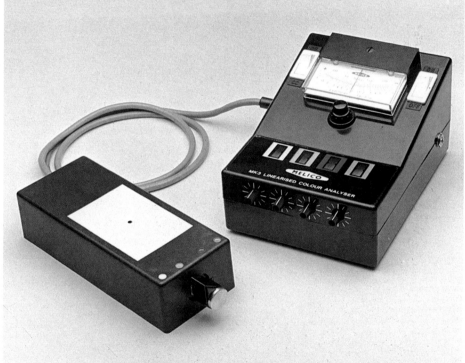

are comparing the density of the negative with your memory of other negatives you have printed previously. But the need to judge the densities of three colour layers at once, through the presence of an orange correcting mask, makes it impossible to do this with colour negatives.

An electronic colour negative analyser, however, can measure the density of each colour layer of a negative and accurately compare them with a 'remembered' reference negative. From this comparison it tells you what filtration you need to put in the enlarger to produce a print with the same colour balance as an acceptable print from the original reference negative.

Setting up the analyser

Because electronic analysers work on this comparison principle you must make a perfect reference print from one of your negatives. You use the filtration for this print to programme the analyser before you attempt to analyse unknown negatives. This step is vitally important, and lack of care in making the reference print or programming the analyser is responsible for most failures of electronic negative analysis.

The reason that you, and not the manufacturer, programme the analyser is because there are a number of variable factors involved which the analyser manufacturer cannot take into consideration.

Different enlargers need slightly different filter combinations. The exact combination will depend on the type of lamp used, its age, and what kind of filters are used.

The particular make and batch of colour paper you use also has an effect. Papers vary slightly from batch to batch, and although paper manufacturers give filter change recommendations for each batch, you may still need to change your reference programme when you use a new box of paper.

You processing technique will also have an effect. Whether you process in trays, a drum or a roller processor, whether you use the paper manufacturer's chemicals or those of an independent maker,

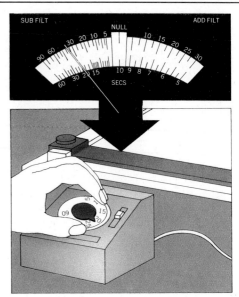

USING A SPOT ANALYSER

1 Place the metering cell over an area of the projected image that corresponds to the tone for which the analyser is programmed. Select the cyan channel and 'null' (or zero) the analyser by adjusting its sensitivity control or the enlarger lens aperture.

2 Select each colour channel in turn and null the analyser by changing the enlarger filtration. This is easiest to do with an enlarger that has a colour head, but can also be done by putting colour printing filters over the analyser cell until a proper balance is reached.

3 Finally, select the exposure channel and read off the correct exposure time. Alternatively, you can adjust the enlarger lens aperture until the readout on the analyser indicates the exposure time you prefer. Set this time on your enlarger timer and make your print in the usual manner.

and the times and temperatures of the processing steps. All these factors must be kept exactly the same from print to print if the readings from your analyser are to be valid.

The negative you use to programme your analyser should contain an even balance of colours, and should preferably be typical of the type of photographs you usually take. It is best to shoot a reference negative specially for the purpose, including a range of colours and a skin tone in the picture. Store your reference negative carefully so that you can find it easily when you need to recalibrate your analyser.

When you have made a perfect print from your reference negative, leave the negative and the filter pack in the enlarger and the magnification and lens aperture as they were for the print.

All analysers have three colour channels, labelled either blue, green and red, or their complementary colours, yellow, magenta and cyan. To programme the analyser, place its light receptor in its working position (either under the lens or on the baseboard, according to design), switch to each channel in turn, and adjust the channel control until the analyser indicates a balance. This will be indicated by a needle on a dial, a pair of lamps, or some other electronic readout. The settings of the channel controls

needed to balance the analyser for the reference negative form the 'memory' of the analyser. For this reason the balancing operation must be performed very carefully.

Analysing a new negative

Put the new negative in the enlarger and select the red (or cyan) channel. Balance the analyser either by adjusting the enlarger lens aperture or the analyser's sensitivity control if it has one. Since the final filter pack should not contain all three primary colours (which would only be the same as including neutral density in the pack) avoid using cyan filters to balance the red channel.

Next switch to the green (or magenta) channel and balance the analyser by adding or removing magenta filters.

Finally, select the blue (or yellow) channel and balance the analyser by adding or removing yellow filters. The filter pack which is now in the enlarger *should* give an accurately balanced print—but sometimes there are problems.

Subject failure

Unfortunately colour negative analysers make no allowances for variations between the subjects of individual negatives. They compare all negatives with the original reference negative. If

Subject failure

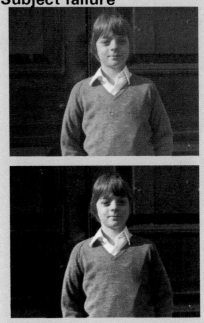

▲ An integrating analyser has given an incorrect reading for the top picture because of the large area of blue background. The strong orange cast must be compensated for by the printer to obtain the correct result, above.

the overall balance of colours of the negative being analysed is significantly different from that of the reference negative, the results will be wrong. A seascape with clear blue sky and water is a typical example. An analyser that reads the entire negative will give readings that neutralize the overall blue cast of the subject, giving a print with an unnatural yellow tinge.

Spot analysers

The problem of subject failure can be avoided by using a slightly different sort of analyser. Up to now we have discussed the use of analysers that read the entire negative—these are known as integrating analysers. A spot analyser reads only a small area of the negative so that the overall cast of the image will not affect the filtration for the subject. Spot analysers can create their own problems, however, and they will only give good results if they are used to analyse an area of similar colour in each picture, such as a flesh tone or better still, a neutral grey card, such as that made by Kodak.

If you are taking a series of photographs under the same lighting conditions, you can include the grey card in one frame and make readings from it that will be satisfactory for the whole series. (It is generally worth using one frame of each roll on a standard colour subject.)

Spot analysers need more care and judgement, but can give better results for printers with some experience.

Colour analyser checkpoints

● If you only make a colour print occasionally, you must decide whether the expense of an analyser is justified by the savings in time and materials it can give.
● Colour analysers are not much help when printing from colour slides. Your eyes will give you enough information for most purposes.
● Filter mosaics will take some of the guess-work out of colour printing for a low initial cost.
● Electronic analysers are quick and accurate, but need careful use.
● An electronic analyser is only as accurate as the information fed into it during calibration. To calibrate an analyser, you must be able to make a perfect colour print without mechanical assistance.
● Decide whether you need a spot analyser or an integrating analyser before you buy. Spot analysers are more versatile, but are usually more expensive. They also need more judgement on the part of the user.

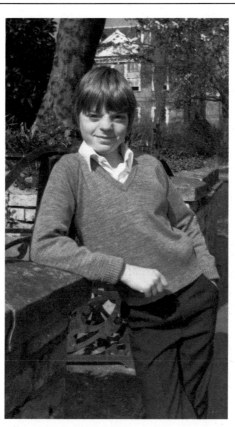

▼ **A print with the filtration given by the Duocube. Colour is almost the same as that in a professionally made print.**

A filter mosaic colour analyser can be very helpful when making prints from subjects that do not have a strongly predominant colour.
◄ **A print made with randomly selected filtration from a negative with an even range of colour and tones.**
▲ **Leaving the enlarger set up as for the print on the left, another sheet of paper was exposed through a diffuser and a Mitchell Duocube. By comparing the resulting print, above, with a grey reference and referring to a chart, the filter values for a good print can be worked out. Duocube filter corrections are given in Kodak colour filter units. If using a Durst colour enlarger or Agfa printing filters (not available in US), the values will need to be adjusted to compensate.**
▼ **A professional print from the same negative. A picture like this is ideal for calibrating a colour analyser.**

Developing black-and-white film

The camera can only do so much; a good deal of the quality of a fine photograph lies in the developing and printing. By doing your own you have more control over the outcome. You can make the print from just part of the negative, increase or decrease the contrast, lighten or darken parts of the picture to obtain more shadow or high-light detail and choose the paper surface you prefer. But, above all, you have the immense satisfaction of creating the end product yourself.

The basic chemicals and equipment needed to develop black-and-white film are simple and relatively inexpensive and if you cannot afford an enlarger you can always join a camera club which has darkroom equipment. Many amateurs also process colour slide and colour negative film at home and make their own colour prints. But first it is advisable to learn about processing with black-and-white film.

This chapter starts with how to develop your own black-and-white films; a subsequent one shows how to make contact sheets from them, explaining how to judge the quality of the negatives.

How developing works

When you release the shutter, light enters the camera and falls on the light-sensitive emulsion on the film. The emulsion contains light-sensitive silver halide salts that react according to the brightness of the light they receive. At this stage the changes in the emulsion are invisible and must be 'developed' with chemicals.

The *developer* turns these exposed silver salts into visible black metallic silver—a lot where the light was bright and less where it was dull. The film must remain in the developer for exactly the right length of time. Then the *stop bath* is used. The stop bath simultaneously arrests the action of the developer and neutralizes its alkalinity so that it will not affect the potency of the next chemical, the *fixer*.

At this stage the film carries a black negative image but the rest of the emulsion, which contains unchanged silver salts, remains creamy as before. The fixer removes all the undeveloped silver salts from the emulsion, leaving it transparent in these areas. The film is now in negative form.

Next the film is washed thoroughly to remove all trace of the fixer. If fixer is left on the film, in time it will cause staining. A few drops of *wetting agent* are added to the final wash. This helps to prevent drops of water clinging to the

drying negatives, which may mark them. Most tap water contains fine particles of rust and grit, which can settle on the film and cause white spots on your prints; an inexpensive water filter fitted to your tap will prevent this.

Buying the equipment

Most photographic dealers stock the basic equipment and will advise you on its use. A universal developing tank will accept different film sizes or develop two 35mm films together. Plastic tanks are widely favoured for general use but the more expensive stainless steel ones last longer.

Ideally, your timer should be a pre-set type that rings at the end of a given period. However, you could use a kitchen timer, a watch, or a clock with a second hand.

You will need one 16 US fl oz (600ml) plastic graduate for each chemical with a waterproof label. If you find it difficult to judge small quantities, a 4 US fl oz (45ml) plastic graduate may be useful.

Preparing the chemicals

Developers and fixers come in either concentrated liquid or powder forms. Powders are less expensive than liquids, but liquids are much easier to handle and are recommended here.

The first step is to read the leaflets carefully as tanks and chemicals come with a bewildering array of instructions. After you have read the various instructions it is an excellent idea to make a preparation chart like the one shown below. But don't just put down the dilution as indicated on the chemical bottle; calculate the actual amount of chemical concentrate plus the amount of water to provide enough solution to cover the film in the developing tank.

Concentrated solutions last for about 6 months, and diluted stop bath and fixer can be kept and re-used. But diluted developer usually has a short life. It is sensible to use a 'one-shot' developer which you throw away after use and so process every film in fresh solution.

Preparation chart
READ THE INSTRUCTIONS AND SET DOWN ON A SHEET OF PAPER:

Dilutions required for chemicals (see instructions with each chemical)	Total amount of liquid needed to cover the film (see tank instructions)
developer	Development time for the type of black and white film you are processing (see developer instructions)
stop bath	
fixer	Time required for fixer (see fixer instructions)

You will need:

EQUIPMENT

1 Universal developing tank
2 Black-and-white film
3 Large jug
4 Mercury thermometer
5 Three 16 US fl oz (600ml) and one 4 US fl oz (45ml) clear plastic graduates
6 Deep plastic basin
7 Timer
8 Plastic or glass funnel
9 Plastic or glass mixing rod
10 Sink with running water
11 Two glass or plastic bottles
12 Photographic hose unit
13 Film clips
14 Drying line (not shown)
15 Film squeegee
16 Scissors
17 Negative storage envelopes

CHEMICALS

18 One-shot developer
19 Stop bath
20 Rapid-type fixer
21 Wetting agent

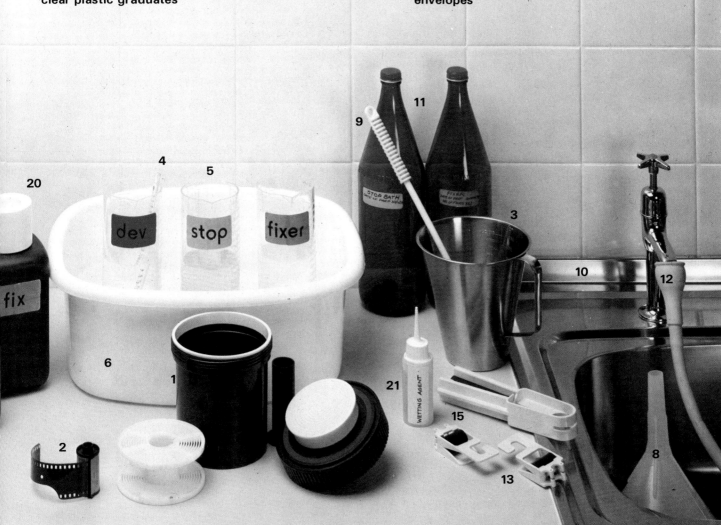

With diluted fixer and stop bath, it is very important to label bottles with the name of the chemical, the dilution and date of dilution.

Prepare dilutions of chemicals accurately. A dilution might be given as 1 + 9 (one part chemical plus nine parts water). You could use 1 US fl oz (10ml) of chemical and 9 US fl oz (90ml) of water to give 10 US fl oz (100ml) of diluted chemical. If this is not enough, increase each amount, for example, 3 times to 3 US fl oz (30ml) chemical and 27 US fl oz (270ml) water. Always add the chemical first and make up to volume with water. Stir steadily to mix. After preparing one solution wash things *carefully* to avoid contaminating the next chemical.

Photographic chemicals often cause dermatitis or trigger allergies so wear rubber or plastic gloves when mixing. Observe a clinical cleanliness at all times, washing away spilt chemicals at once with plenty of water. Always use plastic, glass or stainless steel equipment to prepare the chemicals. Never use aluminium, tin, galvanized or copper utensils for mixing or storing them. Finally, store chemicals safely, well away from the reach of children.

Allow enough time

The process of developing a film will take about an hour to complete. Timing is crucial during development, so make sure you will not be interrupted. It would not, however, hurt if you had to leave film in fixer for 10 minutes.

Loading the tank

You load the film on to a reel (also called a spiral) which then sits inside the tank body. This needs practice as you must load the tank 'blind' in total darkness. Any glimmer of light will damage the film, so use a light-tight cupboard, or a room at night with the curtains drawn. Make sure no light comes through cracks round the door. (The setting up of a proper darkroom is described in a separate chapter.)

Practise first in the light with an outdated film (ask your dealer if he has one). Then try loading the reel with your eyes closed to see if you are still adept. Having mastered the knack, you will be ready to process your first film. Remember that unless the reel is absolutely dry the film may stick; many people keep them in drying cabinets. Make sure your hands are absolutely dry too. If your hands start to sweat while you are in the process of loading the reel, lay the reel and film on the clean work bench and dry your hands.

To prepare film for loading

Always prepare an exposed film for loading in *total darkness* and have the parts of the tank laid before you on the work surface.

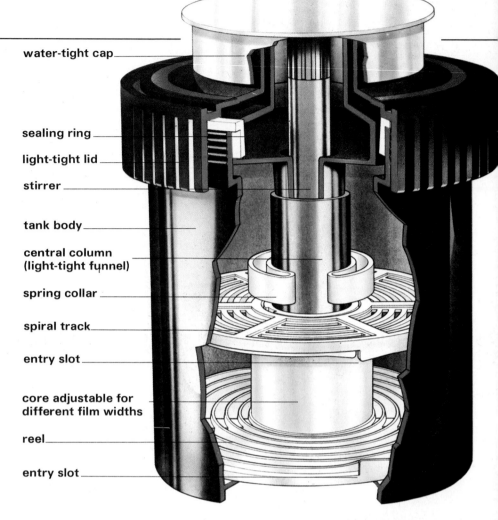

water-tight cap

sealing ring

light-tight lid

stirrer

tank body

central column
(light-tight funnel)

spring collar

spiral track

entry slot

core adjustable for
different film widths

reel

entry slot

Preparing the film

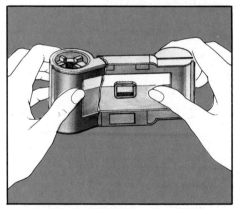

ROLL FILM
Break seal, unwind backing paper until you reach the film; let the film roll up in your hand. When you reach the seal at the end, between the paper and the film, tear it off and let paper and spool drop to the floor. Straighten out the end of the film, ready for loading into the reel.
A blue background indicates that an operation must be carried out in total darkness. A white background indicates that the light may be switched on.

35mm FILM
If the tongue of the film protrudes from the jaws of the cassette, gently pull it out until the full width is reached. Cut it across with scissors between a pair of perforations. *This step can be done with the light switched on.*
In the *dark,* open the cassette by prising off the cap with your thumbs or a cassette opener. If the tongue has been wound inside, open the cassette and cut the film by feel.

110 and 126 FILM
Break open the cartridge by snapping it into two with your thumbs. Remove the pieces of plastic cartridge from around the film spool and unwind the film to separate it from its backing paper, separating it from the film so the film rolls up in your hand. When you reach the seal at the end, tear off the film and let the spool and paper fall to the floor. Note that most reels are not suitable for **110** film.

Loading a plastic reel

1 ADJUSTING THE REEL
Reels adjust to take different film widths—35mm or 126, 127 and 120 or 220. Some reels are also available which adjust to 110 film. If you need to adjust the reel, follow the instructions carefully. You may jam it permanently if you do the wrong thing.

2 FEEDING IN THE FILM
Before you turn out the light, line up the entry slots on the reel so that they face towards you.
In the dark, slip the end of the film into the slots and gently push it—or pull the end—into the reel until you feel resistance, taking care not to kink the film.

3 WINDING ON THE FILM
Rotate each half of the reel alternately back and forth and the film will feed automatically into the tracks on the reel. If it should jam don't use force; you may tear the film. Remove the film from the reel and start again.

Loading a metal reel

1 ATTACHING THE FILM
Metal reels do not adjust for different film widths. Hold the reel in one hand with the clip pointing towards the other hand. Push the end of the slightly bowed film between the clip and the spindle. Read the instructions first as designs vary.

2 WINDING ON THE FILM
Hold edges of film with thumb and forefinger so that it is slightly bowed while you rotate the reel away from the film with your other hand. As the edges of the bowed film are released they slot into reel tracks which keep the film surfaces apart.

Both types of reel

PLACE REEL IN TANK
Cut or tear the film from its spool and check that the last part is completely wound on to the reel. (The end of a 35mm film will be attached to the spool.) Put the reel into the tank body and screw on the lid.

Step-by-step to developing the negatives

1 PREPARE THE CHEMICALS
Fill the jug with water, adding hot and cold until the temperature is 68°F (20°C). Pour the correct amount of chemical into its measure. Add water from the jug up to the correct volume and stir and mix. Stand the measure in a basin of water at 68°F (20°C). Pre-set timer.

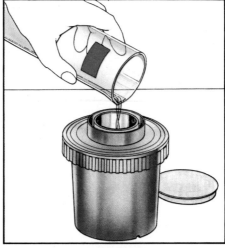

2 POUR IN DEVELOPER
Remove the water-tight cap on the lid. Pour the developer down the light-tight funnel without hesitation (it takes about 10 seconds) and start the timer. Keep the tank upright; never tilt it. Tap the tank, or poke the stirrer down the funnel and swivel the reel to release any air bubbles clinging to the film. Fit the cap.

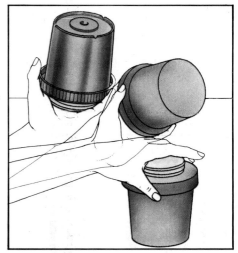

3 AGITATE THE TANK
Agitate the tank according to the instructions to make sure that fresh developer reaches all parts of the film. You may be instructed to invert the tank, rock it from side to side or twist the stirrer.

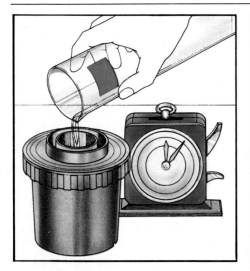

6 POUR IN FIXER
Pour in the fixer, replace the cap and start the timer. Agitate for 30 seconds and then every minute.
Fix for the recommended time, but halfway through remove the lid and examine the film. Check that the milkiness has cleared and the film looks virtually black.
Pour fixer into its storage bottle.

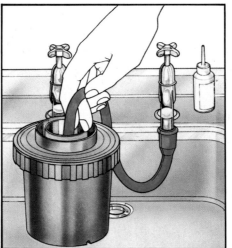

7 WASH THE FILM
Run the cold tap. Check temperature of water. A sudden extreme change of temperature may damage the emulsion. Mix water in the jug to adjust the temperature gradually with several washes if the tap water is too cold. Put the end of the hose in the centre of the reel. Let the water run for 30 minutes. Turn off the tap.
Add the recommended amount of wetting agent to the water in the tank. Agitate for 30 seconds. Remove the reel and shake off the water.

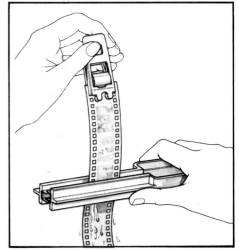

8 WIPE THE FILM
Attach a film clip to the film and gently draw it out of the reel.
Hook the clip over a taut drying line. Wipe away as much water as possible by drawing the film squeegee slowly down the film. (In an emergency you can dip your fingers in water and use them like a squeegee.)
Fix a film clip to the bottom to stop the film curling.
Dry in a dust-free area away from direct heat.

4 REMOVE DEVELOPER
When the timer rings, remove the cap and pour the developer down the sink. (Remember: with one-shot developer you do *not* keep and re-use the diluted chemical.)

5 USING THE STOP BATH
Quickly pour the stop bath into the tank and refit the cap. Agitate for 15 seconds and then leave for 30 seconds.
Using the washed funnel, pour the stop bath into a bottle labelled with chemical and dilution date. This can be reused until it changes colour.

9 STORING NEGATIVES
When completely dry, cut the film into strips: six negatives for 35mm and 126 film; three or four with 120 film. Store each strip in a separate negative storage envelope. Always remember to handle strips only by the edges. Now you have a set of negatives ready for printing.

10 KEEP RECORDS
Mark the bottle of fixer with the date and number of films processed. You may like to put vertical marks on the label to represent the number of films recommended, and cross a mark with a horizontal bar for each film processed. The label should also include the dilution and date of preparation of the solution.

Final reminders

Apart from the advice and techniques already given for developing black and white film, here are 15 more important points to remember. There are no short cuts to good developing practices, in spite of what your friends might say. A fault on a negative will make it, at best, difficult or, at worst, impossible to obtain a good print.

Always . . .

● Wash the mixing rod and funnel after each use.
● Wash the developing tank thoroughly after use. If it is plastic use warm, not hot, water and make sure it is bone dry before use.
● Label each storage bottle clearly with chemical, dilution and preparation date.
● Make up chemicals one at a time.
● Check temperatures of stop bath and fixer—they should be within 4.5°F (2.5°C) of the developer temperature.
● Store chemicals at room temperature. Exteme cold may cause crystals of chemicals to precipitate and alter concentrations.
● Check whether the film in your camera winds on to the take-up spool emulsion-side out. If so, leave it at least 30 minutes after rewinding it back into the cassette before developing. This allows it to resume its natural curl for easy loading.
● Remove the cap from the developing tank, clockwise. It fits tightly and if you twist it anti-clockwise, you run the risk of unscrewing the whole lid and ruining the film inside the tank.
● Agitate the developing tank according to the instructions—too much or too little agitation may cause uneven development.

Never . . .

● Never clean your work area just before you use it: give the dust time to settle.
● Never let yourself become flurried—you might pick up the wrong chemical or tip a solution into the wrong bottle. Work methodically and with forethought.
● Never roll up film when it is dry: cut it into strips at once.
● Never store more than one strip of negatives in an envelope: they will scratch.
● Never leave the spring collar on the developing tank column when not in use: it will lose its grip.
● Never use clothes pins or paper clips to hang a film: it may slip out.

Choosing the developer

There are many developers for black-and-white films in the shops. Some are liquids, others are powders. They have interesting names and numbers, but how is the photographer to choose the best one for a particular purpose?

When choosing a developer it is important to remember that films and developers go together in a partnership— think of a film/developer combination rather than of a film or a developer in isolation. The best plan is first to choose a film according to the lighting conditions and kind of result required, then pick a developer to suit the film. But don't keep changing— experiment at first, then settle down to one or two combinations which suit your kind of photography and stick to these.

Liquids or powders?

Developers are either supplied as concentrated liquids, or as powders which you dissolve. Liquid concentrates are easier to prepare and, because they are used once only (one-shot), there is no need to remember how many films have been developed in the solution. However, liquid developers cost more and are not available to suit every type of film. There is a greater range of powders which keep longer than liquids but, when made up into solution, keeping qualities are about the same.

The qualities desired of films are definition (sharpness), fine grain (no coarse texture of image) and high emulsion speed (ability to react fast to light). Developers can influence these qualities and are often classified as being 'high definition', 'fine grain', or 'high speed' types. Sometimes two desirable qualities can be combined, but most developers achieve a compromise between the different qualities. For example, making the grain finer tends to soften the definition, and so on.

There are other factors to consider. An important one is contrast (the degree of difference between light and dark areas). If a film has low inherent contrast there is little point in using a low contrast developer, because the results will inevitably look flat and dull. Similarly, if a film is grainy, as high speed films tend to be, a coarse-grain developer will exaggerate the sandpaper effect.

Developer types

Universal developers are made for use with films and papers of all types. However, like many multi-purpose products, they are not as good for particular tasks as those developers

▲ Printed from Tri-X film developed in a general purpose developer.

▼ FP4 film processed in Acufine gives good grain and tonal range.

made for a specific purpose; for the best results it is advisable to use different developers for films and papers. The most extreme fine-grain developers lose emulsion speed. You can use a fast film (for example, 400 ASA) and end up with an effective 160 ASA and the same fineness of grain as if you had started with a medium speed film in the first place. However, the quality of image from the slower film is higher than from the fast film slowed down. So if you want fine grain start with a slow (25 ASA to 80 ASA) or medium speed (100 ASA to 200 ASA) film in the first place.

High definition developers tend to give a coarse grain. They should be used only with slowish films that have fine grain to start with, so that making it coarser does not matter much. Generally, such developers are used only for special purposes where sharpness of image is extremely important. Speed-increasing developers allow a higher speed rating to be used than the one on the side of the packet. Generally, the increase is about 60% or two-thirds of a stop. For example, a 125 ASA film could be rated at 200 ASA; which is useful if, for example, you want to stop down to improve lens performance. These developers can also give either reasonably fine grain or good edge definition, or a compromise between the two, and are a good choice for everyday work. However, do not expect any developer to give you everything!

It should be remembered that speed-increasing developers do not push up the speeds of all films equally. Read the instruction leaflets with such developers before exposing the films.

Maximum speed developers are for emergency use only, when you cannot get a picture otherwise. It is only sensible to use them with fast or extreme speed films. Do not use them with slow or medium speed films because you would get better results by employing a fast film with a less extreme developer.

Developer names

Developers are sold under various names or numbers. Sometimes the name makes the manufacturer's aims clear—'fine grain' or 'high definition' would be obvious—but more often code letters and numbers are used which give few clues of type.

Most manufacturers of film suggest their own developers and these are always safe to use and work ade-

PREPARATION OF DEVELOPER SOLUTIONS—Liquid concentrates

1 MEASURE CONCENTRATE
Check how much developer you need to cover the film in the developing tank. Calculate how much concentrate is required based on the dilution ratio. For small volumes it is more accurate to use a 4 US fl oz (45ml) graduate.

2 ADD WATER AND MIX
Transfer the concentrate to a 16 or 32 US fl oz (600ml) graduate. Fill a jug with water adjusted to processing temperature; rinse small graduate, adding washings to large graduate. Add more water from the jug to bring the solution up to the correct volume. Stir well to mix. Check the temperature before use.

POWDER DEVELOPERS

1 ADD FIRST POWDER
Powder developers usually come in two parts. Fill jug with hot water at temperature specified in instructions on package. Measure out ¾ of amount of water. Add first chemical and stir well. After stirring let the liquid settle. Check that no crystals remain undissolved either floating on top or on the bottom. (This chemical dissolves less readily.)

2 ADD SECOND POWDER
Having ensured that the first chemical is completely dissolved, add the next chemical. Stir well to dissolve it. When dissolved add cold water to bring the developer to the correct volume. Finally, stir again. Check the temperature before use.

quately. However, independent chemical firms often produce developers which can be more convenient or are better suited to some particular purpose. The table will help to show the pattern and assist in making a choice.

Characteristic curves

Another quality of developers is tone distribution. This means the way in which tones are rendered. Some developers are especially good for the middle tones (the mid-greys) and tend to squash together the dark shadow tones. Other developers may, for example, give equal emphasis to tone throughout the range. There is no need to worry unduly about this until you start becoming more familiar with chemicals and their properties and specializing in particular subjects. A quick way to see what kind of tones a developer gives with a particular film is to look at the graphs called 'characteristic curves'.

These graphs can seem mysterious at first sight, but they are quite simple. A picture can be worth a thousand words and characteristic curves are a simplified picture of the results of developing a particular film in a certain developer. Exposure is measured along the bottom of the graph and density (blackness of the negative) in the upward direction. The sloping line shows how the tones are reproduced. The steeper the slope the higher the contrast; the flatter the slope the flatter the contrast. The bottom of the line is called the toe and the top is the shoulder. Highlights of the scene (the lightest parts) are recorded in the shoulder of the curve whereas the shadows are recorded in the toe.

If the line is reasonably straight, tones are equally spaced out. If, for example, the shoulder flattens out, then highlights would not be well separated and in a snow scene, or picture of glassware, the essential sparkle would be lacking, though this would not show with other subjects, such as a landscape. Also, the negatives would be easy to print. As you become more expert, however, the characteristic curves will mean more and give you further information; for example, if you wanted to do push processing you would be looking for developer with a long toe portion.

Paper developers

Although there are many makes the situation is remarkably simple when developing black-and-white enlarging papers. For most purposes any of the good makes will serve perfectly well.

There are powders and concentrated liquids. Again, powders are slightly cheaper but you have the trouble of making the stock solution. Do not buy too large a quantity of powder even though it is cheaper, because solutions have a limited storage life and trouble can arise if you try to use only part of the powders at a time.

There are very small differences in the image colours produced by different brands, expecially with warm-tone papers, but most photographers agree that for practical purposes it matters little which print developers you use. If a brand is reasonably economical, keeps well under your storage conditions and gives no trouble in use, then there is no reason to change. Most photographers use the ready-made liquids because they are easier to prepare.

Developers should always be stored in tightly stoppered bottles which are labelled clearly with the name of the developer and date of preparation, and whenever possible they should be kept full. And the bottles should be made of dark glass or non-porous plastic. It is possible to buy special soft-contrast print developers but it is easier, and often more satisfactory, to use a paper one grade softer than you would normally when printing that particular negative.

Characteristic curves for different film: developer combinations

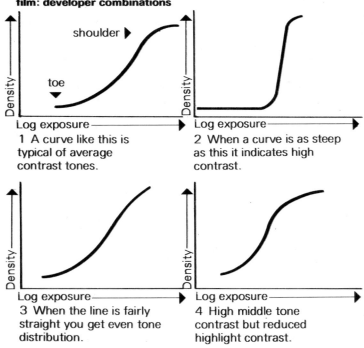

1 A curve like this is typical of average contrast tones.

2 When a curve is as steep as this it indicates high contrast.

3 When the line is fairly straight you get even tone distribution.

4 High middle tone contrast but reduced highlight contrast.

▶ **A combination of HP5 film developed in Microphen which is very good for bringing out shadow detail.**

52

Black-and-white film developers

Developer	Manufacturer	Qualities	Speed rating	Suitable film	Powder or liquid	Remarks
Available in US and UK						
D76	Kodak	Good grain Fair definition	Normal	All types	Powder	Well known, general purpose negative developer
Microphen	Ilford	As above	About 60% extra	All types	Powder	Same general type as D76 but altered to give more speed
Ultrafin FD7	Beseler	As above	About 100% extra	All types	Powder	Has replenisher tablets
Ultrafin FD5	Beseler	Good sharpness Fair grain	Normal	All types	Liquid	General purpose negative developer
Perceptol	Ilford	Very fine grain	Speed reduced to about 50%	All types	Liquid	Sacrifices speed for fine grain
Ultrafin FD1	Beseler	High sharpness	About 100% extra	Slow and medium	Liquid	Grain too coarse for fast films Highlights flatten
Acufine	Acufine	Fine grain	100% to 400% extra	All types	Powder	Good keeping qualities Very high resolution Controllable contrast
Diafine	Acufine	Fine grain	Normal	All types	Powder	Two-part developer Compensating type Controls negative contrast
DK 50	Kodak	Not fine grain	Normal	Very fast	Powder	A clean working developer very suitable with Royal X Pan
Available in US						
ID11 Plus	Ilford	Very fine grain. High sharpness	Normal	All types	Powder	Anti-sludging, general purpose developer
FG7	Edwal	Fine grain	Maximizes speed	All types	Liquid	Rapid development time Good keeping qualities
Blue	Ethol	Medium fine grain	100% to 250% extra	All types	Liquid	High acutance, high contrast
Super 20	Edwal	Very fine grain	Normal	All types	Liquid	Medium-contrast negatives with excellent separation of highlight tones. Good keeping qualities
Available in UK						
ID11	Ilford	Good grain Fair definition	Normal	All types	Powder	Well known, general purpose negative developer
Acutol	Paterson	High sharpness	About 40% extra	Slow and medium	Liquid	Not meant for fast films
Acuspecial	Paterson	Combines sharpness and fine grain	Normal	Slow and medium	Liquid	Compensating type. Gives details in shadows and highlights but squeezes together middle tones
Definol	Johnsons	Good definition	About 30% extra	Slow and medium	Liquid	Not for fast films
Acuspeed	Paterson	Not fine grain	100% to 200% extra	Fast	Liquid	For maximum speed. Use only when you must

Black-and-white negative faults

THE NORMAL NEGATIVE

A normal negative shows a full range of tones from highlights to shadows with details in both. Shadow areas and borders are free from fogging and the emulsion is clean—there are no marks or scratches.

Mistakes made during processing or while the film is in the camera account for a wide variety of negative faults. In fact, if you consider how many things can go wrong, it is a wonder that most people manage to produce such consistently good negatives.

Mistakes can happen when you take the photographs; for instance, you may inadvertently under- or over-expose the film. Or the image may be unsharp and that, too, will have happened while the picture was being taken. It could be a case of camera shake, or mean that the subject moved but, if many frames are fuzzy, there is likely to be something wrong with the camera itself.

It is, however, at the processing stage that the whole film can be ruined by faulty techniques. Most negative faults make it difficult to produce a high quality print, and at worst can make the negative a complete write-off.

Cleanliness and order

The only way to avoid damaging your films during processing is to take great care at every stage from the moment you begin to load the film into the reel. The two keys to success are cleanliness and orderliness. Make sure that all the equipment is always washed thoroughly, especially the reel on which you wind the film for processing in the developing tank. If you are using the same measure for different chemicals, wash it well after each one. Above all, keep your fingers clean; wash them after handling any chemicals, especially fixer, and dry them on a *clean* towel.

The most common faults

Under- or over-development, the most common negative faults, occur during development, which is the most critical stage of processing. Correct development depends on various factors—temperature, time, the age and dilution of the developer, and the amount of agitation. Any deviations from the recommended practice will affect the contrast of the image.

There is a lot to remember when you first begin to process your own films and mistakes are bound to happen, but don't become discouraged. What initially seems tricky soon becomes a matter of routine.

Use the guide on these pages to help you to identify some of the faults which may have occurred, and you will find that you quickly start to produce fine quality negatives without defects.

Examining the negatives

To look at and assess negatives, shine a desk lamp on to a sheet of white paper. Hold the negatives above the paper so no light falls on the front of them and use a magnifying glass to examine them in detail. First look at the image as a whole, then at the highlight (dense) and shadow (thin) areas, and finally at the borders.

The key points to look for are: shadow areas and borders free from fogging; a range of tones from highlights to shadow areas, all showing detail; and a clean appearance to the emulsion.

On a negative, the tonal values are reversed so the 'highlights' are actually the dark or dense areas which were, of course, the lightest parts in the original scene. Similarly, the 'shadow' areas are the thin or light parts of the negative, or the dark parts of the scene.

There is also a standard test which you can use to check the overall density and contrast. Place the negative emulsion-side-down on a printed page. You should just be able to read the type through the densest areas (highlights) and see a slight density in the (thin) shadow areas.

With practice you will learn to notice faults on your negatives. Contact sheets help too, but they are only an average guide to individual negatives because of the single overall exposure for printing.

There is no substitute for the real thing, so bear in mind that the negatives reproduced here in printed form lack the transparent quality and texture of an actual negative, which make it easier to assess the quality. Each negative is accompanied by its contact print to provide an indication of how it would appear printed normally, but remember that many faults won't show up very markedly until the negatives have been enlarged.

UNDER-EXPOSURE

Problem: a thin negative with blank clear shadows and though the highlights show some detail, they are greyer than normal. These are the characteristics of under-exposure.

Cause: the wrong ASA/DIN film speed (too fast), too small an aperture, too fast a shutter speed or a light reading taken from the brightest part of the scene only.
Cure: by chemical or printing means.

UNDER-DEVELOPMENT

Problem: a thin negative with less contrast than normal. It looks under-exposed but that causes blank shadows, whereas in under-development these areas have detail. There is a lack of highlight density.
Cause: too short a time in the developer, too cold a solution, or the use of weak or stale developer. (Faint edge numbers are a sign of stale developer.)

Cure: developer cannot work effectively at a temperature lower than 68°F (20°C) so always watch this, as well as the time, dilution and age of developer. Store developer in well-stoppered bottle to prevent deterioration.

OVER-EXPOSURE

Problem: a dark, dense negative which shows some shadow detail but the mid-tones and highlights merge into a fairly even black. This is a typical sign of over-exposure.
Cause: The ASA/DIN film speed was set wrongly (too slow), the shutter speed was too slow or the aperture was too wide, or the light reading was taken from the darkest part of the scene only.
Cure: by chemical/printing means.

OVER-DEVELOPMENT

Problem: a much denser (blacker) than normal negative, like an over-exposed one. What distinguishes it, however, is a high contrast, which an over-exposed negative lacks.
Cause: too long a period in the developer or too high a temperature.
Cure: watch the timing and the temperature in future. Later chapters explain how to rectify this fault which may be modified by chemical treatment or compensated for during printing.

WHITE SPOTS

Problem: round white spots with dark edges.
Cause: air bubbles on the surface of the emulsion prevented development.
Cure: let fresh developer settle before use—tap water is often aerated. Pour developer evenly into tank and tap tank to dislodge any air bubbles. Some correction is possible by printing means and large negatives can perhaps be retouched.

STREAKING

Problem: uneven density of the image gives the negative a streaky appearance.
Cause: insufficient agitation during development led to some areas receiving more development than others. It is essential to agitate the film at least once every minute during development, especially if you use a rapid developer.
Cure: none. At best, the streaks may not be too obvious on the enlargement.

FOGGING

Problem: shadows and rebates in this negative are fogged (slightly opaque when they should be clear).

Cause: poor blackout during loading. Check the blackout carefully before removing the film from its protective wrapping. Eyes take time to get used to low light levels.

so remain in the darkroom for at least 10 minutes to see if it is light-tight.

Cure: chemical treatment may clear the shadow areas. If the fogging is slight it may not affect printing.

UNDEVELOPED STRIP AT TOP

Problem: a portion of this negative is undeveloped. (During agitation it underwent some development when the solution washed over that part of the negative.)

Cause: not enough developer in tank.

Cure: none. You may be able to crop the picture. Make certain that you use the right amount of developer in the tank for the film size.

UNEVEN DEVELOPMENT AND FIXING
Problem: an unevenly developed and fixed area.

Cause: this film was badly loaded into the reel so that the emulsion on one part of the film was in contact with the back of another part of the film.

Cure: none—put it down to bitter experience. Loading requires practice so if in doubt remove the film and start again. You can often check whether the film is loaded correctly by running your finger tips over the reel tracks to feel if it has buckled or is protruding.

CRESCENT-SHAPED MARKS
Problem: crescent marks on the image.

Cause: during loading the film was kinked. It is easy to do this while you concentrate on loading it accurately into the reel and as a result it is a fairly common fault.

Cure: none. Later chapters explain how to spot out the faults on the print itself. Load film carefully, especially roll film, holding it at the extreme edges only.

NEGATIVE TOO DENSE
Problem: silver halide remains in the emulsion, 'blocking up' the shadow areas with a chemical deposit and making the whole negative much denser than it should be.

Cause: insufficient fixing. To check for correct fixing, hold the negative at a slant to the light and examine the shadows for any trace of milky greyness. It is invisible in direct light, but can be seen easily in reflected light.

Cure: refix and rewash the negatives. Your fixer may be too stale: check it with a scrap of unexposed film (for example, the tongue of a 35mm film), discard the fixer when the time to clear the film is twice that needed by fresh fixer.

CONTAMINATION BY FIXER
Problem: fingerprints or other marks on the negative.

Cause: chemical contamination of the film, in this case from a finger splashed with fixer. Similar staining sometimes occurs along the edges of negatives and this comes from chemical contamination of the reel with fixer. Traces of fixer remained trapped in the tracks and the empty reel was not washed thoroughly enough.

Cure: normally, none. A skilled operator can sometimes 'knife-out' the black marks which appear on the print.

RETICULATION
Problem: a very grainy look with loss of fine detail.

Cause: the processing solutions, especially the developer or stop bath, were too hot. The gelatin which holds the silver halides expands when placed in a hot liquid then contracts suddenly when placed in another solution at a lower temperature.

Modern films are resistant to this but it can occur with excessive abuse.

Cure: none. Keep your processing solutions and final washing water within ±4.5°F (2.5°C) of the developer's temperature.

DRYING MARKS
Problem: areas of increased density across the negative.

Cause: drops of water which have dried on the emulsion cause selective intensification of the silver grains by 'clumping' them together. This is a physical change in the structure of the emulsion so rewashing will not help.

Cure: the uneven density gives small patches of lighter density on the prints which, if not excessive, could be retouched out. To avoid drying marks, always use a wetting agent and gently remove water from the film with a squeegee.

Improving your black-and-white processing

Once you have got over the initial excitement of processing and printing your first black-and-white films you will soon want to improve your techniques. Looking at the prints exhibited by your local camera club or at a photographic gallery will show the standard that can be achieved with a little practice.

The first step is to get the best possible negative. This should have an even density, be correctly exposed and developed, and display a full range of tones with detail in both highlight and shadow areas. It should also be free from dust, scratches and fingerprints.

Refining your techniques

To produce the best negatives and to get the most out of a particular developer you will need to control the processing steps carefully. The simplest way to ensure this is to adhere strictly to the processing procedure suggested by the manufacturers for each film and developer combination, provided it gives you the results you want. Most modern films have been designed to be tolerant of a great deal of variation in exposure level and processing conditions, but carelessness will still give inconsistent and unpredictable results.

Temperature control

Always check that the temperature of the developer is correct just before you pour it into the loaded developing tank. A temperature drop of as little as two or three degrees can result in lower contrast, giving flat prints unless you move to a harder grade of paper.

Try to keep the temperature of the stop bath and the fixer reasonably close to that of the developer. Although damage to the emulsion surface (called 'reticulation') caused by sudden temperature changes is rare, it *does* happen, and there is no remedy for it. (Sometimes slight reticulation can give the appearance of very coarse grain.)

Agitation

Modern developing tanks use reels that roll the film into a small space to minimize the quantity of processing solution used. Consequently the gap between the layers of film is small, and the tank must be agitated to prevent pockets of stale developer from forming, and leading to uneven development. The best way to agitate these tanks is by inversion — turn the tank upside down for a few seconds once every 30 seconds, or as

▶ **For a good quality print you need a good negative processed with care.**

specified in the instructions.

Prolonged agitation acts like an increase in developing time, and increases the density and contrast of the negative. Too little agitation decreases contrast and can also produce uneven density in the negative. Agitation must be intermittent, not constant, otherwise flow patterns can cause uneven density, especially lines from the perforations of 35mm film. Also, do not shake the tank vigorously as this causes air bubbles to form in the solution. These can produce circular marks on the negatives if not dislodged. After gentle inversion replacing the tank on the bench with a sharp tap will usually displace any bubbles that have formed.

Accuracy of timing

Time how long it takes you to empty the solution from your processing tank. Some tanks can be emptied much faster than others. If it takes five seconds, always begin pouring out the developer five seconds before the end of the development time. This will allow you to pour in the stop bath or fixer at exactly the right time to halt development.

Washing

When washing the film ensure that the water passes over the entire surface of the film. Taking the lid off the tank and putting it under the tap is not sufficient, especially with modern reels. Paterson make a Force Film Washer that directs the water to the bottom of the tank, forcing it up between the layers of film. This can also be achieved using a short length of tubing with fits down the centre of the reel.

The temperature of the wash water can be a problem in the winter. Water straight from the tap can be so cold that washing is very slow. Very cold water can also produce slight reticulation, especially if the fixer is not one with a hardener incorporated.

To overcome these problems, fill a container with water at the same temperature as the processing solution. When you have poured out the fixer, fill the tank with water from the container, and agitate. After two or three minutes, tip the water away and refill the tank from the container.

Five or six changes of water should usually be sufficient to wash the film thoroughly. You should allow a little more time for each wash, as each time the water will take longer to be contaminated by fixer.

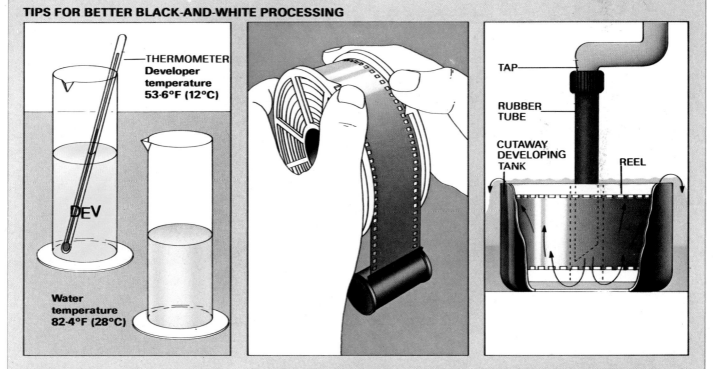

TIPS FOR BETTER BLACK-AND-WHITE PROCESSING

THERMOMETER
Developer temperature 53·6°F (12°C)

DEV

Water temperature 82·4°F (28°C)

TAP

RUBBER TUBE

CUTAWAY DEVELOPING TANK

REEL

TEMPERATURE CONTROL: When diluting a solution from stock chemicals, it is quicker to use warm water than to heat working strength chemicals. For example, if a developer is formulated for use at 68°F (20°C) at 1:1 dilution, and the stock solution is eight degrees too cold (60°F, 12°C), adding an equal quantity of water that is eight degrees too warm (76°F, 28°C) will produce a solution with approximately the right temperature for processing.

EASIER LOADING: Opening a 35mm cassette in total darkness and then attempting to feed the end of the film on to a plastic developing reel can lead to unnecessary fumbling. It is better to leave a short length of film protruding from the cassette when rewinding in the camera (usually there is a slight additional resistance before the film is completely rewound). The film end can then be trimmed to fit the reel in subdued room light and easily started in the spiral groove.

EFFICIENT WASHING: Care is needed to ensure that wash water flows from the bottom of the developing tank upwards, because fixer is denser than water and therefore tends to accumulate at the bottom of the tank. The more turbulent and forceful the water flow the better, and rubber tube attachments are available which introduce air into the flow of wash water and give the film a more thorough wash in a shorter time.

FP4 WITH DIFFERENT DEVELOPERS

Ilford FP4 film was exposed at three ASA speeds and processed accordingly.

▲ **64 ASA in Perceptol gives smooth tones and fine grain (see picture, right).**

▲ **125 ASA in D-76. The standard rating gives good grain and sharpness.**

▲ **400 ASA in high energy developer. Over twice normal speed, more graininess and contrast.**

▲ **FP4 downrated to 64 ASA, developed in Perceptol: shallow depth of field and smooth tones give this portrait a flattering soft look.**

Controlling graininess

Different developers have varying effects on the image. The importance of this varies according to the size and type of film. If you are using a medium or large format, at least 2¼ x 2¼in (6 x 6cm) or greater, and only intend to produce 8 x 10in (20 x 25cm) prints, the effects of different developers on grain may hardly be apparent. With 35mm negatives, the degree of magnification needed to produce an 8 x 10in (20 x 25cm) print is at least eight times, and with selective enlargement may be far more. At such magnifications the grain structure of the negative is going to be visible in the final print.

The graininess, or granularity, of the negative is affected by three main factors:

● The film emulsion. The higher the speed of the film the larger the original grains of silver halide will be.
● The exposure. Excess exposure will increase the density and graininess.
● The developer. These can be divided into three main types: fine grain; high definition; and high energy developers.

Choosing a developer

Fine grain developers give reasonable contrast without loss of film speed and without interfering with the original fine grain characteristics of the emulsion. Examples incude such developers as D-76, ID11, HC110, Aculux and Promicrol (not available in US). They can be used with all the commonly available types of film. Portraits, which need a smooth gradation of tones to show skin textures, and soft, gentle landscapes are ideal subjects for use with this type of developer. Where finer grain is required, Perceptol can be used. Unfortunately this developer only achieves its results by sacrificing the speed of the film by about 50%, and it is often better to use a slower film with an ordinary fine grain developer.

High definition developers produce a good contrast range without increasing granularity while improving the definition, or apparent sharpness, of the image. An example which is currently available is Acutol which should only be used with thin-emulsion films of low or medium speed such as Panatomic-X. The merits of this type of developer are best displayed in photographs of scenes with plenty of fine detail, such as

TRI-X WITH DIFFERENT DEVELOPERS
Kodak Tri-X film was exposed at three
ASA speeds and processed accordingly.

▲ 200 ASA in Perceptol. Very smooth
gradation and slightly finer grain.

▲ 400 ASA in D-76. The standard rating
gives good results for the film's speed.

▲ Tri-X at 1250 ASA, developed in high energy developer: extra depth
of field makes the subject sharper, the background more noticeable.

▲ 1250 ASA in high energy developer.
Higher speed but extra grain (see left).

mountain scenes, or close-ups of architectural detail.

High energy developers, such as Acuspeed and Ethol Blue, produce an increase in effective speed of the film and are useful for shots taken in very low light. They are designed for use with fast films (400 ASA and over) such as Tri-X and HP5. But such developers should only be used when absolutely necessary, as the added speed is achieved at the expense of grain and definition.

Special developers for very specific purposes are no longer generally available in ready-made form. Because of a decline in sales of black-and-white materials, manufacturers have cut down the number of developers available in made-up form. However, most of the formulae have been published, so if the chemicals are available and can be measured accurately, you can make these up for yourself.

Personalized processing

Processing a film is rather like baking a cake, in that consistently good results will be obtained by following the recipe meticulously. However, as with cakes, the 'perfect' result is to some extent a matter of taste, and it is possible to vary the recipe accordingly.

For example, if your negatives seem too flat and lacking in contrast, you can increase the development time to make them more contrasty. If your negatives are too contrasty, you can decrease it. Experiment by varying film ratings, developer and development times to see how the result is affected. For example

shoot a roll of 400 ASA film with the same scene exposed at ratings from 100 ASA (−2 stops) to 1600 ASA (+2 stops), then process and compare results. The best negative is the one with least density but adequate shadow detail. Repeat the process with other development times, aiming at a negative which will print on a normal (grade 2) paper as this gives you the greatest scope for variations in either direction. If you start to experiment in this way, always record the alterations you make, or you will not be able to relate causes and effects, nor repeat your results.

The pictures here show how with two common films and three developers good results can be obtained at ASA ratings from 64 to 1250. The versatility and control this allows is worthwhile.

Making contact prints

Contact prints are made by placing negatives on a sheet of light-sensitive photographic printing paper and exposing the paper to light. Where the negative is thin (in the shadow areas of the original scene) a lot of light passes through to the paper, and where it is dark (in the light areas of the original picture), less light penetrates.

This results in a positive image being formed on the paper. But, like the exposed film in the camera, the image is latent (invisible) and needs to be developed to turn it into a black and white print. Photographs printed in this way are the same size as the negatives and are usually only useful for reference.

The reasons for contacts

In the excitement of handling your own processing, it is a great temptation to bypass the contact print stage and settle straightaway for enlargements. But it is always wise to make contact prints. For one thing, it is easier to judge the merits of a particular negative from a contact print, especially if you are working with small formats like 35mm. It is impossible to judge things like facial expressions from negatives, where the tonal range is reversed. You can tell whether an image is sharp, but you need the positive print on the contact sheet to see precisely what it looks like.

Secondly, a contact print gives you the opportunity to improve the composition. The most interesting portion can be outlined with a Chinagraph pencil or China crayon as a reference for an enlargement.

Contact prints also provide an invaluable quick reference to what is on your negatives, and make filing and finding a particular subject easier.

Choosing equipment

To produce pin-sharp contact prints, it is essential to hold the negatives in firm contact with the light-sensitive surface of the printing paper. This can either be done with a contact printing frame, obtainable from a photographic shop, or, more cheaply, with a sheet of plate glass which must be heavy enough to press the negatives firmly against the paper. Working in subdued lighting makes it difficult to see as clearly as usual so, to avoid cut fingers, you should smooth down any rough edges, or you can use glass with chamfered or bevelled edges.

The normal grade of printing paper with a glossy surface (for example, Kodak grade 2 or Ilford grade 2) is recommended to start with because it can usually accommodate both flat and contrasty negatives. The glossy paper surface is also easier to mark up. With normal paper you will not get a perfect print of every frame but as you are making your contacts for reference, high quality is not vital. When you come to enlargements you may wish to try papers with different characteristics: see later section on printing papers. An 8 x 10in (20.3 x 25.4cm) sheet of paper will take 36 frames of 35mm film and 12 frames of 2¼ x 2¼in (6 x 6cm) film, so one roll of film goes on to the same contact sheet.

White light

The white light source for exposure of the printing paper can be the light from an ordinary 40 watt frosted bulb or the light from an enlarger. If you use the 40 watt room light, check that the bulb is at least 6ft (2m) away from the printing area, to give even illumination. If you have an enlarger, raise the lamp housing until the light covers the whole sheet of paper. Close down the aperture of the lens two f stops and swivel the red filter, which acts as the enlarger's safelight, away from the lens.

The safelight

You need a light-tight room, with a coloured safelight to provide a dim working light that does not affect light-sensitive printing paper. At first, you may find it too dim, but your eyes will soon become adjusted. A safelight can either be a special bulb fitted into the light socket in the workroom, or a lamp housing with a filter, which takes a 15 or 25 watt bulb. Both types are available from photographic dealers. The colour of the filter and the wattage depends on the type of printing paper you are using. An orange bulb or filter is suitable for black and white printing.

Test your safelight

If the safelight is too close to the work area, or is the wrong colour, it will fog the printing paper. (Fogging is a reaction to light which produces an overall grey tone when the material is developed.)

To test the safelight, take a strip of printing paper and expose the emulsion side to the white light source for half the time you would use for an actual negative. Place the paper on the work bench and put two coins on top of it. Leave the coins on the emulsion side of the paper for twice the usual developing period. Then remove the coins and develop the paper. If the safelight is

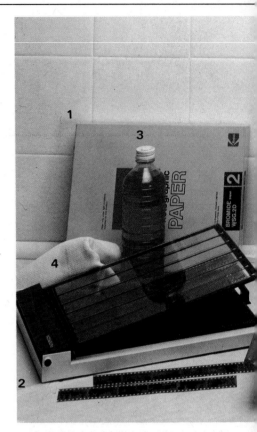

effective there will be no images on the paper, which will be universally grey.

Preparing the chemicals

Before you begin, make a preparation chart. Read through the instructions and record the amounts of developer, stop bath and fixer you need to cover one sheet of 8 x 10in (20.3 x 25.4cm) printing paper. (To assess how much of each dilution you need, fill the dish with water to a depth of ¾in (2cm) and measure the amount.) Record the dilutions for each chemical and the recommended times.

You can use the stop bath and fixer which you bought for developing film, but read the instructions carefully; dilutions may vary. However, unless you bought a universal developer to start with, you will need to get a developer suitable for black-and-white printing papers.

Temperature at the printing stage is not quite as critical as when developing the negatives, but try to hold it around 68°F (20°C). You can do this by prewarming your diluted solutions; by standing your developing trays in a larger tray of warm water; or with a photographic dish warmer.

When making contact prints you must put the negatives on to the paper so the

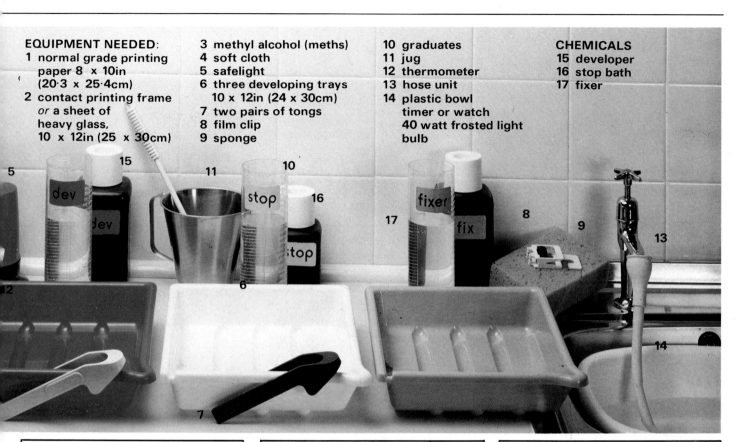

EQUIPMENT NEEDED:
1 normal grade printing paper 8 x 10in (20·3 x 25·4cm)
2 contact printing frame *or* a sheet of heavy glass, 10 x 12in (25 x 30cm)
3 methyl alcohol (meths)
4 soft cloth
5 safelight
6 three developing trays 10 x 12in (24 x 30cm)
7 two pairs of tongs
8 film clip
9 sponge
10 graduates
11 jug
12 thermometer
13 hose unit
14 plastic bowl timer or watch
40 watt frosted light bulb

CHEMICALS
15 developer
16 stop bath
17 fixer

1 PREPARE THE CHEMICALS
Make up the dilutions of developer, stop bath and fixer with water at 68°F (20°C) and pour them into the developing trays. Space the trays so as to avoid one contaminating another with splashes. Try to maintain the room temperature at or above 68°F (20°C). After you have exposed the printing paper, check that the temperature of the developer is still 68°F (20°C) before you begin development.

2 CLEANING
Using methyl alcohol (meths) and a soft, lint-free cloth, clean the glass (avoid leaving finger marks). Remove the negatives from the storage envelopes and hold them by the edges. Clean the *backs* (shiny side) of the negatives with methyl alcohol (meths) on a soft cloth. Do not rub too hard. This removes drying marks and, though this is not essential for contact prints, it is for enlargements.

3 ARRANGE THE NEGATIVES
Line up the negatives in numerical order using the reference numbers on the edges. If using a contact frame, slip them into the frame, shiny side to the glass. (In new frames it may be necessary to ease up the edges of the mask gently with a blunt knife.) If you are using a sheet of glass, wait.
Now: *switch off the main light and switch on the safelight. Diagrams in orange indicate use of safelight.*

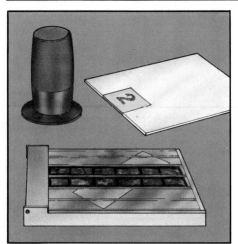

4 PUT NEGATIVES ON PAPER
Take a sheet of printing paper from the box and tear it into three strips. Replace two of the strips in the box. Keep the lid tightly closed. Put remaining strip diagonally across the printing frame. Check that the paper is glossy-side up. Lower the glass; clip it down. If using a sheet of glass put the paper on the bench; place negative dull-side down on the paper and cover with the glass, without disturbing the negatives.

5 TRIAL EXPOSURES
Switch on the white light or the enlarger. While counting up to 15 seconds, expose the whole strip to the light for 5 seconds, then block the light from a third of the test strip by holding a piece of dark card over it. At 10 seconds mask two-thirds of the strip. The remaining position has the full 15-second exposure. Switch off the white light. The best exposure depends on your light source and this test provides the answer.

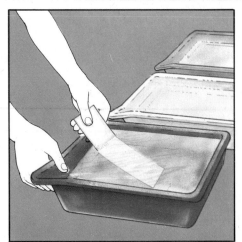

6 DEVELOP THE TEST STRIP
Check the temperature of the developer. Working under the safe-light, hold the paper strip by the edge and slip it quickly into the developer, emulsion-side up. Agitate the tray by rocking it gently for the whole of the developing time (about 2 minutes). After 20 or 30 seconds the image appears and gradually gains density. Leave it for the recommended development time. Do not worry if the image looks dark.

10 DRY THE PRINT
Remove the print, drain it and wipe the drops of water off the print with a sponge or squeegee. Dry it on clean blotting paper, or hang it up by one corner with a film clip. As it dries the print will begin to look less contrasty.

emulsion sides are together. On negatives the dull side bears the emulsion; the shiny side is the back. As a guide, negatives tend to curl with the emulsion inwards. On paper the emulsion side is glossy and also curls inwards.

Using the contact prints
Your first sheet of contact prints is dry. Now you have the pleasure of examining them closely and deciding which frames you want to enlarge.

To do this properly, you need four pieces of simple equipment: a China crayon or Chinagraph (preferably blue or yellow), a magnifying glass (the kind used for map-reading is convenient), and two pieces of L-shaped card. The size of the card depends on the negative format used, but for both 35mm and $2\frac{1}{4}$ x $2\frac{1}{4}$in (6 x 6cm) prints, masks with arms 4in (10cm) and $\frac{3}{4}$in (1.5cm) wide should be right.

First study the contacts carefully through the magnifying glass. At this stage you can immediately reject any pictures which are out of focus, ruined by camera shake or grossly under- or over-exposed. When you have selected an initial batch of frames for further consideration, use the L-shaped masks. Move them around on the print, changing the format of the

picture by moving the cards. This allows you to experiment with different composition. When you have made your selection, mark in the area with the China crayon. Do this boldly so that it can be seen easily. You now have a guide for deciding how to enlarge the negatives, so saving time and printing paper when making the enlargements.

Make a filing system
Finding negatives months or years later is a daunting task unless they are correctly filed. Contact prints are best filed with the negative strips but not in the same transparent storage envelopes. This is because, unless they have been very well fixed and washed, the prints may stain and damage the negatives.

You can buy ring binders which come complete with negative storage envelopes. Then all you need to do is to attach punched, sticky strips, designed for the purpose, to the contact sheet and file it in the ring binder in front of its negatives. Index the binder and give the contact sheet and negative bag the same reference number.

▶ When marking up contacts, a magnifying glass is useful to check fine detail.

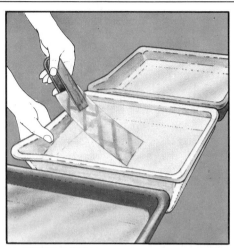

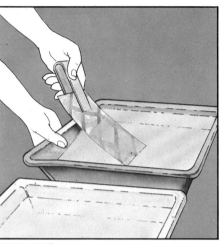

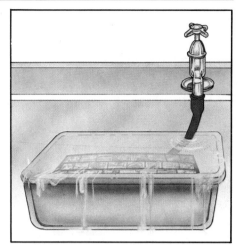

7 STOP BATH
Remove the strip from the developer. Pick up the paper by the edge with the tongs and drain it. Put the test strip into the stop bath, taking care not to let the tongs, which are contaminated with developer, dip into the stop bath. Rock the stop bath continuously. Leave the strip in the stop bath for 30 seconds. Using a clean pair of tongs, remove the strip from the stop bath and allow it to drain.

8 FIXING
Slide the test strip into the fixer and rock the tray. After 30 seconds turn on the white light. Leave the strip in the fixer for the recommended time. Take it out of the fixer. At this stage you will be able to judge the best exposure time. Return to step 4. Take a full sheet of printing paper; expose it with all the negatives for the chosen time. Then proceed through the development process as before, to this stage.

9 WASHING
To remove all traces of fixer, wash print in running water for 2 minutes (for resin coated papers) to 45 minutes (for fibre based papers). Place the print in a plastic bowl in the sink and direct the water to the bottom of the bowl through the hose unit. So clean water is introduced to the bowl while wash water overflows into the sink.

Making enlargements

Few photographers ever forget the thrill of watching the image of their first print appear in the developing tray. But there is more to printing than the technical side—it is a highly creative branch of photography. Selective enlargement of a negative can add greatly to the drama and impact of a photograph. You can make large prints from small parts of the negative, darken unwanted details and emphasize the important aspects.

It is also possible to experiment with a wide range of fascinating darkroom techniques. You can double-print two negatives, deliberately distort the perspective for special effects or even convert everyday views into unusual abstracts.

But before going on to more advanced techniques it is essential to master basic print-making procedure, which is straightforward and very enjoyable. When you look critically at the final print you may feel that parts of it appear too light and lacking in detail, while other areas may appear a bit too dark. These are quite common problems which arise when one overall exposure is given. They can be corrected by using slightly more advanced printing techniques, such as shading and burning-in. These techniques are described later.

The equipment

In addition to the basic equipment for making contact prints, you will also need the following items:
● an enlarger
● a blower brush
● a masking frame
● a focus finder

If you want to produce high gloss (glazed) prints you will also need a special drier. But if you intend to use resin-coated printing paper or matt finish paper, or let glossy paper dry normally, you won't need to have a drier because they can be left to dry by themselves. You can also manage to make enlargements without a masking frame by positioning the paper on the baseboard and securing it at the corners with small pieces of masking tape.

Choosing a printing paper

Resin-coated papers are becoming popular with many photographers because they take less time to process and dry. Fibre-based papers may be cheaper but involve more effort. While you are learning, however, it is advisable to keep using the normal Grade 2 glossy paper recommended for making the

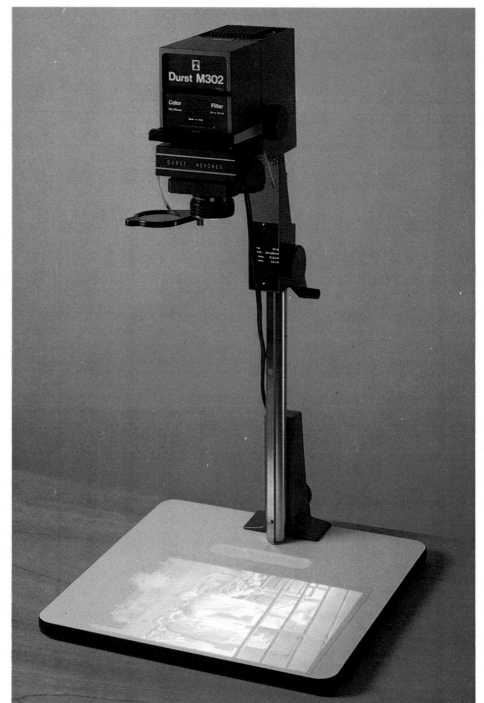

contact sheets, and perhaps to buy some hard (Grade 3) and soft (Grade 1) papers to try out. You will soon be able to tell just by looking at a negative whether it would be most effective if printed on hard, soft or normal paper. Printing papers are available in single or double weight but, unless you want to make large prints—8 x 10in (20.3 x 25.4cm), for example—single weight paper will be adequate and more economical. It is also a saving to cut 8 x 10in

Never focus through the red filter—you probably won't get a sharp focus. Only use the red filter to position the printing paper on the baseboard when you haven't a masking frame. But first focus the image on the back of a print placed on the baseboard.

(20.3 x 25.4cm) paper into quarters (use a steel rule and a very sharp knife or a rotary trimmer). While learning, you will probably want to make smaller

prints. But don't forget to do the cutting by safelight. Further on this chapter gives more information on papers, such as other grades, tone, texture and special surface finishes you can choose from.

Getting ready

Follow the instructions for preparing the chemicals as explained in the section on making contact prints at the beginning of the chapter. When the chemicals are ready, wash your hands and dry them thoroughly. You should *never* handle either negatives or printing paper with damp, chemically contaminated fingers.

When you use your darkroom for the first time it is a good idea to check the safelight. A too powerful bulb, or a faded safelight filter, or the wrong kind of filter for the paper being used, or a light too close to the working surface, can all result in fogging. So make a check as outlined earlier on, but this time fit a negative into the enlarger as if you were going to make a print. Give the paper an exposure of about 5 seconds. (This makes it more sensitive to light.) Don't develop the paper at once but place it on the bench, emulsion side up, with two coins on it, and leave it for about 10 minutes. Then process the paper and if circular areas of a lighter tone appear, the safelight is fogging the paper. Put in a lower power bulb, move the light further away and check that the filter is the right sort. Now test it again before proceeding.

Focusing the image

You usually compose and focus your picture with the enlarger lens fully open so that as much light as possible reaches the baseboard. So set the enlarger lens at the widest possible f number—for example, f3.5—but stop down the lens before printing. This improves the sharpness of the image and helps the lens to give the best possible definition. The smaller the f stop chosen—say, f8, f11, or even smaller—the less light will reach the baseboard.

If the negative is rather dense or the enlargement big—for example 11 x 18in (30 x 45cm)—use a stop of f5.6 or f8. A small enlargement or a thin, underexposed negative may benefit from an f stop of f11 or f16. With practice you will find it easy to select the f stop. But many photographers prefer to work with a standard stop if they can—perhaps f8 in the case of a f3.5 lens—altering the exposure rather than the stop.

It's imaginative to enlarge selectively but, if you choose a very small portion of a 35mm negative and enlarge it 15 times, there is bound to be some loss of definition.

STEP-BY-STEP TO AN ENLARGEMENT

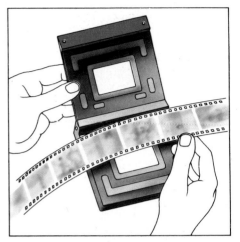

1 PREPARE CHEMICALS
Dilute or mix chemicals according to maker's instructions. Temperature of developer must be over 68°F (20°C), but stop bath and fixer can be within ± 4.5°F (2.5°C) of 68°F (20°C). Pour solutions into developing trays. (Always set trays in a row to prevent fixer contaminating the developer.) If room is cold make regular temperature checks or put solutions in storage bottles and stand in a water bath.

2 PREPARE NEGATIVE
Use contact prints to select negative and place strip on a *clean* surface. If necessary, clean the back with film cleaning fluid or meths on a soft, lint-free cloth; don't rub too hard. Remove any dust from front of negative with a blower brush. Take negative carrier out of enlarger and if fitted with glass check cleanliness. Remove marks with cleaning fluid or meths on a cloth and dust with a blower brush.

3 PUT NEGATIVE IN CARRIER
Insert the negative, emulsion side down, in the carrier, make a final check for dust, and replace the carrier in the enlarger. Switch off the light.
You will be working by safelight from now on, which is indicated in diagrams by an orange background.

Making the test strip

To make a test strip, cut a strip of paper about 2in (5cm) wide from the sheet size on which you intend to make the final print. Focus the image on the baseboard, stop down, and then, using the red swing filter if necessary, position the test strip before making the exposures. (Place it so that you get a representative section of the image.) You will also need a sheet of opaque card slightly larger than the paper.

Exposures

Block the light from consecutive sections along the strip as the exposure proceeds; zones showing the effects of different exposures are then obtained. The length of each step in the test strip exposure will vary according to the degree of enlargement, the overall density of the negative and the f stop chosen. With experience it will be easy to estimate. It should, however, never be less than 2 seconds or more than 10 seconds. An average initial exposure time is 5 seconds. While it is best to use a timer, you can simply count—one-and-two-and—and so on.
To expose the test strip, turn on the enlarger and start counting from 1 to 25 seconds. At 5 seconds cover a fifth

of the strip with the card. (Be careful not to move the strip; hold the card about 1in (3cm) above it.) At 10 seconds cover two-fifths of the strip. at 15 seconds, three-fifths, and so on. Switch off the enlarger at 25 seconds. You now have a test strip showing 5, 10, 15, 20 and 25 second exposures.
Process the test strip and decide which is the best exposure. If the whole strip looks too light, repeat by increasing

Here you can see that the correct exposure is around 17 seconds. To select it accurately do another test strip for 15, 16, 17 and 18 seconds.

all the exposures or open the lens by one f stop—that is, go from f8 to f5·6 and repeat the test strip procedure. If the whole strip looks too dark either decrease the exposure times or close down the lens by one stop.

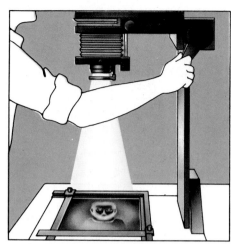

4 DEGREE OF ENLARGEMENT
Switch on the enlarger.
If you have an easel, use the white painted surface as a screen for the image. If not, use a sheet of white card or the back of a print placed on the baseboard. Raise or lower the enlarger head until the correct degree of enlargement is reached.

5 FOCUSING
Compose and focus the image with the enlarger lens fully open—for example, f3·5. Then stop down—for example, to f8. Turn the focusing control to and fro to focus the image sharply. Check focus by looking carefully at the image, but if making a big enlargement or if the image is very dense use a focus finder (you may want to use one in any case). Having set up the enlarger, switch off or move the red filter over the lens.

6 MAKE A TEST STRIP
Make a test strip to find the best exposure for the negative. A full explanation of how to do this is given on the page opposite.
Having made the exposures, switch off the enlarger and develop the test strip, following the method outlined in steps 8, 9 and 10. Decide which is the best exposure.

7 EXPOSE ENLARGEMENT
Take a sheet of paper from the pack. Close the pack tightly. Place the paper, emulsion side up, in the easel. If fixing it to the baseboard with masking tape you will need to swing the red filter across the lens, and switch on the enlarger to see where to position the paper exactly. Then switch off the enlarger and swing the red filter away. Wait 10 seconds, switch on enlarger and begin timing chosen exposure. Then switch off the enlarger.

8 DEVELOPING
Raise the front of the developing tray slightly. Hold paper by edge and quickly slip it into developer, shiny side up. At same time straighten tray so developer washes quickly over paper. Rock tray gently so whole of paper gets a supply of fresh solution. Develop for full time recommended— usually 2 minutes.

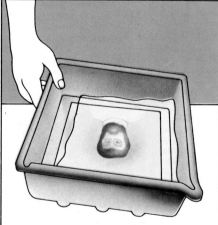

9 STOP BATH
At end of development lift the print from developer with tongs. Hold it by the edge. Pull it out over the edge of the developing tray so that as much developer as possible flows back into the tray. Drop print into stop; be careful not to let tongs become contaminated with stop. Gently rock stop bath. Leave print in stop for 30 seconds.

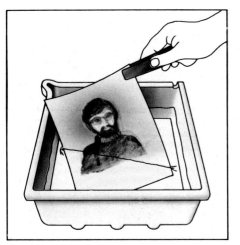

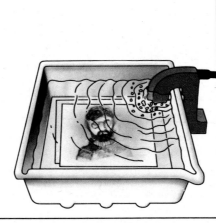

10 FIXING
Remove print from stop bath with tongs and place in fixer. Be sure it is fully submerged. Rock tray for 20 seconds so solution does its job thoroughly.

If using ordinary hypo, after 60 seconds you can turn on light but check first that all unexposed printing paper is tightly sealed up. Using rapid fixer light can be turned on after 20 seconds. Fix for recommended time.

11 WASHING THE PRINTS
If making more than one print, collect them together in a tray of water (not in the fixer) and wash all at once. The washing must be timed from the moment the last print goes into the wash. Use a tray with sink siphon to ensure prints do not stick together and wash in running water. RC papers need about 4 minutes wash, fibre papers 45, according to maker's instructions. Move prints about during this time.

12 DRYING
Blot surplus water off both back and front of print with a clean, damp sponge. You can then hang them up by the corner in pairs, back to back, or lay them face up on a sheet of photographic blotting paper. Or you could use a print drier which is fast and keeps the print flat.

Glossing fibre-based papers
If you leave glossy paper prints to dry normally they will have a semi-lustre look. But this type of paper can be given a high gloss by drying it on a chrome glazing plate.

Using a drier: the secret of making good high gloss prints is a *thoroughly* clean chrome plate. Before you start, clean the chrome plate with soapy water, dry it and then rub it with methyl alcohol (meths) on a clean cloth. To gloss the print add a few drops of wetting agent to the final wash water so that it is evenly wet, remove the print from the water, drain off the excess water, and quickly place the print face-down on the chrome plate.

Use a clean flat squeegee or a print roller to press the print to the chrome plate, moving it across in one continuous movement to expel all the water and air. It is important that there are no air bells (bubbles) under the paper, which blotch the surface.

Place the plate with the prints in the drier. Use a moderate heat. When the prints are ready (after 5 minutes or so), they will unstick themselves from the chrome surface. Don't try to pull them clear sooner—you will damage the emulsion and ruin the print.

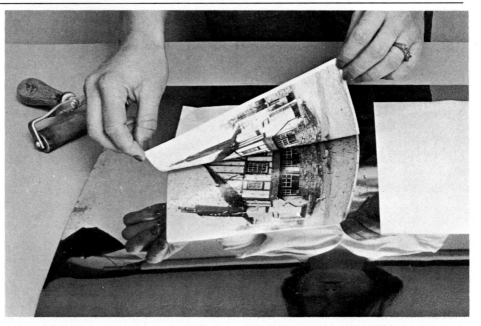

Prints sometimes refuse to come unstuck, because of grease on the plate. To free them, soak the plate and prints in hot (not boiling) water, containing a few drops of wetting agent.

Without a drier: an excellent high gloss can be achieved without a drier by leaving the print to dry on the chrome plate, or you can use a spotlessly clean

Hold the paper with both hands above the glazing plate, emulsion side down. Lay one side down first, then slowly lower the other.

sheet of plate glass. Clean the glass with methyl alcohol (meths) and then with french chalk (talcum powder), removing the chalk with a cloth.

CHOOSING THE RIGHT GRADE OF PAPER

Hard negative

Normal negative

Soft negative

Grade 1 paper **correct**

Grade 1 too soft

Grade 1 far too soft

Grade 2 too hard

Grade 2 paper **correct**

Grade 2 too soft

Grade 3 far too hard

Grade 3 too hard

Grade 3 paper **correct**

Dealing with print faults

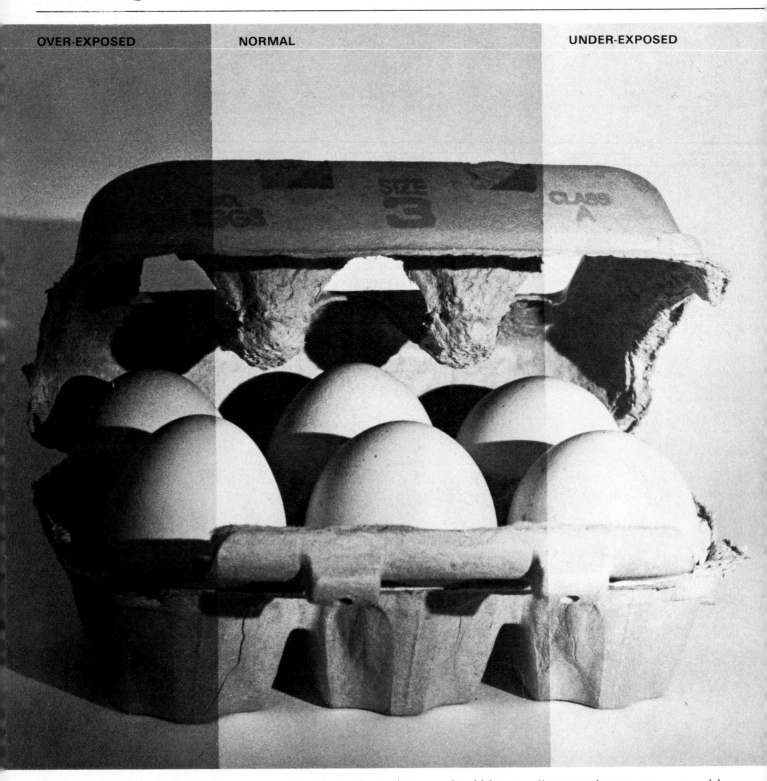

OVER-EXPOSED **NORMAL** **UNDER-EXPOSED**

In the early stage of learning any new skill, no matter how careful you are, a few mistakes are inevitable. Even the most experienced photographic processor can occasionally find that he has produced a dud print which is quickly consigned to the waste bin.

So, having keenly anticipated the appearance of a perfect print, you should be prepared for an occasional failure. By finding out what went wrong and correcting the error, you can use such disappointments to help teach yourself better techniques.

Some typical faults are shown here as a guide. Compare them with your efforts to discover what went wrong and how to ensure that you don't make the same mistake twice! After you have acquired some experience and mastered the basics of printing, white spots on the print, caused by dust and hairs on the negative, are probably the most common fault.

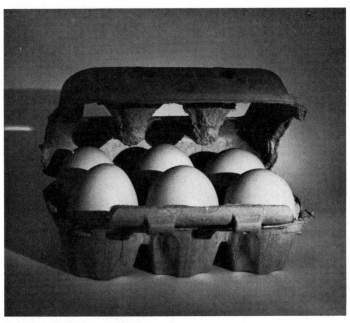

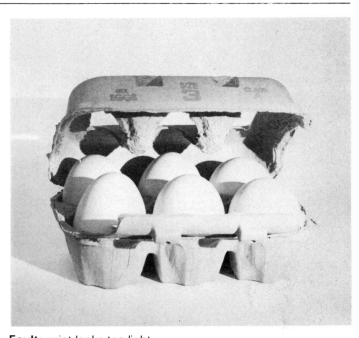

Fault: print looks too dark.
Cause: probably over-exposure.
Prevention: reduce the exposure time unless it is already below 5 seconds. In this case stop down by one f stop—for example, f8 to f11—and repeat test exposure. If the exposure correction doesn't work check development time and temperature; developer works more quickly at over 68°F (20°C).

Fault: print looks too light.
Cause: probably under-exposure but perhaps under-development.
Prevention: increase the exposure time unless this is already more than 60 seconds. If this is the case, open up by one f stop—that is, f8 to f5.6—and repeat test exposure. If this doesn't work check the development time and temperature. At below 68°F (20°C) developer works more slowly.

Fault: image is too flat. There is no sparkle in the highlights and no really black shadows.
Cause: the paper is too soft or the developer may have been too cold, or the development time too short.
Prevention: use a harder grade of printing paper. For example, if you used Grade 2 try a print on Grade 3 and keep a close watch on development time and the temperature of the developer.

Fault: image is too contrasty. The highlights and shadows lack detail, giving the print a soot and whitewash appearance.
Cause: the paper is too hard.
Prevention: use a softer grade of paper. For example, if you used Grade 2 try a print on Grade 1.

Fault: overall lack of contrast and grey veiling. (Only half picture is fogged—the other half is normal to show the effect.)
Cause: fogging from unsafe safelight or other source.
Prevention: check the blackout effectiveness of the darkroom and check the safelight as described in the chapter on making contact prints.

Fault: white finger prints or other white marks.
Cause: contamination of paper by fixer.
Prevention: make certain your hands are clean before touching any paper; wash and dry them carefully after touching fixer. Use print tongs to avoid contamination.

Fault: print is darker in the centre than at the edges.
Cause: uneven exposure owing to an incorrectly positioned enlarger lamp.
Prevention: readjust the light bulb and check the position by projecting white light on to a sheet of white paper and inspecting the density. A poorly positioned lamp will be bright in the middle and dimmer at the edges.

Fault: image unsharp all over. (Check any dust spots—even if the negative is unsharp, dust spots should be in sharp focus.)
Cause: faulty focusing in enlarger.
Prevention: first check the sharpness of the negative, then check the focus of the projected image, preferably with a focus finder. If it persists the lens may be faulty so have it checked professionally. Also the focusing device may be slack, so that the position of the lens alters slightly after focusing.

Fault: small white spots and squiggles.
Cause: dust on the negative or the negative carrier or the paper.
Prevention: some dust spots are almost inevitable if printing in dusty surroundings and they can be spotted out. But they are best eliminated by carefully cleaning the negative and carrier glass.

Fault: dark lines round edge of paper.
Cause: fogging. The unexposed paper was not properly wrapped up or exposed to stray light in the darkroom.
Prevention: check that the paper is carefully rewrapped after use and store it in a dry, dark place. Never take a sheet out of the pack until ready to expose.

Fault: multiple image with a blur in one direction.
Cause: enlarger head moved during exposure or the masking frame was inadvertently knocked.
Prevention: wait until any vibration in the head has died down before you make the exposure. Avoid moving about the darkroom while making the exposure. If traffic vibration is suspected try damping this by placing the enlarger on a thick rubber mat.

Fault: partial lack of sharpness.
Cause: the negative was not lying flat in the carrier. Also, too much heat may cause the negative to rise in the middle, pulling in the edges and blurring the image at this point.
Prevention: position negative more carefully in the carrier. Try using a glass carrier. Don't let the negative get too hot.

Black-and-white printing papers

Unless you are very careful when buying and using black-and-white printing papers, making your own black-and-white prints can be more expensive than having colour prints made by a photo-finisher. The price of the silver in black-and-white paper increases all the time. Two boxes of 100 sheets of 8 x 10in (20 x 25cm) paper can cost as much as some camera lenses. You cannot afford to make several trial prints or to guess at printing exposures, and money is wasted if you buy paper that you do not use.

Resin-coated or fibre-based?

If you have not yet started printing, you can choose between stocking up with the popular resin-coated (RC) papers or with the traditional fibre-based types. This choice will determine not only the equipment you will need for washing and drying the prints, but also how long it takes you to make each print.

RC papers have a base which does not absorb water. Only the surface layer of light-sensitive emulsion becomes saturated with processing chemicals. As a result, these papers use less chemicals, carry less of one solution over to the next, and can be washed and dried very quickly. All processing operations are shorter.

Fibre-based papers have a very absorbent card or paper base. They take longer to process than RC papers, and because they trap fixer salts in the fibre of the base, need to be very well washed after the print is developed. Washing can take over an hour in running water.

Because RC papers can be processed so easily, they are very widely used. However, they are more expensive than most fibre-based papers. In addition, they will not last as long as a properly processed fibre-based print, and do not give quite as high a standard of print quality. For most purposes the differences are small.

Paper sizes

Buying many paper sizes wastes money. You should buy the largest size you normally use. Most people choose 8 x 10in (20 x 25cm). This can easily be handled and cut down with a small rotary trimmer to smaller print sizes. If you use a 35mm camera, the negative proportions will not fit the paper, but you can trim each sheet and use the off-cuts for making test strips. Alternatively, you can crop the negative when you make the enlargement, al-

▲ The variety of printing papers can be confusing. All can give good results if exposed and processed properly.

► Choosing the right paper can make all the difference to your prints. For a top quality negative, only the best is good enough. This picture by *John Swannell* was printed on Ilfobrom doubleweight fibre-based paper. The glossy surface was allowed to dry naturally to an unobtrusive finish.

though this means that you will have to enlarge the negative slightly more to fill the paper. This will increase the graininess of the print.

Other paper sizes are better suited to the proportions of 35mm negatives if you do not want to make a test strip for every print. The larger 11 x 14in (27.9 x 35.5cm) size can be cut into two 7 x 11in (17.8 x 27.9cm) sheets, for example. When a 35mm negative is printed full-frame on a 7 x 11in (17.8 x 27.9cm) sheet, only a narrow ½in (1.25cm) strip at the end is wasted. 8¼ x 11¾in (21 x 29.7cm) paper—known as A4 size in some countries—has similar advantages but is less widely available.

Bases and surfaces

Resin-coated papers usually only come in one base weight. This is because RC paper has little tendency to curl. Fibre-based paper is softer, influenced by atmospheric moisture, and needs a heavier base if it is to lie flat without being mounted. So double weight and single weight fibre-based papers are available. Choose the former for top quality prints and larger sizes, the latter for proofs and small prints.

The most commonly used paper surfaces are glossy, lustre, semi-matt, pearl and silk. Glossy RC papers dry to a shiny finish naturally, but glossy fibre-based papers need to be ferro-typed (glazed) to achieve a very smooth surface. The finish of an unglazed glossy fibre-based paper is liked by many photographers, and Ilford RC Pearl surface resembles this. Lustre has a coarse texture which breaks up reflections from the paper surface and hides grain. Silk has a regular fabric-like texture. Semi-matt shows fine detail well but can look too dead for some pictures. True matt surfaces are only found on fibre-based papers.

Contrast

In order to cope with a variety of negatives, printing papers are made in a range of contrast grades. There are two types—papers in set grades, where each grade is sold in a separate package, and variable contrast papers which

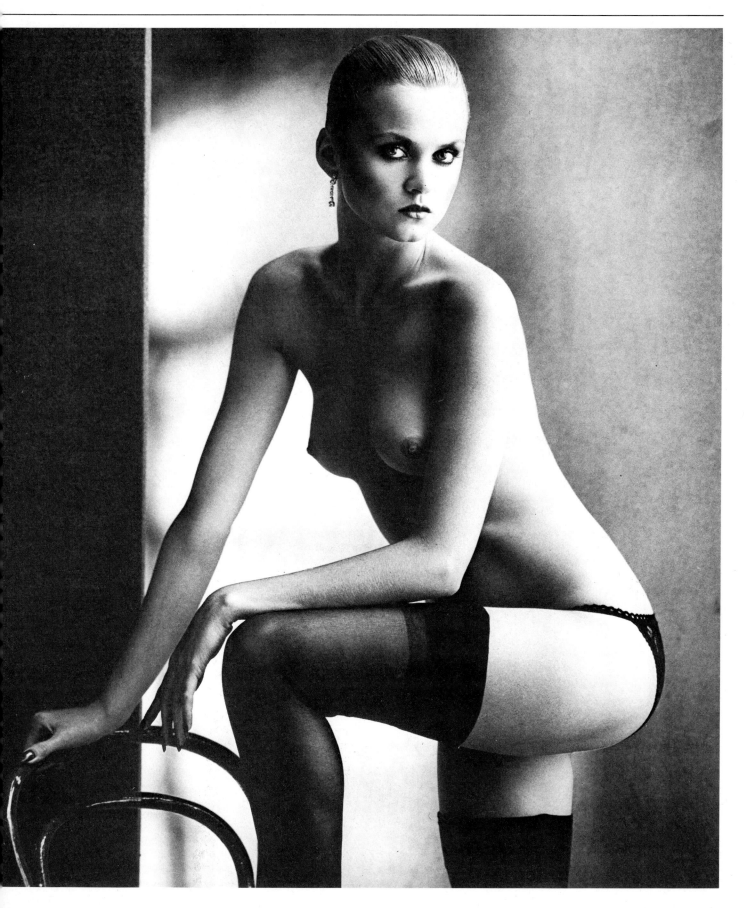

▲ The surface of the paper you choose for prints can completely change the look of the picture. From left to right: *Glossy* gives the best contrast between shadow and highlight, but can reflect light annoyingly. *Matt* paper cannot give such rich shadows; and the texture of *silk* paper will not suit all subjects.

cover all grades with one paper.
Most negatives will print well on grade 2 or the grades immediately above and below it on the scale. The more extreme grades such as grade 0 (soft) and grade 4 (hard) are used to correct for negative faults.

To cover all possibilities with seperately graded paper, you will need to buy boxes of grades 1, 2 and 3, and smaller packets of the more extreme grades.

Variable contrast papers such as Ilfospeed Multigrade and Kodak Polycontrast solve the problem of buying all these grades. One paper covers the whole range, with coloured filters in the enlarger controlling the print contrast. With Ilfospeed Multigrade, yellow filters make the print less contrasty, while magenta filters increase the contrast. There are seven filters altogether, giving more evenly spaced grades than equivalent individually graded papers. Multigrade paper at its highest contrast is not quite as hard as a conventional grade 5 paper, however.

Processing

RC and fibre-based papers need slightly different types of chemicals, though prints made on one type of base can

GRADED PAPER CONTRAST RANGE

▲ The range of contrast grades available with individually graded papers is wide. Here Ilfospeed grade 0 has given a flat, dead-looking print from this negative. This is the softest plastic-based paper in Ilford's range.

▲ Grade 3 is much closer to the correct contrast grade for this negative. Grade 3 and grade 2 are the grades you are likely to need for the majority of your negatives and are therefore the ones you will use most.

▲ Grade 5 is too contrasty for most negatives—prints on this grade will usually be too stark and lacking in detail. If you really need extreme contrast, even harder grades are available on fibre-based paper.

usually be developed in chemicals intended for the other. Chemicals for fibre-based papers are usually slightly cheaper than those for RC papers. RC paper developers give richer tones, better blacks, and shorter developing times when used with the papers for which they are designed.

Ilfospeed Multigrade has it own developer. With some other developers, the image colour may change slightly with different contrast settings. If you burn-in part of a picture at a different contrast setting from the rest this change will be noticeable.

Some developers are intended to give different image tones to prints, so that you can choose between warm-toned, neutral and cool-toned prints without having to stock special papers.

Whatever developer you use, make sure you follow the maker's temperature and development time recommendations carefully. Most fibre-based papers need a stop bath between developer and fixer to prevent the fixer from being contaminated by developer carried over by the print. RC papers also need a stop bath because they can stain badly if fresh developer on the print surface comes into contact with the fixer.

Nearly all fixer solutions are based on ammonium thiosulphate and work quickly. Fresh fixer will treat a print in 30 seconds. When fixer activity has slowed to take 2 to 3 minutes, it is time to discard the fixer. You can check how rapidly your fixer works by timing how long a piece of scrap film leader takes to clear in the fixer tray.

Alternatively, there are some commercial solutions available for testing fixer. With RC papers, a hardening fixer may slow down drying and demand longer wash times, but the print will be less sensitive to scratching and finger marks when dry. Older hypo-based fixers need 5-10 minutes treatment time, but are not advisable unless extreme economy is important. The temptation to turn the lights on before fixing is complete is too great with longer fixing times.

Storage

If you intend to keep a large stock of paper, you should make sure that it does not deteriorate before you can use it all up. Unexposed paper is best stored in a cool, dry place. A cupboard away from sources of heat such as radiators or windows is suitable. Make sure that your paper is out of reach of children, who may find the temptation to open the boxes to see what is inside irresistible.

Points to watch

● Try to match the sizes of paper you keep in stock to your negative size and to your usual degree of enlargement. Unless you particularly like the effect, making prints with wide unexposed borders is a waste of paper and processing chemicals.

● Try to expose and develop your films so that most of your negatives can be printed on grade 2 or grade 3 paper. It is less trouble (and gives better results) to control your negative processing carefully than to stock large amounts of very hard and very soft paper to deal with difficult negatives.

● Use chemicals that are suitable for the paper you are using. Best results are usually given by following manufacturers' recommendations.

When you start making your own prints, you will probably need a variety of different papers and chemicals to experiment with. But as you gain skill and adopt your own printing style, you will settle down with those papers and chemicals that give you the best results for your type of pictures.

USING VARIABLE CONTRAST PAPER

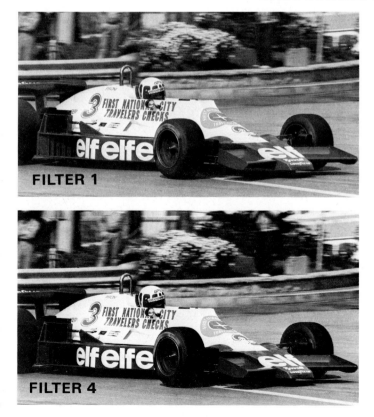

FILTER 1

The major advantage of variable contrast paper is that only one box of each sheet size need be stocked. This advantage is usually sufficient to outweigh the minor disadvantages of the paper:— the range of contrast available is not as great as from individually graded papers, changes in grades require recalculation of printing times, and the paper is only available on a RC base. Left: the softest grade obtainable on Ilford's Multigrade paper. Below left: a normal grade produced by printing through filter 4. Below right: filter 7—the hardest grade. For most purposes this range is sufficient. The range of intermediate grades is useful for experienced printers. Other possibilities include varying the contrast of different parts of the print by burning-in with filters.

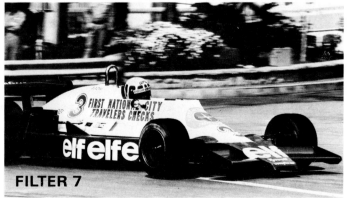

FILTER 4

FILTER 7

Improving your black-and-white printing

With practice the quality of your black-and-white negative processing will improve, and you will want to produce better prints. Although many decisions that affect the appearance of the print are subjective, you need to know the alternatives that are available and how they affect the result.

What to look for

A good print satisfies two criteria:
● the grain of the negative is sharp over the whole area of the print,
● the print has a full range of tones from the darkest black of which the paper is capable to the purest white, with a good range of grey tones in between.

Look at examples of good printing at photographic galleries and exhibitions.

Enlarger lens

The enlarger lens must be good enough to render the fine detail and contrast produced by the camera lens. Even the definition of perfect negatives may be destroyed by a poor enlarging lens. Poor enlarging lenses also tend to give uneven illumination, with falling off towards the corners. Therefore buy the best enlarging lens you can afford. Good lenses include those in the Schneider, Rodenstock and El-Nikkor ranges, among others.

Keep your lens clean. Dust or condensation on the lens elements and fingerprints all spoil definition.

Choosing a paper

If you wish to produce a lot of prints quickly, then the obvious choice is a paper with a resin-coated (RC) base. A skilled printer can produce work of a high quality on RC material. However, it is worth spending the extra time and money on making some excellent prints from your best negatives, and there is no doubt that the finest fibre-based papers can give even better prints.

The richness of a print, the depth of tone in the blacks, depends on the amount of silver halide the manufacturer incorporates in the emulsion. There are noticeable differences between the results obtainable on the various fibre-based papers when working to the most critical standards. Many printers believe that Agfa Brovira and Ilford Galerie give the best quality of all the silver bromide papers. For silver chlorobromide papers, which give a warm tone to the image, Agfa Portriga and Kodak Medalist or Bromesko are good choices. Another factor affecting paper choice is the way different types of paper repro-

duce the tones of the negative. For example, Brovira and Galerie tend to emphasize differences between the middle-range greys, while the warm tone papers differentiate better between the darker shadow tones and compress variations in the middle greys.

Print surface should also be considered. Glossy papers give the greatest difference between blacks and highlights, and also show the sharpest detail, but they may make flaws more visible and they are less easy to retouch. A matt paper can be pleasing for subjects with large areas of undetailed shadow. A good compromise is a lustre surface which is easy to retouch and retains a reasonably good tone range. Try to obtain a manufacturers' sample book and see for yourself the difference which paper surface can make.

Contact sheets

A contact sheet is a first useful step to making enlargements. The sheet allows you to select the negative and framing

◀ **Grade 0: soft.** Selecting the right grade of paper for each negative is important, but your own taste will influence your choice, as well as the negative contrast. However, most would agree that this print, lacking rich blacks, bright highlights, and with dull grey tones, is on the wrong grade.

◀ **Grade 2: normal.** The same negative shows much more acceptable contrast: the tonal range of the print convincingly reproduces that of the original scene. Most photographers would use this grade for their final print from this negative. Grade 2 is the standard grade that best suits most subjects.

◀ **Grade 4: hard.** Notice how the grain of the negative is greatly accentuated by the contrast of the paper. The print gives a greater impression of sharpness, but subtleties of tone have been lost. The effect is bright and crisp, but distortion of the tone scale is shown by the unnaturally dark lips.

you want, indicates the grade of paper to be used, and gives some guide to exposure.

Expose contact sheets for the minimum time necessary to make the clear edges of the negatives as black as the paper will allow, and always use the same contrast grade of paper. By doing this variations between the processing of individual rolls of film will be made apparent, and the necessary compensations in printing can be more easily estimated.

Making the print

Once the enlarger has been set up so that the projected image is in focus and the right size, a test strip should be made to assess the correct exposure.

Use a piece of paper at least a quarter of the size of the final print so that a range of tones can be included. When the test strip has been processed you can estimate the correct exposure and whether you are using the right grade of paper for the negative.

Dodging and burning in

The tonal range of a negative may not suit a grade of paper exactly, or the visual balance of an image may be improved by lightening or darkening certain areas by a localized increase (burning in) or decrease (shading or dodging) in exposure.

The degree to which you can manipulate an image depends both on your skill and the nature of the image. A picture composed of even tones with smooth gradation from one area to another is much more difficult to manipulate than one which is broken up into small areas of contrasting tone. This is because uneven changes in density will be obvious in even-toned subjects but obscured by a subject with a mixture of tones.

The duration of the printing exposure is important when burning in or dodging. With a basic exposure below 10 seconds it is impossible to achieve consistent results unless you are very experienced. The margin of error is too small: a

◀ *Adrian Ensor,* **one of Britain's best printers, used grade 3 paper for this print. Ensor finds that this harder-than-normal paper gives better middle tones, but needs more dodging and burning in. This print was made with a 15 second basic exposure. The face was dodged so it had a five second exposure, the background was burned in for 10 more seconds, and a 20 second burn brought out detail on the sleeves.**

▲ Ensor's first test print. On grade 3 paper with an exposure of seven seconds and without any dodging or burning in, only the face and hands are correctly exposed. The rest is glaring highlight.

▲ Slightly shortening the exposure of the face by dodging gives additional emphasis. The background has been burned in for an extra five seconds, but the sleeves show little detail and the picture lacks drama.

▲ The background has been burned in for a full minute, completely changing the mood. (Ensor's prints were made on Ilfobrom, and developed in Ilford Contrast FF. The enlarger was a Leitz Focomat IIc.)

variation of one second is 10% of a 10 second exposure time, and a change in density of 10% is visible. Conversely, if too long a basic exposure is chosen, dodging and burning in can be tedious. Choose basic exposure times of 15 to 20 seconds, varying the aperture to achieve this. However, enlarger lenses usually perform best at one or two stops below their maximum aperture, and with cheaper lenses stay as near as you can to this optimum setting.

Developing the print

The key to successful print processing is consistent and controlled technique.
Because paper is often thought more tolerant of variations in processing than film, there is a tendency to be more casual in your approach. For instance, the temperature of the processing solutions is often allowed to vary a great deal. But if print developer is too cold, it will be impossible to achieve a proper black tone.
The simplest way of keeping solutions at the right temperature is to keep the darkroom itself warm. If you prefer to work in a cooler darkroom, the processing trays can be used in a sink or larger tray containing a little warm water. Top up the water from the hot tap when necessary, or fit a thermostatically controlled water heater of the type used for tropical fish tanks to maintain the correct temperature. Keep a thermometer in the developer during processing so that the temperature can be checked continuously.
As print development can be observed, there is a temptation to judge development by eye instead of timing it accurately. This should be avoided. Manufacturers give standard processing procedures and these should be followed to get the best possible results.
● Always use the proper agitation, temperature and development time when processing the contact sheet, the test strip, and the final print.
● Never be tempted to pull a print from the developer because it seems to be turning too dark—prints usually look darker under the safelight than under normal lighting conditions. Underdeveloped prints lack contrast. The areas that should be black are dark grey.
● While it is tempting to over-develop prints that are too light because of underexposure, this can lead to fogging, grey highlights and staining.
● If a correctly processed print looks too dark or too light under white light then a new print should be made with a different exposure.

Avoiding contamination

The paper should be transferred from tray to tray with print tongs, using seperate tongs for each solution. Do not let tongs dip into the stop bath. Contamination of the developer by the stop bath or the fixer will seriously shorten the working life of the solution and also alter the image tone.

Fixing

High speed ammonium thiosulphate fixers attack the silver image if the print is left in the solution for too long. This results in a loss of detail in the highlights, and also makes it difficult to wash the print properly.
Time the process and remove the print from the fixer after three minutes. Be careful not to fix more prints in a given quantity of working solution than the manufacturer recommends, or prints will stain and fade in time.

Washing

Washing procedure is dictated by the type of paper you use. Resin-coated papers can be washed effectively in five minutes in running water. Fibre-based papers take much longer as the silver salts formed during fixing are absorbed into the base and have to be washed out. Again, follow the manufacturer's instructions.
When washing it is important that the water circulates freely. Attach a short length of rubber hose to the tap to direct the water to the bottom of the container, so it passes between the prints before flowing over the rim. It is best to

▲ **Fibre-based prints can be dried quickly in a flat-bed drier. This model is double sided to increase the number of prints that can be dried at one time. Prints must be washed carefully to prevent the blanket that holds them in place from becoming contaminated by fixer.**

▶ *John Sims* **gave this landscape a moody atmosphere by printing on contrasty paper and burning in the upper part. Dodging the man on the left emphasizes his separation from the other figures, and reinforces the composition.**

use a specially designed print washer, as these ensure that prints are kept seperate while water flows over both sides. Whichever method you use, never put unwashed prints into water containing clean prints. This contaminates the clean prints sufficiently for them to require rewashing. Washing must be timed from the *last* print to be added.

Drying

It is sufficient to hang resin-coated papers up to dry to get flat prints. For fibre-based papers it is necessary to use a flat-bed drier to get the same result with any speed. The alternative is to dry prints slowly, either between sheets of photographic blotting paper, or on a glass fibre mesh. When drying is uneven it is difficult to get prints to lie flat. However, a well-made print deserves framing or mounting for display, and will give pleasure for many years.

THREE TIPS FOR BETTER PRINTS

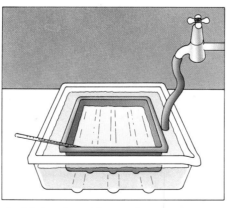

▲ Start by making spot-free prints. An anti-static gun can help remove dust from your negatives. Aim the gun, then gently squeeze and release the trigger. Dust can be brushed off electrically neutral negatives.

▲ Make the effort to keep solutions, especially the print developer, at the right temperature. Put the developer tray in a larger tray holding warm water, and top up from the hot tap as the temperature falls.

▲ Prints will have less curl if they dry slowly in air. Hang them two at a time, back-to-back on a clothes line. Or make drying racks from plastic mesh (obtainable from builder's suppliers) and dry prints overnight.

Black-and-white printing from colour originals

You may sometimes find that you want to make black-and-white prints from colour negatives or slides. For instance, you may find it helpful to make black-and-white proof enlargements from colour negatives to judge such things as expression or pose before going to the expense of making colour prints. Also picture editors on newspapers and some magazines prefer black-and-white prints unless they are producing a special colour supplement. If you have done your own black-and-white enlarging you will have almost all the equipment that you need. You can use an ordinary enlarger and the same trays and solutions you would use for black-and-white prints. For prints from slides, however, you will first need to make a black-and-white negative. You will then use this to produce a black-and-white print in the normal way.

Prints from colour negatives

Some people use conventional paper for making black-and-white prints from colour negatives but they soon find that their results suffer from tonal distortions. One of the reasons is that such papers are sensitive only to blue light so that they don't respond to green and red. The result is that red objects print too dark while blue areas print too light. For example, lips and pink complexions appear dark while blue skies with white clouds reproduce with little detail.

Grain size

Another unfortunate side-effect when working from colour negatives is an increase in the apparent size of the grain. For example, prints from an extremely fine grain colour film such as Kodacolor II 100 ASA may appear more grainy than prints from similar size negatives taken on a high speed black-and-white film. This arises because the yellow dye granules in the colour negative are quite large and, because yellow is complementary to blue, the blue sensitive paper records them as quite a bit darker than the eye sees them. Thus attention is drawn to them and they become very obvious to the eye.

The answer is to use a panchromatic paper such as Kodak Panalure II RC paper. With this paper you can produce a print which looks very like one from a negative taken on normal panchromatic film. All the colours are reproduced in their appropriate shades of grey.

You handle this paper in the same way as you handle colour paper, working with a colour safelight or in complete darkness. Don't use safelights designed

◀ Most people use colour negative film these days. However that doesn't mean you have to do without black-and-white prints. When you have a portrait like this that you may want to send to relatives it is far cheaper to produce the copies in black-and-white.

Below left: Panalure paper is sensitive to all colours and layers of the film and gives a smooth even result which is needed on this formal portrait.

Below: printing a colour negative on bromide paper gives a grainy result. The paper responds mainly to blue light and the yellow dye layer in the film has a very coarse grain structure which the paper records.

▶ Sometimes the exaggeration of grain produced by bromide paper can be used to good effect. In an informal portrait it can add to the atmosphere. Here *Tim Cook* used it to soften the outlines of the image. By making a light print and sepia toning he further enhanced the effect.

for conventional black-and-white papers or the paper will be fogged.

You don't need colour printing filters in your enlarger when you expose Panalure paper. Just produce your enlargement in the same way you would with black-and-white negatives, making a test series of exposures first to get the correct exposure for your

own conditions. The series should range from about 7 seconds to 30 seconds at f8 so that you have a good selection to choose from. Panalure paper can be processed in most general purpose black-and-white print developers and fixing solutions.

Unlike conventional papers, it's best not to develop Panalure papers by inspection. If you do so you will find the safelight illumination so low that you will have difficulty estimating when the density is right. Instead, use the strictly controlled time and temperature method of development that you would use for films or colour paper. At 68°F (20°C) the recommended development time is 1½ minutes. If you follow this procedure not only will your results be more satisfactory but image tones will remain constant from one print to the next.

Using filters

For greater effect you can use filters just as you would on your camera lens and the same rules apply: to darken a colour use a filter of a complementary colour; to lighten a colour use a filter of a similar colour. For example, you can darken blue skies by using a deep yellow filter on the enlarger. The same filter will lighten the golden colour of wheat fields, although for a more dramatic effect you may want to use a red filter.

When you've decided what you want to do just tape the appropriate filter on to the front of the enlarger lens. As with all filters you will need to increase exposure to compensate for the light they absorb. As a guide, use the same filter factor as you would for a panchromatic film in tungsten lighting. For example, a deep yellow filter has a

factor of about 2x and a red filter has a factor of about 5x under these conditions. However, to be really sure make a test strip with the filter in position.

Prints from colour slides

Before you can make a print from a slide you need to produce a black-and-white negative. There are several ways of doing this, most of them using equipment you already have.

Using a projector: the easiest method is to use a medium speed panchromatic film such as Kodak Plus-X Pan film or Ilford FP4 in a 35mm camera. Use a slide projector to throw your transparency on to a smooth screen, a matt white wall or a sheet of white paper. Don't use a beaded screen or a rough-surfaced material otherwise you may pick up the texture in your photograph and the result will look like grain in the finished print.

Position your camera as close as you can to the projector lens-to-screen axis without interfering with the image. Determine the exposure by taking a meter reading off the screen from the camera position and to be really sure of getting a good negative, bracketing your exposures. Develop the film as you would normally.

This technique can produce good quality negatives but only if you make every effort to reduce light flare. Use a clean, good quality lens on the projector, a dark surround to the projected image area and ban smoking while you are at work.

Using a slide copier: for better quality results use one of the many slide copying devices on the market. Again, use a medium speed panchromatic film and estimate exposure as directed in the duplicator instructions.

Some copiers have a method of reducing contrast. You will find this useful for all but low contrast slides. Try a few tests with and without contrast reduction. Using your normal processing conditions you will soon discover the best technique to adopt for your own slides.

Using your enlarger: both methods just described are capable of giving good quality negatives, but for the best quality you should use an enlarger. The technique is not the easiest to use but it does allow you more control over the final quality than other methods. Unfortunately some 35mm enlargers will not give small enough images on the printing frame. Unless the normal 50mm lens can be replaced with a

75mm, enlargers with this limitation cannot be used for this technique.

Place your slide in the enlarger negative carrier and compose the image on the printing frame. If the frame surface is white make sure that it is covered with black paper during exposure to prevent light reflecting from it. Ensure that the image area is no bigger than the largest negative accepted by your carrier. Make sure that your darkroom is really dark and that your enlarger is light-tight. If you do have to light-proof it take care that it doesn't overheat the enlarger head while you are using it.

Use a medium speed panchromatic sheet film such as Kodak Plus-X Pan film or Ilford FP4 cut down to size. Make a test series to determine the correct exposure, stopping down the lens as far as it will go and using very short exposures starting at 1 second.

Most slides are high contrast subjects so you may need to reduce contrast. You can adjust the development time to do this. A reduction of 25-30% should be sufficient.

Once you have your black-and-white negative you can use it like any other black-and-white negative. You can make prints on any of the range of conventional black-and-white papers.

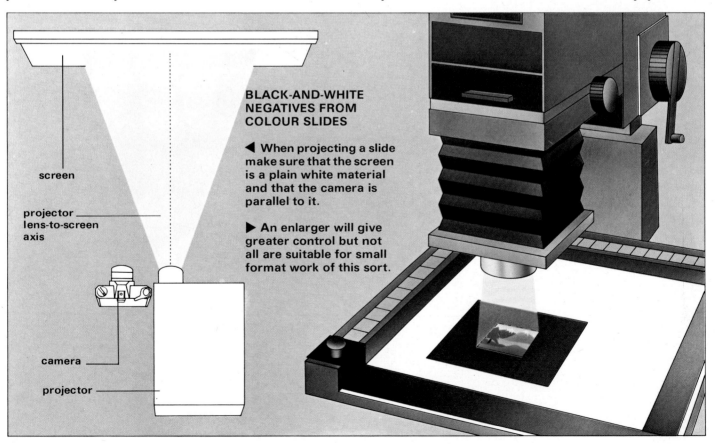

BLACK-AND-WHITE NEGATIVES FROM COLOUR SLIDES

◀ When projecting a slide make sure that the screen is a plain white material and that the camera is parallel to it.

▶ An enlarger will give greater control but not all are suitable for small format work of this sort.

screen

projector lens-to-screen axis

camera

projector

▲ A vivid subject in colour can prove difficult to transfer to black-and-white on occasions, particularly when red and green are involved.

▲ Enlarging the slide directly on to panchromatic film produces very little difference between the flower and the background foliage.

▲ A deep red filter taped to the lens of the enlarger lightens all the red in the image and makes the green darker to give the flower prominence.

▲ Most slides have a greater contrast range than prints. To retain both highlights and shadow detail in the print, development will often need to be altered when using an enlarger.

1 Given a standard development time a negative can be quite contrasty. Detail in the face and background will be lost unless special care is taken at the printing stage.

2 Reducing development by 25% is enough to alter the negative contrast range sufficiently for it to be printed on your usual grade of paper.

Making big black-and-white prints

There is an extra-special thrill about making your first really big print, perhaps one as large as 16 x 20in (40.6 x 50.8cm), but to obtain the quality you see in exhibitions you must take special care. In the first place, since the exposure needed is inevitably much longer than usual, the paper is out of the packet for a considerable time so the darkroom must be checked very carefully for light leaks, the enlarger head must not scatter any stray light and the safelight must not give even a trace of fog during the exposure. Any of these things, which may not affect a normal-sized print, can produce a greying of the highlights in a big enlargement and time spent looking for these causes of trouble is never wasted.

Adapting the enlarger

If your enlarger has a tall column it may be possible to make the print directly on the baseboard. This keeps the effect of vibration to a minimum since, if there is any movement, the head and the baseboard move as one unit. However, it may be necessary to turn the head or column round so that instead of projecting on to the baseboard the image is projected on to the floor, thus increasing the distance between the enlarger head and the paper. In this case it is essential to place a very heavy weight on the baseboard to counter-balance the weight of the head—a large pile of books can be used. Some enlargers have heads that can be swivelled to project horizontally so that the paper can be pinned to the wall or a door.

The lens: a standard focal length (50mm in the case of 35mm or 80mm with 2¼ x 2¼in—6 x 6cm) is needed to give sharp detail in the corners, though if only a small section of the negative is being printed it may be possible to use a shorter than normal focal length with the advantage that less distance is needed between the enlarger head and the paper.

● If you have a top-quality lens it can be closed down one stop for the exposure; inexpensive lenses usually have to be closed down two stops to obtain good corner definition. If the diaphragm is closed more than this the exposure will become too long.

● When you come to make the exposure, avoid using the switch on the baseboard if one is fitted since it may cause vibration. Instead, hold a sheet of card under the lens, turn on the enlarger and then remove the card.

Focusing: this is best done with the aid

When making big prints the focusing controls are often difficult to reach. The height of the Paterson Major Focus Finder helps to overcome this problem.

of a large focus finder. If an ordinary one is used you may find it hard to view the image and reach the focusing mechanism at the same time. However, specially tall ones are available which eliminate stretching.

The paper

Printing paper with a glossy surface gives maximum detail in the print but it also shows up any grain, dust or scratches and unless you are very experienced it may prove difficult to spot and retouch. Generally speaking a 'semi-matt' or 'smooth lustre' surface is more easily handled and does not show many reflections when the print is on display. Large packets of paper are expensive and if you have several negatives of varying contrast to print you may find the cost of having soft, normal and hard grades too high. Consequently there is a lot to be said for using a variable contrast paper such as 'Multigrade' because a very wide range of grades can be obtained from just one packet simply by varying the filter in the enlarging head, though against this must be balanced the cost of the set of filters.

Holding the paper: if you are making a normal-sized print you probably use a printing frame, but a frame to hold very large sheets of paper is expensive and

only justifies the cost if a large number of big prints is made. Instead many people use a sheet of heavy white card, marked with the size of the print they are making, for composing and focusing. The paper is fixed to this by means of double-sided self-adhesive tape or else with pins, though these will leave white marks at the corners that will have to be trimmed off when the print is dry.

Making a test strip

If you do not have an enlarging exposure meter a test strip is essential, and this will probably be larger than normal; it should cover an area of more or less equal density, the skin tones on a face, for instance, being easy to judge. Having determined the right contrast and exposure from the test strip, a full-sized print can now be made.

The processing trays

A handyman may be tempted to make trays large enough to take big prints from wood and hardboard lined with plastic or painted with waterproof paint. This is rarely worth while since they do not have a long life and cost almost as much as trays made for the purpose. Although 16 x 20in (40.6 x 50.8cm) size plastic trays are quite expensive, they are strong, chemical-proof and easily cleaned. Stainless steel trays are too expensive for amateur use while enamelled steel ones can chip or crack unless carefully handled.

Of course such trays have other uses. They will serve as a water bath to stabilize the temperature of processing tanks or trays. This is particularly applicable to colour where the higher processing temperatures are more likely to vary. They are also useful containers in which to wash your prints, so long as you ensure that there is good water circulation.

Processing the print

The normal processing chemicals—developer, stop bath and fixer—are used but a short development should be

▶ To make a big enlargement from a section of a negative, it is often necessary to turn the enlarger head and column round and project the image on to the floor. When doing this, make sure that the weight used to counterbalance the enlarger head is heavy enough to keep it securely positioned and free of vibration while you are working.

avoided since it may give an uneven result; 2-2½ minutes at 68°F (20°C) is about right. Don't skimp on the amount of chemicals used—a minimum depth of ½in (12mm) is needed.

Having slid the paper into the developer, the tray must be rocked in both directions immediately so that the paper surface is covered as quickly and as evenly as possible. Continue rocking throughout the whole of the development and then transfer the print to the stop bath. It is not easy to handle very large prints with tongs and instead the fingers may have to be used. If you think that you may be allergic to chemicals wear plastic or rubber gloves.

After the usual times in the stop bath and fixer, and having made sure that the print is completely below the surface in both cases, the print must be washed thoroughly and this may call for the use of a bath. In theory you could use one of the processing trays but they will probably be in use for other prints. Whatever method you use, the wash water must be changed constantly, the washing time being at least half an hour if ordinary fibre-based materials are used or about five minutes in the case of the modern resin-coated papers.

▲ The exposure will be a long one so fix the paper firmly to the wall before you begin.

▼ If you project the negative on to a wall it is essential to check that the enlarger head is perfectly horizontal and the negative carrier is parallel to the wall. If they are not the image will be distorted.

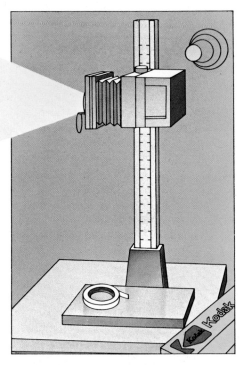

▼ Processing giant prints is best done in long narrow trays. Unroll and re-roll the print so that the processing solutions flow across the emulsion surface. The normal processing times for sheets of paper are used.

Giant enlargements

Prints larger than 16 x 20in (40.6 x 50.8cm), are not easy to do at home. However, the well-organized club with access to a darkroom may have the space necessary. They will also have the money to invest in the large rolls of paper used. It follows that if you do attempt to produce prints measured in feet or metres rather than inches or centimetres a different method of working must be adopted. The first step is to acquire an enlarger with a head that can be turned to a horizontal position. The image is projected on to a wall, preferably one covered in a material into which drawing pins can be stuck. Once you have aligned the image, checked that it is square and the size you require, mark the outline with chalk or stick drawing pins in at appropriate points.

The developer, stop bath and fixer can most economically be laid out in narrow pans or troughs that are wider than the roll of paper.

The test strip should be a large one if it is to be useful. Processing it is good practice for the full-sized print. Having been stored in a roll, the strip will have a tendency to roll up. The curled strip is placed in the developer and rolled and re-rolled, making sure that the leading edge is pushed into the solution and that the developer flows over the emulsion surface. Continue to roll and re-roll the test strip for the normal development time. Processing in the stop bath and fixer follows the same procedure. Washing of large prints is best done in a bathtub.

A large draughtsman's T-square and a sharp knife are the best equipment to cut the paper for the full-sized print from the roll of paper. To avoid damaging the paper, handle the T-square with care. Bruise marks may not become obvious until after you have finished processing and have wasted a lot of time and paper. The print follows the same processing procedures as the test strip. To dry it a line is fixed above the bath and the print hung from it. Weights must be attached to prevent the print from curling.

Print finishing

After washing, as much water as possible should be removed from the print surface by means of a soft viscose sponge or a large rubber-bladed print squeegee. The print is then hung in a current of warm air by a clip at one corner or else laid face down on a sheet of photographic blotting paper. If you make a lot of large prints it may be worth making a wooden frame covered with muslin on which to lay the prints. Trimming large prints requires a different technique to the trimming of smaller ones. The most practical and economical approach is to use a metal-sided ruler that is longer than the longest side to be cut, and a very sharp scalpel or craft knife. The print should be laid flat on a dry clean surface. Check that the ruler is clean as well. Line up the ruler so that it covers part of the image and hold it firmly in place. Cutting on the 'outside' edge of the ruler ensures that, should your hand slip, no damage to the image results. Large prints made on ordinary paper inevitably curl when dry and should be mounted if intended for display. Resin-coated paper lies flat but should still be mounted if over 11 x 14in (30.5 x 40.6cm) in size so that the print can be handled easily.

▼ ▶ When making prints as big as 30 x 40in (75 x 100cm) the image grain will be very noticeable. Marks on the negative will also be magnified. Check the negative carefully before starting to avoid a lot of retouching later.

Developing colour positive film

Many people are apprehensive about developing their own colour films—especially those films that produce colour slides, known as reversal films. Many amateurs believe, mistakenly, that it is difficult and needs a lot of expensive equipment. As a result, they shy away from processing their own colour films, which is a pity because it is almost as easy as developing black-and-white film.

The only difference is that more chemical solutions are needed to develop colour films and, therefore, more steps are required. And if you already develop black-and-white films you won't need much extra equipment—just some form of temperature control, which can be as simple as a water bath, a certified mercury thermometer, range 50°-122°F (10-50°C), accurate to ±0.36°F (0.2C), and possibly a No 2 photoflood bulb in a reflector—make sure it is grounded (earthed). Some methods need a light source to expose unwanted silver salts to light as one step in the processing. Other methods achieve the same effect chemically. This section shows you how to process your own colour reversal films. Following sections deal with processing colour negative film and making your own colour prints from negatives and slides.

How processing works

Unlike black-and-white films, which have only a single emulsion, colour films have three layers of emulsion, each one sensitive to light of a different colour. The first layer on the film base is sensitive to red light, the next one to green light, and the top layer to blue light. When you take a colour picture, the silver halides in each layer react in direct proportion to the amount of red, green or blue light in the subject. (These are the primary colours and all other colours can be made with mixtures of these. For example, anything yellow in the scene is really a mixture of red and green.)

During the first stage of processing, the exposed silver halides are converted into black metallic silver to produce a negative image in each emulsion layer. The film is then exposed to light from a photoflood or treated in a chemical bath to fog all the remaining silver halides.

Next, the film is developed in a colour developer which changes these freshly fogged silver halides into metallic silver. At the same time, a special chemical in the colour developer reacts with other chemicals (called colour couplers) in the three emulsion layers to form dyes. The colour couplers in the red sensitive emulsion produce cyan dye, those in the green sensitive layer form magenta dye, and those in the blue sensitive emulsion layer form yellow dye. For the final colours of the slide to become visible, the black silver produced during the two developing stages must now be removed. This is done with a bleach solution which changes the silver into a form that the fixer, which follows it, can dissolve. After a wash to remove chemicals, the film is treated in a stabilizer, which protects the dyes from fading, hardens the emulsion and acts as a wetting agent. It is then hung dried.

Temperature Control

The biggest problem in colour processing is keeping the temperature of the various chemical solutions within fairly close limits. You must control the temperature of the first developer within less than 1°F (½°C). The simplest, most effective way to do this is to stand all the bottles containing the processing solutions in a bowl of water which is a couple of degrees warmer than the temperature at which you are working. Maintain this temperature by adding small amounts of hot water or by switching on a small immersion heater as the water bath begins to cool.

As only the two developers need critical temperature control, once you have completed these two stages you can allow the water bath to stand without adding more hot water—the thermal inertia of the water will usually keep the other processing solutions within their permitted working temperature range.

The temperature of the water used for the various washes during the process is equally important. If you have a mixer tap you can adjust the temperature of the flowing water, but a good alternative is to use individual changes of water for the washes. As a general rule, use one change of water for each minute of the wash time specified in the process instructions. This means that you can mix the water to the right temperature at the start and then keep it in containers in the water bath until it is needed.

Mixing the solutions

Most colour processing kits come in liquid form which makes it easier and faster to mix solutions. You dilute the concentrated solutions supplied in the kit with the correct amount of water.

If you follow the instructions to the letter, it is difficult to go wrong. There is still a number of kits on the market which are supplied in powder form. These are in no way inferior to the all-liquid kits; it just takes a little more time and care to prepare the working solutions. Again, follow the manufacturer's instructions very carefully, making sure that you dissolve the various chemicals, both liquid and powder, in the correct order and that each is fully dissolved before you add the next one. (Some liquids are oily and difficult to dissolve, so use a stirrer and check that there are no oily globules floating on the surface of the solution.) Many of the solutions used in colour processing contain toxic chemicals which can be absorbed through the skin into the body. So it is advisable to wear rubber or plastic gloves whenever you handle colour processing solutions, and if you get any splashes on your skin, wash them off at once with plenty of water.

The shelf life of liquid concentrates supplied in the Kodak E6 and other kits is up to one year. Most developing tanks only need 1 US pint or 300ml of solution to cover a 35mm film and as kits are usually 1 US qt (600ml) or more you may need to divide the mixed solutions into parts. Mixed solutions kept in full, tightly-stoppered bottles, and stored in a cool, dark place, should keep for 8-12 weeks in the case of all solutions except the bleach and fix which have a life of about six months.

Working temperatures

Processing colour reversal films used to take nearly two hours, excluding drying. To reduce this time, manufacturers have gradually increased the temperature at which the film is processed. As a result the working temperature of a typical colour reversal process may now be as high as 100°F (38°C). At this temperature the process is complete, with the exception of drying, in a little over half an hour.

Steps have also been taken to eliminate the potentially troublesome reversal exposure which took place immediately before the colour development stage. This exposure involves taking the film out of the developing tank (if the reel is not transparent it should be removed from that) and exposing it to light, a method which has now been replaced in some processes by chemical fogging of the silver halides. So once the film is in the tank you don't need to remove it until you hang it up to dry.

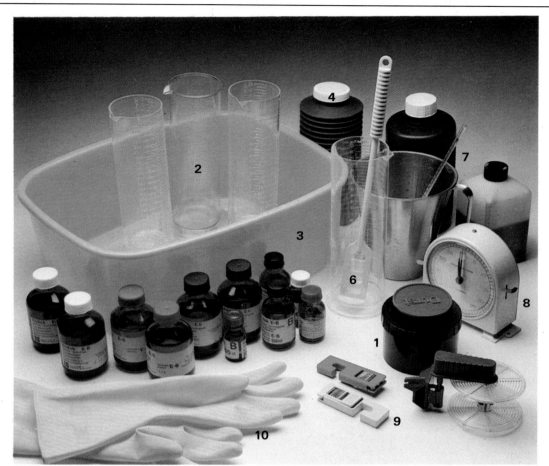

Developing tanks

You can use the same type of developing tanks for processing colour films as for black-and-white work. But if you are going to use a colour process which needs a reversal exposure, buy a tank which has a transparent polystyrene reel rather than a translucent white nylon type. This allows the light to reach all parts of the film easily, keeping the reversal exposure to a minimum. But with a reel it is best to remove the film.

Loading the tank has been covered for black-and-white developing and the same principles apply to colour film. But it is even more important to make sure that your hands are perfectly dry and to avoid touching the emulsion surface of the film because colour emulsions are generally more susceptible to damage than black-and-white ones.

If you haven't a tank with a light trap, you must pour the solutions in and out in complete darkness for the first developer, wash and reversal bath—only switching on the light when the lid is closed. Subsequent steps can be carried out in the light.

A first-time guide

Your processing technique needs to work smoothly, step by step, with strict observances of time intervals, if you are to get successful results. The following points will help you to work confidently so that you produce good results with your first film.

● Make a big chart of the steps in timings and pin it up on the wall in front of the work bench.

● First, do a dummy run; use water in place of the chemicals to get used to the rhythm, temperature control and time for each step.

● It is easier to use a timer that starts from zero, rather than setting one for the full process time and working backwards, as it is simpler to add time intervals than to subtract them. (On a large timer, you could put little strips of coloured tape at the end of each interval.) Some timers for colour processing can be programmed to 'ping' at the end of each pre-set time.

● The most critical processing temperatures are those of the first developer and colour developer. They should be within the close tolerances recommended by the manufacturer.

Other process solutions and the water can be in a wider range—eg, for Kodak E6, 92-102°F (33.5-39°C).

● Check how long it takes to empty the tank. It will probably take between 10 and 20 seconds, so, to prevent over-processing, start to empty the tank at this number of seconds before the end of each time. (You will need a timer with a sweep second hand.)

● If you have a cassette recorder you may like to make a timed step-by-step tape of the process. Then you won't need a clock or a chart. Simply switch on the tape and follow the instructions from beginning to end. Kodak have produced a leaflet which describes how to make such a tape.

● Reversal exposure times vary according to the make of the film. For example, some need 3-minute exposures to each end of the reel, while others only require seconds. The reel is submerged in water in a white bowl to prevent the film getting too hot. (Cover the top of the bowl with a sheet of glass to stop any water splashing up on to the bulb and breaking it.) If in doubt, tend towards over-exposure rather than under-exposure.

KODAK E6 REVERSAL PROCESSING

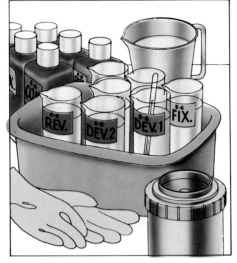

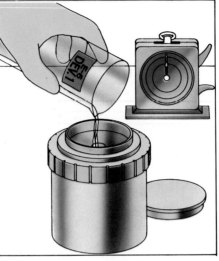

1 PREPARATION
Load film into developing tank.
Put on rubber gloves
and make up chemical solutions.
Pour them into measures or
storage bottles labelled with name
of process and chemical. Stand in
a water bath at about 111°F (44°C)
and let them come up to processing
temperature, 100.4°F (38°C). Stabilize
temperature of chemicals by adding
cold or hot water to bath.

2 FIRST DEVELOPER: 7* MIN.
Check temperature of developer.
It must be 100°F (37.8°C) ± 0.5°F
(0.3°C). Pour first developer into
tank, taking about 10 seconds. On
completion start timer. Tap the tank
on bench a few times to dislodge
any air bubbles clinging to film.
Fit cap and immediately start
agitation.
*See kit instructions for any
changes to this time.

3 DEVELOPER AGITATION
Invert tank, over and up, 7 or 8
times during first 15 seconds.
Then invert tank twice every 30
seconds for rest of 7 minute
development time. Stand tank in
bath between agitations.
10 seconds (or whatever you found
the 'pour out' time to be) before
the end of 7 minutes, begin to pour
developer back into its bottle to
avoid over-development.

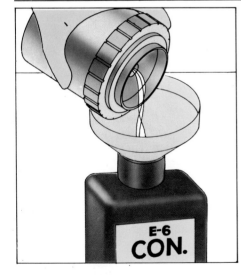

7 CONDITIONER : 2 MIN.
Pour conditioner into tank. Agitate
for 30 seconds. Tap tank to displace
air bubbles. No other agitation is
needed. Fit cap and return tank to
bath. 10 seconds before end of 2
minutes start to pour conditioner
into its bottle.

8 BLEACH : 7 MIN.
Fill tank with bleach solution.
Fit cap and invert tank 7 or 8
times during the first 30 seconds.
Then invert tank twice every
30 seconds for remainder of 7
minute stage.
10 seconds or so before end of
time begin pouring bleach back
into its bottle.

9 FIXER : 4 MIN.
Pour fixer into tank. Fit cap.
Invert tank 7 or 8 times during
the first 30 seconds. Then invert
tank twice every 30 seconds for
the remainder of this 4 minute
step. 10 seconds or so before
the end of 4 minutes, begin pouring
fixer back into its bottle.

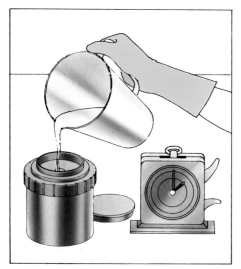

4 WASH : 2 MIN.
Wash film for 2 minutes in running water (or fill tank with two changes of water) at 92-102°F (33.5-39°C). Agitate each change for one minute. Pour out water 10 seconds or so before end of time.

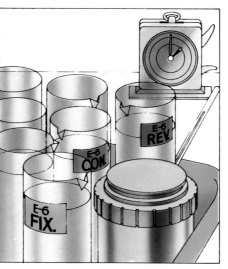

5 REVERSAL BATH : 2 MIN.
Pour reversal bath into tank. Agitate for first 30 seconds. Tap tank to displace air bubbles. Replace cap. No other agitation is needed. Return tank to water bath. 10 seconds before end of 2 minutes, pour reversal solution back into its bottle.

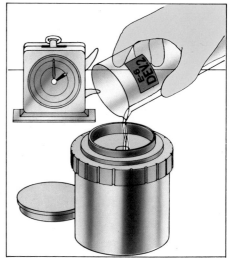

6 COLOUR DEVELOPER : 6 MIN.
Pour colour developer at 100°F ± 2°F (37.8°C ± 1.1°C) into tank. Tap tank to dislodge air bubbles. Fit cap and invert tank 7 or 8 times during first 30 seconds. Then twice every 30 seconds for the rest of the time. Replace tank in water bath between agitations.
Start pouring solution back into its bottle 10 seconds or so before 6 minutes is up.

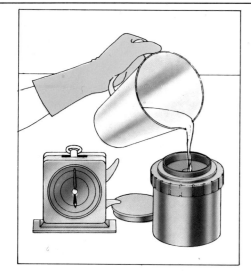

10 WASH : 6 MIN.
Wash the film thoroughly in running water for 6 minutes at 92-102°F (33.5-39°C), or in 6 changes of water in this temperature range.

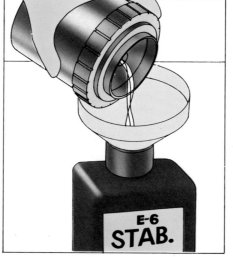

11 STABILIZER : 1 MIN.
Fill tank with stabilizer solution. Fit cap and agitate for 30 seconds. Leave film for 20 seconds. Pour off stabilizer.

12 DRY
Hang film up to dry. Film looks opalescent, but clear on drying. When dry cut into strips and store in storage envelopes, or lay on a clean surface and cut and fit individual frames into mounts.

Mounting slides

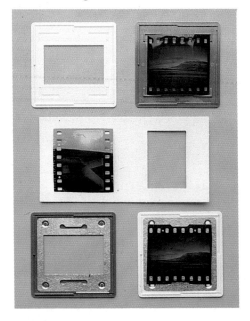

When the films are dry, put the individual transparencies in mounts as soon as you can to prevent them getting damaged. Alternatively, cut them into strips and put them into storage envelopes until you have time to mount them. Avoid handling the transparency surfaces— especially the emulsion side —with your fingers, otherwise fingermarks will appear on your pictures when you project them. If there are any drying marks (dirty streaks) or fingermarks on the film base, remove them with a little methyl alcohol (meths) or a proprietary film cleaner on clean cotton balls. Glass mounts give the best protection to your slides but you must make sure that the glass surfaces are perfectly clean (use film cleaner or meths on a soft lint-free cloth) and thoroughly dry before inserting the transparency. Unfortunately, glass mounts are rather expensive so you may want to use the glassless type, except for your best slides. They do not give as much protection as the glass type, but at least they do prevent damage from careless handling and allow your slides to be projected. This type of mount is also best if you want to send slides through the post; glass mounts can break and ruin the transparency.

If you project your slides regularly, put a small spot in the bottom left-hand corner of the mount. This is the standard position and tells any projectionist which way round to place the slides without having to look at each slide against the light.

Colour reversal films compatible with processes

Process	Agfa 41*	Kodak E6	Chrome-six	Unicolor E6
Film				
Agfachrome 50*	*			
Agfachrome 100*	*			
Fujichrome		*	*	*
Ektachrome 64		*	*	*
Ektachrome 200		*	*	*
Ektachrome 400		*	*	*
Ektachrome 50		*	*	*
Ektachrome 160		*	*	*

*Not available for home processing in US.

A selection of colour reversal film processes

Process	Agfa 41 (Unavailable in US)	Kodak E6	Chrome-six	Unicolor E6
Temperature*	68-75.2°F (20-24°C)	92-102°F (33.5-39°C)	93-107.5°F (34-42°C)	93-107.5°F (34-42°C)
Procedure				
Pre-heat water bath	—	—	1	—
First developer	13-14	7	6	6½
Wash	¼	2***	2	2-3
Stop bath	3	—	—	—
Wash	7	—	—	—
Reversal exposure**	1	—	—	—
Reversal bath	—	2	2	2
Colour developer	11	6	6	6
Wash	14	—	—	—
Conditioner/stop	—	2	—	1
Wash	—	—	1	2
Bleach	4	7	8(blix)	3
Wash	4	—	—	—
Fixer	4	4	—	2
Final wash	7	6	4	2-3
Stabilizer	1	1	—	½
	(not in kit)			
Total time in mins.	70	37	30	27-29

Dry at not more than 158°F (70°C) avoiding localized overheating.

*** Agfa 41** First developer and Colour developer at 75.2 ± 0.36°F (24 ± 0.2°C), washes at 68-75.2°F (20-24°C), other steps at 71.6-75.2°F (22-24°C).

Kodak E6 All process steps at 92-102°F (33.5-39°C) except First developer at 100 ± 0.5°F (37.8 ± 0.3°C) and Colour developer at 100 ± 2°F (37.8 ± 1.1°C).

Chrome-six, Unicolor E6 All process steps at 93-107°F (34-42°C) except First developer and Colour developer at 100.4 ± 0.45°F (38 ± 0.25°C) and Pre-heat at 109.4°F (43°C).

** ½ minute each side of film, 600 watt from 3ft (1m).

*** For 1 US pint (473ml) tank: 2 one-minute washes.

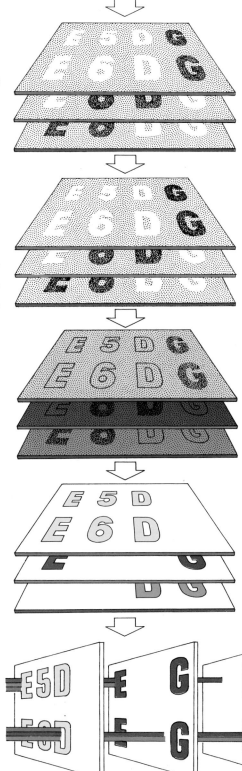

From film to slide

THE SCENE
The primary colours—red, green and blue—record in separate layers of film emulsion. Yellow records in the green and red layers. White records in all three layers.

FIRST DEVELOPER
This chemical solution forms black-and-white negative images in each layer because wherever the emulsion reacted to light, black silver is formed.

REVERSAL BATH
All previously unexposed areas are now fogged. These are important areas as they will be used to reconstitute the original scene.

blue sensitive emulsion ▶

green sensitive emulsion ▶

red sensitive emulsion ▶

COLOUR DEVELOPMENT
Fogged areas are changed into black silver together with coloured dyes —yellow, magenta and cyan—which are complementary colours to the original primary colours.

BLEACH AND FIX
Black silver is removed, leaving dyes in the correct areas; in each layer the dyes only appear where the emulsion did **NOT** react to light in the original scene. The dye images are superimposed and seen as one in the slide.

SLIDE
Each dye layer removes unwanted light of one primary colour. Yellow removes, or subtracts, the blue component of white light; magenta removes green and cyan removes red. So when you view the slide by transmitted light (white light consists of blue, red and green components) you see the original colours.

Always . . .
- Read all instructions on the processing kits carefully before you start.
- Work in a well-ventilated area.
- Wear rubber gloves when handling chemicals.
- Make sure that any electrical equipment, such as a photoflood light or an immersion heater, is grounded (earthed).
- Wash graduates, thermometer and funnel after using them for one chemical, so they are clean for the next.
- Keep storage bottles of chemicals, particularly the developers, brimful or put them in suitable plastic bottles that can be squeezed to exclude air, and make sure the bottles are tightly capped to prevent deterioration through oxidation.
- Be meticulous about the times, temperatures and agitation of the first developer and the colour developer.
- Store transparencies away from moisture, light and heat. Keep them in dust-free boxes designed for holding slides or in storage pockets in plastic sheets which fit into ring binders or files.
- Check that the type of plastic used to make the measures is compatible with colour chemicals; some dissolve certain plastics.

Never . . .
- Make up more than one solution at a time. You may inadvertently get splashes of one into another.
- Dry films at a temperature above 109°F (43°C).
- Be tempted to wash the film again after the stabilizer step.
- Mix or keep chemical solutions in food containers, such as drink bottles, or in a place where a child may find them.
- Use storage bottles with metal caps; the chemical may react with the metal. Plastic caps are suitable.
- Flick drops of water on to a photoflood bulb when carrying out a reversal exposure— it may shatter.
- Use rubber or plastic gloves that have even the tiniest puncture in them.

Developing colour negative film

Perhaps the biggest advantage of using colour negative film and making your own prints from the negatives is that you retain a lot more control over the final result than you do with colour slides. You can, for example, shade and burn-in (give less or more exposure) parts of the print to make them lighter or darker, and even control the colour balance locally— for example, by covering a face with a small piece of blue filter when you burn it in. However, if you intend to submit your work for publication, you will prefer to concentrate on producing perfect transparencies.

Processing colour negative films (colour print film) is easier than processing colour reversal films (colour slide film) because there are generally only three chemical stages— development, bleaching and fixing, sometimes followed by a stabilizer bath to give the dyes some resistance to fading. And no reversal exposure or chemical reversal bath is needed.

Just as in reversal processing, you must be careful to control times and temperatures if you want to produce consistent results. But, if you do slip up— for example, by over-developing the film— there's often a second chance to put things right at the printing stage.

Making a colour negative

Colour negative film, like colour reversal film, consists of three layers of black and white emulsion which is selectively sensitized to blue, green and red light. During processing these layers produce yellow, magenta and cyan dye respectively.

Because there is only one development stage (not two as in reversal film processing) the tones in the processed film form a negative image of the original subject, as in black-and-white film. For example, light reflected from blue parts of the subject produces an image in the blue sensitive layer of emulsion and the dye formed in this layer during processing is yellow. And since yellow is the complementary colour to blue it becomes a negative colour image.

In the other two emulsion layers, magenta dye images of green parts of the subject and cyan dye images of red parts of the subject are produced. During printing a reversal of tones and colours occurs and the print appears in the original colours of the scene.

At the development stage a special chemical in the developer reacts with the colour couplers in the emulsion layers to give the dyes. At the same time, a black silver negative image is produced in direct proportion to the amount of dye in each emulsion layer. This silver image must be removed before the negative can be printed. So a bleach bath converts the silver into a soluble form which is then dissolved by the fixer. Some processes use a combined bleach-fix or 'blix' bath which carries out both of these functions.

A final wash removes the residual processing chemicals and the dissolved silver salts. In some processes, a stabilizer hardens the emulsion and helps to prevent the dyes from fading. Unlike a black-and-white negative, it is difficult to judge the quality of a colour negative just by looking at it because it consists of negative dye images which are hard to interpret. The overall orange colour from the built-in masking system also makes it difficult. (This mask improves the reproduction and purity of the colours in the final print.)

If you want a film to dry quickly, use a small blower-heater to circulate warm air in the vicinity, but it must not overheat the emulsion locally or blow dust on to the film.

Two basic processes

Currently, there are only two basic colour negative processes available—C41 and Agfacolor. The Kodak C41 process was introduced to handle Kodacolor II, Kodacolor 400 and Vericolor II films, but many other manufacturers, such as Fuji and Sakura, have designed their films to be compatible with the C41 process to make it a universal process. The Agfacolor process, however, is designed to be used with its own range of films.

Like the E6 reversal process, the Kodak C41 process has a high working temperature, 100.04°F (37.8C), and so the chemicals must be kept in a water bath to maintain this temperature. At such a high processing temperature the development time is necessarily short—only 3¼ minutes. So unless your timing is precise, you will have negatives which are under- or over-developed. Ideally, the timing of the development stage must be accurate to within 5 seconds so you will need to use a darkroom clock which has a sweep seconds hand, or a stop watch.

Because the Agfacolour process works at only 68°F (20°C) and has a development time of about 8 minutes, neither the temperature nor the timing present the same problems. Processing Agfacolor films, however, takes longer as the process includes an extra chemical stage and a very long wash.

There are several alternative independent processes designed for C41 compatible films, which can be used at any temperature between 95°F (35°C) and 104°F (40°C) as long as you modify the development time according to the instructions provided with the kit. Most processes also use a combined bleach-

Colour negative film processes

Process	Agfacolor (Not in US)	Kodak C41	Photocolor II** (Limited availability in US)
Temperature	68°F (20°C)	100.04°F (37.8°C)	100.4°F (38°C)
Procedure			
Developer	7-9	3¼	2¾
Intermediate bath	4	—	—
Wash	14	—	½
Bleach	6	6½	3 (blix)
Wash	6	3¼	5
Fix	6	6½	—
Wash	10	3¼	—
Stabilizer	1*	1½	—

Time is in minutes.
*Use a solution of Agepon wetting agent.
**For C41 compatible films only.

fix solution and it is possible to process a film completely in just over 12 minutes at 100.4°F (38°C). Some makers' solutions can also be used for colour prints.

Preparation

An increasing number of chemicals for processing colour negative films are now available as liquid concentrates. The Kodak C41 kit is partly liquid and partly powder, the Photocolor II kit is all liquid, and the Agfacolor kit is all powder. Follow the instructions which come with your particular kit carefully to avoid expensive errors. And always wear rubber gloves when mixing the solutions and when processing the films. Any developing tank which you would use for black-and-white work is equally suitable for colour work, but if you use the same one for both processes, be sure to wash all parts of it thoroughly after use, to avoid contamination.

When loading the film on to the reel, make sure that you keep your fingers off the emulsion; only handle the film by its edges.

The equipment needed is the same as for processing positive film (see beginning of chapter) except that no photoflood is required as there is no reversal exposure.

After you have processed the prerequisite number of films in the solutions, follow the manufacturer's instructions for increasing the development time.

Step-by-step to colour negatives (using Kodak C41 as an example)

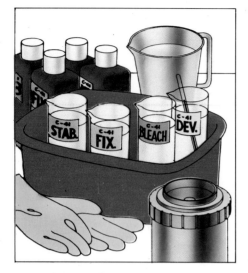

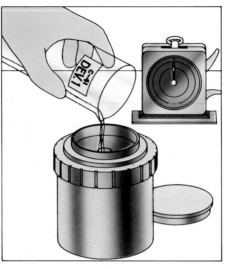

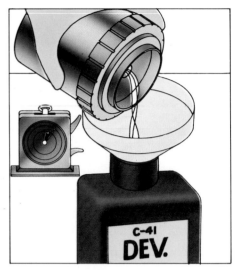

1 PREPARATION
Load the developing tank.
Mix the chemical solutions. Put them into storage bottles, labelled with process, chemical and number of films processed, and bring up to temperature in a water bath. Check that the solutions are at 100.04 ± 0.27°F (37.8 ± 0·15°C) before you begin to process.

2 DEVELOPMENT : 3¼* MINUTES
Pour developer into the tank. On completion start the timer. Tap the tank sharply on the bench to dislodge any air bubbles. Fit cap to tank. Agitate tank vigorously for 30 seconds by inverting it over and up once per second. Then invert tank twice every 15 seconds. Between inversions replace tank in bath.

3 POUR OUT DEVELOPER
10 seconds before end of development time begin to pour developer back into its storage bottle. If you finish before 10 seconds, let tank drain until the 10 seconds is up.
*Development time needs to be extended after the first two films to allow for slight loss of developer activity. Refer to the table in the kit's instructions.

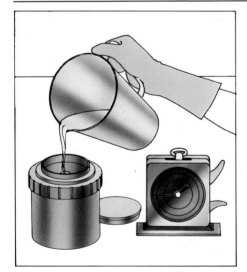

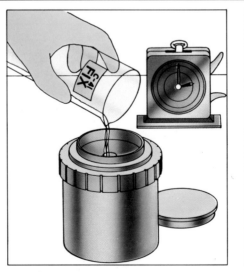

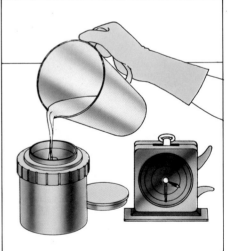

5 WASH : 3¼ MINUTES
Wash film thoroughly in running water at a temperature of 75.2-104°F (24-40°C) for 3¼ minutes. Alternatively, give 3 changes of fresh water at 75.2-104°F (24-40°C). Agitate continuously in each change of water.

6 FIXER : 6½ MINUTES
Fill tank with fixer. Agitate continuously for 30 seconds. Then every 30 seconds agitate 5 times for five seconds. Replace tank in bath between agitations. 10 seconds before end of fix time pour out fixer and, if necessary, let tank drain until 10 seconds is up.

7 WASH : 3¼ MINUTES
Wash film thoroughly for 3¼ minutes in running water at 75.2-104°F (24-40°C). Alternatively, give 3 changes of fresh water which is in this temperature range. Agitate continuously for 1 minute in each change of water.

From film to colour negative

4 BLEACH : 6½ MINUTES
Pour bleach solution into tank. Fit cap to tank. Agitate continuously for 30 seconds. Then every 30 seconds agitate five times. Replace tank in bath between agitations. 10 seconds before the end of the bleach time begin emptying the bleach out of the tank, letting it drain for the full 10 seconds.

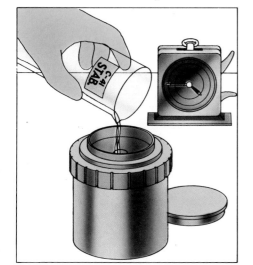

8 STABILIZER : 1½ MINUTES
Pour stabilizer into tank. Fit cap and agitate continuously for 30 seconds. Replace tank in bath. No further agitation is needed. At end of time pour out stabilizer. Remove film from reel and hang up to dry in a dust-free area. When dry cut film into strips and place in storage envelopes. Handle it only by the edges.

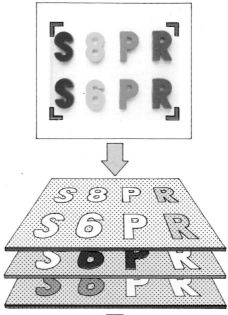

The scene
Primary colours—red, green and blue—record in separate layers of film emulsion. Yellow records in the green and red layers. White reacts in all three layers.

Colour development
Complementary colours to the colours in the original scene are formed in the areas where the emulsion reacted to light. Black silver is also formed. Areas that did not react to light remain unchanged but display the colour of any mask which may be present.

Masking
Because the dyes are not perfect, the magenta may absorb some blue so it performs like a magenta which is contaminated with some yellow. Similarly, the cyan may absorb some green and blue light. Compensations are therefore made for these unwanted absorptions by adding a yellow mask to the magenta coupler and a pink mask to the cyan coupler. (Clear, unchanged areas in the magenta and cyan layers are left yellow and pink respectively.) It is the combined effect of these masking dyes which gives the negative its overall orange cast.

Bleach and fix
These steps remove the black silver leaving clear, complementary dyes which give a negative image. The dyes are opposite in tone to the original scene—light is dark and vice versa.

The negative
To make a colour print this negative is projected on to the colour printing paper. In the paper it is the top layer which absorbs red, the middle layer green and the bottom layer blue. After processing, magenta, cyan and yellow images form which give the original colours when seen by the white light reflected up from the paper base.

Colour film processing faults

No matter how careful you are when processing your own colour reversal and negative films, there are bound to be occasions when things go wrong and faults appear on slides or negatives. But if you know what to look for, you will find it easy to avoid making the same mistake twice. Some of the more common errors, their causes and remedies are outlined here.

Because the temperature of the first developer is so critical, especially when it is fairly high, and the development time is quite short, some photographers adopt a practice known as 'drift-by'.

As the first developer is put in the tank its temperature drops due to the difference between the tank at, say, 71.6°F (22°C) room temperature, and the solution temperature at, say, 100.4°F (38°C). (But if you try to compensate for this by warming the tank in the water bath, it will float!) Depending on the tank, the temperature may drop by 3.6°F (2°C). But to find the exact amount, try a dummy run with water which is at the development temperature — eg 100.4°F (38°C)—and follow the method for the first developer. When time is up, test the temperature of the water. If it dropped by, say 3.6°F (2°C), raise the initial temperature of the developer by the *average* drop, 1.8°F (1°C), to 102.2°F (39°C).

Try this technique if your slides and negatives tend to be under-developed.

Too much first development

Too much colour development

Too thin and cyan shift

Not enough first development

Not enough colour development

Overall strong cyan shift

REVERSAL FILM FAULTS

FAULT	CAUSE	CURE
Faults: overall picture too dark with misty highlights, over-saturated colours and very dense borders. Sometimes accompanied by a shift towards red or magenta.	**Cause:** too little first development as a result of: 1. insufficient time; 2. too low a temperature; 3. exhausted or dilute developer; 4. insufficient agitation.	**Cure:** always check the temperature of solutions carefully and time the stage accurately. Agitate as recommended. Always mix solutions exactly as detailed in the instructions. Don't use developers which have been stored for longer than recommended. If the problem persists increase first development time by 5% or 10%, or try using 'drift-by'.
Fault: overall picture too light with diffused highlights and thin colours. Borders rather thin and sometimes a colour shift towards cyan or blue.	**Cause:** too much first development as a result of: 1. too long in developer; 2. too high a temperature; 3. too little water used in mixing developer; 4. too much agitation; 5. stop bath missed out or saturated with developer and, therefore, exhausted (some processes don't use a stop bath); 6. rinse after development too long.	**Cure:** as before, check temperature, timing and agitation. If the problem persists, reduce the first development time by 5% or 10%.
Fault: magenta or red spots on the slides.	**Cause:** air bubbles on film during first development.	**Cure:** tap tank on work surface as soon as it is full of developer. This releases air bubbles which float up to the top.
Fault: overall strong blue or cyan colour shift with thin borders and diffused highlights.	**Cause:** contamination of first developer with stop bath.	**Cure:** always be sure to wash measure thoroughly to avoid contamination of one solution with another.
Fault: film completely clear.	**Cause:** whole film fogged by light before processing.	**Cure:** always load film into tank in total darkness. Check darkroom for light leaks.
Fault: entire film black.	**Cause:** first and colour developers used in reverse order.	**Cure:** always label bottles carefully as soon as you fill them. And always use the same bottle for the same solution.
Fault: all colours too pale and tending towards a blue or cyan shift. Borders thin.	**Cause:** too little colour development as a result of: 1. too short a time; 2. too low a temperature; 3. developer exhausted or too dilute; 4. insufficient agitation.	**Cure:** follow processing instructions to the letter. Mix fresh solution if you suspect colour developer is old or well-used.
Fault: all colours too dark with a tendency towards a yellow or red shift.	**Cause:** too much colour development as a result of: 1. too high a temperature; 2. too long in colour developer; 3. too little water used to mix developer; 4. too much agitation.	**Cure:** as before, follow mixing and processing instructions carefully, with special attention to time and temperature.
Fault: slides too thin with a cyan colour shift and weak cyan borders.	**Cause:** colour developer contaminated with first developer.	**Cure:** work methodically and cleanly and wash all equipment, thoroughly.

FAULT	CAUSE	CURE
Fault: overall milkiness with slight opalescence *when dry.*	**Cause:** insufficient fixing as a result of: 1. too little time; 2. too low a temperature; 3. exhausted or dilute fixer.	**Cure:** check time and temperature of this stage and the freshness of the fixer. If in doubt, mix fresh solution. Films with this fault can be re-fixed and washed and the fault should disappear. (Some films show an opalescence when wet, but this disappears when dry.)
Fault: shiny, brownish coppery stains on emulsion side of film.	**Cause:** too little bleaching.	**Cure:** check processing instructions and follow carefully. This fault can usually be cured by repeating the steps of the process from, and including, the bleach stage.
Fault: reticulation. (Overall crazing.)	**Cause:** a large difference in temperature between solutions and wash water.	**Cure:** if wash water is much cooler than solutions, wash by individual changes of water at the correct temperature, giving one change per minute of wash time and agitating continuously.
Fault: reddish spots on otherwise perfect slides.	**Cause:** splashes of stop bath or acid fixer on finished films.	**Cure:** do not handle slides where chemicals can splash them. This fault can sometimes be cured by treating in 1 pint (½ litre) water with 1 tablespoon of salt dissolved in it. Then wash and dry the film.
Fault: light streaks from spaces between sprockets on 35mm film.	**Cause:** agitation in colour developer too even.	**Cure:** if your tank takes more than one reel, always place all of them in the tank when processing, even if they are empty. This prevents a single reel moving from top to bottom of the tank each time you invert it.
Fault: strong colour shift overall, including borders which tend to be thin.	**Cause:** film fogged, possibly by safelight. If the shift is towards green, especially in shadows, reversal exposure (where used) is too short.	**Cure:** always load film into the tank in total darkness. If a reversal exposure is needed treat the time given in the instructions as a minimum. If in doubt, double the time. Where a reversal bath is used do not shorten the time in this solution.

Magenta spots **Film fogged**

COLOUR NEGATIVE FAULTS

FAULT	CAUSE	CURE
Fault: negative too dense.	**Cause:** over-exposure in camera *or* too long in developer *or* developer temperature too high.	**Cure:** be sure to check the film speed setting and exposure carefully. Control developer time and temperature accurately.
Fault: negatives too contrasty.	**Cause:** over-development as a result of: 1. too high a developer temperature; 2. too long in developer; 3. agitation too vigorous.	**Cure:** pay particular attention to time, temperature and agitation method in development stage.
Fault: negatives too thin.	**Cause:** under-exposure in camera *or* too short a development time *or* developer temperature too low *or* colour developer exhausted.	**Cure:** as before, check exposure, development time and temperature, and condition of developer. If in doubt, prepare fresh developer.
Fault: negatives too soft.	**Cause:** under-development as a result of: 1. insufficient time in developer; 2. developer temperature too low; 3. agitation insufficient; 4. exhausted or old developer.	**Cure:** exactly as for previous fault.
Fault: pale spots in basic orange mask colour.	**Cause:** air bubbles on surface of film during development *or* splashes of fixer on film before development. In this case the spots will probably be larger and more regular in shape.	**Cure:** tap the tank on the table to dislodge air bubbles. Work cleanly and mop up any spilled chemicals immediately to prevent contamination.
Fault: streaks starting from edge perforations on 35mm films. More apparent in areas of uniform tone.	**Cause:** insufficient or too even agitation during development.	**Cure:** agitate thoroughly but in an uneven pattern if possible. If you are processing more than one film in a multiple tank, fill remaining space with empty reels.
Fault: heavy fogging and part reversal of image.	**Cause:** the film has been fogged by bright light during development.	**Cure:** do not remove the lid from tank during development. If you have to remove the lid, make sure all lights are switched off.

Too dense **Too thin**

Colour printing techniques

There is a certain magic, and satisfaction, in making your own colour prints from colour negatives which you have processed yourself. (Though you could, of course, have your colour negative films processed commercially and just do the prints yourself.) And today, colour printing is not the difficult and complicated process it once was; the introduction of resin-coated papers has simplified processing and made colour printing as quick and almost as easy as black-and-white printing.

Colour prints are processed in light-tight drums instead of the traditional developing trays so, after exposure, the entire processing can be carried out in normal room lighting.

From negative to print

There is one big difference between making colour prints and making black-and-white prints; as well as controlling the density of the print by exposure—which applies to all print-making—you must also control the colour balance.

The white light from the bulb in the enlarger lamphouse is actually made up of almost equal portions of red, green and blue light but, to get the colour balance right, you have to control the amounts of red, green and blue light striking the paper. This is done by placing filters in the light path. There are, however, two ways of using filters—additive filtration and subtractive filtration. Paper for making colour prints, like colour film, has three layers of emulsion selectively sensitized to blue, green and red light.

In the additive method of making colour prints you expose each of these layers separately by giving the paper three exposures, one through a blue filter, one through a green filter and one through a red filter. The filters are very deep in colour so that they only transmit light to which the respective layer is sensitive. You control the colour balance of the print by varying the individual exposures.

The additive system has the advantage of being inexpensive—you only need three filters—but it is slow and there is always the risk of moving the paper or enlarger head slightly between exposures. When this happens the images in the three emulsion layers are out of register. Because of these drawbacks, additive filtration is not often used and is not really recommended.

Subtractive filtration—often erroneously called white-light printing—needs only a single exposure. The amounts of blue, green and red formed in the print are controlled simultaneously by inserting yellow, magenta or cyan filters in the light path, between the light source and the negative. These filters come in a range of different densities to control the various degrees of colour bias in the print. They may be individual filters, made from acetate, which are inserted in a drawer in the enlarger head, or continuously variable filters in a specially designed mixing head. In practice a maximum of only two colours is ever used because all three filters together produce grey. So all they do is subdue the light.

When the paper, with the colour balance adjusted by additive or subtractive filtration, has been exposed correctly, the print is processed.

Development is the first step in processing. During this stage a silver image forms in each of the three emulsion layers together with a dye image which is in direct proportion to the amount of silver; a chemical in the developer reacts with colour couplers in the emulsion to give these dyes. The dyes formed in the blue, green and red sensitive layers are, respectively, yellow, magenta and cyan.

Since the silver image is no longer needed once the dye images are present, it is bleached out and dissolved in a bleach-fix or blix solution, then sluiced away during a wash. These two chemical stages and a wash are the only steps in many colour print processes, though some also include a stabilizer to prevent fading.

After washing the prints are dried. You can spread them out or hang them up to dry naturally, or use a heated air drier such as a blower heater or hair drier, to speed up the process. Don't use an electric black-and-white print drier. Until they are dry, the prints have an opalescent appearance and the colour balance also changes as the prints dry, so don't be tempted to judge the prints while they are still wet.

Buying the equipment

The most expensive piece of equipment you will need (if you haven't already bought one previously for black-and-white printing) is an enlarger. Practically all modern enlargers are fitted with a filter drawer in the lamphouse so, if you already have an enlarger, all you need is a set of filters of the right size to convert it for colour.

You need a set of filters in various densities of yellow, magenta and cyan plus an ultra-violet filter which must always be used with every filter combination. Colour papers are very sensitive to UV light and without a UV filter prints have a blue cast.

Several manufacturers of photographic materials make sets of filters but it is advisable not to mix filters made by one with another as densities may vary slightly. Density gradations may range from 025 to 50 and sometimes more, though 05 is probably the lowest detectable colour change for a beginner. Each filter is labelled with its value and should always be stored and handled carefully to avoid scratches and finger marks.

You will need:

EQUIPMENT
1 enlarger with set of colour filters *or* dial-in colour head
2 processing drum
3 graduates
4 funnel
5 stirrer
6 storage bottles
7 contact print frame
8 base board

If you are buying an enlarger specially for colour printing, it is worth considering one fitted with a colour mixing head, sometimes called a dial-in head. These have simple built-in yellow, magenta and cyan filters which are progressively moved into the light beam as you adjust calibrated dials on the front of the head. The light is then thoroughly mixed in a 'mixing box', or similar device, to give a uniform colour over the whole negative area.

Enlargers with colour mixing heads have been rather expensive, but budget priced models are beginning to be produced costing only a little more than enlargers with filter drawers.

The other main piece of equipment necessary for colour printing is a processing drum. These are available in different sizes to take papers ranging from 8 x 10in (20.3 x 25.4cm) to 16 x 20in (40.6 x 50.8cm). You load the exposed paper into the drum in the dark, fit the lid and then all processing can be carried out in normal room lighting. The drum is agitated by rolling it back and forth along the bench top, or you can buy a motor-driven unit which does the job for you. Always read the drum instructions, especially any recommendations for the pre-wet stage. Very small quantities of solutions are used to process colour prints in a drum—only

about 1¾ US fl oz (50ml) for an 8 x 10in (20.3 x 25.4cm) print—but always check the amount needed on the drum instructions. You use the solutions only once and then discard them, which gives a high degree of consistency under the same conditions, since every print is processed in fresh solutions.

Most colour print processes operate at 86°F to 104°F (30°C to 40°C); the colour thermometer you bought for processing colour negative films will be suitable. Again, stabilize the chemical solutions at the correct working temperature by standing them in a water bath which is one or two degrees warmer than the process temperature.

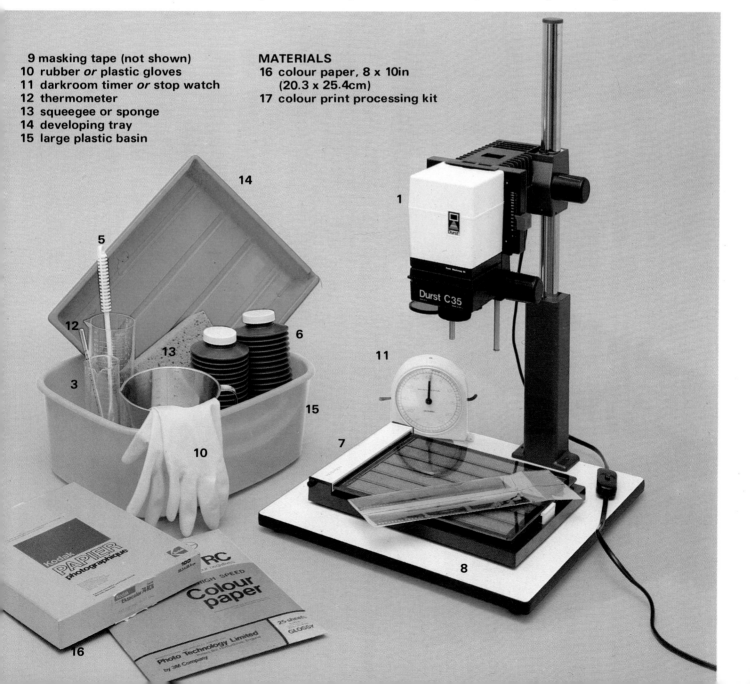

9 masking tape (not shown)
10 rubber *or* plastic gloves
11 darkroom timer *or* stop watch
12 thermometer
13 squeegee or sponge
14 developing tray
15 large plastic basin

MATERIALS
16 colour paper, 8 x 10in
 (20.3 x 25.4cm)
17 colour print processing kit

An alternative, though rather expensive, way to process colour prints is in an automatic roller processor. This thermostatically controlled machine accepts the exposed paper through a feed slot, transports it through the chemical solutions and ejects it, completely processed, some minutes later. Colour papers should ideally be placed in the masking frame in complete darkness but if you feel that you must position the paper by safelight check that it meets the manufacturer's specifications, and that you use it at the distance recommended, and don't leave the paper exposed to it for longer than the maximum time indicated.

Choosing a colour paper

All colour papers consist of three layers of emulsion, containing silver halides that are sensitized to one of the three primary colours plus colour couplers to form the dye images. These layers, only a fraction of a millimetre thick altogether, are coated on to a white paper base because prints are normally viewed by reflected light.

The paper base is sealed on both sides by a thin coating of resin so that it soaks up very little solution during processing and therefore dries quickly. This property is usually designated by the letters RC (resin coated) and sometimes PE (polyethylene). In any country there will probably be a selection of only three or four colour papers as few manufacturers make them. But, whichever paper you decide to try, make sure that you buy a compatible processing kit.

There is only one weight—medium—but the finish may be lustrous, glossy or silk, which is widely used by printing services. The size which you will probably find most useful is 8 x 10in (25.4 x 20.3cm) because it can be cut into four for making test prints or into two to accommodate two 35mm enlargements. But don't forget you should cut the paper in complete darkness or by the very dim glimmer of a safelight as recommended by the paper manufacturer. (In darkness is safer.)

Finally, colour papers deteriorate in the heat so it is best to store them in the refrigerator. Don't forget to take the packet out at least three hours before you intend to print so that the paper can slowly come up to room temperature to avoid moisture condensing on its surface.

Mixing the solutions

In colour printing you normally choose a paper and then buy the kit recom-

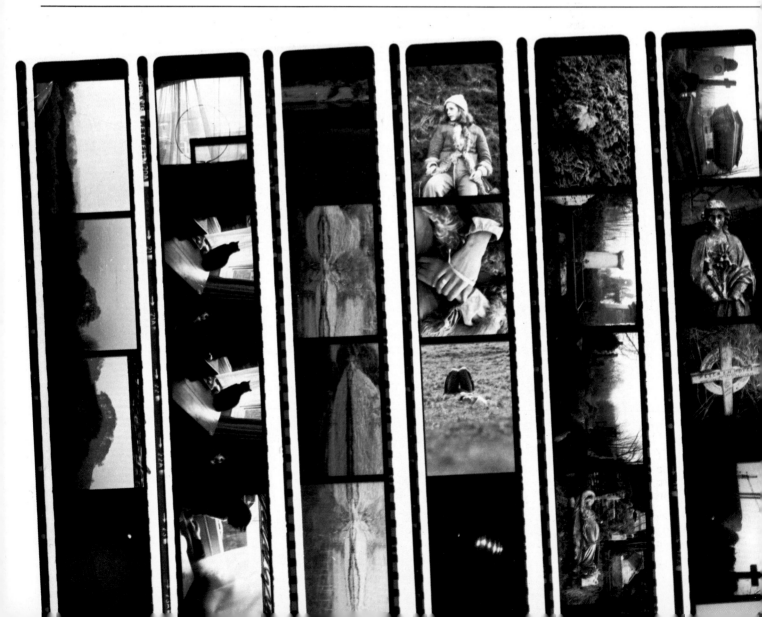

mended for that type of paper. The trend is towards supplying chemicals as liquid concentrates but a few manufacturers still supply their chemicals as powders.

Whichever kit you decide to use be sure to mix the chemicals in the order laid down in the instruction leaflet, making certain that each is fully dissolved or mixed before you add the next. Some developers contain a chemical which forms oil globules in water. Make sure that these globules are fully dispersed before you add the next chemical.

When you have mixed each chemical, pour it into a storage container, cap it tightly and label it. For the developer, use a light-tight bottle which you can fill right to the brim, or use a flexible plastic bottle and squeeze it to expel all the air above the developer.

COLOUR PRINT PROCESSES			
Process	Kodak Ektaprint 2	Agfa 85 (Not available in U.S.)	Photocolor II (Limited availability in U.S.)
Temperature	91.04°F (32.8°C)	86°F (30°C)	89.6°F (32°C)
Procedure			
Pre-wet	½	1	1
Developer	3½	2	3¾
Stop bath	½*	—	10 sec or
Wash	½	¼	10 sec
Bleach-fix	1	2	1¾
Wash	2	2	3
Stabilizer	—	1	—
Time is in minutes	*Use 28% acetic acid diluted 1:21 with water		

Step-by-step to a colour contact sheet (Kodak Ektaprint 2 process)

Making a contact sheet is an ideal way to check the overall quality and colour balance of your colour negatives. Use a basic filter pack of 50 units yellow (50Y) and 50 units magenta (50M) and a UV filter and the colour balance of the prints should be acceptable. Use the contact sheet as a reference to decide what changes are necessary to the filter pack for individual negatives.

1 PREPARATION
Put on gloves. Mix chemical solutions and bring them up to working temperature in a water bath. Put jug of warm water in bath. Remove gloves and clean contact frame glass with methyl alcohol (meths). Insert strips of negatives in frame, base side to glass. Handle negatives only by edges. *A blue background indicates a step must be done in total darkness.*

2 ADJUST LIGHTING
Adjust height of enlarger head on column so that illuminated area on baseboard covers the size of the contact frame. Focus, at maximum aperture, on the image of the edge of the negative carrier on the baseboard. Close lens by two stops. Mark area covered by light beam with small weights or strips of masking tape.

3 INSERT FILTERS
Insert basic filter pack of 50Y + 50M together with the UV absorbing filter into drawer in enlarger. Alternatively, dial this filtration on the colour mixing head if your enlarger has one.

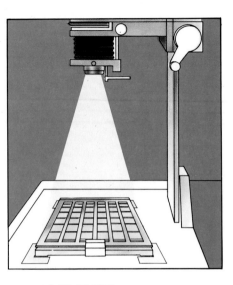

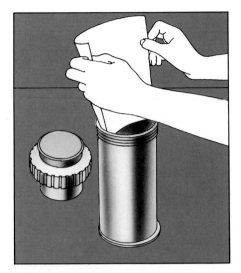

4 POSITION PAPER
In complete darkness, or by the light of a safelight designed for the particular colour paper, place a sheet of paper in the contact frame. Make sure it is emulsion side up. Close packet of paper tightly.

5 EXPOSE PAPER
Place contact frame on baseboard. Make sure it is aligned accurately to the weights or masking tape. Switch on enlarger lamp for 5 seconds. If this exposure turns out to be too short or too long make a second contact sheet with modified exposure. Use the new exposure for all future contact sheets.

6 INSERT PAPER IN DRUM
Remove paper from contact frame and insert it in the processing drum. Fit the lid securely. Turn on room lighting. Put on gloves.

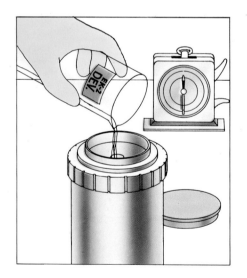

8 COLOUR DEVELOPMENT
At end of pre-wet time, pour out water and replace it with colour developer at 91°C ± 0.5°F (32.8° ± 0.3°C). Timing for development is critical: it is 3½ minutes.

9 AGITATION
Agitate the drum by rolling it manually or place it on a motor-driven base. Keep agitation even. 10 seconds before end of the 3½ minute development time start to pour out developer into the sink. Then fill the sink with stop bath. To get rid of the developer rinse paper ½ minute in stop bath, ½ minute in water.

10 BLIX AND WASH
Pour bleach-fix into drum. Agitate for 1 minute—temperature range 86°-104°F (30°-40°C). Empty tank and refill with water. Agitate for 3½ minutes then pour water away. Give four ½ minute washes. Cold tap water may be used provided it is not below 59°F (15°C) and frequent changes are given. When you fill the tank with water you can safely remove the lid.

7 PRE-WET
Check temperature of developer.
Pour pre-wet water at 95°F (35°C) into drum.
Fit cap and start timer.
Agitate for ½ minute by rolling drum back and forth along bench.

11 DRY
Remove print from drum. Take great care not to damage the emulsion which is very delicate when wet. To dry print, hang up, or lay it face up on absorbent paper, or place in a hot air drier. Wash drum thoroughly and dry it ready for next print. For longer lasting results a stabilizer is advised. If not provided with the kit it can be bought separately.

Make a standard negative

One of the most valuable aids for colour printing is a standard (reference) negative which you use to make a print whenever you change to a new packet of paper. (Colour paper varies from batch to batch and different combinations of filters may be necessary when changing from one batch to another.)

To make a standard negative you need:

● a set of colour patches, such as a paint card

● grey Kodak neutral test card
● black card
● white card

Arrange these items under flat even lighting and photograph them. Make a perfect print (see next page) from this standard negative and write on the back the filters used and the exposure time and aperture. Whenever you change the paper, chemicals, or anything else, make a new print from the standard negative. From the result you will be able to see what filter changes to make.

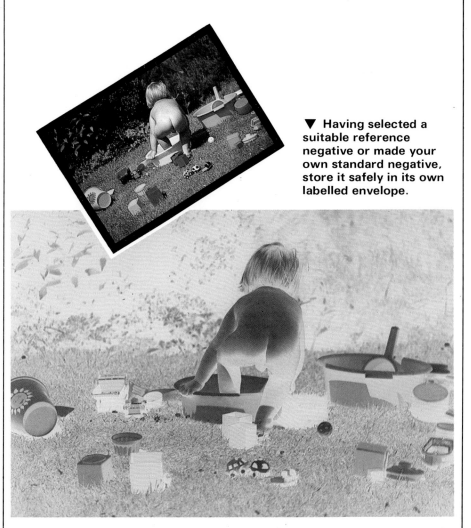

▼ Having selected a suitable reference negative or made your own standard negative, store it safely in its own labelled envelope.

If you cannot make a standard negative like the one above, choose a quality negative from your personal collection that has a good range of primary colours as well as flesh tones. Ideally, it should be a close-up of someone wearing primary coloured clothes, sitting on green grass against a blue sky and holding grey, white and black cards! However, something like this family photograph will be easier to find without setting up such a complicated photograph.

Colour enlarging from negatives

Getting the colour balance right always seems to be the tricky part of colour printing. But it is only difficult if you don't fully understand the principle behind it. If you approach the problem in a logical way, one step at a time, you quickly learn the technique.

Producing the perfect colour print involves two factors: correct exposure and correct filtration. But don't try to solve both of these problems at the same time; you will only waste a lot of paper and become frustrated. Keep the two separate—find the correct exposure and then move to filtration.

If you cut a sheet of 8 x 10in (20.3 x 25.4cm) colour paper into four pieces, each 4 x 5in (10.2 x 12.7cm), you should be able to make a perfect print with just this one sheet. You have to cut the paper in total darkness so you will need to make two stiff card templates,

one 4 x 10in (10.2 x 25.4cm) and the other 4 x 5in (10.2 x 12.7cm). Cover exactly half the sheet of paper with the larger piece of card and, using the hard edge to guide the scissors, cut the paper in half. Then use the smaller template to divide the paper in half again.

Correct exposure

As in black-and-white printing, this is determined by a simple test strip. Use

▼ The test print: you can make horizontal or vertical test strips but be sure to get a representative range of colours in each strip.

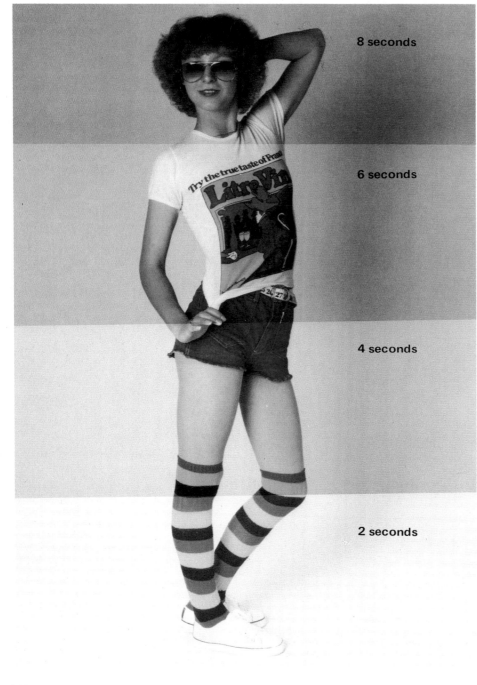

8 seconds

6 seconds

4 seconds

2 seconds

▼ No filters used: this shows the effect of exposing the negative (above) with no filters in the enlarger filter drawer.

116

▲ Over-exposure with correct colour balance gives a dark print.
▼ Under-exposure produces a print with low contrast and flat highlights.

a basic filter combination of 50Y + 50M in the filter drawer of the enlarger, or dialled into the colour mixing head if the enlarger has one. (And always use the UV filter—leave it in the drawer, so that you don't forget about it.) This basic filtration usually produces results somewhere near the correct colour balance making the next stage easier. With practice, and using the contact sheet as reference, you can start with a filter combination which may be more accurate than this basic filtration.

Raise or lower the enlarger head to produce a 4 x 5in (10.2 x 12.7cm) image on the masking frame. Focus with the lens at maximum aperture, then stop down to f8. In complete darkness put one of the pieces of paper in the masking frame and make a 2-second exposure. Cover a quarter of the paper with a piece of opaque card and give another 2 seconds, cover half and give another two seconds. Lastly cover three-quarters and make a further 2-second exposure. You can count the seconds from 1 to 8 or use the automatic exposure time-switch to make a series of 2-second exposures.

The paper will now have received four different exposures—2, 4, 6 and 8 seconds at f8. (A larger size of paper needs longer exposures—for example, 5, 10, 20 and 40 seconds for 8 x 10in [20.3 x 25.4cm] paper.) On the back, with a soft lead pencil, write the exposures, the lens aperture and the filters. Process and dry the test strip and then examine the print in a good light to decide which of the four strips is correctly exposed. If one strip is too light and the next too dark, take a point midway between the two as the correct exposure. If all the steps on the test strip are too light (or too dark), make a new test strip using the same exposure times but with the lens opened (or closed) one stop respectively. If this first test print has a very strong colour bias, it may lead you to a false evaluation of the correct exposure. You will then need to run another exposure test strip when you have adjusted the colour balance.

The right filters

Having found the correct exposure, you must now get the colour balance right. When you examine your test strip you will almost certainly see that it has a colour bias of some sort. You now have to decide what colour this bias is and how strong it is. You will find a colour ring-around (ask the paper manufacturer for one) helpful

until you get used to judging prints. There is a basic rule of filtration to remember: *to correct a colour bias, add filters of the same colour as the bias or remove filters of the complementary colour* (see chart at end of section).

For example, if the test strip has a fairly strong magenta bias you should add about 20 units more of magenta to the filtration.

Make a second test print in strips using

▼ Correctly exposed and filtered, this print has a full range of tones and colours.

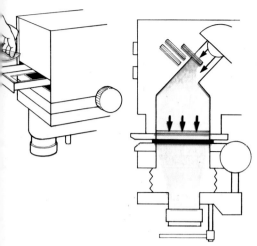

COLOUR FILTRATION SYSTEMS

Colour enlargers are fitted with either a filter drawer (top) or a dial-in colour head. To change the filter combinations add or remove filters in the filter drawer. In the dial-in head combinations of three filters (cyan, magenta and yellow) are progressively introduced into the light beam.

Gelatin filters	
Filter	Multiplication factor
05Y	1.1
10Y	1.1
20Y	1.1
30Y	1.1
40Y	1.1
50Y	1.1
05M	1.2
10M	1.3
20M	1.5
30M	1.7
40M	1.9
50M	2.1
05C-2	1.1
10C-2	1.2
20C-2	1.3
30C-2	1.4
40C-2	1.5
50C-2	1.6

the corrections to the filter combination which you estimate will eliminate the colour bias, plus slight variations of this filtration.

This test is slightly tricky as you need to mask the paper while you make each exposure and change the filtration. Make two masks from black card—one should be two-thirds the size of the paper, and the other one-third. Place them on the print and remove them or slide them along to expose each strip in turn.

Expose one part of the test print to the new filter combinations, one strip to slightly more and one to slightly less. For instance, if your original test strip looks too red and you estimate you need to add 20Y + 20M to the original filter pack of 50Y + 50M to correct it, then expose one strip of your second piece of 4 x 5in (10.2 x 12.7cm) paper to a filter combination of 70Y + 70M, another to 60Y + 60M and a third to 80Y + 80M.

But it is not quite as straightforward as that. Because you have added more

Dial-in filters			
Filter setting	Multiplication factor		
	Yellow	Magenta	Cyan
00	1.00	1.00	1.00
05	1.03	1.08	1.06
10	1.04	1.15	1.11
15	1.06	1.21	1.16
20	1.08	1.26	1.20
25	1.10	1.31	1.24
30	1.11	1.36	1.28
35	1.12	1.40	1.31
40	1.13	1.44	1.34
45	1.14	1.48	1.37
50	1.15	1.52	1.40
55	1.16	1.56	1.43
60	1.17	1.60	1.46
65	1.17	1.64	1.49
70	1.18	1.68	1.52
75	1.18	1.72	1.54
80	1.18	1.76	1.56
85	1.19	1.80	1.58
90	1.19	1.84	1.60
95	1.19	1.88	1.62
100	1.20	1.92	1.64

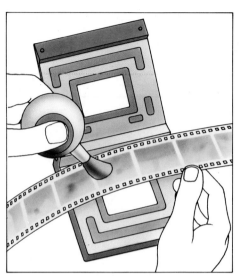

1 PREPARATION

Put on gloves and mix chemicals. Bring them up to temperature in a water bath. Carefully clean negative with a soft brush. Remove drying marks on base with methyl alcohol (meths) on a soft cloth. Place negative in carrier.
A step with a blue background must be done in complete darkness.

5 DEVELOPMENT

Pour developer into drum and start timer. (You can use Photocolor II at any temperature between 89.6°F (32°C) and 104°F (40°C) following the instruction leaflet.) At 89.6°F (32°C) it is 3¾ minutes. Agitate drum by rolling. About 10 seconds before end of time begin to pour out developer.

Step-by-step to colour enlargements (using Photocolor II process as an example*)

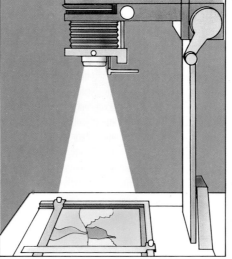

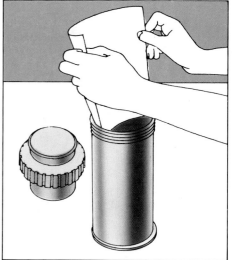

2 SET UP ENLARGER
Set magnification of enlarger to give the required print size. Focus carefully at maximum aperture. Close lens down two stops. Position easel on the baseboard. Insert combination of colour filters in enlarger drawer or, if you have a colour mixing head, dial in filtration.

3 EXPOSE PAPER
In complete darkness (or by the light of a specially designed colour printing safelight) place a sheet of colour paper in the masking frame. Re-close the packet of paper tightly. Switch on the enlarger lamp and carefully time exposure. An automatic enlarger time switch is a good investment for consistent colour printing.

4 PLACE PAPER IN DRUM
Remove paper from masking frame and insert in processing drum. Fit lid on drum: make sure it is firmly in place. Now you can turn on room light. Pour in water at a suitable temperature as explained in manufacturer's instructions. Agitate for 1 minute by rolling. At end of time, pour water out of drum.

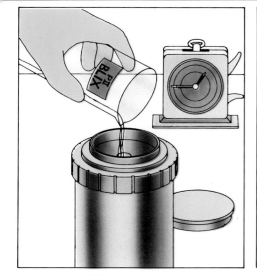

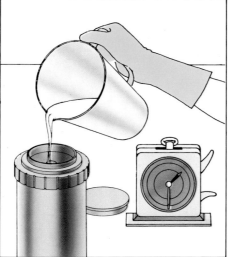

6 BLEACH-FIX
After a brief 10-second rinse in water, pour in bleach-fix (or use bleach followed by fixer if indicated). Agitate drum by rolling for 1¾ minutes. Empty drum at end of bleach-fix time. If preferred, a stop bath can be used instead of water at the start of this step.

7 WASH
Take print out of drum and wash in running water in developing tray for 3 minutes. You can keep the pre-wet water for this final wash if you wish. Stabilize or apply wetting agent if required.

8 DRY PRINT
Carefully remove surface water from print with a squeegee. Hang print up to dry or lay face up on absorbent paper. Alternatively, place print in hot air drier. Wash processing drum well and dry it ready for the next print.
*NOTE: *other processes will differ in minor details so read the kit instructions carefully.*

COLOUR CORRECTION These prints show abnormal colour balances that can be corrected by altering the filter combinations in the enlarger. A correction value of about **10** should be enough to restore balance.

MAGENTA

Caused by too much yellow and cyan or not enough magenta.

GREEN

Caused by too much magenta or not enough cyan and yellow.

CYAN

Caused by too much magenta and yellow or not enough cyan.

RED

Caused by insufficient yellow and magenta or too much cyan.

YELLOW

Caused by too much cyan and magenta or insufficient yellow.

BLUE

Caused by insufficient cyan and magenta or too much yellow.

filters to the original combination you have to increase the exposure to allow for the reduced amount of light reaching the paper. Use the table of filter factors to work out by how much each exposure needs to be increased.

First, multiply the correct exposure from the first test strip by the filter factor for the additional yellow filter, then multiply the result by the filter factor for the additional magenta filter. So, in the example above, assuming that the correct exposure indicated by the first test was 6 seconds, multiply 6 by 1.08 (the factor for 20Y) to give 6.48. Then multiply this by 1.26 (the factor for 20M) to find the final exposure of 8.165 seconds—8 seconds would be close enough.

You have to carry out this type of calculation each time you change filtration. But there is no need to be put off by the mathematical effort involved—you can buy a calculator which makes the task quicker and easier. (Some filter packs include these calculators.)

It is a good idea to keep a record of the various filter combinations, exposures, aperture and subject in a special darkroom notebook. Make the entries systematically as you proceed so that you don't forget anything. After processing and drying the second test print, select the step which has the best colour balance and decide what small changes are necessary to perfect the print.

Again, make a test print with the additional filtration plus slightly more and less. If, for example, you think that an extra 05Y will bring the print to perfect balance, make this test print with no additional yellow, with 05Y extra and with 10Y extra. Remember to allow for the extra filters by increasing the exposure time.

When this test print has been processed and dried, choose the correct combination and make a perfect colour print on the last 4 x 5in (10.2 x 12.7cm) piece of paper you cut earlier from the full 8 x 10in (20.3 x 25.4cm) piece.

By carrying out the tests in this order, you can produce a perfect print from an unknown negative using no more than a single sheet of paper. And, if all the photographs on the roll of film were taken under similar conditions, you should be able to produce acceptable prints without having to carry out further tests. But if you have a difficult negative, this step-by-step analysis will soon give you perfect results.

Guide to colour bias and filtration		
Colour of bias	Add or	Remove
yellow	yellow	magenta and cyan
magenta	magenta	yellow and cyan
cyan	cyan	yellow and magenta
blue	magenta and cyan	yellow
green	yellow and cyan	magenta
red	yellow and magenta	cyan

The final print was made with a filter pack combination of 80M +100Y+UV filter. The exposure was 15 seconds at f4.

Colour printing from slides

For photographers who prefer to record their colour work as slides the option to make colour prints remains open. There are now several processing kits on the market which are suitable for the amateur who wants to make prints from favourite slides. You can of course have prints made from your slides commercially, but unfortunately the results are often far from satisfactory. If you have a darkroom, or even just a light-tight space in which you can set up an enlarger to expose the paper, it is easy to make your own reversal prints.

The advantages

Obtaining a colour print from a slide offers several advantages:
● The main advantage is that you start with a positive image—the slide—and therefore have a standard of comparison to see whether or not the colour balance of your print is correct. Obviously, this is not possible when making prints from negatives.
● Reversal printing paper is more tolerant of minor variations in colour and exposure than the type of paper used with negatives. It is therefore easier to produce satisfying prints.
● By using one type of slide film and one type of reversal paper, you will have little testing to do after the first print has been successfully produced. The only variations in filtration and exposure will be caused by variations in lighting conditions during exposure in the camera, or a colour shift during processing of the film. As these differences are visible, it is possible to make allowances for them before making a test to check your assessment.

The disadvantages

There is, though, a disadvantage. Because a colour slide (which is viewed by transmitted light) can handle a much wider brightness range than a print (which is viewed by reflected light), you will inevitably lose a certain amount of colour saturation in your print. But such a loss can be minimized by carefully choosing the slides with this in mind.

The equipment you need

Any enlarger equipped with a filter drawer or dial-in colour head is suitable for printing from slides.
A useful extra accessory is a 'negative carrier', made specifically to hold slides still in their standard card mounts. The facility to print from slides without having to remove them from their mounts or remount them afterwards is not only convenient, it cuts down the risk of fingermarks and other damage caused by handling delicate emulsions. Another very valuable accessory is a blower-brush with very soft bristles for cleaning slides before they are printed. Any specks of dust will reproduce as black specks in the final print, and this can be particularly unpleasant in portraits. In negative-to-positive printing, dust specks produce white spots, which are fairly simple to retouch out. The black specks produced in direct reversal (positive-to-positive) printing may have to be taken out with a sharp knife or scalpel, which requires skill and practice.
You will also need a processing drum, graduates, a thermometer, a timer and storage bottles for the processing solutions.
Reversal paper is sensitive to all colours so a safelight is not recommended. But as total darkness is only needed from the time the paper is removed from the packet to the point when it is sealed into the processing drum, this is not too great a limitation.

Two different processes

You have a choice of two quite different processes. One is a conventional chromogenic process using Kodak Ektachrome 2203 and 14RC papers, and the other is Ilford Cibachrome-A—a dye bleach process using a special type of print material.
Kodak 2203 and 14RC. Kodak Ektachrome 2203 and 14RC papers are coated with three layers of emulsion sensitive to red, green and blue light and incorporating colour couplers which are changed into cyan, magenta and yellow dyes respectively when processed. There are about 10 stages.
The first step is to expose the paper in the enlarger—this fogs the emulsion layers in proportion to the colour content of the slide. The first developer produces a black-and-white silver negative image in each of the three layers of emulsion. After a stop bath and wash the paper is then given a colour development which produces a positive silver image and a positive dye image in each layer of emulsion.
The silver negative and positive images are next removed in a bleach-fix bath and the print is finally washed to remove chemicals and dissolved silver salts.
Kits are available in a number of sizes; usually the larger the kit the more economical it is. However, once the solutions are mixed they will deteriorate within a few weeks, so making up large amounts is not advisable. Buy the kit you expect to use completely within six to eight weeks at the most. When the solutions are made up, store them in dark, airtight containers and label them with the date of mixing.
Cibachrome-A. Ilford Cibachrome is different—and unique—in that each layer of emulsion contains a dye before you expose and process the material. The dye in each layer is complementary in colour to the sensitivity of the emulsion; for example, the blue sensitive layer contains yellow dye, and so on.
During exposure, each layer of emulsion is fogged in proportion to the colour in the slide, as in conventional materials, and the first stage of the process is also the same: the material is developed in a black-and-white developer to form a silver negative image in each emulsion layer. But this is where the similarity ends.
After development the Cibachrome material is treated in a dye bleach bath containing a chemical which causes the silver in the image to react with the dye and bleach it in direct proportion with the silver in the image. Cyan dye in the red sensitive layer is bleached in areas where red light fell during exposure, and so on. At this stage the silver itself is also removed, leaving a pure dye image. Finally, the material is fixed to remove unexposed and unprocessed silver halides.
Though the Ilford Cibachrome process sounds complicated, in effect it is much simpler than other reversal processes, and the colours will not fade for many decades, unlike chromogenic dyes. The materials and chemicals are more expensive than those for other reversal processes but, since the failure rate is very low, in practice the prints can be no more expensive than with other processes.
The print material is available in sizes from 4 x 5in to 16 x 20in (10 x 20cm to 40 x 50cm). The chemical kits make 2qts, 5qts or 5 litres of working solution. The chemicals come in liquid concentrate form that can be diluted in small volumes if it is inconvenient to make up the full kit. Both the paper and chemicals have long storage life if kept in a cool, dry place.

Making your prints

In principle, making prints from slides is the same at the exposure stage whether you use Ektachrome 14RC paper or Cibachrome material. Apart from the

totally different processing procedure the only difference is in the length of exposure time—Cibachrome is considerably less sensitive than Ektachrome 2203 or 14RC and so needs a longer exposure. Whichever material is used, set the enlarger for an 8 x 10in (20.3 x 25.4cm) magnification.

Ektachrome 2203 and 14RC

Set the lens aperture to f11 and place a basic filter combination of 30M + 30C together with a CP2B UV filter in the drawer of your enlarger. Now make a test strip on a quarter of a sheet of paper, giving exposures of 5, 10, 20 and 40 seconds.

Process your test print and dry it before examining it in a good light. If you are used to making colour prints from negatives, you will notice something unusual: with each increasing exposure step the print is lighter in density, not darker as you would expect. But this is a reversal process, just like taking colour slides in the camera.

When you decide which exposure is correct (you may even decide to choose an exposure between two steps) check the colour balance of the test print and make any corrections necessary to the filter combination. The rule for colour corrections is the opposite to that for prints from negatives.

Correcting the colour. *To correct a colour bias, remove filters of the same colour as the bias, or add filters of the complementary colour.*

So if your print is too magenta, you remove magenta filters or add yellow and cyan. If the colour bias is strong, use 40 or 50 unit filters—or possibly both of them—but a weaker bias will only need about 20 units. Values less than 20 units will make little difference because of the low contrast of the paper. Don't forget to multiply the exposure by the factor for any additional filters, as given on page 118.

Cibachrome-A

The first thing you will notice about Cibachrome is that Ilford has printed

PROCESSING PROCEDURE FOR EKTACHROME 14RC AND 2203		
Processing temperature	86°F (30°C)	100°F (37.8°C)
Step	Time 14RC	Time 2203
Pre-wet	30 secs.	1 min.
First development	3 mins.	2 mins*
Stop bath	30 secs.	30 secs.
Wash	2 mins.	2 mins.
Colour development	3½ mins.	2 mins.
Wash	2 mins.	30 secs.
Bleach-fix	3 mins.	3 mins.*
Wash	3 mins.	1½ mins.
Stabilizer	1 min.	30 secs.
Rinse		¼ min.

*These times are for tube processing. For drum processing: First development 1½ mins., Bleach-fix 2½ mins.

The kit contains:
1 Developer part A. 2 Developer part B, 3 Bleach (powder). 4 Bleach (liquid). 5 Fixer. 6 Neutralizer (powder) to treat used solutions. In addition, extra items from the Cibachrome system are: 7 Three measuring beakers. 8 Daylight developing drum. 9 Set of 19 colour printing filters (6 each yellow, magenta and cyan plus a UV absorbing filter). 10 Packets of 8 x 10in (20 x 25cm) Cibachrome print material (one sheet has been taken out so you can see the dark emulsion surface).

CIBACHROME-A PRINTING MATERIALS

suggestions for a basic filter pack on each packet or box. These basic filter suggestions vary according to the type of reversal film used for the slides.

In many cases the suggested filter combination will give you a good print but it is more likely that you will need to modify it a little. Once you have found by how much your established filter pack differs from the suggested one, you can add the difference for all future packs of Cibachrome.

It is best to use a full sheet of hi-gloss Cibachrome for your test strip because it is made from plastic and is difficult to cut. Ilford suggests you cut a 4 x 5in (10.2 x 12.7cm) section from one corner of the black card inside the pack of material so you can use the card as a mask to expose a quarter of an 8 x 10in (20.3 x 25.4cm) sheet at a time. If using other sizes you could position this sheet of material so that it receives a representative portion of the image and make four test strips across it.) The material must be positioned in complete darkness so you may need some bits of masking tape to guide you. Also to check that the material is emulsion-side-up.

Set the lens aperture to f5.6 and give an exposure of 25 seconds with the mask covering three-quarters of the paper. Then move the mask around to expose the rest of the paper a quarter at a time, leaving the exposure at 25 seconds, but changing the lens aperture to f8, f11 and f16 respectively.

After processing and drying your print, select the correct exposure and decide the colour and density of any bias the print may have. Make any colour corrections to the filter pack in the same way as for Kodak Ektachrome 2203 and 14RC prints.

The simplest way to make better prints from slides is to choose suitable slides to work with. Not every slide will give

PROCESSING PROCEDURE CIBACHROME-A

Processing temp. 75.2°F (24°C).

Step	Time
Development	2 mins.
Bleach	4 mins.
Fix	3 mins.
Wash	3 mins.

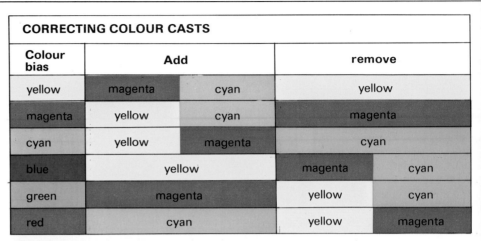

CORRECTING COLOUR CASTS

Colour bias	Add		remove	
yellow	magenta	cyan	yellow	
magenta	yellow	cyan	magenta	
cyan	yellow	magenta	cyan	
blue	yellow		magenta	cyan
green	magenta		yellow	cyan
red	cyan		yellow	magenta

Choosing a suitable slide

A very under-exposed slide will produce too dark a colour print.

A slightly under-exposed slide gives the best print.

An over-exposed slide will produce a flat, washed-out print.

Step-by-step from slide to print

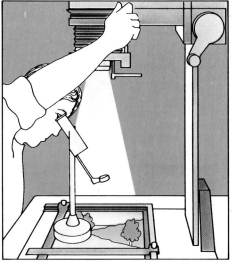

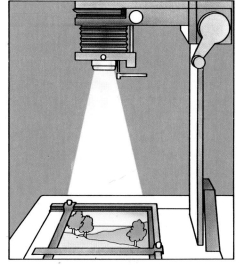

1 PREPARATION
Carefully clean slide by brushing gently with a soft brush. A slide in a glassless mount may sometimes be put in the carrier without removing film from mount. Slides in glass mounts should be removed. Prepare chemicals and stand in water bath. *A step with a blue background must be done in complete darkness.*

2 SET UP ENLARGER
Set magnification of enlarger to give print size required. Focus carefully and close lens aperture to f11 for Ektachrome 14RC and 2203 prints or f8 for Cibachrome-A. Position masking frame on baseboard. Insert filter pack in drawer, or dial required filtration on colour head. Filtration will depend on whether it is the Cibachrome or Ektachrome process.

3 EXPOSE PAPER
In complete darkness, place a sheet of colour printing material in masking frame. Be sure to re-close packets of paper.
Switch on enlarger lamp and carefully time exposure. The time will be much longer for Cibachrome than for Ektachrome.

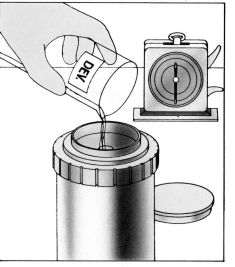

4 INSERT PAPER IN DRUM
Remove paper from masking frame and insert in processing drum. Make sure lid is firmly in place. Now you can turn on room light. If using the Ektachrome process, pour 16 US fl oz (500ml) of pre-wetting water into the drum at 87.8°F (31°C) and agitate by rolling drum for 30 seconds. (If using Cibachrome ignore pre-wetting step.)

5 FIRST DEVELOPER
Pour into drum appropriate amount of first developer at the correct temperature for the particular process. Agitate by rolling drum or by placing it on a motorized unit. 10 seconds before end of development time, begin to pour developer out of drum. Pour in stop bath then wash water if using Ektachrome process.

6 REMAINING STEPS
Complete process according to instructions for appropriate method. Follow times given in processing instructions on page 123. Pour in each solution, agitate drum and begin to empty drum 10 seconds before end of each stage. Finally, pour 16 US fl oz (500ml) of water into drum as a wash. Agitate for given time and drain. Dry print carefully.

a good print, so choose slides with care. They should be clean and free from scratches, sharp, not over-exposed and not too contrasty. (An original slide is much more contrasty than an orange-masked colour negative, and contrast tends to be a problem when making prints directly from slides.)

First, avoid slides which are over-exposed, where the highlights are pale and lacking in detail. These areas will tend to burn out in the final print.

Second, avoid slides with large areas of dark shadows containing important detail. These areas will tend to 'block in' when you make the print, producing large areas of solid black.

From the printing point of view, the best type of slide will be flat rather than contrasty, but will be slightly dense. A slide of this type will have greater colour saturation, while the highlights will still contain plenty of detail. The print can always be made slightly lighter than the original slide by increasing the printing exposure. But if you start off with a too-contrasty slide, you may lose both highlight and shadow detail if you give the correct exposure for the mid-tone areas.

The ideal slide

It is useful to shoot and print an 'ideal' slide, like the one used here. This might contain a flesh tone and various colours, or be a landscape, or the sort of picture you take most often. When you are about to print a new slide you can compare it side-by-side with your 'ideal' or standard slide. This will help in your assessment of variations of exposure and filtration.

Cibachrome responds differently to

▲ The ideal slide for colour printing is not too contrasty and has plenty of detail in highlight and shadow areas. Ours has a range of colours and includes a skin tone too.

different makes of slide film, even when the slides appear to have the same colour balance, so you must compare like with like. Either stick to printing one type of slide film, or make standard reference slides for the two or three types of film you use most often.

Exposure and filtration

Whatever type of paper you use, the basic exposure and filtration needed to balance your film and enlarger light to a particular packet of reversal paper are calculated by using the same principles. A strip of paper is cut from a sheet. A number of exposures are made, either at different times or at different aperture settings, and the strip is processed in the light-tight drum under normal lighting conditions. The processed test is assessed for density and filtration against the slide, and the exposure and filtration altered accordingly. Another test may be made and the procedure repeated until the slide is matched by the print.

Once this basic level of exposure and filtration has been reached there will be little variation while you are using a particular batch of paper. Recommended starting filtrations are included on the information sheets packed with the paper or printed on the packet.

Never be tentative in your alterations to the filter pack. As already mentioned, reversal paper is much coarser in its response to changes in filtration than the paper used to print from negatives. Always think in terms of making changes of at least 10 or 20 units.

Consistent exposure times

One minor disadvantage of reversal paper is its sensitivity to large changes in exposure time and the effect this has on print colour. Even if the filters remain unchanged, increasing the exposure time from, say, 30 to 60 seconds to make a print lighter will also cause the colours to change. (With Cibachrome try to keep printing times below one minute to avoid the problems of reciprocity.)

Although the changes can be predicted and allowed for, it is simpler to vary exposure by changing the aperture setting, which does not have the same side effects. However, small changes in exposure time—the equivalent of half a stop—can be made without noticeably affecting the colour.

Precautions

● In principle, each step in the process

stops the chemical action of the previous one. In practice, this is not always the case and care is needed to ensure that all of one solution is poured out before the next is introduced.

● To prevent contamination, colour code storage bottles and graduates, and use the same one for the same processing solution each time.

● Follow the manufacturer's instructions when making up solutions.

● Always wash the drum thoroughly after you have finished processing each print. With Cibachrome, any fixer carried over to contaminate the next development stage will probably result in a magenta colour cast on the following print.

● Never dip your fingers in the solutions. Quite apart from the safety reasons, reversal papers are very quick to pick up fingermarks, and contaminated fingers will produce coloured fingerprints. Try never to touch the surface of the emulsion with your fingers.

● Extra care is necessary when handling wet Cibachrome prints as just after processing the surface is very fragile indeed. A careless fingernail will, quite literally, scrape off the upper layers of emulsion.

Making white borders

Unexposed reversal paper is black after processing. This means that the borders of the print, protected by the easel during exposure, will be black. To make white borders it is necessary to expose the edges of the paper separately while the image area is covered by an opaque mask.

To make this mask, cut a thin metal sheet to a size a millimetre smaller than the image. Make sure that the edges are filed smooth so that the emulsion is not scratched. The weight of the metal on the paper ensures a good contact between the two, and this creates a sharp line.

After exposing the image on to the paper, remove the slide from the enlarger and place the mask on the paper. Lift the arms of the easel and, leaving the filters in place, make an exposure about twice as long as the exposure for the picture. Because the mask is a millimetre smaller than the picture area, the chance of getting a dark line around the image at any point is eliminated.

If you would like a coloured border instead of the usual white, simply change the filters to the colour you want before making the second exposure.

CHANGES IN EXPOSURE	CHANGES IN FILTRATION

▲ One stop under-exposure produces a print which is too dark and therefore looks dull. Shadow detail is lost.

▲ 20CC Magenta added. With reversal printing, adding a colour filter produces a cast of the same colour.

▲ Correct exposure produces detail in highlight and shadow. Colours are close to the original (opposite page).

▲ 20CC Yellow added. Yellow casts often seem acceptable until compared with a correct result (left).

▲ One stop over-exposure makes the print too light. The highlight detail is lost and the colours look washed out.

▲ 20CC Cyan added. This gives a cold cast. Filtration changes less than 20CC have correspondingly less effect.

127

Better colour slide printing

When you have learned how to make prints from slides which accurately reproduce the colours and tones of the original, you will want to go a little further. In many cases it is possible to improve on the quality of a slide when you make a print from it. A straight print from a slide does not necessarily give the very best final result. When you make an enlargement you can use most of the techniques to improve the final print that you use when you make ordinary black-and-white prints.

Dodging and burning-in

The technique that you will find most useful is that of local control by dodging and burning-in. Reversal printing paper is made in only one grade of contrast, roughly equivalent to the softest black-and-white papers in contrast range. The paper has such low contrast because the average slide, which is primarily meant to be projected, has a far higher contrast than a negative, which is meant to be printed.

Dodging and burning-in can be used to emphasize parts of the image, but you are likely to use these techniques more often to make the bright and dark parts of the image fall within the contrast range of your reversal printing paper. When making a reversal print, those parts of the print which receive more light during the exposure will come out lighter after the print is developed, and those parts which are given less light will be darker. This is the opposite of printing from a negative. Use pieces of cardboard taped to wire handles for dodging. For burning-in, a hole cut in a piece of card, or your cupped hands are the most useful tools.

When printing from colour slides you will need to make more pronounced exposure modifications than are necessary when printing from black-and-white negatives. Usually you will need to give 30%-50% less or more exposure to see a visible difference in those areas of the print that you have dodged or burned-in. Too much burning-in of shadow detail, however, can give an unrealistic smokey-grey appearance to the shadow.

Correcting colour casts

If your slide shows poor colour balance you can correct an unwanted cast by adding or subtracting printing filters. When printing with acetate or gelatin filters, you can use these to help you determine the amount of colour correction needed. Simply examine the slide through the filters until you find a filter or combination of filters that corrects the cast of the slide.

Correcting for colour casts is slightly more straightforward than when printing from negatives, since you remove an unwanted cast simply by taking it out of the filter pack. If the appropriate colour is not in your standard filter pack, add filters that are complementary in colour to the cast that you wish to remove. For example, if the slide is too blue, either remove cyan and magenta filters, or add yellow.

Local filtration

This combines dodging and burning-in techniques with the techniques used for correcting colour casts. You can make a washed-out sky turn a rich blue, for example, simply by holding a blue print filter over the sky during exposure.

Local filtration is best when you have a set of colour compensating filters to choose from. For this reason you should have a set of filters even if you have a colour head on your enlarger. The extra density of colour filters will make those parts of the print that you shade

◀ Contact sheets are useful when printing from slides. Filtration and exposure changes for different film types can be estimated, and the sheet is handy for reference.

▲ DODGING AND BURNING-IN: detail in the highlights and shadows was visible in the original Kodachrome slide by *Fred Dustin* from which this Cibachrome print was made. But the contrast range was too high, losing detail.

▲ By dodging the distractingly bright background around the girl's head, and by burning in the face, Dustin managed to reduce the contrast range. The final print resembles the original slide more closely.

▲ Exposing the left-hand side of the print through green filters held under the enlarger lens—and slightly increasing the overall print exposure—removed magenta cast (see right) without destroying the warmth of the image.

▲ LOCAL FILTRATION: unusual lighting in this dockyard at night meant that although the out-of-focus crane shows the pleasant warmth of tungsten light, the woman in the foreground has an odd magenta cast. *Lawrence Lawry.*

▲ FLASHING: this technique is useful for overall contrast control. Excessive contrast in this picture by *Steve Bicknell* washed out the highlights facing the window when a print was made on Cibachrome.

▲ To restore normal contrast and detail in the highlights, a second print was made with an exposure calculated to give good highlight detail. With the slide removed from the enlarger, a brief flashing exposure improved middle tones.

slightly darker, as well as altering the colour, and you may need to make allowance for this when deciding how much local filtration to use.

You can also use camera filters under your enlarger lens for special effects. Manufacturers produce a wide assortment of filters in colours such as sepia and tobacco that would require an unwieldy filter pack to reproduce with gelatin filters.

Contrast control by flashing

An easy way to reduce the contrast of a print is to give the paper another exposure without the slide in the enlarger. This is called flashing. It has the effect of adding an overall lightness to the print which is more visible in the shadows than in the highlights.

First, expose the print with the slide and filters in place. Use a test strip to determine the minimum exposure necessary to retain highlight detail. Then remove the slide, and with the filters still in place give a second shorter, exposure to the paper. As a starting point, try an exposure time not more than 10% of the original exposure.

Since this technique affects the shadows more than the highlights, you can experiment with changing the filtration of the flashing exposure to help neutralize colour casts in the shadows.

Diffusing the image

Enlarger lenses are designed to resolve the image of the negative or slide with maximum sharpness. But sometimes this sharpness can detract from the mood of the picture. In such cases, a better print can be made by softening the image by diffusion.

Diffusing the image is more effective when printing from slides than from negatives. When you diffuse an enlarged negative image, the diffused light makes the shadows of the print spread into the highlights, which can give the print a gloomy appearance. When diffusing a print from a slide, the highlights tend to spread into the shadows, and the picture retains its brightness.

If you have diffusers for your camera lenses, these can easily be used under the lens of your enlarger. It is not necessary to go to the expense of buying attachments specially for darkroom use. A piece of glass smeared with petroleum jelly or hair spray can be used instead. Another method is to crumple a cellophane cigarette wrapper into a small ball, then flatten it out. If this gives too much diffusion, you can make holes in the cellophane to get greater sharpness. Alternatively, more control can be exercised over the degree of diffusion by holding the diffuser under the lens for only part of the exposure.

▲ **DIFFUSING THE IMAGE:** this portrait by *Michael Busselle* has excellent sharpness—more in fact than the subject needs. The picture is a good likeness, but lacks mood.

▼ **By printing through a 35-denier nylon stocking, grain is softened, highlights spread into shadows, and detail is made less obtrusive. Prints by *Fred Dustin*.**

Optical effects under the lens

Many commercially available camera attachments can be used under the enlarger. Split prism filters, fog filters, graduated filters and spot filters (pieces of coloured glass with clear centres) can all be held under the lens to create interesting effects.

As with using these filters on the camera, the further you hold them from the lens, or the more you stop the lens aperture down, the sharper will be the gradation of colour. The particular advantage of using such filters at the printing stage rather than on the camera is that the decision to use a filter is not irrevocable—if you decide that a picture would look better sharp or a different colour you need only make another print with different filters.

Certain filters such as starburst filters and those based on diffraction gratings depend on pin-point sources of light within the field of view of the camera. These are not effective in colour enlargers where the light is evenly distributed across the slide.

Using the contact sheet

Many painters use a sketch book to develop their ideas for painting. From the basic concept comes a series of refinements that lead to the final image. For the photographer the contact sheet is the raw material from which he fashions his final print; it is an essential stage. The ability to assess the potential of a negative at this stage is one of the most important skills that any photographer can possess.

Printing the contact sheet

A little care taken when making your contact sheet pays dividends. An extra minute or two devoted to a little more quality often saves wasted hours later when you are enlarging individual frames. Slapping a sheet of paper from the first box that comes to hand into the contact frame or under a sheet of glass together with the negatives is not the way to get the best results.

Black-and-white contact sheet: first take a look at the negatives and try to judge which grade of paper is most suitable. With practice you will make a very accurate assessment. A lot of the time it will be the same grade. With experience your film processing techniques also become standardized so there is only an exceptional variation from a particular grade of paper. Remember, you want the maximum number of frames to display a full range of tones— so work on that basis.

Making the most suitable exposure is also important, so make a test strip for every contact sheet while you are still a beginner. As with the grade of paper, experience leads to skill in assessing such factors before you start. However, at the beginning, despite the fact that it may seem laborious, ensure that the full sheet is exposed to give as many highly detailed frames as possible.

Colour negatives: if you use colour negative film it is advisable to produce a full colour contact sheet. Producing a monochrome one on bromide paper gives some idea of subject matter, and such factors as whether a negative is really sharp, but it does not help much in deciding whether a negative is really worth enlarging.

Colour paper and print processing is so expensive and time consuming that the elimination of a false start helps to avoid frustration. It also ensures that you have

a basic filtration from which to work when you begin enlarging.

A further precaution you have to take with colour is to print in complete darkness. When working in black-and-white, under safelight conditions, you can see if a strip of negatives slips out of position. This isn't possible with colour, so make sure, if you are using a contact frame, that all the strips are securely positioned.

If you use a sheet of glass stick the strips to the glass with very small pieces of self-adhesive tape. Remember, if you do this, that the sheet of glass is turned when printing, so fix the strips emulsion

▲ **Many variations are possible when an image is cropped. In this picture by** *Homer Sykes* **there are two possibilities that are totally different in their effect. Such strong alternatives are rare. The image framed by the red outline gives an impression of all the elements of the confrontation that occurred in the crowd. The alternative is a very bold composition with a strong diagonal formed by the youth's arm. However, all the subtle variations in facial expressions that convey the atmosphere of the situation are lost.**

◄ **A well printed contact sheet is essential when selecting and cropping individual frames. By using L-shaped pieces of card the most appropriate framing can be chosen.**

◄ **Not all shots need to be cropped. If more of the frame is included the magnification needed to fill the printing paper is smaller. This will obviously aid the image quality of the finished print.**

side up so that they are the correct way round when printed.

● If you are not sure which is the emulsion side, moisten your lips very lightly and press the film edge to them. The emulsion side will feel stickier than the base. (This test also holds true for paper should you ever become confused in the dark while printing.)

Assessing the contact

Once you have a dry contact sheet you can begin to weed out the obvious failures: those where your subject turned away or blinked at exactly the wrong moment; those that are clearly blurred or out of focus. (A magnifying glass is a great help at this point.) After a few minutes' observation the more successful ones become obvious: the portraits with the 'right' expression; the groups where everyone is smiling; the view of the lake where a swan swam into position at the moment you pressed the shutter release.

Modern films give such short exposures that luck or very quick reactions play a part in many photographs and you will often be surprised at the images you do have. Few of us are as skilled as the famous photo-journalist, Felix H. Man, who would return from an assignment and tell the printer which frames to enlarge before the film was processed.

Cropping

When you think you know which images have some potential as enlargements you need to use a very simple aid to try to sort out the best way to frame each subject. This aid is a pair of L-shaped pieces of card. Any card will do but it is important that it is cut square with straight sides. There is nothing more annoying than to have to compensate for a corner that isn't 90°. With this tool to hand you can try various ways of creating a frame around the image. The important thing to remember is to follow the dictates of the image. Conventional paper sizes and proportions are irrelevant. If a long, narrow shape suits the composition you have in mind, then don't be afraid to use it. If a square is best then use it. So-called 'rules' are there to be broken. Sometimes you have to crop off a large part of the negative to get a really effective picture. Sometimes merely cropping a fine line off one side will do the trick.

Experience will teach you certain things that are best avoided unless you are using them for a specific reason. Small bright areas next to dark ones near the edge of a frame inevitably draw the eye and are usually best cropped out. A similar fate can be reserved for obtrusive backgrounds.

Don't be afraid to remove anything that isn't necessary. If you are unable, for various reasons, to get close enough to your subject while shooting or if, when taking a portrait, there is no way of avoiding an expanse of ceiling, cropping of the negative at the printing stage is essential.

Cropping can also be used to intensify the mood of the picture. By eliminating any sense of space round a person or an object you can make it seem to burst from the frame. This is particularly effective if the subject is an emotionally charged one, such as a child crying. When you have decided on the framing you want to use, mark it in on the contact sheet with a blue China crayon and move on to the next frame to be examined. Once you have dealt with the entire sheet it is time to begin enlarging.

▼ **There are many reasons why it is often not possible to get as close as you would like when taking a photograph. Here the road is the obstacle that made a close viewpoint impossible. By excluding all details other than the facade of the house when making the enlargement (right) the viewer's attention is concentrated on the pattern created by the windows, door and the foliage.**

Colour print faults

Faults in colour prints can be roughly divided into two sorts. Those caused by contamination and those which happen because of incorrect exposure and filtration. Faults from contamination are more difficult to trace and cure, but you can avoid them by being particularly careful in your working methods.

Most colour prints are processed in drums and it is here that a lot of the trouble starts. Some drums have small cavities and grooves which can capture and hold tiny amounts of processing solution, only to release them at the wrong moment.

This doesn't matter too much for the first print you make each session, nor does it matter if a small amount of developer is retained because it is quickly neutralized by the bleach-fix. But if you don't wash out the drum after the bleach-fix step—and that may mean taking it to pieces—a tiny amount of bleach-fix may be trapped somewhere in the drum. When you place the next exposed piece of paper in the drum, this bleach-fix will seep on to the surface of the paper and retard the action of the developer in patches. This usually results in pink stains which are impossible to get rid of.

But contamination by bleach is only one type of fault. There are many more and some of them are shown here.

It is worth remembering that many of the stains and mechanical damage faults listed under prints from negatives apply also to prints from slides.

Faults in prints from negatives—Incorrect exposure or filtration

Fault: fogging of printing paper.

Cause: box or packet of paper not closed tightly and paper was exposed to light.

Cure: always check that box is closed tightly after removing a sheet of paper.

Fault: low contrast print.

Cause: there are several possibilities.
1. Negative under-exposed or under-developed.
2. If print is also very pale, print was under-exposed.
3. Under-development of print.
4. Safelight too bright.

Cure: if problem is in the negative, there's nothing you can do about it. If print has been under-exposed or under-developed, make a new one, paying particular attention to exposure time and development time, temperature and agitation. If you used a safelight, make another print in total darkness.

Fault: print too dark.

Cause: over-exposure or over-development of print.

Cure: make a new print. Give a shorter exposure or control time, agitation and temperature of developer more accurately. Check particularly that pre-wet water is at correct temperature.

Fault: overall coloured fogging.

Cause: accidental use of safelight designed for use with bromide papers, or a correct safelight is too bright or too close to working area. Possibly paper was exposed to safelight for too long.

Cure: if you must use a safelight, make sure it's the right one and has the correct wattage bulb as recommended by the paper manufacturer. Check, too, that it is the correct distance from working area.

Faults from negatives coloured fogging

colour reproduction inaccurate

muddy colours

Fault: colour reproduction is totally inaccurate.

Cause: almost certainly due to wrong filter combination. If using a colour mixing head you may have forgotten to operate lever which inserts filters after focusing.

Cure: to correct a colour cast you add filters of the same colour to the pack. And always check filter lever on colour head.

Fault: different densities of several prints from same negative.

Cause: either exposure or development times, or temperature or agitation varied from one print to another. Also room temperature variation which will affect a motorized-base drum or one not used in a water bath.

Cure: Make sure each print receives same exposure and development time, and the temperature of developer remains constant. In an industrial area heavy electrical machinery may cause a voltage drop so that the light from enlarger lamp varies. If you suspect this, fit a voltage stabilizer to your enlarger.

Faults in prints from negatives—Contamination

Fault: red or pink stain.

Cause: either the developer was contaminated with bleach-fix, in which case the stain will be in a random pattern, or the print has been insufficiently washed.

Cure: in the first case, make sure that you wash your drum out thoroughly after processing each print. In the second, increase the number of water changes when washing your print.

Fault: muddy colours, especially strong yellows.

Cause: insufficient bleach-fixing. Silver image is not being removed completely.

Cure: mix up fresh bleach-fix and re-treat print.

Fault: blotchy backgrounds.

Cause: inadequate agitation during processing.

Cure: follow carefully drum manufacturer's recommendations when agitating drum. If possible, use a motorized base to ensure thorough agitation.

Fault: cyan or blue-violet stain.

Cause: developer strongly contaminated with bleach-fix.

Cure: mix up fresh developer; take great care not to get it anywhere near bleach-fix. A common cause is storing developer in a bottle previously used for bleach-fix and not washed out. Always use the same bottle for the same solution and label them clearly.

blotchy background

cyan or blue-violet stain

correct print

Fault: random bluish-green spots on print.	**Cause:** splashes of water on paper before processing.	**Cure:** avoid splashes of water on unprocessed paper.
Fault: red or pink finger marks.	**Cause:** surface of paper was touched by fingers contaminated with bleach-fix.	**Cure:** always wash and dry your hands before touching paper if you have had them in bleach-fix solution.
Faults: scratches on print surface.	**Cause:** when removing print from drum you may have caught the surface with your fingernail or a corner of the sheet of paper.	**Cure:** as the wet emulsion is very delicate, be particularly careful when handling wet prints.

Faults in prints from slides

Fault: print dark and lacks contrast.	**Causes:** insufficient first development (or development in Cibachrome) caused by low developer temperature, inadequate time, or inadequate agitation.	**Cure:** check times and temperature carefully, and agitate as recommended.
Fault: print too light and lacks maximum density.	**Cause:** too much first development (or development in Cibachrome) caused by high developer temperature or too long a development time.	**Cure:** as previously, check the time and temperature carefully.
Fault: dull, foggy print.	**Cause:** insufficient bleach or bleach-fix time.	**Cure:** time bleach or bleach-fix stage carefully.

Faults from negatives: random spots and pink fingermarks

scratches on print surface

Fault: in Cibachrome prints, fogged and dull results with dirty stripes. | **Cause:** drum not washed properly before use. | **Cure:** be clean and methodical in your work.

Fault: dark print with no image. | **Cause:** no exposure, or in Ektachrome prints use of first and colour developers in reverse order. | **Cure:** follow working procedures very carefully and check that you don't miss out any steps.

Fault: in Cibachrome prints, a flat, yellow appearance. | **Cause:** fixing stage omitted. | **Cure:** again, follow the instructions carefully. You can rescue prints with this fault by fixing and re-washing them.

Fault: in Cibachrome prints, dark, fogged and dull results. | **Cause:** bleach and fixing baths used in reverse order. | **Cure:** follow processing instructions carefully and label bottles clearly.

Fault: strong overall colour shift, including the edges of the print which tend to be lacking in density. | **Cause:** fogging, probably by a safelight. This is especially so in the case of Ektachrome prints because the paper is very fast. | **Cure:** work in total darkness; no safelight is really safe for this type of printing.

Fault: in Cibachrome prints, light, bluish results with low maximum density. | **Cause:** developer too concentrated, or too warm or time too long. | **Cure:** check your mixing of the developer; you may have forgotten to make up the final volume.

Fault: fogged and dull Cibachrome print. | **Cause:** bleach solution too diluted, or too cold or exhausted. | **Cure:** mix fresh bleach solution, being very careful to follow instructions.

Faults in prints from slides: overall colour shift

print too dark

print too light

Printing controls

Although you are probably quite satisfied with your prints as a rule, there may be times when they don't quite come up to your expectations; there may be areas which print darker than you want or highlights which burn out (are too pale and lack detail). In these cases you can improve the results considerably by controlling the exposure locally. This is called shading or dodging (making an area lighter) or burning-in (making an area darker). Shading or dodging is also referred to as 'holding back'. Other controls include flashing, to reduce the contrast of a print and improve highlight detail; correcting distortion such as converging verticals; and, in colour prints, correcting the colour balance locally. (You can also dodge, shade, burn-in and correct verticals on colour prints, but you cannot flash colour papers.)

Dodging tools

Quite a lot of shading and burning-in can be done with nothing more elaborate than your hands. For example, if you want to darken the sky in a landscape, simply hold your hand so that it casts a shadow over the land part of the picture but lets the sky receive extra exposure.
And if you want to burn in, say, a

window in an interior shot to give added detail you can, with a little practice, form your hands into a cup shape so that just the area of the window receives extra exposure. But a few simple tools will make the task easier. One or two companies manufacture them but they are easy to make. All you need are two or three pieces of black card cut into geometric shapes and attached with tape or staples to thin, stiff wire—such as bicycle spokes or florist's wire. (The wire has no appreciable effect as it is moved constantly.) The shapes should be a circle, a triangle, and so on—make them in several sizes—and one piece of wire with a small wad of cotton balls on the end is particularly useful. You can tease the cotton balls into all sorts of shapes which will enable you to shade areas such as a tree.
Pieces of card with holes in them are useful for burning-in small areas. Again, make several with different shaped holes in them. Ideally, the card should be black on one side and white on the other. You can then hold it with the white side uppermost, so that you can see the image, while the black underside prevents light being reflected back on to the printing paper and degrading the highlights of the print.

When you use dodging tools, the important thing to remember is to keep them moving in a random pattern—round and round, back and forth and so on—all the time. This prevents hard lines forming in the areas you have been shading or burning-in, caused by the edges of the shadow cast by the dodger on the printing paper.

Shading and burning-in

The best position for dodgers for shading or burning-in is about a third of the way up from the baseboard of the enlarger to the lens. If you hold the dodger too near the lens the shadow cast will be too soft around the edges and it will be difficult to control the dodging accurately. On the other hand, if you hold the dodger too near the baseboard the shadow will tend to have hard edges and you'll need much larger dodgers for any given area.
Of course, if you want to dodge areas of different shapes from your dodging tools, you can tilt the dodger to form a modified shape. A round dodger, for instance, will form an elliptical shadow when tilted, while a square shape when tilted will form a rectangle.
The test strips you make to establish the overall correct exposure will also help you to decide how long you need to burn-in or shade an area. Perhaps the test strip of a landscape indicates an overall exposure of, say, 12 seconds but the 20-second step may be right for the sky, while a dark clump of trees in the middle distance needs only 8 seconds. To get the tonal balance right you would give a 20-second exposure to the print but after 8 seconds shade the trees and after 12 seconds shade all the land, leaving the sky to receive the full 20-second exposure.
With practice, you will soon develop your own style for shading and burning-in whether by dodging tools or simply with your hand. Local colour correction, however, will be a refinement that is needed only occasionally. Other printing controls—vignetting, flashing and correcting verticals—are explained next.

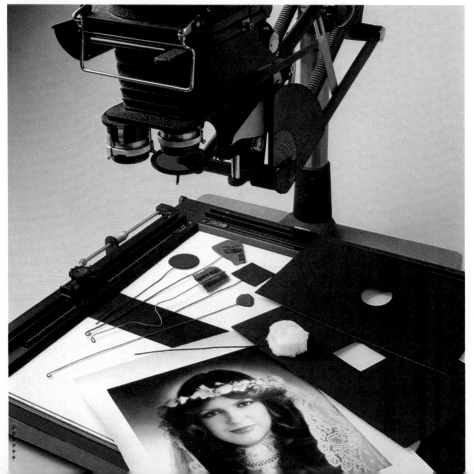

◄ **A set of simple dodging tools can be easily made in an hour from readily-available materials. Don't use coat-hanger wire because it is too thick. Attach the pieces of card to the wire handles with staples, glue or adhesive tape.**

BURNING-IN

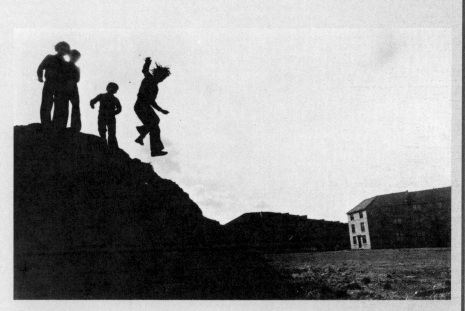

▲ Burn-in large areas, such as the sky by giving that part of the print increased exposure. Hold your hand or a piece of card over the image so it shades the lower half of the print. Burn-in smaller areas by cupping your hand or use a card with a hole in it.

▲ **BEFORE**
A dramatic photograph taken against a cloudy background. But the print, given an overall exposure of 10 seconds at f8, has a blank sky.

▼ **AFTER**
The solution is to burn-in the clouds by giving that part of the print more exposure—an extra 15 seconds in this example, but use your test strip to assess the right amount. You can use your hand or a piece of card (black side facing down) to keep the light from the lower half of the print while you burn-in the sky.

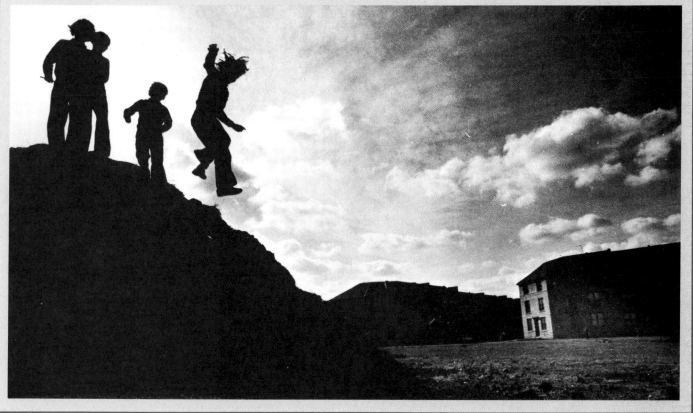

SHADING

▲ To reduce or hold back the exposure for a small area, use a piece of card attached to stiff wire to shade the area during part of the exposure. But do not forget to keep the dodging tool moving to prevent hard edges from forming. The shaded area will be held back and therefore appear lighter in the print.

▲ BEFORE
This print was given a single 30-second exposure which was suitable for the boy and the exterior of the building, but too much for the interior which has lost its detail.
▼ AFTER
A small dodging tool was used to hold-back (shade) the interior so it received just

enough exposure (only 10 seconds) to reveal the blacksmith while the rest of the print received the full 30-second exposure. The photographer kept the dodger moving so no hard edges formed.

LOCAL COLOUR CORRECTIONS

Occasionally the colour balance of one area of a colour print needs to be changed without altering the rest of the image. Basically, this technique is similar to shading, but instead of using a small piece of card on a stiff wire you use a small piece of filter. (You will need to buy spare filters.)

For example, a portrait taken partly in direct sunlight and partly in shade will show a distinct bluish bias in the shadow area when the sunlit area is correctly balanced. And if you get the shadow area right the sunlit side of the face will be too yellow. The answer is to set up the filter pack to give the correct balance in the shadows then dodge the sunlit side of the face with a piece of CC05Y or CC10Y for the whole of the exposure.

You will usually find that a filter of 05 to 10 units will be sufficient to control colour balance locally, so buy an extra pair in yellow, magenta and cyan. But buy colour compensating (CC) filters rather than colour printing filters; they are of better quality and are recommended for use under the lens.

Use a small piece of CC filter for local colour corrections. You can fix it to wire or hold it with your fingers (but move them round so they don't affect the exposure of the print). Always keep the filter moving.

Areas shaded by the sun hat came out with a distinct bluish bias though the sunlit area has good colour balance. In this particular case the photographer held a piece of CC20 blue filter over the area with the bias for the entire 12-second exposure. But because of the extra filtration this area was burned-in for an extra 3 seconds.

Although shading, dodging and burning-in are used more frequently to improve prints, there are other equally useful manipulations such as correcting verticals, flashing and vignetting. And sooner or later you will find that a superb architectural shot has disturbing verticals which need to be made parallel, or a fairly ordinary photograph would be more appealing if vignetted. Flashing, however, applies only to black-and-white prints and is a rarely used technique.

Flashing

An otherwise unprintable negative which has little detail in the shadows and extremely dense highlights, which normally print to an unrelieved white, may be salvaged by this technique.

Flashing, as its name implies, consists of giving a very brief exposure to the printing paper with no negative in the enlarger before giving the normal exposure to the negative.

What happens is that flashing gives a very light exposure all over the paper which produces a slight tone in the highlights but has little effect in mid-tone and shadow areas.

The easiest way to give a flash exposure is to place a neutral density filter

(obtainable from your photographic supplier) of 2.0 density in the enlarger negative carrier instead of the negative and give the same exposure as for the negative. A 2.0 density filter transmits only 1/100 of the light falling on it, so if the exposure time is 10 seconds, the paper receives a flash exposure equivalent to 1/10 second.

▲ White highlights spoil this print. So flashing was tried. The paper was exposed normally, then given a second exposure to white light from a greatly dimmed 15 watt bulb for 2 seconds.

▼ This is the improved result.

Correcting verticals

When you take a picture of a tall building you sometimes have to tilt the camera up to get the top of the building in the frame. This produces converging verticals which can ruin the photograph.

You can correct this distortion when you make the print by tilting the masking frame on the enlarger baseboard—but make sure that it can't move easily otherwise you may get a blurred print. Because one part of the image is now further from the enlarger (it should be the top of the building), it is enlarged progressively more than the rest so restoring the verticals.

On some enlargers you can tilt the negative carrier, which gives the same result. But the best solution is to tilt both the negative carrier and the masking frame in opposite directions, because this lessens the angle to which each is tilted.

One part of the negative is enlarged more than another, so the image can only be brought into sharp focus over the whole area by stopping the lens down considerably. However, a few of the more advanced enlargers available also allow the lens panel to be tilted and when correctly adjusted the whole image can be made sharp even at full aperture.

When the masking frame is tilted, the part nearest to the enlarger lens will receive more exposure than the rest, so you must progressively burn-in the rest of the print slightly to avoid a gradual lightening in tone.

▼ **Inset shows how the verticals were converging before correction, as seen in the larger print.**

▲ **To correct verticals tilt the masking frame, supporting it on a block of wood or books.**

Vignetting

A step further on from burning-in is vignetting where only the central part of the paper is exposed to produce an image which gradually goes to white at the edges of the paper. To produce this result all you need is a piece of card with a fairly large oval shape cut in it. You then hold this in the same position as a normal dodger so that it casts a shadow over all but the central area of the paper.

▲ Vignettes normally refer to images where the edges fade off into white. However, they can be made with black borders instead. Expose the full sheet normally, then use an oval dodger to hold back the image while you fog the surrounding paper.

▶ Vignetting removes distracting surroundings and, when followed by sepia toning, is an effective way to turn records of family events into something rather special.

It is not only black-and-white photographs that can be vignetted. Groups taken in colour often provide material for charming, individual vignetted portraits.

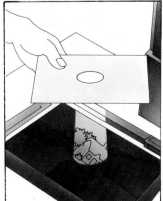

▲ A soft-edged vignette gives a portrait an elusive quality.
▶ Most vignettes are oval but any simple shape can be used. If you want soft edges, rotate the card gently during exposure.

Retouching

A small amount of simple retouching can often transform a rather unattractive spotty print into something you can be proud of. Most of your retouching work will be done on prints (black-and-white and colour), as negatives and transparencies are very difficult to work on.

Basic equipment

For basic print retouching you need: a good quality brush (around 00 size), which you can buy from an art materials shop; retouching dyes—obtainable from your photographic suppliers; absorbent material such as blotting paper or paper tissues; a small hobby knife—the sort which comes with detachable, sharp blades (the rounded blades are best); a small vessel to hold water (such as a small jam jar); and a flat surface for mixing dyes (a saucer or painter's palette).

Most of these materials are available in ready-made retouching kits which can be bought from photographic suppliers. It is very important to look after your brushes and to ensure that the hairs do not become straggly. If your brush comes with a small plastic sheath, always make sure you replace it after use, as a damaged brush is of little use to anyone.

White spots on the print

Even if you are a meticulous worker and you take every precaution to avoid marks appearing on your prints, there are always a few dust specks which will show up as white spots on the print. Occasionally, a negative gets scratched and as a result you may have black spots and lines to remove on the print.

If you find that your prints have a large number of unwanted marks, you should check your enlarger and other equipment for dust. The main problems arise from dust in the negative carrier, especially when it has glass, and for this reason many photographers prefer glassless negative carriers. Unfortunately, the glassless carrier makes it more difficult to maintain a flat negative and therefore an overall sharp image. No one system is perfect; you should try both and see which you prefer.

The use of cans of compressed air, blower brushes and cleaning brushes (preferably of the antistatic type) helps to keep dust away from the negative and carrier.

The white spots, caused by small dust particles on the negative or carrier, are removed by adding small amounts of retouching dye. There are three types of dye; watercolour paints which are unsuitable for glossy prints because they leave surface marks, water-soluble powder dyes which again tend to leave surface marks on glossy prints and—best of all—photographic dyes which do not mar the print surface.

Select the dye colour which most closely matches the tone of your black-and-white prints; the image tone of black-and-white prints depends on the type of paper and varies from warm browns through neutrals, to blue-blacks. Before you begin, make sure that your work area is clean and that you have enough light and that it does not cause distracting reflections on the print surface; a gooseneck lamp placed to one side is ideal.

Make up a weak solution of dye and immerse your brush in it. Now remove most of the dye solution from the brush by gently stroking the brush tip on an absorbent material such as blotting paper or paper tissue, and work the tip of the brush to a point. Using the brush in a stippling manner, add dye to the white spots which are within areas of the same tone or darker than the dye mixture in the brush. It is important, however, that the brush is kept almost dry.

The idea is to gradually add dye to the white spots and build their density until it matches the surrounding area. It is best to work outwards from the centre of the area to be retouched. This building-up of dye prevents dark areas appearing near the edge of the retouched area.

Continue this stippling technique until all the spots within the lighter tones are camouflaged. Now increase the strength of your dye until a mid-tone is achieved. Using the same technique, retouch all the white spots within the mid-greys. Finally, increase the dye strength, possibly as undiluted dye, and retouch all the dark areas.

There are not quick ways to retouch a print; it simply requires patience, care and practice. It is obviously best to learn by practising on reject prints.

Black lines and spots

Black marks on a print are caused by white marks on the negative, and may result from scratches, dust in the camera, or dust in processing.

The first step is to remove the black spots by 'knifing', which is done by scraping the spots very carefully with a small hobby knife. Again, it is best to

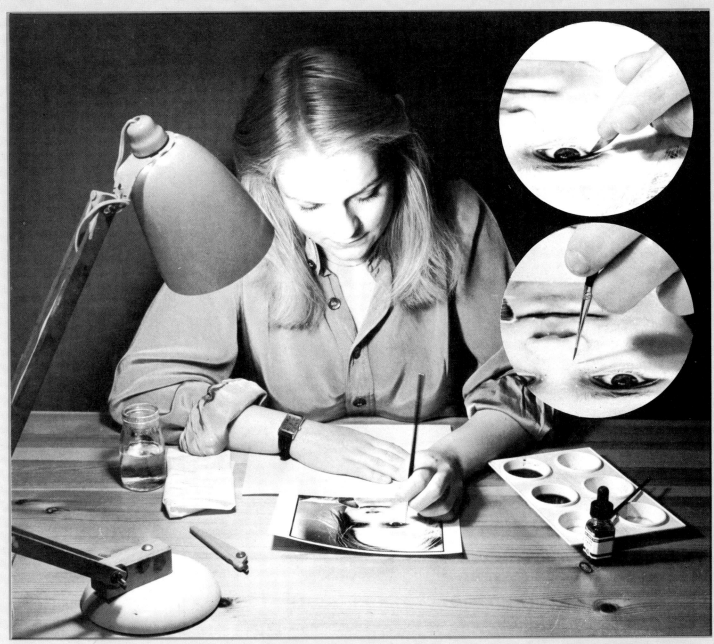

remove the black spots very gradually, working down from black through a mid-tone to a white. Sometimes it is possible to scrape the darker area until it exactly matches the surrounding area, although in practice this may be difficult. Generally speaking, it is best to produce a tone lighter than the surrounding area. This light tone is then 'rebuilt' to the adjacent tone by the method described previously for filling in white spots.

Chemical reduction

Where easily-accessible areas of a print need to be partially or completely removed, as in the case of a distracting background, it is often best to use chemical reduction. This technique involves rewetting the print and carefully, with a Q-tip (cotton bud) or brush, applying a bleaching solution (such as Farmer's reducer or iodine bleach) to the necessary area. The strength of the bleach should be tested first on a reject print, before starting work on your best print.

This method works best on a part of a print where a gradual reduction is required over a fairly large area, or where small defects appear on an otherwise clear background. Chemical reduction is usually much quicker than conventional retouching techniques.

▲ A well-lit surface is important for successful retouching. When applying the dye protect the lower part of the print with a clean tissue or piece of paper. Start with the lighter tones and build up the density gradually till it matches the surrounding tone. Test dye strength, first, on a plain piece of paper. Don't overload the brush, and spot the dye by stippling.

Insets show how to hold the brush for stippling and how to control the blade in knifing out. Though a 00 brush gives more control, you may want to use a bigger brush.

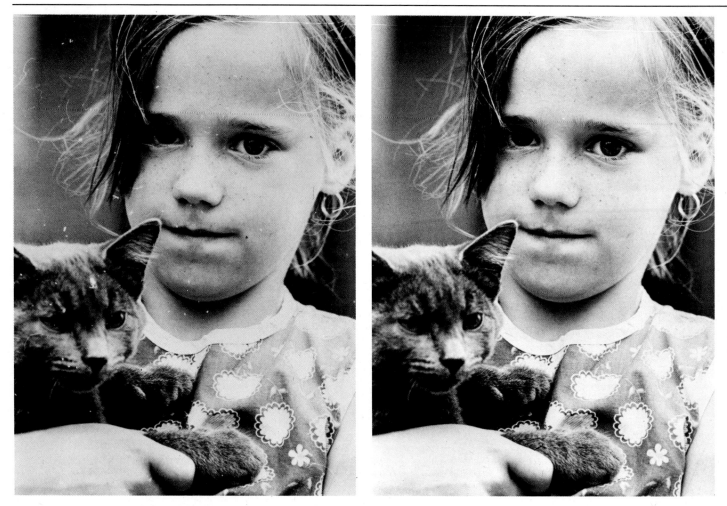

Printing paper surfaces affect the degree of success with retouching and the ease with which it can be accomplished. Papers with a matt surface are less likely to show obvious evidence of retouching than glossy surfaces, and conventional papers are easier to work on than resin-coated (RC) papers.

In fact, some matt papers can be successfully retouched by pencil. Try using an HB pencil. If surface marks give away your retouching, you may be able to overcome this by adding small amounts of shellac or gum arabic to the dye solution, or by using dye specially formulated for glossy prints. Add a little gum arabic to some dye on the palette and mix, altering the amount of gum arabic, if necessary, to obtain the right sheen. If you haven't any gum arabic solution use envelope glue.

Sometimes, respraying the entire retouched print disguises the work.

Retouching negatives

Unless black-and-white negatives are at least 1¾ x 2¼in (4.5 x 6 cm) in size, it is impractical to attempt to retouch them.

Even if they are this size or more, it is much harder to work on a negative than a print; besides, you can easily make another print, whereas the negative is often irreplaceable. So, if your print requires a lot of retouching and you want several prints, it is probably advisable to make one good retouched print and rephotograph this to produce a copy negative. It is then a simple matter to run off many good prints from the copy negative.

One technique which can be used on negatives is to block out areas such as distracting backgrounds with an opaquing solution. This means that any area which is opaqued will appear as white on the final print. This is only practicable where large negative areas, such as backgrounds, are involved, and where there are no difficult edges between the area and the subject.

Photo-opaque materials can be bought from your photographic shop, either as a thick solution or as a powder. Apply the solution very carefully, keeping it as dry as possible. It is painted on to that part of the negative which will print as

white, and is normally applied to the back of the film (the shiny non-emulsion side). Opaquing is easier to do on larger negatives.

Colour prints

The method of retouching colour prints is similar to that of retouching black-and-white prints, but it is very important to work with a light which reasonably matches the light where the print will be hung. In practice, most prints are viewed by daylight and by tungsten at night; the retouching light should therefore be a mixture of daylight and tungsten if this is possible. A suitable compromise may be to work by a window but with a table lamp.

There are three types of coloured pigments which can be used. For small amounts of retouching, especially with matt surface prints, coloured pencils (such as the Stabilo range) are suitable. Because it is not possible to mix colours with pencils, a wide colour range is needed. If there are any black spots, these can normally be covered with a white pencil; the final colour is then

◀ **A black-and-white print before and after retouching shows how spotting medium, applied skilfully, masks unwanted blemishes which are caused by specks of dust and fine hairs on the negative or the glass of the negative carrier. Always use a shade that matches or is slightly lighter than the surrounding tone.**

▲ ▼ **A colour print before and after it was retouched with colour photographic dyes. Colour is also added by stippling but retouching is more difficult and requires practice. Cover black spots first with white and build up the correct colour on this base. It is best to spot the colour from the centre outwards.**

applied on top of the white spot. As with black-and-white retouching, it is best to build up colour, and camouflage the area rather than obliterate it.

A second method is to use dry retouching colours; this technique is more suitable where large areas need to be retouched. The retouching dye, in a form similar to a wax polish, is applied with cotton wool (Q-tips or cotton buds are ideal). If too much dye is added or a difficult colour is needed (colours can be mixed), as long as they haven't been moistened it is easy to remove the dyes by wiping them off the surface. The retouched colour print is set by steam; about 10 seconds in front of a kettle should be enough. Once set, the dyes are very difficult to remove. This dry retouching technique is very suitable for any print surface.

Perhaps the most convenient method is the use of photographic dye solutions (and dry retouching dyes used with water), which are applied in a similar manner to black-and-white retouching dyes. Again, black spots should first be treated with opaque white, and the correct dye added later. It is best to use an almost dry brush, with the dye being built up gradually.

There are a number of colour retouching kits available. The range of colours available depends on the manufacturer but is likely to include cyan, magenta, yellow, red, green, blue, brown, black and flesh. Sometimes a wetting agent is included in the kit to help dyes become more easily absorbed into the print surface. Most liquid dyes do not adversely affect the print surface.

Retouching colour negatives and transparencies is not really a proposition for the amateur and is normally best left to the professional retoucher. Much work on large transparencies and negatives is done with an air-brush — a miniature spray gun. Considerable skill and practice is needed to achieve acceptable results.

Retouching is a skill which requires much patience and practice, and each photographer has his own pet techniques. Don't be afraid to experiment on your reject prints, and with practice it is possible to develop a basic retouching skill into a creative technique with imaginative results.

Where photography finishes and painting takes over is sometimes difficult to determine, but used together the two disciplines can produce such exciting results that any pigeon-holing becomes completely irrelevant.

Black-and-white emergency measures

No matter how well you have mastered the art of developing your black-and-white films, there is always a moment of suspense as you draw the film from the reel. The more important the subject matter on the films, the greater the pulse rate. In most cases the film will reveal a dozen or so well exposed frames. Each negative image will contain a range of densities from light to dark and all will be well.

Occasionally, however, things go wrong such as a slip up when setting the film speed, or a misreading of the developer temperature or processing time. Such mistakes can result in negatives with too dense an image or images that are far too thin. In extreme cases they will be difficult to print and the cost will be high in terms of time and printing paper.

Often you can discard faulty negatives and put the whole thing down to experience. Sometimes, however, the images may be too important—like a wedding or the birth of your child, for example—to be dismissed so casually. In these cases you will want to salvage as much detail as possible.

The most appropriate line of attack depends on whether the negatives have been over-exposed and/or over-developed, in which case you may need to use reduction, or whether they have been under-exposed and/or under-developed, in which case you will perhaps need to use intensification. These are both chemical treatments; reduction, as its name implies, acts on the silver and by dissolving some of it decreases the density. Intensification does the reverse—it either increases the density of the image by adding another metal to the silver image or it stains the image, making it less transparent to light. Most intensifiers unfortunately increase the grain.

It must be stressed that these are emergency measures and as such cannot be expected to turn the negative into A1 quality.

Materials

The most widely used intensifiers and reducers are available in the form of prepared chemicals from some of the large photographic retailers and mail order suppliers. Before buying a preparation, it is worth checking, either with the supplier or the manufacturer, that the treatment you select will produce the desired effect. If you are in a shop ask to see the instructions. You should always read the instructions

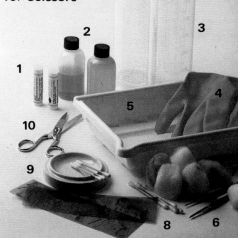

You will need
1. **Tubes of powdered reducer**
2. **Solutions of reducer and intensifier**
3. **Graduates**
4. **Plastic gloves**
5. **White processing tray**
6. **Fine painting brushes**
7. **Cotton balls**
8. **Q-tips (cotton buds)**
9. **Mixing palette**
10. **Scissors**

Step-by-step to intensifying the negative

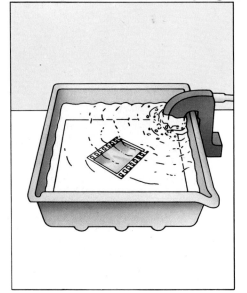

1 WASHING THE NEGATIVE
Begin the process by thoroughly rewashing the negative. This removes any traces of fixer. It also makes the gelatin swell. Dry gelatin is very absorbent and if film is placed in the solution of intensifier without washing it will absorb too much.

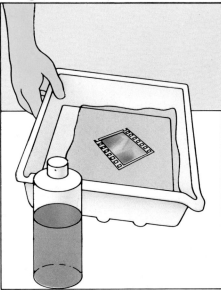

2 BLEACHING
Once the negative is washed immerse it in the intensifier solution.
Agitate continuously until the black silver image is completely bleached to a pale buff colour. Take care when doing this as the solution is corrosive and will damage clothing.

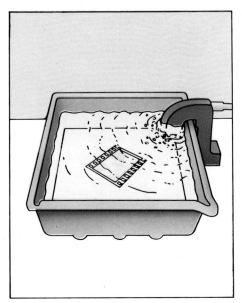

3 THE SECOND WASH
Wash the negative thoroughly for about five minutes until the overflow is clear and colourless.

carefully before you begin work on your negatives.

You will need a small, white, plastic container (not one used for food—keep it exclusively for photographic work) or a small developing tray in which to process the negative, and some graduates for making up your solutions.

Finally, when handling photographic chemicals it is always advisable to avoid contact with the skin. Thin plastic gloves, which are available from most drugstores or chemists, protect the hands and are ideal for tackling the delicate manoeuvres necessary when handling small pieces of film and working on individual areas of photographic prints.

Rescuing faulty negatives

In some cases you may be able to compensate for the lack of quality in the negative by printing on a suitable grade of paper, but if this doesn't work you will need to use chemical treatment. If you have to resort to this always remember to rewash the negative to be treated before you begin.

Under-developed negatives look thin and lifeless because they lack contrast though they may contain plenty of information in both highlights and shadows. If the effects are not too marked, you may be able to produce a passable print by using a hard grade of paper. But in extreme cases you will need to resort to intensification.

Intensifiers increase the density of the image in proportion to the existing density so highlights are intensified more than shadows, which increases the contrast of the negative. A widely used metal intensifier is a chromium preparation in which the proportions of the working solution can be varied according to the degree of intensification required.

Leave the negative in the working solution until it has been bleached to a yellow-buff colour and then rinse it thoroughly in water. Finally, the negative is redeveloped in an ordinary print developer.

Under-exposed negatives show details in the highlights but contain little or no detail in the shadows, and in extreme cases of under-exposure these areas are clear film. This type of negative is very difficult to print and is not greatly improved by intensification because nothing can be deposited where there is no image. If you are determined to rescue this negative, of those intensifiers readily available, chromium will give the best results.

Over-developed negatives are dense and contrasty. They contain plenty of information in the shadow areas, but detail in the highlight areas is clogged

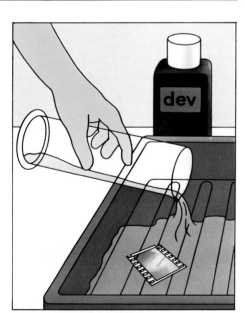

4. REDEVELOPMENT
Redevelop the negative in any standard print developer until the buff image has gone completely black. This usually takes 2-3 minutes at 68°F (20°C). Wash for a minute and then refix in a fixing solution containing hardener. Finally wash again and dry.

▲ A typically under-developed negative lacks contrast but does possess a little shadow detail. The print looks very dull and lifeless. It is difficult to print on harder grades of paper and must be intensified.

▲ The intensified negative lacks the fineness of definition and smooth contrast range of a properly developed negative. However it will print to give an acceptable result and thus overcome an often difficult situation.

in an excess of silver. A slightly over-developed negative can sometimes be printed on a softer grade of paper. Considerable over-development requires reduction of the negative and for this you need a super-proportional reducer which will remove silver in proportion to that which is already there, taking more from the highlight areas than the shadows and thus reducing contrast. Ammonium persulphate will do this but can only be made up from high quality chemicals and has to be used immediately.

Over-exposed negatives are dense and lack contrast. They contain all the details of the subject buried in too much silver. If this effect is too extreme to be remedied by printing on a harder grade of paper you will need to resort to reduction. Here single bath Farmer's reducer, such as Tetenal reducer, is used. (There is also a potassium per-manganate reducer.) These are known as proportional reducers because they tend to reduce in proportion to the amount of silver already there. However, in practice there is less density in those areas derived from the shadows of the original subject and so reduction is noticeable in those areas first.

The actual treatment is easy enough. You dilute the reducer as directed and immerse the washed negative until there has been sufficient decrease in density. As you are checking this visually it is best to use a white tray or container. When reduction has gone far enough just remove the negative and wash it thoroughly. As the diluted reducer becomes useless after about 15 minutes it is best to make up a small quantity for each treatment.

Rescuing prints

There should be little need for emer-gency measures in black-and-white printing if you follow the procedure of making test strips. In the case of big enlargements, if you do slip up, you may want to try and rescue the print. For example, if the print is over-exposed it is possible to lighten it by immersing the print for 5 to 10 seconds in a weak solution of Farmer's reducer

▶ **Always work slowly when bleaching parts of a print. Remember to wash it every minute to prevent staining.**

▼ **Sometimes it is not possible to take a photograph in the way you would like. Here background detail distracts from the subject. To remove it work gradually in from the edge towards the subject, bleaching the print section by section. Never be tempted by short cuts. One mistake can mean that you have to start all over again.**

— use a one bath working solution and dilute it by one part of solution to five parts of water.

Local reduction of prints to lighten small areas—for example, around the eyes in a portrait—can also be carried out with a weak solution of Farmer's reducer applied with a brush or a small swab of cotton or Q-tips (cotton buds). You treat the print after it has been fixed and washed but while it is still damp. The solution acts quite rapidly so watch it carefully. Work near a tap so that you can rinse the print every minute. This will avert any staining. After treatment, wash and dry the print in the usual way.

Local intensification of prints is not possible. However, if as you develop the print, you can see that there is too little detail appearing in parts of the image, you can help things along if you are quick. To do this you can increase the action of the developer in a particular area by the local application of heat: simply rub the area with the ball of your finger while the print is in the developer. You can also apply concentrated developer on a swab of cotton to obtain a small increase in local density and contrast. The paper then needs to be rinsed, fixed and washed in the normal way. Be wary of this procedure—over-zealous action can lead to print staining.

Special precautions

It is worth taking the following precautions to be certain of the best chance of successfully treating your negatives.

● The negative image must be correctly fixed.

● Make a really good print from the faulty negative before treatment—just in case the negative gets damaged.

● Do a trial run first with an old unwanted negative to test the method.

● Wash the negative thoroughly before you start working on it. This ensures that the film gelatine has swollen evenly and that disproportionate acceptance of the chemicals does not occur because the film is in its dry, highly absorbent state.

● Treat only one negative image at a time.

● Hold the negative by the edges only —wet negatives are easily scratched.

● While the negatives are being treated for reduction or intensification agitate continuously.

● Some of these chemicals are very poisonous and should be locked away when not in use.

Push processing

The prospect of taking pictures at night makes most photographers reach for their flash guns. But there is another solution to the problem of low light—one that:

● preserves the natural drama of the scene lighting,
● minimizes the amount of extra equipment the photographer needs to carry,
● can be used with any camera that has an f2 or faster lens,
● makes exciting pictures by ordinary artificial light.

The answer is to push your film.

Pushing means exposing the film as if it had a higher speed than the manufacturer says, then changing the development to compensate. It is a common technique with black-and-white film, but you can also push colour slide and negative films with good results.

Typically a pushed film will have a grainy appearance and less detail in the shadow areas. If it is a colour film it will probably show changes in colour as well. These qualities can all give extra impact to the right pictures, so you may want to push your film for creative as well as practical reasons.

Limitations of pushing

If pushing was the answer to every photographic problem then there would be no point in exposing film at its normal ASA rating. In practice the strengths of pushing can also be its weaknesses. Less exposure and more development means less detail and more grain, and if you are photographing a scene that needs to be recorded sharply and with plenty of detail in the shadows then you will be disappointed by the results.

When you push negative films, the contrast will be increased by the longer development—but only until base fog begins to show (see box). So the best subjects for pushing are those that are not too contrasty to begin with.

How far can you go?

In practice you can push the effective speed of your black-and-white negative films by two or three stops. This means that you can set your light meter to four or eight times the recommended film speed. Colour negative films can also be uprated by two or three stops, but some unusual colour shifts can be expected.

Colour slide films can usually be pushed by only one or two stops. Kodachrome films cannot be pushed because they must be processed by a laboratory, and very few labs are willing to give the film the necessary special treatment.

Pushing black-and-white

Although you can use an ordinary developer for pushing, simply by extending the development time, it is better to use a specially formulated speed-increasing developer that won't increase the base fog too much. Developers such as Acuspeed, Ethol Blue, Emofin (not available in US) and several others are made to give high film speeds with short developing times.

Pushing with an ordinary developer can require long developing times. This can soften the film emulsion, so be sure to

◀ **Colour negative films can be pushed successfully as long as the subject does not need very accurate colour reproduction or fine grain. This picture is a print from a small section of a 35mm Fujicolor 400 negative that was exposed at 3200 ASA. The dancer was lit by coloured lights, so colour accuracy was not important.**

▶ **400 ASA colour slide film pushed two stops to 1600 ASA will give results like this picture by *Michael Boys*. Grain and sharpness are much worse than normal, but the effect has been used to accentuate the soft mood of the picture. A subject like this suits pushing.**

◀ Although 35mm cameras are usually chosen for low light photography, modern roll-film cameras can also be used, despite their slower lenses. Here Kodak Royal-X Pan film, which has a normal rating of 1250 ASA, was exposed at 6400 ASA and developed in DK50. The large film size, requiring less enlargement, minimized the increased grain of the pushed film.

▶ Working with tungsten-balanced slide film uprated to 800 ASA accentuated the blue of the sky and the atmosphere of the fair at dusk, at the same time rendering the light bulbs in their natural colours.

▼ Kodacolor 400 negative film was rated at 1000 ASA and processed for 5¼ mins. in Paterson Acucolor 2.

(see below)

How base fog affects your pictures

When you develop your film it isn't only the *exposed* silver halides that are turned into black metallic silver. If you develop your film long enough, *unexposed* silver halides will start to be developed as well. This unexposed silver creates 'fog' which can spoil your pictures if you aren't careful.

The bars in this diagram represent the different densities of silver created in a normally exposed and developed film. The shaded area represents the fog level. The shortest bars correspond to the shadow details of the image.

This diagram represents an over-developed film: the base fog level has risen to swamp details in the shadows. The image has lost information. A print made from a negative like this will have muddy grey looking shadows and will have to be printed on harder paper to give an acceptable print.

use a stop bath and a hardening fixer if you push your film by extending the development time.

Pushing black-and-white films is now so common that film manufacturers have begun to design their products in such a way as to give better results with pushing.

For example, Ilford's HP5 can safely be pushed to an equivalent of 1600 ASA, or even higher if the contrast or the subject lighting is low enough.

Pushing colour slides

To push slide film, the processing is altered by increasing the time the film spends in the first developer. Kodak publish data for pushing E-6 Ektachrome films. By following their instructions Ektachrome 400 can be exposed as 1600 ASA, and similar techniques can be used on other makes of film.

Many processing laboratories will push slide films for a small extra charge. Slide pushing can also be done at home with standard kits— apart from the increased first development time, all the other processing steps are normal. It is best to use fresh rather than used chemicals for push processing.

Pushing colour negatives

When colour negatives are push processed they give considerably increased graininess and soft colours. For this reason most commercial laboratories will not push colour negatives, and processing has to be done at home. Any of the 400 ASA colour negative films available can be push processed fairly well. All are compatible with the Kodak C-41 process, but the kits made by such firms as Photo Technology, Paterson or Tetenal can also be used. Strange colour casts may be noticeable due to the phenomenon known as 'crossed curves', but this will not necessarily spoil your pictures. If your pictures need accurate colour, then you shouldn't push your film.

UPRATING YOUR FILM

This table gives developing times in minutes for uprating 400 ASA films to higher speeds.

Equivalent ASA rating	Black-and-white times for Tri-X at 68°F (20°C)		Colour slides first development times at 100.4°F (38°C)		Colour negatives first development times at 100.4° (38°C)	
	D-76	Acufine	E-6	Tetenal UK-6	C-41	Photocolor II
800	9	5½	9	8½	4½	3¾
1600	11	7½	12	12	6¾	5
3200	15	11½	20	19½	8	6¼

The development times given are only a guide for further experiments. However, they should give usable slides and negatives for the exposure ratings listed.

Making black-and-white photograms

You don't always need a negative to make photographic prints. Working by safelight in the darkroom, you can place objects directly on a sheet of photographic paper, expose the paper and then process it in the normal way. In its simplest form the print will have a black background around the white silhouettes of the various objects which were placed on the paper. This essentially graphic effect is known as a photogram and there are several refinements of the basic technique.

All you need to make photograms are the basic materials, some design ability, ingenuity and a few hours to spare.

Making photograms is not new—Wedgewood, Niépce, and Fox Talbot all made them as a fundamental part of their experiments. Much later, in the 1920s, famous exponents of photographic effects, such as Man Ray and Moholy—Nagy, realizing the more abstract possibilities of this technique used it to explore new space relationships and shapes.

Materials

You will need some printing paper (it can be old, out-of-date stock), an

▶ Two profiles were cut from black card and held over the paper as if they were masks. They were placed initially close together, taking care that the paper was masked to the sides, and a 10-second exposure was given. Then the cut-outs were moved apart in 3 stages at 3-second intervals to give grey tones and an impression of depth.

◀ Hands held on the paper with objects arranged around them can appear to do various amazing feats. Both hands and eggs are particularly good subjects for combination photograms where an ordinary negative of a scene or a person is printed into the white unexposed area left by the hand or egg.

▶ You can use almost anything to make a photogram provided it is small enough to be placed on the paper. But geometric shapes work best. A pocket flashlight is sometimes useful as a light source.

enlarger, a safelight, the processing chemicals for making black-and-white prints and a miscellaneous collection of objects and materials—some opaque and others translucent. A supply of black card and an alternative light source such as a pocket flashlight could also be useful.

For most photograms an exposure of several seconds is enough, but you may like to make a test print of a series of exposures which give different grey tones through to black. (You will need to standardize on the height of the enlarger head and the stop used). When you are using the enlarger solely as a light source, and don't need to worry about focusing, it is a good idea to move the enlarger head to the top of the column and stop the lens down. This will give a longer exposure time and allow you to move objects if necessary.

Grey tones

As a relief from the starkness of black-and-white effects you can produce softer grey tones, either by moving the opaque objects slightly and giving another brief exposure to give a grey tone margin at the contour where the paper was previously unexposed, or by using translucent objects. Useful translucent items are glass ashtrays, textured glass, wine glasses, marbles, cling film wrap, cellophane, light bulbs, and net curtains. Place the objects directly on the printing paper on the baseboard. Scrunch the softer materials up to create contours and form.

Displacing some items, or even removing them completely and replacing them with others during exposure, also gives grey tones. For example, you might have a scattered pattern of small cut-out paper shapes which could be slightly displaced during the exposure by blowing them gently from one side. If you choose to remove the objects and replace them with other things, a smaller shape must be put down in place of the shape which has been removed.

Oblique light sources

Instead of using the overhead enlarger light for exposure, try using a flashlight and shine the light obliquely at the objects. This is especially effective if used for translucent objects such as small glass bottles. There is plenty of scope to experiment with angles and times, and if the flashlight beam is too bright it can be masked by taping pieces of card over the glass or cutting down the light by covering part

▶ **Glass perfume bottles were placed upright on the paper and the exposure made by briefly shining a flashlight, held high, obliquely at the bottles.**

▼ **Translucent objects such as glasses, bottles, marbles or acrylic boxes give unusual effects when exposed by flashlight. You will need to experiment with the timing, distance and angle of light and tape masks if it is too strong.**

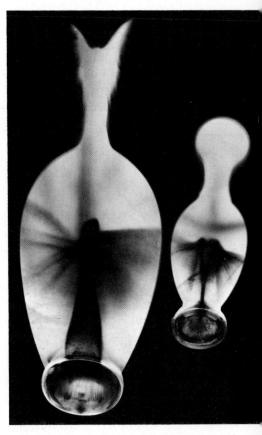

of it with red adhesive tape for a fine beam. Light from a small pen-light can also be used to squiggle a freehand sketch on the paper.

Projection photograms

If you have a glass negative carrier, a wide variety of items such as feathers, lace, insects, and leaves can be inserted and enlarged with superb sharpness, after careful focusing, to reveal minute detail. You can also make combined effects. For example, put a lettuce leaf in the carrier and place cut-outs of two frogs, or children's toys, directly on the printing paper.

Thinly sectioned radishes, parings of lemon peel and fragments of orange segments also have hidden wonders. But blot up any excess moisture or leave the section to dehydrate as you don't want vegetable or fruit juices leaking on to the masks around the negative carrier. If you feel more adventurous you can prepare your own glass plates for use in place of the negative carrier. Some unusual abstract effects can be made with crystals—for example, unrefined sugar, set in dishwashing liquid, which is allowed to dry hard. Alternatively, try ink (a few drops) on glue smeared between two glass plates.

Variations

More variety still can be introduced by achieving soft and hard-edged images on one print. To do this you place some of the objects directly on the paper and other objects on a sheet of glass which you hold above the paper (for the softened effects).

Another variation is to print a combination of photograph and photogram. For example, a negative of a real field with hedges and trees could be placed in the negative carrier and skeleton leaves and dried grasses laid on the paper, after composing and focusing the negative. The combination is then exposed normally.

It can be interesting to introduce some colour. Kentmere and Luminos produce a line of tinted papers which are brightly coloured and are processed just like bromide papers in ordinary developers. Colour may also be added as an after treatment, using vegetable or fabric dyes, or even with felt-tipped pens. You use a tablespoon of vegetable dye to 17 US fl oz (½ litre) water and tone more fully than desired as a certain amount of colour washes out. Cold water fabric dyes are best but they may stain your hands so lift the print out of the dye with tongs.

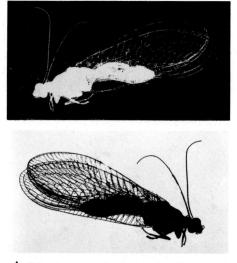

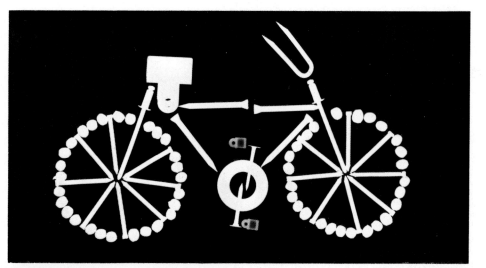

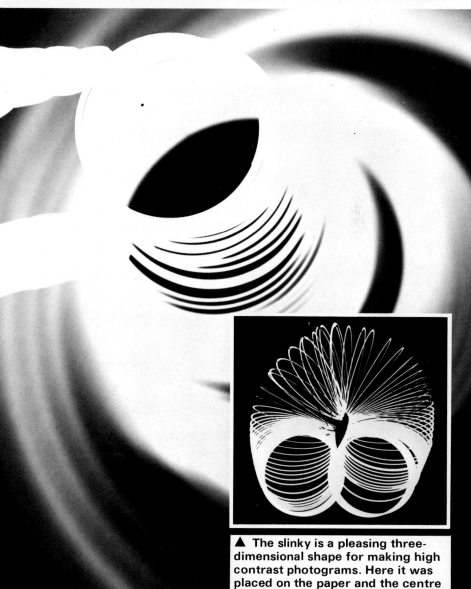

▲ The image of a lacewing fly, placed directly on the glass of a negative carrier, was projected on to the paper. The photogram obtained was then used as a paper negative to contact print a white-and-black print.

▶ Top right: with a supply of tacks, lentils, rice, pins, paper clips, washers and similar objects, you can make many amusing designs similar to the example shown here. Use translucent objects if you need grey tones.

▶ This looks like an abstract photograph of a potter working at his wheel. It is really a child's toy, a slinky, held so it swings gently halfway between the enlarger lens and paper; exposure 3 sec. at f4.

A photogram can be used as a paper negative; you turn it into a positive simply by laying it face down on another sheet of printing paper (emulsion to emulsion) and exposing through the back just as if it were a negative that you were contact printing. (A print on lightweight paper is best and you will need a sheet of glass to keep the papers flat.)

As you see, there are endless permutations and combinations, so some original thought is required when planning a photogram. Too frequently they suffer from randomness and until you have some experience it is best to keep the design simple, using only two or three objects.

Apart from the satisfaction of producing a pleasing visual effect, photograms may make original book or record cover designs or even Christmas or greeting card themes—use masks with cut-out letters for black wording.

▲ The slinky is a pleasing three-dimensional shape for making high contrast photograms. Here it was placed on the paper and the centre was allowed to fall to one side.

Making colour photograms

Colour photograms are easy and interesting to make. Like any photogram, they are essentially shadowgraphs on photographic paper of objects with decorative shapes or translucent patterns.

With colour reversal papers, such as Ektachrome paper or the Ilford Cibachrome material, you can make a photogram in natural colours. Or, if you wish, you can turn the spectrum upside down to produce photograms of familiar objects in bizarre colours using negative colour paper such as Ektacolor.

As you are not usually concerned about accurate colour balance, this is a good opportunity to use up those packets of old paper or chemicals you were wondering what to do with. The limits will not be your materials or your knowledge of photography; they will be the extent of your imagination. Here is a photographic field where artistic skill counts for more than photographic ability.

Materials and equipment

You will need a darkroom, an enlarger with a set of colour filters or a dial-in colour head, a thick sheet of glass (with smoothed or tape-bound edges to prevent cuts), a supply of colour printing papers and the compatible print processing chemicals.

Colour negative papers such as Kodak Ektacolor give unusual photograms in complementary colours—for example, green in real life becomes magenta in the print.

For photograms in natural colours you use the reversal print materials of the type used to make prints from slides—either the Ilford Cibachrome process or Ektachrome 2203 or 14RC paper with the appropriate Ektaprint chemicals.

Finally, for creating abstract photograms you need a small torch, some thin card for masks, and tricolour filters (obtainable from a photographic dealer), such as No. 25 (red), No. 58 (green), and No. 47 (blue), or you could use coloured acetate film (bought from graphic art shops).

Choosing suitable subjects

Subjects fall into three general groups: natural subjects such as leaves, flowers and foods; created scenes such as landscapes; and abstract patterns.

Whatever subject you choose, remember that you will be producing a shadowgraph in colour. It therefore helps to choose colourful items that are also translucent, such as marbles, acrylics, and leaves, so that they transmit light. Leaves and small flowers are among the simplest subjects for photograms. They can produce delicate colours which you can change by using different filters.

Many larger flowers will need some surgery to allow them to transmit light.

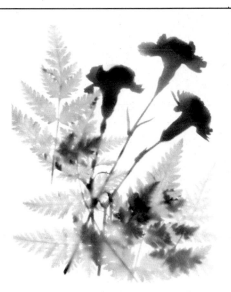

▲ ▶ **You can make beautiful photograms by laying flowers on colour reversal paper. (Thicker flowers need cutting away to make them translucent.) The enlarger lens was set at f8, filtration 30M, time 30 sec.**

▼ **Protect the paper with a thin sheet of plastic and lay the section of pepper on top. Left: Ektacolor 74 paper, filters 110Y + 70M, time 20 sec—use unexposed, processed colour negative film in carrier. Centre: Ektachrome 14RC paper, filtration 30M + 10C, time 20 sec. Below: filtration 30M + 30C, 15 sec.**

Step-by-step to a colour photogram on colour negative paper.

1 PREPARE ENLARGER
Set up your enlarger as if you were going to make some colour prints. Put a piece of unexposed but processed colour negative film into the negative carrier instead of a negative. This will allow you to use your normal filtration.

2 ENLARGEMENT AND FILTRATION
Adjust enlarger so the light covers an 8 x 10in (20·3 x 25·4cm) sheet of paper. Set the aperture to f8 and insert filters to the value of 100Y and 70M into the filter drawer. Switch off the room light and, if required, switch on a safelight with the appropriate filter. Take a piece of colour paper from the packet and place it in the enlarging easel.

3 MAKE A TEST STRIP
Place a simple object such as a leaf on the paper. Give a series of stepped exposures of 5, 5, 10 and 20 seconds. (The actual exposures will amount to 5, 10, 20, and 40 seconds.)

▼ Green leaves on Ektacolor 74 paper, filtration 110Y + 80M, time 18 sec.

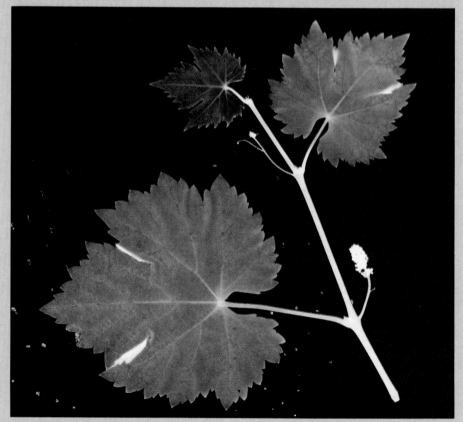

4 PROCESS PAPER
Process the paper and decide which exposure gives a good density and whether you need slightly more or less exposure to get good detail. Use your knowledge of colour printing to modify filtration. If the image is blue and you want yellow remove yellow from the filter pack. Colour photograms always need bigger changes to filtration than for ordinary colour printing.

For example, those flowers with lots of petals will not show their true colour unless most of the petals are removed. Roses come into this category. Try cutting flowers like these in two. You may even have to remove most of the inner petals, leaving just the outer ones intact to give the flower its distinctive shape.

Not all foods make suitable photograms. Choose those with bold colours such as oranges, red or green peppers, peaches, tomatoes, or brown bread. Light coloured foods don't have so much impact.

However, it is in the world of created scenes and abstract patterns that your artistic ability will have greatest scope. With colour reversal paper and using tricolour filters (or coloured acetate film) and shaped masks, you can create such colourful scenes as a sunset in America's Death Valley or a spectacular burning house. With a blue tricolour filter and a few twigs you can simulate moonlight over the moors or a dark haunted wood. The main thing to remember is to keep your composition simple.

◀ ▼ **For a sunset scene on Ektachrome 14RC paper** *David Nicholson,* **who did all the photograms for this section, used various materials. For the orange background he used a piece of orange acetate filter with a hole punched in it by a paper punch to represent the sun. The filter was put in the negative carrier. The dark foreground line was a piece of card which rested on books about 8in (20cm) above the paper. The mountain shape, cut from card, was placed on top of the other card. A piece of cactus with a suitable outline was then laid on the paper. The lens aperture was f8, filtration 30M + 30C and the overall exposure was 20 seconds but the mountain shape was removed after 15 seconds to add depth.**

Then there are the abstract patterns you can produce with cut glass or prisms. For the light source use a small penlight covered with a tricolour filter and experiment first to see what lighting patterns you can make by shining the beam from different angles. Then switch out the lights, position your glass object on the photographic paper and repeat your experiments. Two or three separate exposures using a variety of coloured filters and taken from different directions will produce a whole range of colours and shapes you never imagined existed. Exposure depends on size and power of the light and will be around 1 or 2 seconds.

The table of filters for different effects tells you which filters produce which colour. For creating fantasy scenes it is worth noting the following colour associations to help you choose suitable colours for the subjects you have in mind: red—sunsets, fire; green—spring, fields, woods; blue—snow; dark blue—moonlight; cyan—sea; yellow—harvest fields, beach, desert.

Exposure and filtration

With negative colour paper all the tones are reversed. The areas that receive the greatest exposure go black while colour objects produce colours that are complementary to their natural colours. This gives a dramatic effect but you may prefer the more natural colours, obtained with colour reversal paper.

Treat colour reversal paper as though you were printing slides in the usual way (see section on printing slides). Colours can be reproduced close to the originals, providing filtration and exposure are adjusted appropriately. With natural colours, accurate reproduction is desirable but not always essential. For created scenes and abstract patterns, accurate reproduction is not too important.

Set up the enlarger and give the same range of exposures as suggested for negative colour paper (see step-by-step illustrations). However, filter values should be 30 magenta plus 30 cyan.

Judge density and colour balance just as you would for a print from a transparency and modify if necessary. For guidelines on how to do this see section on 'Colour Printing from Slides'.

Working in the dark

Working in the dark or near darkness need not be a problem. It is largely a question of practice and preparation. With flat subjects, simply compose your

Filters for different effects		
Filter colour	Print colour	
	Negative colour paper	Reversal colour paper
red green blue	cyan magenta yellow	red green blue
cyan magenta yellow	red green blue	cyan magenta yellow

▼ For abstract designs on colour reversal paper use a colour filter over a pen light. Give one-second exposures for each colour and change the position of the light each time.

design on a suitable glass sheet, then switch out the lights. In the dark, position your photographic paper, emulsion side down, over the objects and cover the paper with another glass sheet. Turn this sandwich over, place it under the enlarger and expose.

With large or bulky objects you have no option but to use the correct colour safelighting—even for colour reversal paper—to enable you to position the objects properly. However, you can keep safelight exposure to a minimum in two ways. First, decide what your composition is going to be and practise positioning the pieces until you can do it quickly. Second, before you remove the photographic paper from its packet, allow yourself 5 to 10 minutes for your eyes to become accustomed to the low lighting level.

After about 30 seconds exposure to a safelight with a Kodak No. 13 safelight filter set 4ft (1.2m) away from the paper, the maximum density of Kodak Ektachrome paper begins to be affected. (In normal colour reversal printing, however, you should *never* use a safelight.) However, for the less critical photograms, safelight exposures of up to 1 minute can be tolerated.

But if you can manage to work in complete darkness it is always best. Working with moist objects brings its own problems, the main one being how to protect the sensitized paper. One way is to use a thin, clear polythene bag which is large enough to hold the photographic paper. Place the object— say, a slice of fruit— on top of the polythene and arrange the composition. Then, switch off the white light and insert the paper, emulsion-side-up, into the polythene envelope. Pull the polythene tight to remove most of the creases. For most applications, slight creases won't show in a photogram.

▲ An unusual composition on Ekta-color 74 paper. The roses were cut in half and the centre removed, leaving the outer petals. Roses and glass vase were laid on the paper along a glass sheet for the 'table'. Filters 80Y + 50M, exposure 20 sec.

Adding texture

Having spent many satisfying hours in the darkroom producing prints, you will probably want to progress to more creative ways of presenting the image. Perhaps one of the simplest and, if applied imaginatively, a most effective device is the use of textured screens.

The effects obtained range from simple lines to a coarse, grainy appearance, and the patterns can be so subtle as to be almost invisible, or they can be boldly graphic. Generally, less obtrusive patterns complement the subject better. In fact, part of the fun of this technique is that you can find so many different patterns to use—all on the same image if you wish.

In the early stages of trying to match texture to image you will find that some effects do not work, but keep experimenting and you will soon be creating interesting prints. Though you can buy texture screens from photographic suppliers, it is easy to make your own.

Texture screens can be used in two ways: by sandwiching within a glass negative carrier or by contact with the printing paper. By the second method you have the choice of a negative transparency, a paper negative or even a piece of thin fabric or paper.

Choosing a subject

As with any graphic effect, the simpler the theme the better the result. And screens are especially good for breaking up large areas of rather flat tone. But if you have an image which has natural texture, an old stone building, for example, a superimposed pattern can clash with the inherent texture. Similarly, a subject which has a lot of detail, such as a varied landscape, looks too busy if given a pattern.

The actual size of the details in any screen is important and the smaller they are—grains of sand, perhaps—the more even is the effect of the pattern. Provided the texture is chosen with care, screens can add a new dimension to your printing.

Making your own screens

When you take your next roll of black-and-white film it may be worth setting aside about six frames for taking examples of different textures. (You use black-and-white screens for colour printing.) Or you may decide to use the entire film for this exercise. But remember, so that the screen is not obtrusive you will need a thin negative, so under-expose by at least two stops. Then develop the film normally. Some photographers prefer to over-expose the film and under-develop it (time cut by a third) to keep the shadow detail. Lighting should be fairly flat and you should be no closer to the subject than around 3ft (1 metre). If in doubt about the texture looking too big when enlarged, try taking several exposures of a subject from different distances.

Where will you find texture? You certainly won't have to search far—it is all around you; concrete, paving, brick walls, sand, sandpaper, textured ceramic tiles, crazed ceramic surfaces, linen-look fabrics, textured wallpapers, spun metal, sawn wood, leather, polyurethane foam, textured glass, fur, lentils, are just some ideas. In time you will be able to build up a collection of favourite patterns. For contact screens you will need a supply of various translucent materials, each piece large enough to cover the printing paper. Fine silk, tulle, chiffon, muslin, net curtain material, tissue paper, a single layer of a paper table napkin and similar materials are all suitable for this method. Letraset, stuck down on clear acetate film, is another source of ideas for contact screens.

You could also make up your own patterns by drawing a series of fine lines with black ink on thin tracing paper. Yet another way is to 'ink up' a piece of textured paper by rolling printer's ink across it; then press it firmly on to a piece of tracing paper so the texture pattern is transferred. Both negative and positive single weight paper prints of a particular pattern can be used as contact screens. As you can see there are endless ways to achieve a textured effect and you will have a rewarding time thinking of new ideas and applying them.

Sandwiching screens

This is the most controllable way to introduce texture to a subject. After cleaning carefully, the screen and negative are simply placed emulsion to emulsion in the negative carrier (it should be a glass one to keep the sandwich firmly together) and projected on to the printing paper in the usual way — that is, by adjusting the height of the enlarger head to cover the image area and focusing sharply. Occasionally, a more diffuse effect is sought and in this case the negatives of the subject and the screen are put back to back. First the subject negative is placed in the negative carrier and focused sharply, and then the screen negative is introduced also, emulsion side up.

▲ Matching the screen to the mood of the picture is important. Here the Paterson Rough Etch screen emphasizes the historic setting.

▲ A very bold effect. The aggressive shape of the building is carefully matched to the geometric lines of the Paterson Concentric screen.

▶ Take care your home-made screens are not too dense. After the film was briefly exposed while in contact with a piece of dry mounting tissue it was deliberately under-developed.

◀ Far left: the texture of a white ceiling tile obliquely lit overlays a slightly over-exposed portrait to give an impressionistic effect.

◀ Monochromatic colour and simple outlines make a good foil for this Paterson Rough Linen screen.

▼ A shot of backlit dress fabric adds interest to the broad area of subdued colour in this sunset.

Before you make your print, however, you should make the usual test strip for exposure and with colour you should also make tests to balance the colour filtration. The use of a screen will marginally increase exposure times (about one stop for film and about three stops for paper) so you might like to take this into account for your initial exposure step. Finally, don't forget to observe all the normal precautions when handling light sensitive materials. Colour printing with a texture screen is perhaps a little more difficult than black-and-white material, but equally rewarding in the outcome. Rule one is not to try combining a colour negative of the subject—the double mask will defeat you!

If you want to add texture successfully to a colour negative sandwich, use one of your black-and-white negative screens or a colour slide screen. In the latter case, if there is much colour present be prepared for some unusual colour change effects in the print.

If you intend to make a colour print from a slide you can sandwich the subject slide with a black-and-white *positive* film screen or use a colour slide screen. Whichever system you adopt, always make colour filtration tests on the sandwich itself and not just on the main image.

The contact way

As mentioned earlier, to be successful the contact screen and the printing paper must be in firm contact—weighted by a clean sheet of heavy glass or held together in a contact frame (one without masks). Contact screening is not so satisfactory for colour work because of the need to work in complete darkness. Also the effects can be too coarse. However, it may be worth experimenting with say very fine tissue paper or gauze.

Home-made texture screens

Grained leather

Enlarged magazine illustration

Weathered plywood

Dress fabric

Rough wood

Side of brick

Rough wall rendering

Paper

Enlarged magazine illustration

Wallpaper

Underside of linoleum

Silk blouse

Diffusion and distortion

There are many ways of transforming an image in the darkroom. Some of these ways are quite intricate. However, diffusion and distortion are fairly simple and they can be very effective visually.

Diffusion

One of the first priorities when printing is to make sure that the end result is going to be as sharp as possible. However, sometimes by doing the very opposite—that is by diffusing part or even all of the image—you can add something extra that brings out the best of your negative or transparency. The less important details are merged so that attention is concentrated on the ones you want people to notice.

As with all special effects, choosing the right subject is very important. Soft and misty images tend to go with mellow thoughts—the sort of thing inspired by weddings, babies, beautiful flowers or pretty views.

Diffusing materials

What you choose as the diffusing material really depends on how much of an effect you want to create. A very slight effect can be created, for example, by painting clear nail varnish on to a clean sheet of glass. Cellophane can be crumpled, flattened out again and stuck to a piece of card with a hole cut in it. Black nylon stocking can be stretched over a small frame made from a few light pieces of wood pinned together, or a sewing hoop. Vaseline can be smeared lightly over a piece of glass—this technique is particularly handy if you only want to diffuse part of the print. Whatever you choose, remember that the image has to pass through the diffusing material and that, if the scrambling effect is too strong, the result could well be a mess. Another point to consider is that when working in black-and-white it may be necessary, depending on how much diffusion you are using, to work on a harder grade of paper than you would normally expect: the merging of tones may make the print look a little flat.

Making the print

It is important to have the diffusing material in place when you are testing for exposure or colour balance. Glass in particular can cause a noticeable shift in the colour filtration necessary to get a neutral print. The density of the diffusing material will also affect the exposure.

The height of the material above the print affects the degree of diffusion—the nearer the enlarging lens the greater the effect. So, if you want to simplify things, you can work with one diffusing material and vary its distance from the print rather than going to the trouble of making a set of diffusers.

Finally, during exposure it is as well to move the material, especially if it is near to the print surface. This stops any marks or patterns in the material appearing as obvious blemishes on the print.

Working in colour

Also worth bearing in mind is the slight difference between working from a negative and working from a transparency. Whenever you diffuse the image projected from the enlarger the beams of bright light are spread out. If you are printing from negatives this means that the light that produces the shadows on the print spreads. If you are printing from transparencies (using either Ektachrome 2203 or 14RC or the Cibachrome process)—see

▶ A motorbike is an unusual subject to diffuse. However *Ralph Court* has very successfully used Vaseline on glass to suggest the blurring you would get if you panned the camera with the bike during exposure.

▲ Darkroom diffusion demands an original image with strong contrasting areas, preferably close to one another. When working from negatives, as here, you should bear in mind that you will be spreading the light that is producing the shadow area.

▲ Assemble a variety of diffusing materials when you begin and experiment by varying the distance between the diffuser and the lens. You can also remove the diffuser during the exposure to alter the effect.

◀ To produce this strongly diffused portrait a circle of Vaseline was smeared on to a piece of glass kept in place throughout the exposure.

earlier—the highlight areas projected from the enlarger produce the highlights in the print and it is these that spread. So, basically, a diffused print produced from a negative tends to look slightly darker than a straight print, while a print from a transparency appears to be a little lighter.

Distortion

Distortion is done by bending or kinking the paper so that it is not flat while it is being exposed under the enlarger. To be successful it is essential to select a suitable image. Distortion is best done in black-and-white.

Selecting the negative: it's no good working on a print of some branches, for instance, as the effect will be lost. What you need is an image with regular lines or something that is familiar. Big city sights, such as Nelson's Column, the Eiffel Tower or Big Ben, are obvious examples with their simple, clear shapes. The human face or figure also makes a useful starting point. Gestures can be exaggerated or created by bending or kinking the paper, noses or ears can be enlarged out of proportion. Whatever your subject the effect is enhanced if the background is the sort that doesn't record the distortion very clearly. In this way the effect on the subject is isolated and thus rendered even more striking. Suitable backgrounds should be either featureless tones, such as clouds, blurred details or, best of all, the clear white areas of a bright sky.

Making the print

Before you begin it is a good idea to assemble a few small boxes of varying size to act as supports for the paper. You will also need some self-adhesive tape.

Once you have selected the negative you wish to use, set up the enlarger as if to make a normal print. Follow your usual procedure for making a test strip taking care to stop down the lens to its smallest aperture. This is necessary because the paper will tend to be quite convoluted when the final print is made and the maximum depth of focus is needed to ensure that as much of the image is as sharp as possible.

When you have done this rotate or slide the red filter into position across the enlarger lens. If you don't have one attached, taping one in position works perfectly well.

● If your enlarger has been in use for a while, or is secondhand, it is sensible to check the efficiency of the filter. This is done by exposing a sheet of paper with the filter in position but without a negative in the enlarger. The widest lens aperture is used and the enlarger head is positioned at the height necessary to produce an 8 x 10in (20.3 x 25.4cm) print from a 35mm negative. A coin is laid on the paper surface for the duration of the exposure, which should be about five minutes. If the filter has faded the processed paper will show a white circle where the coin was placed against a grey tone covering the rest. Replace the filter if this happens.

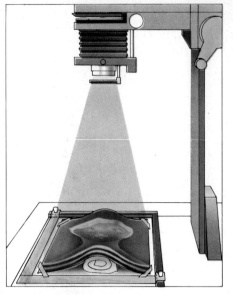

▲ Check that the paper is firmly fixed in position before beginning the exposure. If the paper moves at all you will have to start again.

Once you have established that the filter works the paper can be manipulated under the enlarger while the image is being projected without fear that fogging will take place. From this point the practical steps are largely improvised to follow the dictates of the image. A sheet of printing paper is placed in position under the enlarger head and flexed gently to see how the image is affected. When you are satisfied with the result arrange the boxes so that they support the paper. Anything but the gentlest curve will normally need to be taped in position both to the boxes and the printing frame. Be sure to use the smallest pieces of tape practicable as the marks left by them on the paper will have to be trimmed from the finished print. However it will need

▲ A portrait of a strong character can be a good starting point for a distorted image. Try to avoid backgrounds with lines that give away the method.

▲ Printing with the paper curved and bent means that you will need to stop down the aperture as far as possible to keep the print sharp overall.

▲ If you create extreme distortions take care when bending the paper that light does not reflect from one part of the paper surface on to another.

to be strong tape as modern resin-coated paper is very springy.

Switch off the enlarger and remove the red filter from the light path. You are now ready to expose the paper. The basic time will be that suggested by the test strip made earlier. As you have stopped down the aperture further than normal it will be longer than your usual time. However, this basic time applies only to those sections of the paper lying on the printing frame. Those raised areas nearer to the enlarger lens receive correspondingly more light and as a consequence need to be shaded for a part of the exposure to compensate. A number of trials are needed to ascertain the amount of shading that is necessary. Once you are satisfied with your efforts the print is processed as normal.

▼ If you do create a successful darkroom caricature of a friend make sure that they don't object if you intend to show it in public or send it to a magazine for publication.

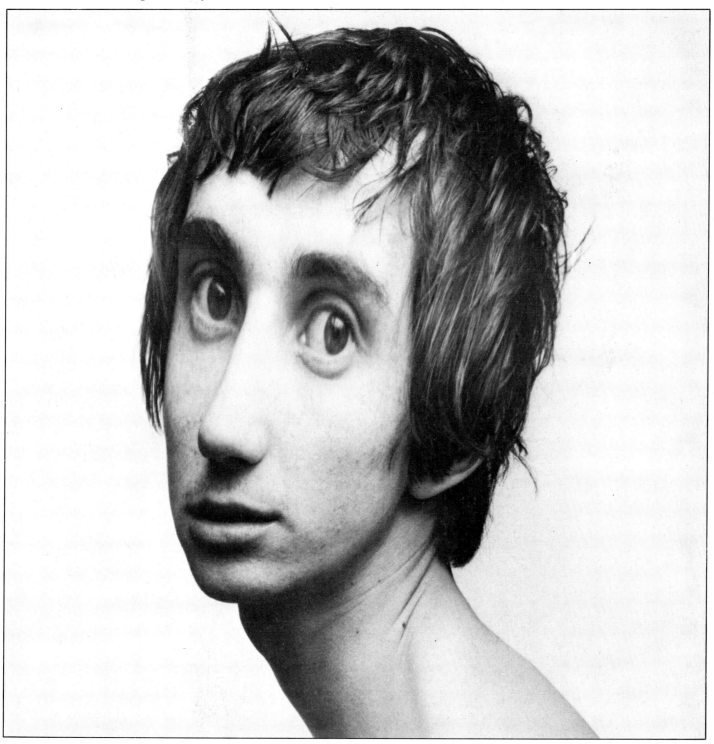

Combination printing

Combining different images to form an unusual composition is not a new technique. Several Victorian photographers experimented with putting two or more negatives together to produce a different picture. This technique is known as combination or double printing and often involves the use of masks or dodging tools to eliminate unwanted material in the final print. But the images were not necessarily designed to be unusual—a favourite trick among early photographers was to use a separate negative of clouds which was then superimposed on to a cloudless sky to add visual interest.

In England, during the thirties, photographers such as Angus McBean and Winifred Casson used combination photography to produce fantasy images. Sometimes very beautiful and unusual effects can be created by the imaginative combination of widely different subjects.

There are various ways of combining images—some may be contrived deliberately by careful double exposure in the camera, but many can be achieved with the enlarger. The basic methods are simultaneous printing (known as sandwiching), and successive printing, both of which are covered here.

Equipment

Apart from the usual darkroom equipment it is useful to have a wide selection of negatives. If you have a negative file and contact sheets, it is comparatively easy to sort through them to decide which negatives would fit together to make a fantasy image. The simple images give better visual impact and make it easier to merge the images. If the negatives are not suitable for superimposition, you could take photographs with the idea of using them for creative imagery. You will also need a sharp, pointed pair of scissors, some thin card, a yellow pencil and a set of dodging masks.

Successive printing

Successive printing allows more scope for the imagination than sandwiching which is limited in its results. With this technique two or more negatives are printed in succession on to the same sheet of printing paper. For complicated combinations, specially cut masks and dodgers are needed. The basic procedure is shown in the step-by-step illustrations. But don't expect immediate success. First results are often disappointing so don't be disheartened as the techniques require practice and patience. If your first print is not entirely satisfactory, keep it for reference to check what adjustments are necessary when you make the next one. You might like to practise by adding clouds to another photograph to make it more interesting. When adding backgrounds such as clouds or foregrounds such as branches or leaves, it is usually best to print the main image first and the clouds or branches second.

▶ Keep it simple at the start. Here the cat negative was printed first shading the figures, then their negative was printed shading the cat and grass.

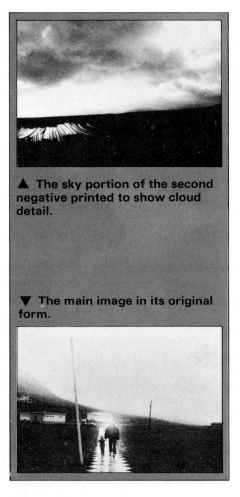

▲ The sky portion of the second negative printed to show cloud detail.

▼ The main image in its original form.

CREATING THE PICTURE
Select 2 suitable negatives with light, featureless backgrounds. Place the main negative in the carrier and focus on to a piece of white paper. Arrange the image as you like and draw the main outlines on the paper. Remove the first negative and insert the second. Arrange it in the frame and draw the main lines on the same paper.

MAKING THE MASK
When you are satisfied with your layout remove the paper and substitute a piece of thin card the same size. Projecting the main negative, outline the boundary on card between the 2 images. Cut along line carefully. This gives you 2 masks. Make test strips to check exposure, ensuring both negatives are enlarged to layout size.

THE FIRST EXPOSURE
Place a sheet of printing paper in the frame. Check it is firmly located. Make your exposure covering the area for the second image with the appropriate mask. Keep it moving slightly to avoid a sharp line on the print. Remove the paper. Mark a china crayon dot in the top right corner of the border area. Place in a light-tight box.

THE SECOND EXPOSURE
Substitute the second negative for the first. Place the layout in the frame. Align and focus the second image. Remove the layout and replace the printing paper. Check that the dot is positioned top right. Make the exposure with the second mask covering the area previously exposed. Again keep it moving. Process as usual.

If a thin line shows around a combined image then the mask was probably not cut accurately enough, or it was not correctly positioned, or perhaps it was poorly manipulated during printing. No doubt many ideas will occur to you after you have begun to experiment.

You will also find it easier to work with negatives which you have photographed with a specific idea in mind. For example, to put an object into a glass or a bottle you would photograph an empty bottle against a white background (avoid highlights on the bottle). You then photograph the object against a light background. The resulting negatives can then be manipulated through the enlarger.

Ghost pictures

The easiest way to produce these is by making a double exposure in the camera. Alternatively, take a negative of a landscape, or an interior, and another of a figure against a white background such as a wall, a sheet or the sky. Then expose the negatives in turn using the combination printing technique. Colour transparencies may also be used; when printed they become negative prints. For example, a positive transparency of a white cat with white eyes, which might be useful for some fantasy images.

Negatives with photograms

For a more graphic look you can combine a negative with a photogram. You will need a sheet of glass that fits over the printing paper. The glass should completely cover the paper otherwise the edges will print as a rectangle on to the picture.

Place the negative in the carrier and focus it sharply. Broken glass, leaves, torn paper, netting, seeds, or beads are arranged on the glass which is then placed carefully on top of the printing paper in the frame. Expose the negative on to the paper through the objects on the glass sheet.

You can also draw or trace directly on to tracing paper with opaque black drawing ink. This drawing can then be combined with a projected negative by contact printing.

◀ This is the sort of work that is possible after a lot of practice. Commissioned by Peter and Tressillian Garner as a portrait, *Hag* assembled it from 5 negatives—the house and grass —2 separate portraits—the interior with the sofa—the sky. Prints this complicated need more than 1 enlarger.

Other combinations

A negative may be used repeatedly (multiple printing) in the same print to form a pattern or create some other effect. For example, a photograph of gulls, taken against a clear sky could be printed several times to give the effect of a sky full of gulls. Each time the exposed paper is re-exposed to light the print becomes darker, so you must allow for this when you plan your imagery. Multiple printing methods and their effects are dealt with in greater detail in the next section.

Print finishing

Sometimes a little retouching is needed on the final print. Perhaps the change from a light area to a dark one is too sudden, or a light patch on grass requires blending in. This can be done by spotting (see previous chapter). Take a fine sable brush and stipple the area with the correct tones of grey.

Colour

Combination printing in colour entails the problems of correct filtration. It is not impossible but, whether you use colour negatives or slides, it is very time-consuming.

The easiest way to get fantasy images in colour, apart from sandwiching transparencies, is to superimpose two or more images on to a screen with projectors (one for each transparency) and then to rephotograph the projected image. The transparencies could, of course, be projected on to something else—an object such as an egg, for example, or even a nude. These are just a few ideas for creating surrealist images.

It is now up to you to experiment, for the number of negatives that can be used together is limited only by your own skill and imagination.

▼ Simple changes of scale can produce quite strange effects. The main image is the man standing on the stone mole with the foreshore around him. By combining it with the clouds, which appear much closer, and shading the sky in to the sea, the finished picture becomes very ambiguous.

Images can be combined by printing different negatives successively, as has been seen, but sometimes they can be printed as one. In simultaneous printing you take separate (usually two) negatives and superimpose them; this sandwich is then placed in the negative carrier and projected to give an image of the combination. A test strip is made and the print is exposed and processed in the normal way.

Selecting the negative

When you are making a selection of negatives suitable for black-and-white sandwiching, it is best to choose those that have some clear areas on the negative so that the negative sandwiched with it can print through these clear regions. (The clear area would, of course, print as solid black if this negative was not sandwiched but printed as normal.) By sandwiching, the clear area becomes filled with a texture, another subject or some spatial illustration such as a room or a street.

Check that the negatives slot into place by holding them up to the light and trying all sorts of combinations. (You may find it difficult to assess the effect on a small format such as 35mm—especially in negative form. If so put the sandwich into the enlarger and look at it in projection.)

When negatives are sandwiched there is a build-up of density where tones overlap, so longer exposure times are necessary and some prints will need a lot of burning-in in these areas to bring out the detail. With experience you will begin to judge how far to go with this, and exactly what works and what doesn't work. For example, you will quickly find that opening up the enlarger lens by one or two stops doesn't necessarily solve the problem of long exposure because one negative will print through sharper than the other. This is because the two images are separated by one thickness of film base (unless sandwiched emulsion to emulsion with no separation of the images and here you can open up the lens), and are therefore at slightly different distances from both the lens and the printing paper. So focus somewhere between the sharpness of the two images and stop down three stops. (You will often find that, in order to marry properly, two images have to be sandwiched base to emulsion.)

Increase the interval of your test strips from the usual 5 seconds to 10 seconds. In the case of very dense film sand-

wiches it could be as much as a 20-second interval or more. Try opening up one stop just for the burning-in, but do this on a test before attempting it on the final print.

Black backgrounds

When purposely shooting material for sandwiching it is useful to have a large piece of black velvet or felt as a portable backdrop which can be pinned up wherever you need it. You can then photograph objects or people against it to obtain a negative which is clear apart from the tonal part that is the image of the figure or object. Slightly underdeveloping the negative also helps to suppress any details of this backdrop.

You could then take a close-up negative of leaves or other shapes and patterns and sandwich the two. The final print would show the foliage instead of a black background and the leaves would also print faintly through the figure. (They print faintly because light would have been blocked from this region to a certain extent.) The final print as a whole, being in one plane, has a rather

▲ To make this print a silhouette of a girl in profile was taken while she was sitting behind a black picture frame. This was combined with a negative of some foliage which appears in the final image only in those places where the first negative was clear.

flat effect. You could get a three-dimensional effect by sandwiching the object or figure with a street scene or strongly dimensional setting.

Some texture screens are available commercially or you can make your own. (See earlier). Sandwiched (emulsion to emulsion) with the main subject negative they produce a print that may have an overall speckled, etched, canvas or crazed appearance.

Silhouettes

A deliberately photographed silhouette sandwiched with a texture screen gives a deceptively simple effect. You can photograph a silhouette by directing the lights at the white background paper or wall, and by placing the subject well forward of the lights. Take the reading for the exposure from the

SELECTING NEGATIVES FOR A SANDWICH PRINT

The selection of the right negatives to sandwich together is very important. One of them should have a large clear area through which the details of the second will print. Here *Ian Hargreaves* has chosen a landscape with dark rocks, which are almost clear on the negative, as a background for this portrait. The printing through of the textures of the rocks in the skin areas adds interest.

To print well sandwiched negatives should have a similar contrast range.

lit wall. Overdeveloping the negative also helps to darken the silhouette.

With natural light a silhouette photo can be made by placing the model in front of direct sun and exposing for the sky, or by placing an object on a window sill and exposing for the bright background: to obtain a light sky avoid under-exposure. Because the background prints white in the positive — that is, it appears dense on the negative — the texture sandwiched with the silhouette only prints through in the silhouette area.

Accidentally thin or under-exposed negatives can sometimes make fortuitous sandwich material. However if you use a larger size negative than 35mm — for example, 6 x 6cm or larger — you may be able to remove the parts of the image you don't want with Farmer's reducer with a very fine brush. It is too tricky to apply Farmer's reducer locally to a 35mm negative, even if you use the finest paint brush.

Sandwiching colour

Because of the built-in orange mask you can't sandwich colour negatives successfully but you can combine a colour negative and a colour transparency or two colour transparencies (slides). And even if you don't intend to make a print from the combination yourself, you could take it to a processing and printing laboratory to have one made. In any case it might be amusing to slip several of the more surrealistic examples into a show of a family holiday, for example.

As with black-and-white sandwiches you should look for simple images where there are pale or almost colourless areas so that the images marry well and without producing unnatural colour effects or too great a contrast. In many instances you will need to take photographs specifically for this technique.

And don't discard thin, over-exposed slides that look disappointing when projected because they may be useful for this type of project where a perfect exposure is not essential.

When putting a sandwich together make sure that each slide is clean and dust-free. Then bind them firmly together with adhesive tape or put them in the same mount. To make a print from the colour slide sandwich follow the guidelines for making prints from slides given earlier but remember, because of the increased emulsion thickness, the exposure time will need to be increased. However, if you find that your exposure times are running to several minutes be careful that you don't burn out your filters.

You can have endless fun with this technique, creating unusual effects, or you may simply use it to add interest such as a sunset, to an otherwise dull and lifeless image.

▲ Special effects such as this need a little care. By combining this photograph of locomotive controls with blue rays, a futuristic image is achieved.

▲ A good example of the effect you can get by combining a colour negative and a transparency. The negative of the boy is sandwiched with a transparency of a hand spread over a pane of glass with condensation and water droplets at the bottom of the picture.

◄ Such a precise alignment between two images is particularly effective. The radiating lines of the dandelion emphasize the spreading beams of the sun while contrasting with the solid line of the hills.

▶ One of the easiest ways to make a sandwich is to combine two slides. You don't even need to make a print. You can put them together in one mount and project them in the same way as your other slides.

Multiple printing and movement

During printing you can move the paper to create different effects such as several distinct impressions of the same image (that is, multiple effects), or a single image with streaks so that it appears to be moving very fast, or an image with fainter ghostly after-images. Of these three effects the most unusual treatment, and one that is worth mastering, is multiple printing. It has a strong element of design about it which is visually very pleasing.

Choosing a negative

When considering a subject for any of these techniques there are certain requirements that must be met. As with most of the creative darkroom effects, rule one is to look for simple imagery. Rule two is that the backgrounds around the subject must be white or extremely pale. (On the negative they will, of course, be dense black.) This acts as a built-in mask and allows you to move the paper and again print the image, or part of it, in a previously unexposed area.

Alternatively, you could take a negative and mask the background around the image by painting a special opaque fluid on the film base. This is, however, extremely difficult to do with a 35mm negative, even with a fine brush. 2¼ x 2¼in (6 x 6cm) negatives can be masked successfully if care is taken.

Subjects which suit multiple effects are often those where the action has been frozen—for example, a hurdler going over a hurdle, a sprinter taken from the side of the track as he dashes for the finishing line, a tennis player serving, a dancer performing some graceful routine, a high diver executing a mid-air turn and so on. You could also use less obvious action such as a close-up of hands playing the piano. Static imagery of people can also be effective provided that the form is interesting enough in itself to be presented in a repetitive pattern.

If you prefer to choose an inanimate object then go for something which is simple and has good symmetry and form.

And there is no reason why the subject couldn't be as large as a car, for example, or as small as a shiny brass hexagonal bolt. It is worth spending time to think the concept through from beginning to end and foresee any possible hitches. Sometimes it helps to make repeated tracings of the outline of your enlarged image to get an idea of how it might look.

Making multiple images

If you expose several times but move the paper after each, so the image prints in a different spot, you end up with a series of separate images.

The images can be quite separate or they can be made to overlap slightly;

they can be of equal tonal density or become progressively paler; they can be arranged horizontally, vertically, diagonally, circularly or even randomly to suit the effect you desire. So you see why you should think about the composition before you start to make your prints.

Making a tracing: the first stage in creating multiple images is to make a tracing of the multiple effect. Place the negative in the carrier and project and focus it on to the back of an old print on the baseboard. Then replace this with a piece of tracing paper and draw in the first image, move the paper along until you feel the spacing looks right and trace a second image. Continue until you have at least five or six tracings. Use this diagram to work out the appropriate spacing for your print.

The test series: now make a test strip to find the right exposure. Having determined this, take half a sheet of printing paper for a test series which will help you to work out any final adjustments to the spacing and enable you to check that you are not getting a build-up of density in the white background area (there will be unavoidable increase of density where images overlap). If this occurs, choose a harder grade of paper — say, grade 3 or 4 if you have been using grade 2 paper.

Having established from your tracing that 1½in (3cm), for example, appears to be the right spacing, you will need to move the paper along by this amount after each exposure.

Reverse images: to reverse images laterally on either side of a central point, mark with china crayon dots the end of the image just exposed; turn off the enlarger and put the print in a light-tight box. Now flip over the negative in the carrier and check the focus after you have done this. Finally, reposition the printing paper with the safety filter across the lens. When you are ready, make the next exposure.

◀ A white background is essential when making multiple prints from negatives. It also helps to have a simple but elegant subject. *Amanda Currey* has created a chorus line from one dancer by moving the paper a regular distance between exposures.

▶ If you don't already have a suitable subject on a white background, an everyday object can be used to create one. Here a decanter has been shot from above and the paper turned in printing frame between exposures.

Circular patterns

Printing the image in a circular pattern is slightly more complicated but aesthetically well worth the effort. You need to turn the printing paper round a central point. This is done by securing it in the centre (measure this accurately) to the baseboard with a drawing pin. This does leave a small hole but enables you to turn the paper freely. Alternatively, stick a drawing pin into the centre of a piece of corrugated cardboard, turn it over and you have an improvised turntable to which the printing paper can be taped. In this way you can make your print as before but without a pinhole in it.

To get some idea of the final effect you will need to make a tracing. Place the negative in the carrier and focus the

▲ This flower-like pattern was created by pinning the paper to the baseboard and turning it a measured amount between exposures.

image. Take a piece of tracing paper the same size as your final print will be and secure it in the centre to the baseboard with a drawing pin. Trace the first image, then turn the tracing paper round until you are satisfied with the spacing and trace the second image. Measure the distance between the identical point on each image—turn the paper and check that this distance exists between the third and second images. Continue in this way until the circular pattern is completed. You can then see what spacing adjustments may be necessary.

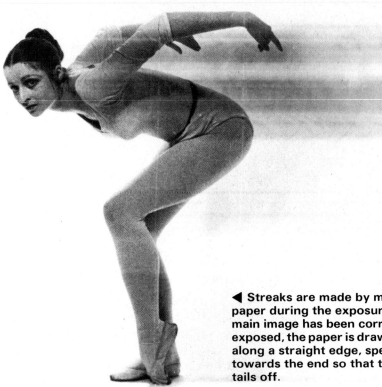

Making a print: first do a test strip to find the correct exposure. When exposing the full-sized sheet of paper swing the red filter across after the first exposure and mark (with a black china crayon) a tiny cross just over the top of the first image but never where any tone will be. (It marks the starting point of the circle.) Then use this point to measure the correct distance between images and turn the paper the measured amount. Make the exposure, shading where necessary. Continue in this way until the circle is complete. The china crayon washes off in the developer.

Multiple effects may sound intricate but once you have tried several different examples and assimilated the methods you can expect to produce first class prints.

Making streaks

During printing you can move the paper so that you get streaking, or multiple ghost after-images, depending on the effect you wish to achieve.

To introduce streaks (they give the image a feeling of fast movement) all you do is expose the paper normally for three-quarters of the exposure and draw it smoothly and slowly in one direction for the remainder of the exposure. If you want the streaks to taper off, increase the speed as you pull the paper across. The print should show a sharp image with streaks flowing from it. To make sure that the streaks are straight, tape a ruler to the baseboard and slide the printing frame along it.

So if you have taken a shot which, in retrospect, you wish had been panned you may be able to achieve a similar effect in the darkroom. Streaking effects don't necessarily need to go in straight horizontal (or even vertical) lines, sometimes you might need a whirling effect and for this you must move the

◀ Streaks are made by moving the paper during the exposure. Once the main image has been correctly exposed, the paper is drawn smoothly along a straight edge, speeding up towards the end so that the streak tails off.

paper circularly.

Ghostly after-images: for this effect allow the paper to remain stationary for a few seconds between movements.

Moving the enlarger head

Instead of moving the paper during printing you can move the enlarger head to create multiple or blurred images. You will need to choose a simple image such as a face or a single object like a flower which is against a white or pale background.

▶ To create these ghostly after-images *Amanda Currey* made a full exposure initially. She then drew the paper along a ruler for a set distance between exposures. She also progressively shortened each exposure so that the resulting images gradually became paler and paler.

For a blurred effect, focus the negative with the enlarger head fairly low on the column and stop the lens down four stops to increase overall sharpness when you make the print. Make a test strip to find the correct exposure. When you make the print, expose the paper normally for half the exposure then wind the enlarger head to the top of the column during the remainder of the exposure. This will produce a slightly blurred three-dimensional effect.

For a less continuous effect, expose the paper normally for three-quarters of the time then move the enlarger head up the column in four separate stages (swing the red filter across or switch off the enlarger while you move the head), giving the paper a quarter of the remaining exposure at each stage.

▶ If you want to try making a multiple print from a transparency choose a simple image on a black background. One colour or variations on one colour are more effective than a mass of conflicting colours.

▼ Working in colour rather than black-and-white is more difficult as you have to do so in near or total darkness. Instead of making china crayon marks on the print surface, a series of pieces of card need to be taped to the printing frame or baseboard that you can feel in the dark. In this example by *Amanda Currey* a circular pattern of card stops was made. The transparency was enlarged on to an intermediate negative masking out the floor and was then enlarged on to colour paper as normal.

The techniques of hand colouring

As the pictures on these pages show, hand colouring of a black-and-white print, interpreted imaginatively, has a subtlety and charm which no colour print could imitate. This is not a new technique. From Victorian times onwards the art has been practised, though sometimes with dubious success. Many people will recall the rather artificial hand-coloured studio portraits, especially of children, of the thirties, and the picture postcards of the time; though, no doubt, collectors of picture postcards have a few less garish gems among their collections.

There are many ways to express this technique, from the real to the surreal; and from choosing to isolate the main subject from its surroundings, to colouring the whole print from corner to corner. And you don't have to be able to paint. The skills are quickly learned. Probably the most difficult aspects are finding a suitable print, and, with prints of people, getting good flesh tones.

Choosing a print

The best subjects are undoubtedly people as they offer a simple image which stands out from its surroundings. Landscapes tend to look rather like a water colour study when hand-coloured and lack the impact that a figure has. But whichever subject you choose it should preferably have a full range of tones, though not too much black because you cannot effectively colour over a black or even dark grey. However, do not exclude high and low contrast prints for experimental purposes when you are practising.

The 8 x 10in (20.3 x 25.4cm) size of print is a good format to work on but at first you may wish to practise on something smaller to get the feel of the materials and see their effects. The ideal surface is matt or semi-matt. Glossy prints and resin-coated papers, however, are more difficult to colour with oil paints because the colour tends to sit on the surface and looks painted on, forming a separate thin layer rather than blending with the emulsion. RC papers respond better to photographic dyes.

There are no suitable black-and-white printing papers which are a warm brown (the nearest being Medalist—warm black—and Bromesko—brown/black), so you will have to treat a black-and-white print with sepia toner. (Some developers, however, give a warm-black effect on chlorobromide papers.)

Colouring materials

Ordinary artists' oil colours were used to colour the prints shown on these pages but some hand colourists prefer to work with photographic dyes, and you may like to experiment with this medium yourself. They have one drawback—they are absorbed quickly into the gelatin emulsion and cannot be removed if you make a mistake or want to change an effect. Coloured inks and crayons are other materials which you may like to experiment with. Air brushing is also used sometimes, but it is a specialist's technique and beyond the reach of most amateurs.

Hints on hand colouring

Basically, all colours can be obtained from just three—yellow, blue and red. By mixing various proportions of these, different colours or hues can be made. But it is easier to work with a larger manufactured range than to mix all the colours yourself. The colour mixing chart will help you to get your colours right. Black, in theory, can be mixed by using all three primary colours, but for a pure black it is best to use a manufactured colour. And red and green give brown. As already mentioned, it is the flesh tones that

You will need:
1 Brushes (sizes 000, 00, 0, 1 and 2)
2 Q-tips (cotton buds)
3 Paper tissues
4 Small bottle of distilled spirit of turpentine
5 Small metal or ceramic palette
6 Container for turpentine
7 Small tubes of oil paint, such as scarlet lake, alizarin crimson, cobalt blue, Chinese blue, ochre, sap green, viridian, raw sienna, spectrum yellow, spectrum violet, white, black, flesh colour, gold and silver.

After each colouring session clean the palette with a little white spirit on a cloth. Brushes should be cleaned in turpentine and stored carefully to avoid damage.

present the greatest challenge, and if you are using oil colour you can buy tubes of this flesh colour. (It is perhaps worth noting that 'warm' colours— the yellows, oranges and reds—tend to 'come forward' in a picture, whereas the so-called cool colours—the blues and greens—recede.)

How you manipulate and apply the paint is something which you will want to develop for yourself but it is useful

to have guidelines to work from until you have the confidence to experiment with your own systems.

Coloured dyes are water soluble so, when working with them, the print should be dampened first and the excess water removed with a print squeegee. The print should be kept damp with a wad of moist cotton. You will need one or two small containers of water, and a saucer or

▲ The theatre is a valuable source of subjects for hand colouring, especially when only the figure is coloured so it stands out dramatically from its background. For a rich touch to costumes use gold or silver oil paint—the type which is made for retouching picture frames.
All the work shown in this section is by Amanda Currey.

COLOURING WITH OILS
1 Preparation
Choose a print—preferably one with soft tones for your first attempt. Attach the print to a clean sheet of blotting paper with small pieces of masking tape and pin the blotter to a drawing board. (You can dry mount your print first, but finished oil-painted pictures can be dry mounted successfully 2 weeks after completion.) Work under good lighting.

2 Colouring
Put the tiniest dab of each oil colour on your palette—you use a minute amount and unused paint dries and is wasted. Moisten a brush with turpentine, pick up some colour and mix the density you need—more paint makes the colour more intense. To get different shades mix colours together but always rinse the brush in turpentine and wipe it on a tissue between colours. Charge the brush with paint and apply it to the print. If you are not happy with the effect, remove the colour

two might be useful. Use the dyes well diluted: add just a few drops of dye to the water. Dip the brush into the diluted dye and apply it to the surface of the print, spreading it as quickly and evenly as possible—don't be tentative or the dye will soak into the gelatin irretrievably.

Start with large areas of colour, such as the background, first, and use a medium-sized brush—say, size 2. Start with a pale colour as you build up the colour intensity in layers. You can use a damp cloth or small piece of natural sponge to mop up the excess dye. Having dealt with large areas of colour first, change to a finer brush to fill in the smaller details. (Sable brushes are best, but are the most expensive.)

The prints shown here were made on a special Kodak paper which is no longer available, so for a warm toned background you could tone a black-and-white print. Sepia toner kits are available from photographic suppliers,

A GUIDE TO MIXING COLOURS
Mix colours on a clean bit of palette.

and overleaf this process is shown in step-by-step diagrams.

For hints on working with oil colours, look at the illustrations on these pages. Finally, don't be dismayed if your first attempt is not as fine as you had imagined—hand colouring is by no means child's play.

▼ Fairgrounds offer a variety of subjects which are suitable for hand colouring. The busy background was purposely left uncoloured so it would recede, leaving the little boy and his balloons as the focal point. Q-tips (cotton buds) are useful to apply colour to large areas.

with a little turpentine on a cotton bud. However, use the turpentine sparingly. Colour large areas first and small details, such as eyes and lips, last. You need to model flesh tones with shading, so study real life. Shadows are not grey but a darker tone of the same colour, tinged with adjacent colours. A print takes at least 24 hours to dry so you may want to work on 2 or 3 prints at the same time.

3 The finished print
One of the delights of hand colouring is that you can choose to do just as much as you like and with colours of your own choice. Here only the clown has been coloured so he stands out magically from the diffused background. You may prefer to colour your backgrounds with a soft tint, such as pale green. Given the same print there are hundreds of individual interpretations.

Sepia toning black-and-white prints

Sometimes a black-and-white print (or even a black-and-white transparency), though well composed, lacks impact. It can, however, be transformed by colouring the black silver image with a toner. There is a range of colours available, so you can select a tone to suit the subject. For example, landscapes and portraits often look particularly attractive if they are toned brown, whereas seascapes and snow scenes lend themselves to a blue effect. It is also possible to tone some parts of the image one colour and tone other parts in a different tone, or even leave them plain; the possibilities are endless. And one of the pleasures of toning is that it can be done in normal lighting.

There are three main methods to choose from—this section deals with sepia toning and is followed by one on metal toning and colour toning. For consistent results, you should always follow the manufacturer's instructions carefully.

Preparation

In all toning processes, it is essential that the print is thoroughly fixed and washed, and that it has had full print development. Failure to follow any of these precautions may result in blotchy or uneven toning. There must be no grease or other marks on the print, and it is important that you do not retouch

▲ You probably have several black-and-white studies or even action shots of children which could be vignetted and sepia toned to great effect. To make a vignette, cut an oval out of black card. Use the surround to mask the paper during exposure. Slowly rotate the mask throughout the exposure for a softened edge to the image. You may not want full sepia toning. Instead you may want a warm brown-black. To obtain this you shorten the bleach time in the two-bath process or the time in the one-bath system. This print has been fully sepia toned.

before toning. The density and contrast of the print to be toned must be suited to the particular toning process. For example, prints to be sepia toned should be slightly darker than normal as the sepia toning process reduces the overall density of the print.

Sepia toning

This is probably the most popular toning, producing reddish-brown image tones. There are two methods—a selenium toner (which produces a slightly less warm tone) and a sulphide toner. The sepia images, once formed, are more permanent than the original metallic silver ones—in fact, it is impossible to reconvert the sepia tone (now silver sulphide or silver selenide) to metallic silver.

When sepia toning, it is important to work in a well-ventilated area because some sepia toner solutions give off unpleasant odours which may be harmful.

You can sepia tone your print by a two-bath (see the step-by-step instructions) or a one-bath method, and make up your own solutions from formulae or buy the ready-made kits which are more convenient. The actual colour obtained depends on various factors—the type of paper used, the print developer and the toner formulation. Chlorobromide papers tend to give a warmer sepia tone.

There are various sepia toner kits on the market and you should ask your photographic supplier which brands give a warm effect, or a cooler one, depending on your personal preference. There are also formulations which are odourless, if you find the smell of conventional sepia toners too obnoxious. They are slightly more expensive than conventional preparations.

In the one-bath process you place your pre-soaked print directly into the toner, thus avoiding the use of a bleach bath. This method, however, is much slower than the two-bath system and complete toning takes about 15 minutes. The print should be removed just prior to the required density, as the process continues in the final wash for a short time. You will need to learn to judge this from experience—it is advisable to stop when the print looks lighter rather than darker. Prints may be sepia-toned as part of the normal print processing after the final wash. But drain them well before you put them into the bleach or one-step process bath, otherwise the excess water will weaken the processing solutions.

Step-by-step to a sepia print

1 PREPARATION
Make sure your work area is well-ventilated. **Read the instructions that come with the kit and make up the solutions. Take care to avoid contamination. Pour the bleach and the toner into labelled, clean developing trays, placed 1ft (30cm) apart. Check that print is free of finger marks. Soak in clean water for at least 5 minutes to soften the emulsion.**

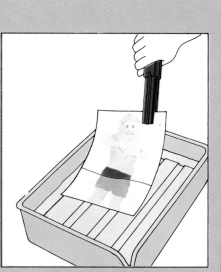

2 PLACE IN BLEACH BATH
Drain the excess water off the print. Gently slip the damp print into the bleach bath. Agitate by rocking the developing dish to and fro. Continue till the image gradually becomes straw-coloured and almost disappears.

3 WASH PRINT
**Using tongs remove print from bleach bath. Thoroughly wash print under running water for about 5 minutes.
It is important that no bleach remains on the print.**

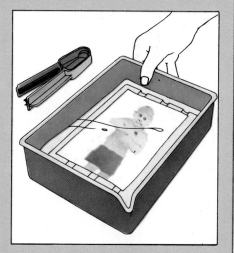

4 PLACE IN SEPIA TONER
After washing, place the print in tray of sepia toner. Agitate the tray by rocking it continuously. Full density should be reached in about 1 minute, depending on the temperature and concentration of toner. Using tongs remove print from toner and wash thoroughly under running water—RC prints for about 3 minutes, fibre-based for 45. Dry the print normally.

▲ A candid shot at a remembrance parade. Taking into account the occasion plus a lot of skin texture, *Jack Taylor* decided sepia would be more effective than black and white.

◄ For this portrait in richly detailed surroundings, *Amanda Currey* used a sepia toner to warm the dark, slightly sombre interior of the room and complement the Victorian theme.

► Warm-toned sepia is good for images where there is a lot of soft texture, especially pattern such as lace and embroideries. *Martin Riedl.*

PARTIAL TONING

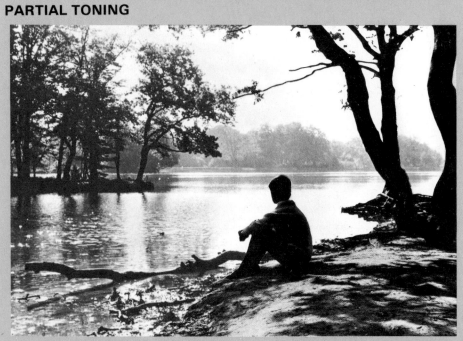

▲ Choose which part you want to tone. Paint a rubber masking solution over remainder.

▲ You can select just part of the image and tone it without affecting the rest of the print. A mask is applied to the areas to be protected from the sepia process. This device gives a montage effect and is useful when you want to create a real and unreal situation in the one print.

▲ The mask hardens in a few minutes and you can sepia tone safely. Use a piece of adhesive tape to lift the mask off.

Colour from black-and-white: colour toners

Given a black-and-white negative, the next step is usually to make a black-and-white print. But there is no reason why a black-and-white negative shouldn't be used to make a print of any other colour if this suits the picture better. The print will still be monochromatic (one colour) but the colour can be brown, red, green, blue or whatever you choose.

An easy way to make coloured prints from black-and-white negatives is to use chemical toners. Toners can be bought ready made-up. They work by changing the silver image of a black-and-white print into an image of a different colour. The white base of the paper stays white. Very dark areas on the print take a lot of colour and remain nearly black. The toning effect is therefore most visible in the range of grey tones in between.

How toning works

With all current toning processes, a normally developed black-and-white print is produced first. This is then put through chemical after-treatment to change its colour. There are two sorts of toners available.

One-bath toners work directly on the silver image of the print, turning it into a new chemical compound of a different colour. One-bath toners act gradually so that you can watch the colour building up while the print is in the bath. They are very easy to use, but the range of colours available is limited.

Two-bath toners need extra processing steps. The black silver image of the print is first turned into a silver salt in a bleach bath. Then the print is washed to remove the bleach solution, and immersed in, or swabbed over with, the toning solution. The silver salt reacts with the toning solution to make a coloured chemical compound, after which the print is washed and dried as usual.

Two-bath toners give a wider range of colours than one-bath toners, but the widest range of all is given by dye replacement or colour developing toning. In practice, these processes are like two-bath toning: the black silver image is bleached out and then redeveloped in a solution which fixes pure dye colours in the print emulsion. In the case of colour redeveloping, a silver image is also produced, which is then re-bleached out and removed by fixing, leaving the dye colour alone.

Choice of papers

Most of the toners currently available are intended for use with resin-coated (RC) papers. However, some sepia toners do not react well with RC papers and produce very dark tones. A fibre-based paper should be used with these toners, but it may be necessary to find by experiment whether a neutral image-tone paper such as Ilford Galerie, or a warm-tone paper such as Kodak Medalist or Kentmere Kentona, gives best results. Red, green and blue toners, on the other hand, work better with resin-coated papers, and many of the problems associated with toning fibre-based papers, such as the base white becoming coloured, have been eliminated. Some kits are intended for RC papers only. Most metallic toners produce an image which is at least as permanent as a normal black silver image. With RC papers, however, the image may be fragile as much of it can be on the very surface of the emulsion. Coating with matt spray or mounting using a heatseal overlay will give extra protection. Dye toned prints are generally no more permanent than ordinary colour prints.

Brown and sepia tones

Brown and sepia tones are ideal for portraits, woodland scenes, texture studies, and imitation antique prints. Suitable toners are available from Kodak, Tetenal, Berg and other manufacturers. Conventional sepia toners are bleach-and-tone types, and their sul-

▶ Ingredients for simple colour toning: 1 Metallic blue toner. 2 Copper toner for a range of brown tones on all types of paper.
3 Colorvir dye toners are available in many colours which can be used singly or combined. Dye toners are best used on resin-coated papers. Fibre-based paper will absorb the dyes used and spoil the effect.
4 Metallic brown toner, supplied as liquid concentrates so that powdered ingredients need not be dissolved.
5 Metallic blue toner.
Note that the processing trays in the background are new and unused. Buying new trays for toning, and using them only for toning, will ensure that no deposits of silver will exhaust your solutions unnecessarily.

▲ ▶ A straight-forward photograph of a militaria enthusiast takes on the patina of age with sepia toning. A contrasty print, partially vignetted in the enlarger to give the effect of a Victorian photograph, was only partially toned so that good density and rich detail would remain in the shadow areas.

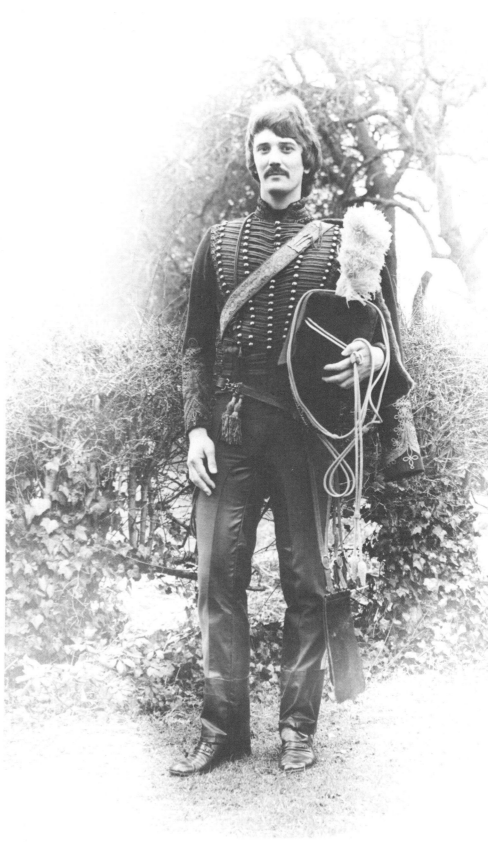

phide base may give off an unpleasant rotten-eggs smell in use. For deep brown tones, make the original print of normal density; for warmer brown and sepia tones, make a lighter print and avoid solid black. For economy, solutions can be swabbed over the print with cotton balls. Partial toning effects are possible by partial bleaching; use the bleach bath at twice the stated dilution and take the print out before it bleaches completely. The blacks will remain pure black, and only the lighter greys of the print will be toned brown.

Copper toner also produces brown tones and is more controllable with some RC papers. This is a single bath process, and the effect is governed by the immersion time.

Selenium toner may be used either as a single or a two-bath process according to how strong an effect is required. If used without a bleach bath the colour change is small, but it is widely believed that the plating of selenium metal given to the silver image will enhance print permanence. Used as a two-bath, selenium toner gives rich brown tones with a hint of purple.

STEP-BY-STEP TO TWO-BATH TONING

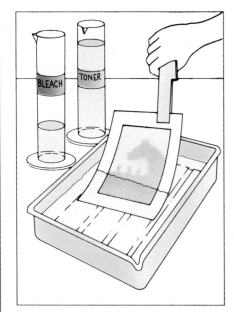

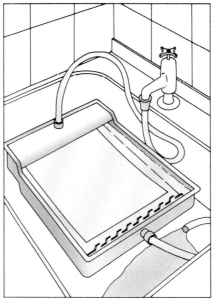

1 BLEACH
Turn the silver of the print you want to tone into a salt with bleaching solution. The image will become very faint in a few minutes. Use a weaker bleach solution if you want a partial toning effect in the final print.

2 WASH
After the image on the print has faded, wash all traces of bleach out of the print with running water. The toning solution will not work properly if it is contaminated by the bleach, so be sure to give a long enough wash.

3 TONE
Put the washed print in a tray of toner and agitate gently. Use tongs, and handle the print by the borders. If the emulsion is scratched it may tone unevenly. Do not dip your fingers in either the bleach or toner solution.

4 DRY
Wash the print again, then wipe surplus water from the surface and allow to dry. Prints that have had a lengthy soaking in processing solutions have delicate emulsions when wet, and should therefore be handled with extra care.

Other sepia toners may be used in a similar way to produce a slight warming of tones to brown black by omitting the bleach step. Immerse the print in the toning solution for about five minutes.

Yellow and orange tones
Tones from yellow to amber can be produced using commercially available two-bath toners. A common bleach bath is used with different toning solutions to produce the required range of tones. A dense print produces the best effect on RC papers.

Red tones
Copper toner will give a warm reddish-brown effect if the print is left for long enough in the bath, but the tonal range of the print may be degraded and the long-term stability of the image is not as good. It is better to use a two-bath red toner or a dye replacement toner for brilliant reds.

Green tones
These can be produced by a cobalt two-bath process.
At present there are no commercially available cobalt toners, although these can be prepared at home using standard formulae and chemicals from laboratory suppliers. The simplest way of making green tones is to use a dye replacement or colour developing kit such as that made by Berg or Colorvir. These will give very bright results, although they will not be as permanent as those given by metallic cobalt toner.

Blue tones
Most blue toners are single bath, iron based solutions which produce a brilliant blue effect rapidly from all types of photographic paper. The print is simply immersed in the solution until the desired effect is produced, and then rinsed in a very weak solution of normal acetic acid stop bath. The toner has an intensifying effect, darkening the original picture and making it more contrasty; grain is also emphasized so it is best to use a soft, light print.

Other toners
You may come across other types of toner or formulae for toning baths. Some of these are not particularly permanent or attractive, but most proprietary toners work well. Some, such as the Berg, Edwal and Colorvir kits, include solutions for green, orange, yellow, red, blue, and other colours, and buying one of these kits opens a full range of colour possibilities.

▲ A two-bath toner was used to give this yellow effect on resin coated paper. Colour toning should suit the subject; here, yellow gives an impression of sunshine.

▲ The greens of this print, though not the leafy greens of nature, have a tranquil appearance appropriate to the picture. A two bath dye toner was used.

▲ A moody blue colour was given here by a two-bath dye toner, but a similar effect could have been produced with a single bath toner.

▲ A colour development replacement gave this deep red effect. Strong colours like this are typical of dye toning processes.

▲ In comparison the reddish-browns of this print are less garish. The effect was achieved by extended treatment in copper toner.

Successful toning

There are two common problems with toners: incomplete or patchy tone effects, and colouring of the white paper base.

These can be avoided by adhering closely to some simple rules.

● Prints to be toned should have been made freshly and never stored. It is best to tone a print immediately after washing, before it has been dried.

● Prints for toning, even if low in density and contrast, must always be fully developed, and for safety you should exceed the usual development time slightly. Exposure should be the minimum necessary to avoid any trace of grey in the highlights, for this will pick up toner.

● Stick closely to stated times and temperatures with all toner kits, and always use clearing or acid baths if these are recommended. Many toners must be made up freshly and discarded after use. Failure to follow such instructions can result in poor colours, tinted whites and uneven toning.

● Be particularly careful with RC papers not to touch the picture area with tongs; even slight abrasions of the emulsion surface may tone differently from the rest of the image.

● Finally, make sure that trays used for toning are completely clean. If this is not done much of your toner may be used up on silver deposits on the tray, causing stains that will be very difficult to remove.

Printing on coloured-base papers

A black-and-white photograph does not have to be printed on white paper. It is just as easy to print a black image on a coloured base using ordinary photographic methods.

Coloured-base papers, either produced by manufacturers or made at home, can put extra variety into decorative or exhibition prints. A good black-and-white image printed on a strong background colour can have more impact than an ordinary colour print. The colours available as base tints are often very pure and bright, and can even be fluorescent or have a metallic sheen.

In general, the most suitable pictures for printing on coloured base papers are shots with simple strong lines, and bold tones. For the coloured base to show through the picture must have plenty of lighter areas: very dark, low-key shots, or pictures with strong greys and subtle gradations, are rarely suitable.

Posterized black-and-white prints (see page 218) work very well. These pictures are made using lith or line film intermediate negatives. The techniques for printing on coloured-base papers are the same as those for making line prints on normal white-based paper.

Types available

The most readily available coloured-base papers are Luminos Pastel, Kentint and Autone. These are available either in sheet form or rolls, and in fibre-based or resin-coated (RC) types.

The fibre-based papers are very light in weight, difficult to handle, and are being superseded by more versatile RC papers. Resin-coated coloured-base paper handles and processes just like any other RC paper. Standard colours include blue, red, green and yellow. There are also metallic gold and silver papers and fluorescent green, pink, yellow and orange papers. The fluorescent papers will glow vividly under 'black' ultra-violet light.

Coloured-base paper is available in sizes ranging from 8 x 10in (20 x 25cm) sheets up to long rolls. Trial packs containing an assortment of different colours in 8 x 10in (20 x 25cm) sheets are made by some manufacturers and give an introduction to the possibilities of these papers. Coloured-base papers generally cost about 50% more than ordinary printing papers.

Using the papers

Because coloured-base papers have a particularly striking appearance, the subjects that are printed on them should also have a strongly graphic content.

Photographs of subjects on uncluttered backgrounds, with bold patterns, textures or shapes are ideal.

One subject which is ideal for coloured-base paper work is lettering. By photographing dry transfer lettering or artwork for signs or notices it is possible to make very effective display panels on these papers.

With matt surface fibre-based papers, it can be difficult to tell which is the emulsion side of the sheet before putting it under the enlarger to make a print. An easy method is to bite a corner of the paper. The emulsion side will feel softer and slightly tacky.

Using the colours

Red, orange and yellow: These three warm colours stand out well. It is less necessary to have a strongly graphic subject with these colours, and they are also easy to handle under safelighting because the base looks light in colour. Red and orange go well with dramatic, action shots, while yellow gives a sunny effect to the final print.

Blue and green: These colours have less impact, and simple compositions or line reductions are advisable. Keep the print light rather than dark. Under the safelight the base of these papers appears very dark—blue looks almost the same

as black—so you will find judging development difficult. Test strips for exposure are essential.

Fluorescent colours: All these have great brilliance when viewed by daylight, and you can print a normal full-tone picture without losing impact. Choice of subject on these vivid papers can be wider than with most coloured papers—as no particular subject is normally associated with fluorescent pink, any subject may be chosen!

Metallic papers: Being essentially light in tone, metallic papers also allow more leeway in choice of subject. Nevertheless, line prints look highly effective on a gold or silver base. Seascapes look excellent on metallic silver or blue, while portraits are a suitable subject for gold. Care must be taken when displaying these prints to ensure that the light by which they are viewed reflects the metal grain of the base colour brightly.

Commercial coloured-base papers and print dyes open up new fields for photographic experimentation. Used selectively, they can add new vividness to your pictures.

Ordinary RC papers can easily be dyed to give a coloured base after the print has been made. Special dyes to do this are sold in kits. If unable to obtain these kits, dyes used for food, clothing, or retouching colour prints can be used and give fairly good results.

COLOURED-BASE EFFECTS

Deciding which coloured-base paper to use for a negative is largely a matter of personal choice. Here, a subject that might not normally be chosen for coloured-base paper work has been printed on different coloured papers to show how their characteristics can change the effect of the picture. The colder colours, green and blue, seem slightly out of harmony with this subject. If the bird was one that hunted by night, such as an owl, then the dark tones of the blue paper might be more appropriate. Note how the edge of the bird's head is lost in the black background on the green paper—not all coloured base papers have the same speed and contrast. Of the warmer colours, yellow, orange and red, the orange gives perhaps the strongest impression of the bird's bright alertness. The choice is unnatural, but effective.

Make your own coloured papers

To dye an RC photograph, make a fresh print, fix thoroughly, and wash. Do not use a hardening fixer, and be very careful not to scratch the emulsion. Immerse the print face up in a clean tray containing a solution of dye and water, and agitate the print gently but continuously. Do not hold the edges of the print with your fingers, as this can stop the dye being absorbed evenly.

Lift the print quickly out of the dye from time to time to check its progress, and remove it when it has become a little darker than you finally intend. Then wash out the surplus dye in a tray of still water. Dry the print in the usual way after wiping off excess water with a soft sponge or a paper towel.

If the final colour is too weak, repeat the process. If it is too strong, a rinse in warm water can reduce the colour. By carefully lowering the print into the dye bath a little at a time you can make prints with a graduated base colour tone that cannot be obtained by any other means.

▲ Immersing a print on glossy resin-coated Ilfospeed paper in a strong solution of bright pink dye gave this unearthly purple hue.

▼ An ordinary black-and-white print on resin-coated paper takes on a deeply sombre atmosphere when dyed a pastel green.

Etch-bleach on coloured backgrounds

Etch-bleach is a simple way of using coloured-base papers to make white images on a coloured background. A special bleach softens the emulsion of the print wherever there is a black silver image, allowing it to be rubbed away to expose the white paper underneath. The original print has to have a contrasty negative image, and can be made from a slide or a positive duplicate on lith film. The print should be well exposed to ensure that there is enough silver for the bleach

to work on. After the image has been bleached out, the print is rubbed with cotton balls under running water until all the gelatin is wiped away, then rewashed and dried.

The bleach has two parts: (A) 2oz (50g) cupric chloride mixed with 8½ US fl oz (22cl) acetic acid and made up to 38 US fl oz (1 litre) with water: (B) 20 vols hydrogen peroxide. Mix equal parts of A and B, making up quantity needed only. Wear rubber gloves and handle with care.

▲ ▲ **Internationally famous rock musicians Bob Geldof and Johnny Fingers of The Boomtown Rats make a lively subject for this portrait by** *Lawrence Lawry*. **A high-contrast negative print on green coloured-base paper, left, was etch-bleached, right.**

▼ **Blue coloured-base paper etch-bleached and dyed yellow gave a green image in the dark areas of this variation.**

Colour from black-and-white: special effects

It's easy to make vivid, multi-coloured prints from your black-and-white negatives—the techniques are simply extensions of those you have already learned from the two previous sections on making colour prints from black-and-white negatives. Those sections discussed techniques of applying a single colour to each print; here we look at ways of combining colours.

How multiple toning works

Special toner kits are available that work by turning the silver of an ordinary black-and-white print into a silver compound, and then treating this compound with metal salts or special dyes that give a brightly coloured image. This is just like the toning described previously, and can be carried out in normal room lighting and at normal temperatures. The difference is that the toners used form part of a compatible system that works gradually. What this means in practice is that you can watch the colour build up in a print you are toning, and stop the process whenever you wish simply by removing the print from the toning bath. You can then apply a completely different colour to the parts

of the print that haven't yet been toned by putting the print in a second toning bath.

The **metal salt toners** in the kits give colours similar to those produced by ordinary blue, green or yellow toners. The **dyes** have a very different effect, and give more subtle results. Often the dye solution looks almost clear until it meets the bleached silver of the print—only then does the colour appear on the print image. The colours given by other dyes in the kits appear rapidly in the image area, but are also capable of staining the white paper base if allowed to work for too long. Some dyes have a different effect depending on whether or not they are used on an image already coloured by a metallic toner.

These special kits also give ordinary toning effects in sepia, red or blue, and can be used to dye the paper base different colours. They will produce all the effects mentioned in previous sections and a range of multi-colour effects besides.

Two typical kits

Two currently available special effect toning kits are the Berg Color Tone kit

from America and the Colorvir system invented by French photographer Pierre Jaffeux (not yet available in US).

The Berg system is the simpler of the two. Compared to the Colorvir it requires less elaborate making-up of baths, and is more suitable for treating batches of prints together. The Colorvir kit gives the widest range of effects and is far more versatile, but requires more individual attention for each print and is less suited to repeated effects on several prints. Both kits use a final fixing or clearing bath—a special chemical

▼ SPECIAL EFFECT TONING KITS
The Colorvir kit (left) contains:
bottle F, grey freezing; G, sepia toner,
L, yellow polychromie dye; C, toner
additive; B, yellow toner; A2 and A1,
blue toner. Other bottles (not shown)
are D for solarization; H, I and J,
violet, green and red dye; and K and
M, red and blue polychromie dyes.
The kit also includes salt for fixing (in
the bag) and a graduated test tube.
The Berg kit (right) contains small
bottles of dye, two large bottles of
activator, and a clearing agent in the
small jar in front of the bottles.

▲ *David Kilpatrick* achieved this vivid effect by using the yellow solarization concentrate from the Colorvir Kit to colour the darker details. Subsequent treatment in blue dye only affected the lighter tones.

with the Berg kit, common salt with the Colorvir.

Using the kits

Both the Berg and Colorvir kits work best on resin-coated (RC) papers. The Berg kit is tolerant, and can be used on almost any make of paper. The Colorvir kit can also be used with any RC paper, but results change dramatically from type to type and can even vary with the surface. Glossy gives best results.

With both kits you should use extra care when making the print:

● Always use fresh developer and develop fully.

● Always use fresh fixer without a hardener.

● Don't use tongs or even let two wet prints rub together in the wash. Any surface abrasion, even so slight that it would be undetectable in a normal print, can be emphasized in full colour by the Colorvir process. Veribrom (not available in US) and Agfa Brovira RC papers are particularly sensitive to this. Ilford's Ilfospeed paper seems less so, but is also less sensitive to certain Colorvir special treatments.

● Avoid allowing the chemicals used to

VERIBROM AGFA ILFOSPEED MULTIGRADE

▲ How strongly special effect toners work depends on which paper is used. The procedure used in the picture at the top was applied to four different RC papers.

Results were unsatisfactory with Veribrom (not available in US). Agfa gave stronger yellows. Normal Ilfospeed was not very good, the more complex Multigrade was best.

come into contact with your skin—wear rubber gloves.

● Use clean trays, graduates and bottles, preferably ones that have not been used before.

The Berg Color Tone kit

The Berg kit contains five colour dyes, a tin of powder to make up a special clearing solution used after toning is completed, and a concentrated activator. Each of the chemicals make up to 1 US qt (1 litre), and they are best stored in dark glass bottles with tight stoppers. The quantities of dye supplied are enough to treat up to 100 prints, but the activator supplied is only sufficient for 50. More activator is available separately so that the full capacity of the dyes can be exploited.

In use, the black-and-white print is treated with the activator for one to five minutes, until the image looks a weak, brownish-grey colour. Then the print is immersed in dye solution until the colour change is complete. Excess colour in the highlights is removed by bathing the print in the clearing solution.

The Colorvir process

The Colorvir kit shown earlier is more complex than the Berg. Rather than making up bottles of each solution to keep, you dilute small quantities of concentrated dyes to make 17 US fl oz (500ml) of working solution at a time. A typical Colorvir treatment bath can contain as little as two drops of concentrate, but is powerful enough to tone several prints. The solutions will keep for up to five days, depending on which concentrates have been used. In combination, toners A1, A2, B and D will give a range of colours from yellow to green and blue, with D-toner also useful for solarization effects in combination with other dyes. Solution F makes the light grey tones of the original print immune to treatment by the other solutions, so that toners only affect the dark areas of the image. Solution G can be used for sepia toning or to change the colours of already-toned prints. Dyes H, I and J colour the toned image and leave the white print base unaffected. Dyes K, L and M have the opposite effect, toning only the lighter areas.

With Colorvir it is possible to imitate the effects of colour solarization and such complex processes as contour film derivations, in which the density of the original image determines the final colours of the print. Startling gradations of colours combined with black or white can be produced.

◄ Mixed red and blue Berg dyes gave this mauve image with blue highlights. Below: a negative print made direct from a slide was solarized, dyed in Colorvir polychromie red, then in a mixture of all three polychromie dyes.

► Colorvir solarization followed by red polychromie dye gave this effect.

▼ Left: Berg and Colorvir kits—a print was solarized with Colorvir, then Colorvir blue toned, immersed in Berg activator and finally dyed with Berg Red-1. The Berg activator lightens the Colorvir blues.
Right: A three stage colour separation with Colorvir. Yellow toning and solarization were followed by treatment in red dye J, producing the russet midtones. Finally, blue and yellow polychromie dyes were mixed to make a green dye which was used for the final treatment.

Black-and-white solarization

Of all darkroom techniques, solarization and Sabattier effect are among the most spectacular. However, because of their similarity of appearance, they are often mistaken for one another.

Solarization is the complete reversal of the image due to over-exposure—about 1,000 times. Owing to the exposure latitude of modern materials this is extremely difficult to achieve. Sabattier effect (or pseudo-solarization) occurs when a partially developed material (film or paper) is re-exposed to light and the development is continued, resulting in an image with both positive and negative parts. Where the two meet there is a clear undeveloped line dividing them called the Mackie line (after the man who discovered it).

Having established the textbook differences, the effect will be referred to as solarization from now on for the sake of simplicity.

▼ **With the right subject and the right lighting a very fine result can be achieved with film solarization. This portrait for Robert Palmer's record album** *Secrets,* **photographed by** *Graham Hughes,* **uses the Mackie line to emphasize the outline of the profile.**

Choosing the subject

Solarization is an effect many people have tried but few have used successfully, so that no subject, or group of subjects, has been established as particularly suitable for the effect.

Detailed, well-defined, hard-edged subjects, such as profiles or buildings, are best. For these it is important to have strongly modelled lighting with well-defined shadow and highlight areas. In other words, dramatic but not too contrasty lighting. Avoid subjects such as nudes, or rolling landscapes, since big, even, flat areas result in objectionable tone quality.

Suitable materials

All sizes and type of film and paper are usable but, as a rule, the slower and finer grain materials give better results than the faster ones.
● Kodak Plus X and Ilford FP4 are preferable to Tri-X and HP5.
● In the case of papers, the greater the contrast the better; use grades 4 or 5 or Agfa grade 6 if available.

Exposing the film

Producing a normal top-quality negative takes experience and care; subject brightness range, exposure and development all have to be taken into account and need to be in harmony with one another. In the case of film solarization two more factors are introduced: re-exposure and second development. As a consequence, success at the first attempt is difficult. The third or fourth attempt is usually more rewarding.

When working on 35mm format it is not necessary to use the whole 20 or 36 frames for each trial. It is far too expensive. The film can be cut to lengths of six to 10 frames, or you can expose a suitable number of frames and cut off the exposed bit.

To do this, go into the darkroom, switch off the light, open the camera back and press the rewind catch. With the other hand lift the film up from the film gate, about a couple of centimetres, slide scissors under the film near the cassette end and cut off the exposed bit. Next press the rewind release again and pull the exposed length off the take-up spool. Put it into a light-tight container and put the light back on.

There are various methods of solarizing the exposed film, two of which are discussed here.

The safelight method

You need a timer, a thermometer, a reel from a developing tank, four containers the same size as a developing tank and a safelight with a red filter and 15W bulb. Any good print developer at its dilution recommended for printing is suitable. The stop bath and fixer can be those normally used.
● Arrange the containers on a working surface in the following order: developer, stop bath, water and fixer. The working temperature is 68°F (20°C). The level of the chemicals in the containers should be enough to cover the reel. The safelight should also be nearby, not more than a yard (metre) away. A ceiling safelight is not suitable at all. Once you have laid everything out you can turn out all the lights and begin.
● Transfer the film on to the reel and place it in the developer, starting the timer at the same instant. Agitate continuously, up and down, for 2 to 2½ minutes in the case of 125 ASA films or 3 to 3½ minutes for 400 ASA.
● Once development is complete place the reel in the stop bath and agitate continuously for 1 minute.
● The safelight can now be switched on. Pull the film off the reel and expose it to the safelight for 20-30 seconds at a distance of about 30in (75cm).
● Switch off the safelight and see-saw

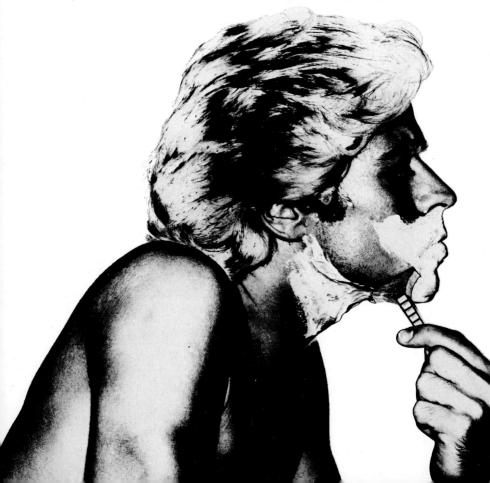

Step-by-step to a solarized negative *(A blue background indicates total darkness)*

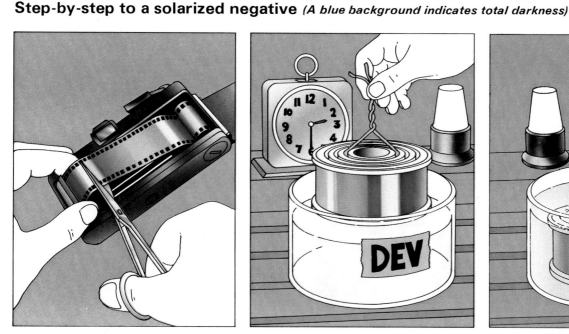

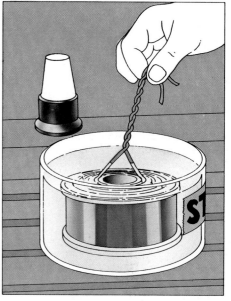

▲ After you have exposed six to 10 frames, open the camera back in the dark. Press the rewind button and lift the film up from the film gate a few centimetres. Slide scissors between the film and the camera, cut off the exposed length and put it in a light-tight container. You will now have a convenient length of film.

▲ Arrange the processing solutions in the order in which they will be used and check that they are at the working temperature of 68°F (20°C). Turn out the light and load the film on to a reel. Once development has begun agitation should be a continuous up and down movement.

▲ When development has been completed, transfer the reel to the stop bath and agitate continuously for 1 minute. (A useful tip is to attach a string halter to the reel: this facilitates agitation and at the same time minimizes the risk of contaminating your fingers with the developing chemicals.)

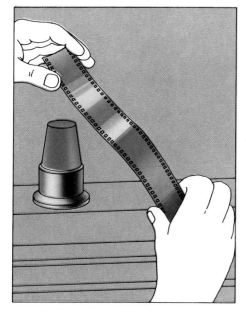

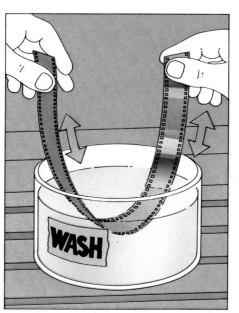

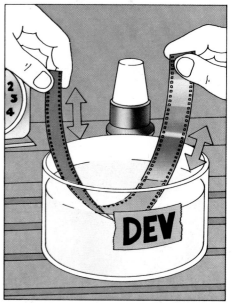

▲ Switch the safelight on and take the film off the reel. Expose the film to the safelight for 20 to 30 seconds at a distance of about 30 in (75 cm), emulsion side towards the light source. Do not let the film drip on to any electrical connections.

▲ Once the second exposure has been completed, switch off the safelight. Hold the film at each end and see-saw it through the wash water, making sure that both ends are immersed. This is to remove the remaining stop bath solution.

▲ The second development lasts for 2 minutes. It is followed by the normal sequence of stop bath, fixer and wash.
The solarized image that is produced will be very dense when compared to your usual negatives.

◀ Plenty of fine detail thrown into sharp relief by the sunlight makes this subject a good one to solarize. Having decided to do so *Richard Brook* enlarged the negative on to high contrast film which he solarized. He contact printed this on to more high contrast film and then enlarged on to paper. Notice how some areas have changed greatly while others have stayed roughly the same.

the film in a loop, emulsion inwards through the wash water for at least a minute, making sure that both ends are rinsed. This removes the stop bath before second development begins. As wet film can be rather tricky to handle it is probably easier to continue with this see-sawing technique during the rest of the process.

● Develop the film for a further 2 minutes. Then follow the normal sequence of stop bath, fix and washing. The film should now be solarized and if your results are successful the film can now be printed.

The white light method

This is the Kodak recommended method for Plus X film and was probably originally intended for sheet film as it involves using small developing trays. However it can be adapted for use with 35mm or 6 x 6cm. Allow about 2½in (6cm) extra when you cut

the film up and clip each end to the lip of the tray, making sure that the film bows down into the centre. The developer is Kodak HC-110 diluted 1 part to 16 of water and used at 68°F (20°C). You need to work in complete darkness. First development lasts for 1½ minutes.

● Pour the developer into the tray and agitate continuously by rocking from side to side for 1 minute 20 seconds.

● Leave it still for 10 seconds and then expose to white light, that is an ordinary bulb or an enlarger, while the film is still immersed. The exposure time is likely to be in the region of 2 to 5 seconds with a 15W bulb about one yard (metre) away. With an enlarger it is possible to give stepped exposures like a test strip as long as the film is protected from stray light being reflected from the base of the tray.

● As soon as the exposure is finished agitate again until the film has been in the developer for 3 minutes in total.

● Proceed with the stop bath and fixer, and wash as usual. This completes the process and successful results can be printed.

Assessing the results

All solarized negatives are very dense compared to normal ones so don't panic. The negative image from the camera exposure and first development is usually neutral grey in colour. The positive image from the second exposure and development is very much warmer and tends to be creamish in colour. In between the two ought to be a clear line, the Mackie line, though you may need a magnifying glass to see it. With luck both images will have adequate detail and contrast and the lines between them will be clear.

Normally, on the first attempt, the problem is to decide what went wrong. Remember that the density of the negative is due to exposure and the

contrast results from development. As the first exposure was made quite normally in the camera, it is not likely that there will be a lack of detail in the neutral tone negative image. It might be too flat or too contrasty. If that is the case, first development should be increased or decreased accordingly by between half a minute and a minute.

It is much more likely that the positive image will be faulty. To make a correction the same rule is applied but this time to the second exposure and development. Density is increased by a longer second exposure while it is decreased by a shorter one. Too much or too little contrast is altered by varying second development.

Sometimes the Mackie lines are not very clear. This may be because the original scene did not contain well defined boundaries between the light and dark areas. If this is the case then you are wasting your time and another subject should be chosen. If the subject is suitable then the definition of the Mackie lines can be improved by cutting agitation in both developments. Agitate for the first half then allow the film to remain still for the second. To compensate, increase the total development time by 20%. As a further refinement vigorous negative developers, such as Agfa Rodinal at dilutions 1:10 to 1:25 or Kodak HC-110, can be used.

Solarizing prints

The results of this technique can easily end up as very dark images lacking contrast and detail unless great care is taken with the selection of an image and the intensity and duration of the solarizing exposure. As with negative solarization plenty of vivid variation in tones is needed in the image. Otherwise too much fine detail will get lost.

● Expose a print in the normal way.

● Half-way through development, that is when the image is clearly visible, re-expose to white light. An enlarger is useful here as the aperture allows a fine control of the amount of light.

● The moment you see a change in the image switch off.

As the paper is still in the developer, the image will now change rapidly so you will need to transfer it quickly to the stop bath once you have achieved a satisfactory result.

Over-exposure is the commonest cause of failure when working with prints. A judicious use of reducer can rescue marginal failures but it will probably be quicker to go back and do it again using a shorter second exposure.

▲ Solarized film is very dense and quite unlike a normal negative.

▶ This still life by *Heino Juhanson* was illuminated from below. When the film was solarized a Mackie line was created between the light and dark areas creating an outline that gives coherence to the shape of the entire group. Solarization also radically changed the tones of the vegetables.

▼ The flat, metallic look of a solarized print needs the right subject for a successful image.

Successful colour solarization

Solarized black-and-white photographs are composed of positive and negative tones. Although it was possible in the past to create such effects by gross over-exposure, modern materials have such exposure latitude that an alternative method has to be used.

Pseudo-solarization, or Sabattier effect, occurs when development is interrupted, the film or paper is re-exposed and processing is completed. The result is similar to true solarization for black-and-white film or paper.

With colour materials a set of colours complementary to the original are created, that is, yellow replaces blue, magenta replaces green and cyan replaces red, so long as white light is used to make the second exposure.

As the colours that are produced are bizarre and unnatural, it doesn't matter whether you start with a slide or a negative when making either a solarized transparency or print. In view of this the image that is your starting point, whether it is a slide or negative, is usually called the colour source.

Solarizing slides

One of the most useful materials on which to make solarized slides is print film. This is a print emulsion, coated on a translucent film base. It is normally used to make colour transparencies from negatives. The Kodak version, Vericolor Print Film, is processed in the same way as colour negative film, that is in the C41 process. The Agfa Print Film (not available in US) is processed in their colour print chemicals at present. Both types are only available in sheets but 8 x 10in (10.2 x 12.7cm) boxes can be ordered through a good photographic store.

Making an exposure grid

As two exposures are necessary and the relationship between them is important a special type of test strip is needed.

Working in total darkness, take a sheet of print film from its box and place it emulsion side up on the baseboard under the enlarger head. (Remember, the emulsion side is stickier than the base when placed in contact with a moistened lip.) Place the colour sources emulsion side down on the film and cover them with a piece of plate glass that will hold them flat. If you are working from 35mm originals, six will fit comfortably on an 8 x 10in (10.2 x 12.7cm) sheet. Make a test strip as a colour contact sheet, keeping the covering card parallel to one edge.

Processing is carried out in small processing trays standing in a larger one, which acts as a water bath to maintain the temperature of the solutions. For Kodak materials this is 100°F (38°C) and for Agfa 75°F (24°C). Use a reasonable depth of processing solution to ensure that the sheet of film is completely covered. There is no way of checking this visually once you begin. As tongs are impractical when working in complete darkness, you will need plastic or rubber gloves to handle the materials. Colour developers are extremely irritating to the skin and such protection is always necessary.

After the first series of exposures slide the sheet of film into the developer. Be sure to handle the film without delay as the development time is short. Half way through development extract the sheet and, supporting it on a piece of glass to keep it flat, make a second series of exposures, each twice the length of its equivalent in the first series, at right angles to the first set.

The light source for the second series should be a 30W bulb approximately 5ft (1.5m) from the film. Filters can be used to colour the light source—any strongly coloured filters will do. As the

▲ Even a simple composition can form the basis of a striking solarization.

▼ Here a pale red filter was used to make a selective solarization.

214

The original image, or colour source, (above) need not be boldly coloured. But the picture should be composed in an interesting manner with clearly defined patterns.

The simplest form of solarization (above right) involves a second exposure to an ordinary light bulb. Print film is the best material for this. Using the enlarger to make this exposure gives greater control over the level of illumination, but the colours will still be rather crude.

Greater subtlety and variety (right) can be achieved by placing filters in the negative carrier of the enlarger so that the light only affects parts of the emulsion. Here, a pale red filter has been used with a neutral density filter, which prolongs the exposure slightly.

The process is taken one stage further (below) by printing the solarized print film directly on to another sheet of print film without any further solarization. This reverses the colours so that blue becomes yellow, and vice versa.

▲ In the past solarization has been a trial and error technique. The grid allows the effect of the second exposure to be accurately assessed.

intention is to create an unusual and artificial image, such modifications will often enhance the effect.

Return the film to the developer and complete the process as normal. Once the film is dry, the grid that you have produced will indicate the variations in colours that are possible and you can select the combination that you prefer. Once you have established the exposures that you prefer, the film need not be re-exposed on glass but may be left in the developer. The results obtained will feature strong colours but their range will be limited. The highlights will be coloured.

Solarizing prints

The most straightforward way of solarizing colour prints is similar to its black-and-white counterpart. A slightly curtailed first exposure is given and the paper is placed in the developer. The second exposure, to a white or coloured light source, is made one third of the way through development, while the print is in the tray. The length of each exposure is calculated by making a test grid.

Although simple, this method has the disadvantage of being difficult to control. The results, relative to other methods, are rather crude.

Using tricolour filters

An alternative method of making solarized prints, that gives much more control over the final result, involves the use of special filters.

Tricolour filters were originally developed for the printing industry. Each one is a very pure primary colour. They are available in the Kodak Wratten range and the red, blue and green filters are numbered 25, 47 and 58 respectively. When they are used over the light source during the second exposure only one layer of the emulsion is solarized.

The first step is to make a colour print in the normal way, creating the density and colour balance that you want. Process the paper in trays. Once you have a satisfactory print, place a piece of glass on the printing frame and refocus, using a sheet of white paper. The glass protects the frame from chemicals during the second exposure. When you have refocused, stop the lens down to the aperture used for the standard print and make the first exposure, reducing the time given by about 10-15% when compared to the standard print.

Half way through development, extract

Step-by-step to solarization

▲ An exposure grid can be used with any of the solarizing techniques. The first step is to make a test strip, giving shorter exposures than usual. Try to keep the card parallel to the edge of the paper or print film, creating steps of equal width. *A blue background indicates total darkness.*

▲ Processing is always done in a tray. Make sure the tray is at least one size larger than the material being processed and that the developer fills it to a depth of at least ½in (1.5cm). Check the temperature of the developer before you begin. Agitate continuously by gently rocking the tray.

▲ For the second exposure the film or paper should be handled without delay. Take the material from the developer, support it on a piece of glass and make the second series of exposures at right angles to the first series.

▲ Immediately the second series of exposures is finished the material is returned to the developer. The process then continues through its normal sequence, which depends on the type of material and the manufacturer.

the sheet of paper and place it on the glass, having first removed the colour source from the carrier and taped one of the tricolour filters in place under the lens. Give a second exposure approximately the same length as the first, return the paper to the developer and complete the processing sequence.

If you do encounter difficulties with this method, make a test grid to determine the exposure more accurately. Take great care not to drip any developer on electrical connections or switches that are close to the enlarger.

Filtering with a source

This is a variation on the previous method. The first exposure is made as before and development begun. A filter is taped in position but the source is retained in the carrier. Half way through development the paper is removed from the processing tray and then placed, emulsion side up, on the glass.

A cotton ball is soaked in developer and used to swab the print flat. The enlarger is turned on and the half developed image is quickly aligned with the projected image. It is swabbed continuously with developer until the print appears to have changed in the way that you want. Such an assessment can only be based on experience gained through trial and error. Switch off the enlarger, remove the print from the glass and place it quickly in the bleach-fix and complete the processing.

Using a lith mask

This is a third variation involving tricolour filters that gives white highlights. The negative is contact printed on to lith film so that the black image does not form more than 25% of the entire image area.

The first exposure is given as before and development begun. The filter is taped in place and the source replaced with the lith mask. Half way through development the print is removed from the processing tray and swabbed flat on to the glass with a cotton ball as before. The enlarger is turned on and the image of the mask aligned with the image on the print. The second exposure should be approximately half of the first one. Complete processing as before.

As can be seen, there are many variations in technique that can be employed when making colour solarizations. From them it is very easy to develop your own style. All you need is the inclination to experiment.

▲ The strong patterns made by photographing the twin towers of the World Trade Center in New York from below combine with the unrealistic colours of the solarization to create a bold abstract image.

◄ Even in a simple print solarization, the combination of positive tones and solarized colour creates a disturbing effect.

Tone into line printing

Tone into line techniques are used to produce photographic images in black-and-white only, without any intermediate grey tones—like pen and ink drawings. That means increasing the contrast to a degree where all the grey tones have been eliminated. The bold shapes and patterns that result from the simplification of the image are often very eye-catching. There are several ways of achieving this, the following being the most widely used.

Using a high contrast original

The first method is to produce an original negative of particularly high contrast in the camera, using an ordinary black-and-white film. It might seem to be the easiest procedure, but this is not the case. For instance, the subject lighting must provide full modelling and adequate contrast. Any other sort will make life very difficult.

If you do try this method, the way to begin is to uprate the film two to four times or even more—for example, give a 125 ASA film a value of 600 ASA. This effectively under-exposes the film, recording only the highlights of the subject. Development times are increased by about 50% for every doubling of the ASA rating. The results may seem disappointing, but experience will refine your technique. The best subjects to use are those involving simple shapes.

The contrasty negative that results is printed on the hardest grade of paper available. If necessary the paper developer concentration can be doubled. The final traces of mid-tones, if there are any left, can be eliminated with Farmer's reducer. The main advantage of this method is that, after the initial experiments, a whole cassette of high contrast negatives can be produced at one go. The primary disadvantage is that the negatives produced are of no use for normal printing.

Using a high contrast duplicate negative

This method involves copying an original negative on to extremely high contrast negative materials, for example, Kodalith Ortho Film 2556, Type 3. This comes in 35mm size in 50ft (17 metre) lengths and in sheet film in sizes up to 12 x 28in (31 x 72cm). Such lith films are made for the graphic arts industry to provide extremely high contrast and acutance. (Acutance is a way of describing the visual and physical definition of the edge of an image.) A very rough indication of the contrast would be to compare it with grade four or five paper. It is at least grade 20.

As a rule all lith films are orthochromatic, that is they are sensitive to blue and green light. Hence a red safelight is an absolute must. If you wish to use colour transparencies as originals, you must use panchromatic lith film to get a correct rendering of the colours, and you will have to work in complete darkness.

Lith films require their own special lith developers, which come in two parts, A and B, in liquid or powder form. (The liquid is preferable as the powder can prove very difficult to dissolve properly.) As a rule equal parts of A and B are mixed just before use as the mixed solution oxidizes rather rapidly. The tray life of the mixed solution is about one hour. Separately, in closed bottles, the solutions will keep very nearly indefinitely.

The technique is simplicity itself. The chosen negative, again with good detail and modelling, is contact printed on to a piece of lith film. To get the correct exposure make a test strip. Even with 35mm it is possible to get at least three steps on a frame. Use a piece of glass or a contact printing frame to keep the original negative and the lith film in contact. Remember, in contact printing the two films must be emulsion to emulsion. If you use glass put a piece of black paper under the film to avoid

▶ **Sometimes the conversion into line can add to the atmosphere of a picture. Here the bleak and dismal appearance of the original subject is emphasized by the harsh contrasts. However, even here the shapes are quite simple.**

▲ When selecting images to transfer on to high contrast film look for those with bold shapes that feature subjects that will be easily recognizable in the simplified final form.

▲ As the reduction of the picture to pure black-and-white creates a very artificial image, the negative form can often be as effective as the positive version.

▲ The proportion of black to white in the image depends on the length of the exposure given when converting tone into line. The longer it is the greater the amount of black that results.

reflections from the white base of the printing frame. As a rough guide, the speed of the lith film is about twice that of bromide paper. (No speed indication is normally given by the manufacturer.) Unlike most test strips the one produced by this technique will not consist of different densities. Here the changing exposures produce varying areas of black: the longer the exposure the larger the area of grey in the original negative that is converted into black. It is up to you to choose the proportion of black that you judge to be the most appropriate to the image.

The development time is 3½ minutes in a tray at 68°F (20°C). Try to keep the temperature constant, it makes all the difference. Lith developer is very susceptible to temperature variation. For the first 15-20 seconds in the developer agitate continuously, then leave the tray absolutely still for the rest of the time. Still bath development gives better acutance and, if the format is 35mm, you will need all the acutance available.

The red safelight can be put very near to the developing tray. A glass tray may even be used on top of a box safelight. However, if you do this make sure that all electrical connections are properly protected. In time you will learn to judge the degree of development visually and vary the time used to suit your purpose.

After development, give a short rinse of about 10 seconds, fix for 2 or 3 minutes (in your normal fixer) and wash for the same time as other films.

When dry, the positive that you have produced is contact printed again on to another piece of lith film to produce a negative. This time test for the minimum exposure necessary to give solid blacks in the 3-3½ minute development time. When you print lith negatives, any grade of paper will do. They all give the same result—black-and-white only.

Avoiding the snags

The main enemy is dust. You can't be clean enough. Lith film, due to its high acutance, shows up the minutest spot of dust, which would not show on an ordinary emulsion.

One way to deal with this, if your equipment allows it, is to work on a larger format than 35mm. If necessary, use the enlarger to make bigger positives. It is easier to spot out the blemishes on a larger format. If you can afford it, enlarge the positives to the final print size and make all subsequent

images by contact. On this size a lot of retouching and handwork is possible, and a lith negative or positive on film can look marvellous when sprayed with gold or silver paint on the emulsion side and mounted.

If you should get some slight fogging, you are possibly using old film, which may have base fog due to age. Don't despair. Farmer's reducer will remove this. The black on lith is dense enough to stand a lot of reduction.

▲ Old buildings with ornate shapes and plenty of fine detail can make suitable subjects to convert into line. However, care is needed when assessing the amount of tone to change into black, for confusion can result from the loss of too many details.

▶ The graphic shapes created by line work make eye-catching party invitations. The small spot of colour emphasizes the broad black areas.

▲ Although line prints do not have grey areas, stippled areas of fine, contrasting detail, such as that shown in the fur of this cat, provide a contrast to the solid areas of black and white.

▶ Line film can be used as a mask to give unusual effects with colour film. Here *Fred Dustin* has sandwiched a lith positive and a colour negative together to give highlights in shadow areas.

Pen and ink drawings on prints

If you wish to make a pen and ink drawing of a rather complicated subject, such as a landscape, and do not have the skill to do so, there is a way in which photography can help. Make a very flat and soft black-and-white print showing all the required detail. Use soft paper, and curtail development to about 1 minute. Make sure that there are no blacks and no dark greys. It doesn't matter if the print is slightly uneven due to short development time. Fix it, give it a short wash (5 minutes) and dry.

Now draw in or outline on the print the relevant detail with waterproof ink or waterproof felt-tip pen and let the ink dry properly. The result is a pen and ink drawing on top of a photographic image.

The next step is to eliminate the photographic image with Farmer's reducer (see page 152). Provided the image is soft enough, this should cause no difficulties. The easiest way is to fill a tray with the reducer to sufficient depth to immerse a print. Once the photographic image is gone, fix the print once more to make sure that no silver halide is left in the emulsion, wash and dry.

As a rule it is better to use matt paper or other non-supercoated papers which simplify the drawing technique because they take ink well. On glossy paper Indian ink tends to flake off and most of the waterproof felt-tip pens tend to smear slightly. They require very careful and delicate handling in the reducer and in subsequent fixing and washing.

If many copies are required it is advisable to make the first one about twice as large as the final size and then copy that with the camera once more. This helps to camouflage the imperfections in the drawing as they will be reduced in size and are hence less noticeable.

Tone separation in black-and-white

Tone separation, also known as posterization, is one of the most elaborate darkroom techniques used in photography. It requires advanced darkroom skill. Yet it can produce quite special images, particularly when it is used with colour materials (the subject of a separate section). The original picture is simplified into layers of tone in much the same way that contours on a map simplify the original landscape.

To understand it, imagine a continuous tone scale on a piece of paper from white to black. All the possible gradations of a photograph are set out on it. If we take a similar strip of paper and divide it into four sections with each composed of flat, even areas of white, light grey, a darker grey and black we have tone separation.

In practice, to get such a result, a lot of intermediate tones have to be eliminated and, although four tones are normally used, there is no need to stick strictly to this. But the more steps you create, the more the result will resemble an ordinary photograph.

Choosing the format

Good results are possible on any film format but, as with other techniques, the bigger the size the less precision and care are needed to get a good result. If you do not have access to an enlarger that takes the larger formats it is possible to do everything by contact printing, working in the size of the final print required.

Unfortunately, as at least three positives and one negative on film are required, the cost of the materials can become expensive, especially if the final print is to be 8 x 10in (20 x 25cm) or larger. If these considerations are important then it is best to produce the largest positives and negative that can be put in the carrier of your enlarger. If your enlarger only takes 35mm you will have to work by contact.

Equipment necessary

The first things you need are a pin register board and a matching punch. These can be very expensive but, fortunately, a home-made substitute is easy to construct. The author's equipment is an inexpensive paper punch to make a paper template and two wooden pegs set into a piece of blockboard which fit exactly the holes made by the punch. This is important. It must be a tight fit with no slackness, no tearing of holes. Ten minutes' sandpapering will get this right. The pegs only need to be about ¼in (5mm) high but it is

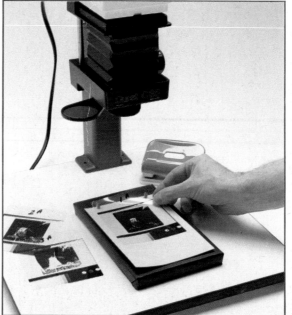

◀ A pin register board is essential for tone separation work. Here white paper has been positioned on the board so the negative can be seen. The matt black surface prevents the image reflecting back on to the film.

▶ The most striking examples of tone separation are often those with sharply defined areas. The separation of the image into bands of even tone, that follow the shapes of the building and gravestones, gives a dramatic effect.

▼ Landscapes should have a good contrast range. If they do not, clear separations will be difficult.

probably easier to work the wood if they are a little longer. They should be slightly rounded on the top.

The board itself should be about 4 x 6in (10 x 15cm)—big enough to be easily visible in the darkroom. Paint or dye the top surface black, or stick a piece of black paper or cloth on it. This prevents any light reflecting back through the film base and causing a halo effect.

A piece of clean glass at least 1in (3cm) bigger all round than the largest size of film will be needed, as will scissors to

cut the test strips, a magnifying glass and a red safelight.

Choosing the materials

You will need two sorts of film in this technique: a high-contrast film, such as lith film (for example Kodalith Ortho Type 3), and a non-colour-sensitive continuous tone film, such as Kodak Gravure Positive Film or Ilford SP 352. all of which are available in sheet form. Obviously you will need lith developer for the lith film. The continuous tone

222

Step-by-step to tone separation

Making the separation positives

▲ Once you have selected a negative, place the pin register board on the enlarging baseboard and focus. When you are satisfied, tape the register board firmly in position. If it moves at any stage you will have to start again.

▲ Do not try to make too many test steps on one sheet of film. If you do not get the range you want at first, make another test. As the manufacturers do not specify the film speed, guesswork is inevitable initially.

▲ When processing lith film, rock the tray to give continual agitation. Remember that the steps produced will be of the same density but will contain different size areas of black.

Making the separation negative

▲ To calculate the exposures for the separation negative, make a test strip on continuous tone film without any film in the negative carrier.

▲ The first step of the test should be a very pale grey, the third a mid-grey. If they are not, dilute the developer and re-test until you are satisfied.

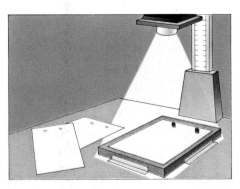

▲ Having found the correct exposure to give a pale grey, use it to contact print the three positives, one by one on to a sheet of continuous tone film positioned on the register board.

film is processed in print developer, which works more quickly than most negative developers.

Suitable subjects
Pictures of women are rarely enhanced by tone separation. Landscapes, animals, buildings or practically anything else will work. Avoid big flat areas of tone: they can make the subject look like a still from a science fiction film.
As for negative quality, it is easier to work from one which has a full tonal range with good modelling. It also helps if it is slightly contrasty.

Separation positives by enlargement
If you have an enlarger that takes a variety of film sizes use it to produce

the largest positive the carrier will accommodate. A longer focal length lens than normal, that is a 75 or 80mm rather than a 50mm, is useful. If such a lens is used it ensures that the enlarger head is farther from the pin board, so that the exposures are longer and more manageable.
To get the size of enlargement you require, place the pin board on the enlarger baseboard. As the pin board is black, focus on a piece of white paper. When you are satisfied, tape the pin board firmly to the baseboard to prevent any movement. Insert and focus negative and then make a test strip. To avoid wasting film, cut a sheet of 5 x 7in (10.2 x 12.7cm) lith film in half lengthwise. Punch holes in it so that it can be firmly positioned on to the pin

board. Make a test strip. Process the strip in lith developer at 68°F (20°C) for 3–3½ minutes. When examining the results three different densities should be chosen. On the first only the shadow areas should be black. The second should record half the middle tones as black, while the third should be completely black except for the highlights. Once you know the exposures necessary to produce these results take three full sheets of film and punch registration holes in each. Fit each one in turn on to the pin board and make a different exposure each time, using the exposures already selected from the test strip. Place small coins on the free corners of the film to keep them flat. Process the exposed film in exactly the same way as the test.

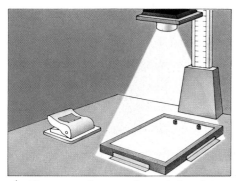

▲ Once you have selected the three exposures, punch holes in three sheets of lith film. Place each sheet in turn on the register board and give each one an exposure calculated from the test strips. Process as before.

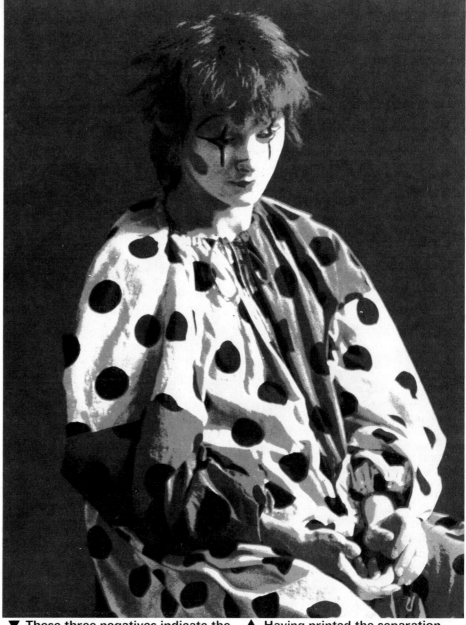

▲ The separation negative is composed of four different densities. Three are produced by the three exposures; the fourth is clear film which was covered during every exposure.

▼ These three negatives indicate the degree of separation into areas of black produced on lith film by different exposure times. Clear differences are necessary for a good final result.

▲ Having printed the separation positives on to one negative it is very simple to make the final print. The negative is enlarged in exactly the same way as any other.

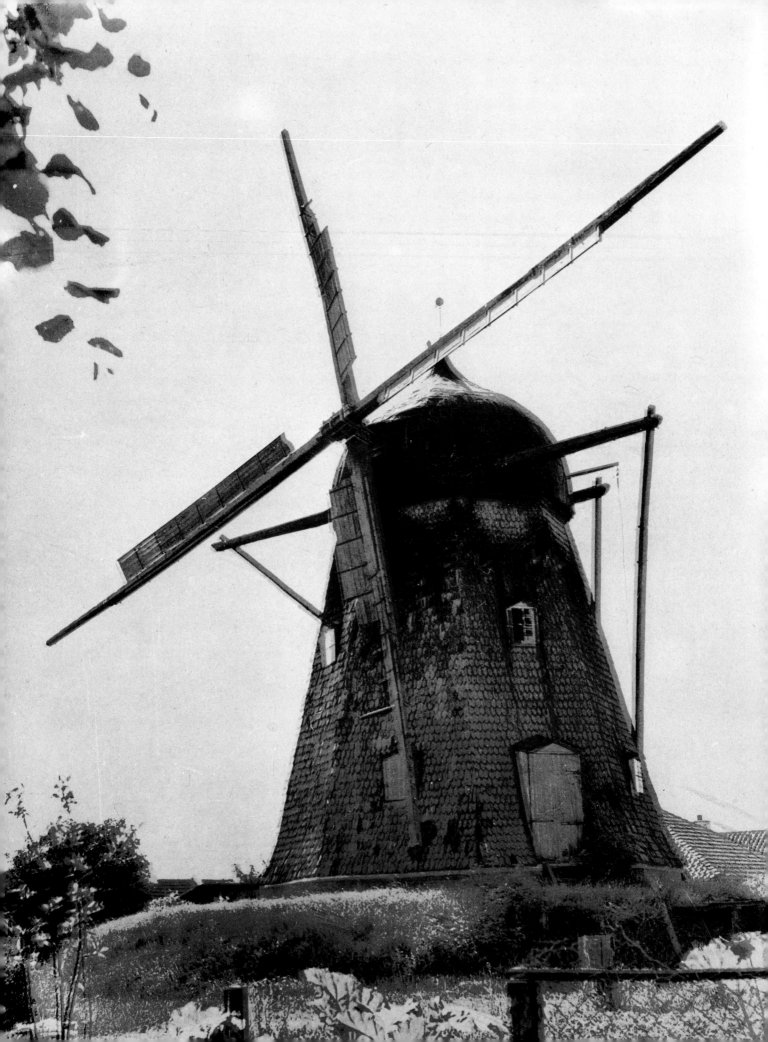

Separation positives by contact

When making contact positives use the enlarger as the light source. Cut a 1½in (3cm) wide strip of sheet film and tape it edge to edge to the negative. Punch two holes through the strip of sheet film so that it can be positioned securely. Cut a piece of lith film in half and place it, emulsion up, on the pin board. Place the negative on top, emulsion down, cover it with a piece of glass and make a test strip. From the result, select the three exposures that give the three different areas of black image described above.

Once the three exposure times have been calculated, make the three separate positives. To do this cut two sheets of 5 x 7in (10.2 x 12.7cm) sheets of lith film into half lengthwise and punch holes in the three you intend to use. Fit one on to the pin board, emulsion up and fit the original negative, still attached to the strip of film, on top of it, emulsion down. Place the glass on top and make the first exposure. Repeat this procedure with fresh film for the

two other exposures and process the films as before.

Retouching the results

Once you have a set of three separation positives they should be checked with a magnifying glass for dust spots. Any pin holes in the black areas can be filled with photo opaque. Black spots in the clear areas can be removed with reducer. If the images are 35mm size such work will require great care.

Calculating exposures for the negative

Once the positives have been made, either by enlargement or by contacting, the next stage is to make a series of exposures, without a negative in the enlarger carrier or on the pin board, to produce a graduated series of grey tones. Such a series is known as a grey scale. A continuous tone film, such as Ilford SP 352, which can be processed under yellow safelight conditions, is used for this and the making of the subsequent negative.

Although the exposures necessary to

give the desired results vary from enlarger to enlarger, the following suggestions can be used as a guide. Raise the enlarger head until it is about 25in (65cm) above the baseboard. With a 75W bulb, and the lens stopped down to f11 or f16, the exposures should be about 2, 4, 8, and 16 seconds.

Develop the sheet of film in print developer at 68°F (20°C), agitating continuously for 1½ to 2 minutes. Rinse and fix in the normal way. The first step on the scale should be very pale with the tone only just visible. The third should be the equivalent of cigarette ash. If the scale is too dark dilute developer and re-test. Never alter density by changing the developing time.

Making the separation negative

Once you are satisfied with the steps on the grey scale, punch holes in a sheet of the continuous tone film. Fit it on to the pin board and fit the first of the separation positives on top of it, that is the one with the smallest image area. (Remember, they should be emulsion to emulsion.) Keep the two in contact with a sheet of glass placed on top.

Give the exposure that was found necessary to produce the palest tone on the grey scale. Replace the first positive with the second and give an exposure equivalent to the first on to the same sheet of film. Finally, replace the second positive with the third and make an exposure double the previous one, again on to the same piece of film.

The exposed film is now taken from the pin board and processed in the same way as the grey scale. Once it is dry the tone separated negative that has been produced will be seen to have four areas of differing density: a clear area which was always covered during exposure; a pale grey produced by the first exposure; a dark grey area that was illuminated during the first and second exposures; and a black area that was uncovered during all three exposures. This negative can be printed on to paper without any difficulty or special techniques, producing your posterized print.

Once this technique has been mastered it is very easy to move on to colour posterization. Although the images are created on colour paper the negatives and positives are made on high—contrast black and white film. The colour is produced by making the exposure with strongly coloured gelatin filters over the light source. This process is described next.

◄ **Working in black-and-white can often result in large areas of mid-grey that are restful to look at.**

▼ **The same image used in conjunction with posterized colour (see overleaf) can give an exciting result.**

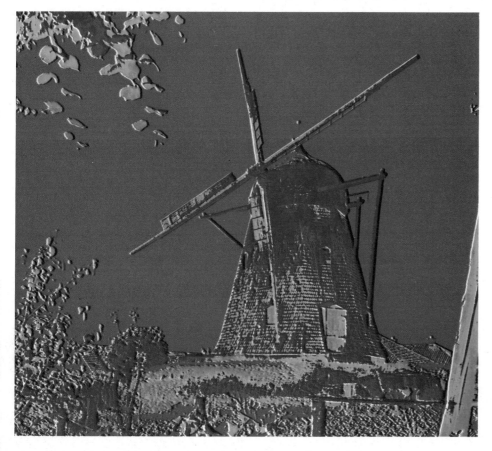

Tone separation in colour

This darkroom technique, also known as posterization, makes it possible to create striking colour images composed of areas of pure, flat colour. This is done by exposing colour paper to various combinations of high contrast black and white positives and negatives while placing strongly coloured gelatin filters over the light source. It requires a set of separated positives and a complementary set of separated negatives to be produced from one original black and white negative.

The positives are made as for black-and-white tone separations.

To make the complementary set of negatives, punch registration holes in a sheet of lith film and fit it on to the pin board. Place one of the positives on top of it, cover both with glass and make a test strip. Choose the shortest exposure that gives a dense black image as the standard exposure. All the positives are then contact printed on the pin board, each on to a separate sheet of lith film, giving the same exposure in each case. The exposed film is then processed in the normal way.

It is sensible to number the separation positives 1, 2 or 3 on the edge of the film, and the complementary negatives 1A, 2A and 3A. The negatives and positives are also known as masks.

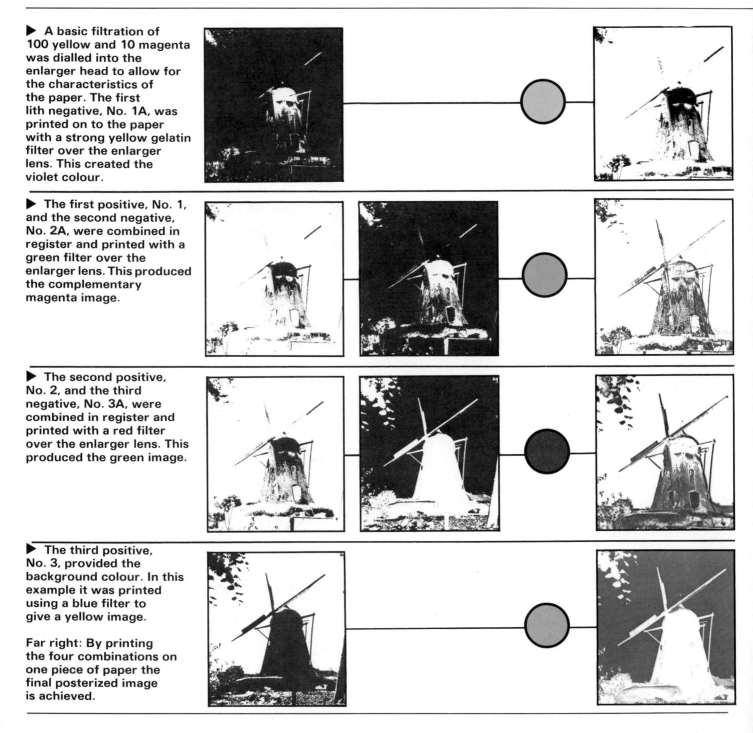

▶ A basic filtration of 100 yellow and 10 magenta was dialled into the enlarger head to allow for the characteristics of the paper. The first lith negative, No. 1A, was printed on to the paper with a strong yellow gelatin filter over the enlarger lens. This created the violet colour.

▶ The first positive, No. 1, and the second negative, No. 2A, were combined in register and printed with a green filter over the enlarger lens. This produced the complementary magenta image.

▶ The second positive, No. 2, and the third negative, No. 3A, were combined in register and printed with a red filter over the enlarger lens. This produced the green image.

▶ The third positive, No. 3, provided the background colour. In this example it was printed using a blue filter to give a yellow image.

Far right: By printing the four combinations on one piece of paper the final posterized image is achieved.

Posterized colour prints

The number of colours in a posterized colour print is determined by the number of pairs of negatives and positives derived from the original negative. A pair is needed so that, after an exposure has been made through one, the complementary mask can be used to protect the already exposed area while a second exposure is given. Prints can be made on either negative/

◀ Think carefully about the finished effect before posterizing an image of the human figure. By using green across the face *Lawrence Lawry* has created a very sinister result.

◀ One way of creating a variation on posterization is to begin with a colour negative, make a set of separation positives and then print one of these in register with the colour negative.

▶ Posterized colours make their strongest impact when used with simple shapes. The choice of filters is also important. By selecting this discordant colour combination *Heino Juhanson* created a powerful image.

▼ Not all posterized colour images are intended to give a dramatic effect. Here *Fred Dustin* has created a lighthearted image by changing the duck into a pure yellow shape and setting it against the blue of the water.

positive or reversal paper, as well as print film if a transparency is preferred. To produce the pure colours needed, strongly coloured gelatin filters are used to cover the enlarging lens during exposure. Those used on theatrical lighting offer a suitable range of colours and are inexpensive.

Making the exposure

Your first posterized colour print is best made with just one pair of masks. Fix the pin board in position on the enlarger baseboard. Turn out the light and cut a piece of paper down to the approximate size of the pin board. Punch two register holes and fit the paper on the board, emulsion up. Place one of the masks, for example No 2, emulsion down, on the paper and cover with a sheet of glass. Tape the first filter under the lens and make a series of exposures to produce a test strip. Remove the first mask and replace it on the register pins with the complementary mask, in this case No 2A. Cover with glass, tape a different gelatin filter under the lens and make another series of test exposures. Process the paper in the usual way.

The processed test will indicate the most pleasing densities for the colours involved. No correction for colour balance will be needed as the effect of the gelatins is so strong that any colour casts are obliterated.

To produce the final print, repeat the sequence giving the selected exposures through each of the masks. Once the basic technique has been mastered, printing sequences involving more than one pair of masks can be attempted. The elaborate images that can be produced will only be limited by your experience and imagination.

Storing and filing photographs

These days most people first see their photographs as colour prints, which they usually store in the packets supplied by the processor. However, it's easy to become tired of sorting through pictures you don't like to find those you want. To solve this problem most people buy an album in which to keep their best results.

Print albums

The least expensive albums are those that hold just one print per page in a transparent envelope (they are also supplied to take instant pictures) and they have the big advantage of being compact and easily carried. But, since you can only see two prints at a time, they do not allow you to produce an imaginative or amusing display; in order to do that you need a much bigger album.

The best of these have large pages, perhaps 9 x 12in (30 x 22cm), and are of the type in which the whole page is covered by a sheet of transparent self-adhesive plastic. Instead of having to use rubber solution or print corners to attach the prints to the page, you simply lift the plastic sheet, position the prints and then smooth the plastic back into position. It holds them securely in place, but if ever you want to change the prints or reposition them it only takes a few seconds to lift the covering sheet and replace it. There is no adhesive and no mess.

People often try to make a symmetrical arrangement of prints on the page. This lacks interest and it is much better to have prints of varying size, large ones of the more interesting subjects and small ones to supply background information. Try laying them out on the page surface and rearranging them to find the most interesting and eye-catching layout before you fix them in position.

The captions, which can be written in white ink if the album page is dark, should give information you cannot obtain from the print. If there are people in the shot note down their names. Before long it will be difficult to remember the identity of people met casually on holiday. The same goes for the name of the place as well.

Filing prints and negatives

If you become really involved you will quickly realize the need to build up some kind of filing system, otherwise you will never be able to find what you want without a vast amount of trouble. Various systems are in use, perhaps the

An album is the best way to store prints if you wish to show them to your friends. By taking a little trouble over the layout and the labelling a very attractive book can be created.

KIDDIES TOUR

◀ Some storage systems are flexible enough to accommodate both slides and prints. The sheets for this binder are made for a variety of formats.

most common being the one in which each processed film is given a number. The individual negatives are already edge-marked from 1 to 36 or from 1 to 12 by the manufacturer. By combining the two numbers, for instance 151/22, you have a system that allows you to locate a particular negative very quickly. This number should always be written on the back of any print made from the negative. (Use a soft pencil to do this to avoid any print damage.) It is also a good idea to write the date and location on the back of the print for your own benefit to save having to look them up in the negative file where such details should always be noted.

Prints stored in boxes and envelopes can develop a curl, if they have been made on fibre-based rather than resin-coated paper. Place a sheet of heavy card on top of them to keep them flat.

Print life

Unless black-and-white prints are fixed and washed properly they will stain and fade even if stored in ideal conditions. Because resin-coated paper can be processed so rapidly, for instance, many photographers think it safe to shorten the already short times still further. If this is done the prints will not last very long. It is always better to wash for too long rather than for not long enough.

Colour print processing times are so precise that there is little opportunity to cut corners. However, the dyes in all the colour materials on the market at present tend to fade eventually if the prints are exposed to bright sunlight for long periods, though the rate at which this happens varies considerably according to the type of material involved. If stored in the dark in boxes or

envelopes, or in an album, they will last for very long periods indeed.

However, prints should not be kept in envelopes made from very cheap paper for this will cause fading or staining wherever it touches the print surface. The specially made storage products are, of course, quite safe.

Storing slides

As with prints, most people start off by storing their slides in the boxes in which they were returned. Though these boxes give good protection and are useful as a temporary store, it really is essential to get your slides into a proper filing system, correctly captioned, as quickly as possible.

The first step is to examine the returned slides so that you can reject any that are incorrectly exposed, out of focus or suffering from any other defect. It is then necessary to record the subject and date (Kodachrome slides are returned with the date of processing marked on the mount) as quickly as you can.

As your slide collection grows it is best divided into different subjects. Starting off with 'holidays', for example, you may soon have to subdivide the category into slide boxes holding 'holidays-sailing', 'holidays-climbing', and so on. Under the heading 'portraits' you might

▲ If you do not want to store your prints in an album this print box provides protection while still allowing easy access. Negatives are stored in the base.

▲ Once you have selected the slides you wish to keep, it is important to store them in dust-proof boxes. Any dirt on a slide will be very obvious when it is projected.

have male, female, children, character, etc. If you then need a slide of a particular kind of subject it is simply a question of turning to the correct box and choosing one.

Slide albums

An alternative system is to use a slide album. These look very like ordinary print albums but usually hold 15 slides per page in transparent plastic pockets. The sheets are detachable with a translucent back so that the slides are viewed by diffused light. By holding a sheet up to a window all the slides on the page can be seen at the same time and it is a comparatively simple matter to find any particular one.

If you have assembled a slide show it is best kept ready for projection in a magazine with all the slides the right way up for projection and in the correct order. The magazines should be stored in a box or covered by a dust-proof lid. Sheets are also sold to fit suspension file cabinets.

Slide life

Slides will quickly fade if exposed to bright light for long periods. Since they are usually stored in the dark, this problem only arises if they are projected too often or for too long. The major enemy is humidity. This can cause mould to grow on the gelatin emulsion and once it is there nothing much can be done to save the slide.

Air conditioning deals with this problem. But fortunately, for those homes without, the average living room is usually quite dry enough for slide storage. The places to avoid are damp darkrooms, cupboards, sheds or cellars. If the boxes of slides have to be stored for very long periods they should first be dried out thoroughly to rid them of unwanted moisture. Then the lid should be sealed round the edges with waterproof tape to prevent any damp from entering.

Filing and storing negatives, prints and slides calls for a certain amount of mental discipline. There is always a strong temptation to put if off until later, but once you get behind with your filing it becomes extremely difficult to recall the necessary information. As in everything the maxim is, 'start as you mean to go on'.

◀ **These wallets have the advantage of thoroughly protecting your slides when they are being carried around while allowing them to be viewed easily as the occasion arises.**

How to make pictures that last

Photographs have always been taken for the same reason—to provide a permanent record of the passing moment. As the years go by these records grow in value and importance. Yet if the pictures do not last but fade away or change colour with the passing of time the whole exercise is self-defeating.

Pictures, including paintings, have always faded or changed. Many early photographs have deteriorated irretrievably, and the reason we think 19th-century processes were more permanent is that the only examples we see are those prints that have survived.

What precautions can be taken to prevent pictures deteriorating? Problems of preservation can be split into three sections: preservation of black-and-white prints, preservation of colour prints, and preservation of original negatives and slides. An additional distinction may also be made between preservation for ordinary purposes, the prints lasting, say, up to 20 years, and long-term or 'archival' storage of 100 years or even longer.

Black-and-white prints

The image on black-and-white prints is usually silver. This is a reactive metal which readily combines with gases in the air, which is why silver objects tarnish. Old prints often show a blackish sheen on the surface in places. This is silver sulphide and can be avoided by storing prints where fumes, especially those containing sulphur compounds, cannot reach them. If the image turns yellowish in patches or fades away this is usually caused by incorrect fixing or washing.

Fixing

It is very important to use fresh fixer for long-lasting prints.

● A good method is to have two fixer baths. The first does most of the work leaving the second, fresher bath as a safety measure to make sure that the fixed emulsion can be washed easily. After several prints have been fixed the second bath becomes the first and a new second bath is prepared. Give prints half the manufacturer's recommended fixing time in the first bath, then transfer them to the second to complete fixation.

● Keep a record of the total volume of fixer used, and make sure that you don't try to fix more prints than the recommended capacity.

● Always allow prints sufficient time in the fixer and move them occasionally while fixing.

● Prints on resin-coated (RC) papers should not be fixed too long because liquid can start to soak in at the cut edges, making them impossible to wash properly. However, the edges can be trimmed off afterwards.

Washing

Washing must be done well. Fibre-based papers take half an hour or longer to wash. RC prints wash more swiftly—five minutes or so is usually ample.

● The water should not be too cold. When the temperature goes below 59°F (15°C) chemicals wash out more slowly—the ideal is 64.4°F to 75.2°F (18°C to 24°C).

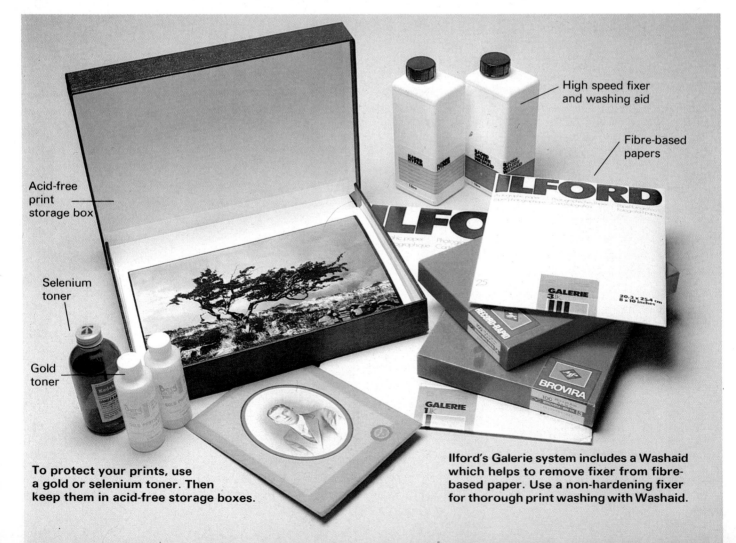

Acid-free print storage box

Selenium toner

Gold toner

High speed fixer and washing aid

Fibre-based papers

To protect your prints, use a gold or selenium toner. Then keep them in acid-free storage boxes.

Ilford's Galerie system includes a Washaid which helps to remove fixer from fibre-based paper. Use a non-hardening fixer for thorough print washing with Washaid.

● Make sure fixer-laden water from the bottom of the washing container can drain away—there is no point in having fresh water flow in at the top and away again while prints sit in a stagnant pool below.

● Prints wash more easily if the fixer is not a hardening one, though this means care may be needed with delicate emulsions—for example, Ilford Multigrade—that can be damaged easily when wet. It is a good plan to make a test on a print occasionally to check that your washing procedure is efficient. Commercially available testing solutions are simple to use: you put a drop of the liquid on the print margin and see if it changes colour. One way to speed up washing is to use a 'hypo eliminator', but modern research does not recommend this. An idea which does work is the washing accelerator produced by Ilford for their Galerie paper-base materials. After a preliminary wash the print is soaked in this bath, which loosens the hold the fixer has on the fibres of the paper. The print is then washed again. This method will work with all papers of the older type, not just Galerie, and instead of the special chemical you can use a solution of sodium sulphite.

Toning for permanence

A good way of preserving the silver image in a print is to convert it into a more stable chemical compound. A slight change in image colour will also result. Turning the silver into silver sulphide (usually warm brown or sepia) or selenium sulphide (brown with hints of purple) is quite simple, and ready-made chemicals can be bought.

An excellent alternative is gold toner, but this is very expensive and tends to give a bluish tone suitable for snow scenes, seascapes and the like. The layer of inert gold formed does give the silver image of the print a high degree of protection.

Other processes such as carbon and platinum printing are too specialized for general use.

▶ **Superior negatives deserve to be made into superior prints. This picture by** *Naru* **was printed by Adrian Ensor on Ilford Galerie, which is designed to give long lasting prints when processed with special chemicals. Compared with other fibre-based papers, Galerie has a less brilliant base tint, a good tonal range with rich shadows, and slightly lower contrast for each grade. It suits negatives like this very well.**

Colour prints

The dyes in ordinary colour prints are not as permanent as most photographers would like. One problem is that the three colours of which they are made (yellow, magenta, and cyan) do not fade at the same rate. A slight change in colour balance is more noticeable than an overall loss in density. If the blue dye fades more quickly than the others, the print will take on a yellow cast.

Little can be done in processing to increase the life of colour prints. If the photographer processes his own colour prints, then the three solution method, using a final stabilizer bath, is safer for long-term storage than the more convenient two-bath method.

Storage

Many black-and-white papers and almost all colour ones are on the modern waterproof RC base. While this makes washing easier the base itself has drawbacks for storage since the polyethylene coating can grow brittle and crack in time. This is particularly likely to happen if the prints are exposed to light and handled often. (Some Cibachrome prints are on white acetate plastic; this

can also grow brittle with age.) For long-term storage, dry conditions and low temperatures help, as is shown in the box, below right.

Papers particularly suitable for archival storage are Ilford Galerie, which has a neutral black tone, and Kodak Medalist or Bromesko, which give a warm black image. These are on ordinary paper base. Both black-and-white and colour prints fade most rapidly when exposed to strong light. Therefore they should be placed where direct sunlight will not reach them. Glass in the print frame stops some ultra-violet radiation, which is the main cause of fading, and also guards against fumes. The surface of the print can be sprayed with special aerosol lacquers to give similar protection. A clear wax polish can also help in the same way.

One slide-to-print material has significantly better lasting qualities. This is Cibachrome, which has very stable dyes. Prints for long-term viewing are often made on this material, though it is not completely permanent.

In general, colour prints keep better in the dark, and should therefore be stored in albums or boxes.

▲ **Half this colour print was exposed to bright light. Dye fading and paper base discolouration have turned the exposed half yellow. All colour prints will fade in light if given sufficient time; the amount of fading and the colour of the image left depend on the strength and colour of the light, and on the printing paper used.**

Keep prints cool and dry

High temperatures and damp conditions can make your prints fade much faster. Your pictures will last longer if kept cold and dry. For example a print that would last four years without noticeable fading in a warm room at 75°F (24°C) would only last two years in a room at 86°F (30°C). The same print stored at 44°F (7°C) could be expected to last 40 years; frozen at 14°F (−10°C) the print would last 400 years! Of course, nobody will keep their prints in a refrigerator, but the lesson is clear: keep your prints cool to make them last. Never hang photographs in a warm, damp room such as a kitchen.

◀ Two prints of the same negative were made on ordinary black-and-white paper—one processed properly, one badly fixed and washed, then stored under hot, damp conditions. This is an extreme case.

▲ ▼ This old photograph shows signs of fading and discolouration. A new print made from a copy negative exposed through a blue filter restores some of the detail that the years have hidden.

Preservation by copying

If a print fades it is possible to have another made from the negative or the slide. These may also have altered during storage, but some compensation can be made during printing.

If the base material of a colour print is breaking up a copy print can be made, though there is not usually any provision made for correcting colour changes if this is done commercially.

Old photographs, such as Daguerreotypes or tintypes, need special techniques for cleaning and it is best to leave this to professional restorers. Yellow stains on old prints can be made to vanish by using a yellow filter on the lens when a copy is made. A blue filter can increase the contrast of a copy made of a uniformly faded print.

Storing negatives and slides

Since negatives and slides have an impermeable base, there are usually fewer problems from residual chemicals that might affect the emulsion than there are with prints. Storage envelopes for negatives and slides should be those specially made for the purpose, since ordinary envelopes may contain harmful chemicals or allow moisture to reach the film in humid climates. Do not keep negatives in wooden containers; use boxes or cabinets of metal or plastic that have been specially made for photographic storage. Some types of vinyl give off fumes that can damage film.

Colour negatives and slides, like prints, are subject to fading even in the dark, though it is projecting slides for long periods that causes most deterioration.

Different types of film will fade at different rates: Kodachrome slides have the best keeping characteristics because the dyes they contain are added to the emulsion during processing. As a result they are more stable, and have an estimated storage life greater than 60 years. Other types of slides give an image that is made up of dyes that are less stable, and may show measurable fading in six to 10 years, though this will probably not be enough to make the photograph unusable for everyday purposes.

Colour negative materials are the most unstable, and cannot be expected to remain unchanged for more than six years. For all but the most precise technical and scientific purposes, however, all materials can be expected to last longer than these figures indicate.

Displaying your photographs

Having put a lot of time, skill and money into making a fine print it is worth spending a little more time and effort to show your work to advantage. Of course, the right mounting and framing won't turn an indifferent picture into a work of art, but it can enhance a good picture, just as bad presentation can ruin one.

How you choose to mount and frame your pictures will depend largely on personal taste. But there are general principles which have been well tried by professional photographers and people who mount exhibitions, and these form a base to work from.

Borders in the enlarger

There are two techniques involved in presentation to be considered at the printing stage. The first is to have a black line bordering the edges of your picture, about 1in (3cm) in from the edges of the printing paper—a refinement especially suitable for pictures with mainly pale tones near the outside. Some enlargers have metal carriers—or carriers with all-round masking facilities—which provide a space large enough to accommodate a single frame together with some of the borders around the frame, between the frame and the sprocket holes on 35mm film. (You must not let the sprocket holes get into the black border because they may give it a tonal variation.)

If you have an enlarger like this, simply position the frame centrally in the carrier and adjust the masks if necessary. Decide how wide a border you want between the image and the sides of the printing paper and adjust the illumination accordingly. A 1-1½in (2.5-4cm) border is suitable on a print 8 x 10in (25 4 x 20.3cm)—the larger the size of paper the larger the border can be—with the border at the bottom slightly wider than the top and sides. Now expose your print in the normal way and your image will have an even black border to its edges.

If your enlarger has a glass negative carrier, the process is a little more complicated. Decide on your image size and measure the area accurately on the enlarger baseboard. Take a thin black card, the size of your paper, and with a sharp craft knife, cut out a piece equal to the size of your image. Then trim off ¹⁄₁₆in (1.5mm) from all round this piece.

Now place the outer frame on top of the printing paper, weight it down, and expose the picture. Remove the negative from the carrier, and put the cut-out piece of black card on top of the print so that the small gap is equal all round. Turn on the enlarger lamp for about 4 seconds: develop the print.

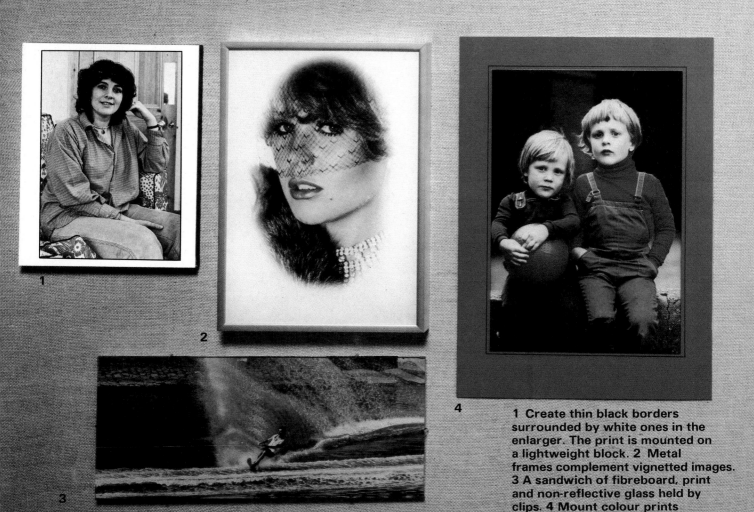

1 Create thin black borders surrounded by white ones in the enlarger. The print is mounted on a lightweight block. **2** Metal frames complement vignetted images. **3** A sandwich of fibreboard, print and non-reflective glass held by clips. **4** Mount colour prints

Vignette

The second presentation technique which you can do at the printing stage is to frame the image—or part of the image—in a vignette. Take a piece of black card and cut out an oval from the centre. Don't worry if the oval is not perfect. With the red filter in place, switch on the enlarger. Hold the card with the cut-out vignette between the lens and the baseboard and move it up and down until only the area of the image you want to print appears on the paper.

Swing the red filter away and time the exposure. During the exposure keep the card moving very slightly round and round, to soften the edges of the image. This gives the picture a vignette shape with a white surround. If you want a black surround, take the oval piece of card and attach it to the end of a piece of coat hanger, or similar wire, with a piece of adhesive tape. First expose your picture normally. Then swing the red filter into place and switch on the lamp again. Find the right spot between the lamp and the baseboard for the oval cut-out to mask the area you want to exclude. Swing the red filter away and, as before, keep the wire-handled tool moving. Allow enough time for the surround to be completely fogged, and then develop as normal.

Fibreboard mounts

How you choose to mount your photographs depends largely on the style of the picture and where it is to be displayed. One simple and effective way to present photographs—and one which is suitable for most situations—is to attach them to ½in (15mm) thick fibreboard, chipboard or blockboard. Ask your timber dealer to cut you a piece the same size as your print. Smooth one of the surfaces and the four sides with sandpaper, and drill a hole in the centre of the back about 2in (5cm) from the top edge wide enough to take the head of a nail, on which the board hangs.

Block mounts look their best with the prints flush mounted, and there's a choice of three ways to do it: adhesive spray (also called photo-mount), rubber cement or dry mounting tissues (they come in several sizes). These materials can be bought from most photographic dealers and artist's suppliers. A spray is quick and easy to use (always follow the instructions on the side of the can and work in a well-ventilated room) but not the most reliable method.

If you use a rubber cement, make sure that it is suitable for photographic prints. Spread it thinly and evenly on

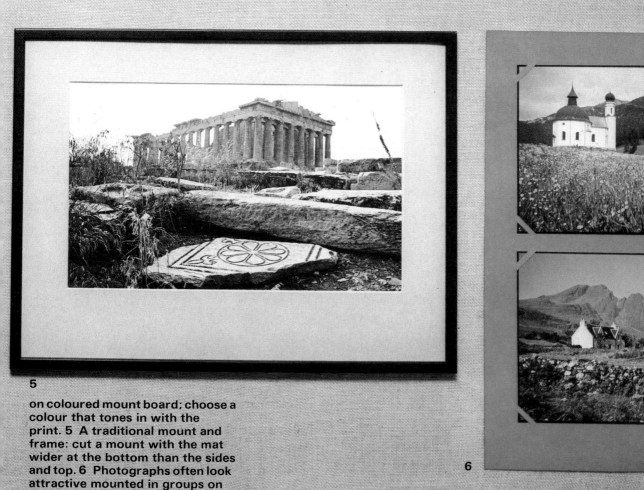

5

on coloured mount board; choose a colour that tones in with the print. **5 A traditional mount and frame: cut a mount with the mat wider at the bottom than the sides and top. 6 Photographs often look attractive mounted in groups on the same mount board.**

6

the mount and on the back of your print. Wait until the two surfaces are dry and then bring them into contact, starting at one corner and smoothing the two surfaces together with a soft cloth. Rub away any excess cement that may get squeezed out at the sides. The disadvantage of rubber cement is that the print may start to curl at the edges if it is kept in a constantly warm room.

Dry mounting is the most satisfactory method. However, it requires an electrically heated press and so is more expensive, initially. (If you belong to a camera club you may have access to one there.) But it provides lasting results as well as allowing a protective heat seal and, if desired, a selected texture to be added to the surface of your print. A heat seal protects the print from dirt, damp and scratches.

When dry mounting you can always trim the tissue to size after the mounting is completed—but use a sharp razor blade and a steel rule to guide you so you don't nick the edge of the board and spoil its appearance.

Framed photographs

Attractive as block mounts may be, there is still nothing to match a photograph well displayed in a proper frame. First you need to fix your print to a piece of mounting card. Although this comes in a variety of colours, most professional photographers prefer to use white, cream or grey and sometimes black for colour prints.

Your mount should be large enough to give your print plenty of space—a print 8 x 10in (25.4 x 20.3cm) needs at least 12 x 15in (38 x 30cm). The print can be placed centrally or slightly above centre, whichever you think looks best. And you can attach the print by any of the three methods outlined for block mounting—the technique is the same. However, as the print and mount are to be held between a backing board and a sheet of glass, you can simply use a tape hinge or photo corners to attach it to the card.

You could now frame your picture as it is, but you can improve its appearance further by first adding a windowed card mat (or overmat). This not only provides a frame within a frame, but also prevents the print from coming into contact with any other surface.

Cutting a picture mat

This is more difficult than you may think and success depends on practice, the sharpness of your knife, the thick-

ness of the mount card and the steadiness of your hand. So if you find it difficult, you could buy professionally or machine cut mounts from an art supplier.

But if you want to try your hand at it, here is how it is done. Using a sharp craft knife and a steel rule, cut a piece of the mounting card to the required size. Now cut another piece about ⅛in (3mm) smaller all round, and check both pieces with a set square. Put the print in place on the slightly larger piece of card and mark its position all round with a pencil.

Cut out this area of card by placing your steel rule 1/16in (1.5mm) outside the pencil mark. Hold your knife at an angle of 45° to the card to produce a cut with a bevelled edge. Using the steel rule as a guide, grasp the knife firmly and draw it through the card.

When all four sides have been cut, push the 'window' through and, if necessary, trim the four corners with a razor blade and smooth down the edges with an artist's bone-honing tool. Place the windowed mat face down alongside the mount. Join the two pieces together with a strip of 1in (3cm) brown paper tape which acts as a

Making a tape hinge

▲ To attach a photograph to a mount, place it on the mount in the correct position and outline the corners at the top with a pencil. Flip the print over so it lies face down with its top edge in the same place. Hold the print securely in place with a weight while you tape it along this edge to the mount, using masking tape or gummed tape. Now swing the print back.

hinge. Now slip your print between the two pieces of card and position it in the window. Hold it firm with a weight, open the mat and mark the print's position along its top edge with a pencil. Attach the print to the mount with a tape hinge.

Now you have to choose a frame. The choice is vast, but remember that frames should focus attention on a picture and never become the focus of attention themselves. Often a modern, metallic frame looks out of place in a traditional décor—and vice versa. You could play safe—and save money—by using a 'frameless' frame. The mounted print is sandwiched between a piece of hardboard and a piece of glass with clips to hold it together. If you plan to hang your picture where it catches a lot of light, use non-reflective glass.

The final touch

If you decided not to add a black border to the print itself, you can add one to the mount—the final touch before you add the frame. You should use water colour—a neutral colour, black or grey is most suitable. Apply it with a lining or 'bow' pen, using a steel rule as a guideline. But be sure to test the colour first on a piece of waste card.

Whether you use ordinary glass or non-reflective glass (which is more expensive) is purely a matter of taste. Although the non-reflective type seems a natural choice, some photographers believe that its advantages are overrated.

Photographs should be hung at eye-level and, if possible, where they can be examined closely. Colour prints will fade in time if left in direct sunlight or under spotlights. The rate of fading appears to be related to film speed—the lower the speed, the more permanent the colour image. Black-and-white prints have a much longer life.

Finally, a word of warning about the materials you use in mounting. Standard mounting card and the adhesive tapes contain acids which in time migrate into the print and cause tarnishing and deterioration. It is still not clear how long it takes before this acid migration starts to do real damage. It could be as much as 25 or 30 years, but the risk is there. However, there are acid-free materials on the market, so if you want a mounted photograph to last, it is these archival, acid-free materials which you should be using when you mount it.

Step-by-step to dry mounting

1 DRY MOUNTING TISSUE
Trim a single sheet of dry mounting tissue to a size slightly larger than your print. Place print face down on a clean surface. Attach tissue to back of print by touching the centre lightly with a hot tacking iron (bought from a craft shop). Alternatively, use the tip of a domestic iron, set on low to medium heat.

2 TACK TO MOUNT BOARD
Carefully position print, with tissue attached, on mount board. Lift one edge of print and tack tissue to the board beneath; use the tacking iron or a domestic iron. Repeat the process, lifting the opposite corner of the print this time.

3a THE MOUNTING PRESS
Put mount with print face up in the mounting press. Cover print with silicone release paper. Close press; leave under pressure for about 20 seconds at recommended temperature—about 176°F (80°C). If using an RC print, protect the surface with an acetate foil overlay between it and release paper.

3b ADDING A HEAT SEAL
To heat seal a print, cut off the required amount of seal. Roll a spiked roller over the seal to perforate it and prevent air being trapped during sealing. Tear off backing paper and tack heat seal, through the release paper, to the print. You can also put an embossing sheet on top of the seal. Finally, place in mounting press.

3c MOUNTING WITH AN IRON
Follow the directions up to the mounting press stage. As an added precaution, however, place 2 sheets of silicone release paper over the print. Apply the iron, set at medium heat, with firm even pressure at each spot. Don't move the iron across the picture, lift it from one spot to the next.

4 FINISHING BLOCK MOUNTS
You can dry mount your prints on mounting board which is very thick card, often coloured. You can also dry mount on to chip board cut to the size of the print. This is a block mount and the edges should be painted. The colour will depend on the picture and where you intend to hang it. Matt black or white probably will work best.

Making duplicate slides

Even if you have only a modest collection of slides you will still occasionally need duplicates. For those with extensive collections the need can arise very frequently. For displays or exhibitions it is generally better to provide a duplicate rather than a valuable original slide, since repeated projection and examination inevitably causes fading.

Duplicating also gives the same advantages to the slide user as are enjoyed by those who produce prints from colour negatives. For example, some copiers allow you to crop unwanted portions from the edge of the image or to enlarge areas to make new pictures. Slides that are a little too dark, and even some slides that are too light, can be duplicated to produce better images. It is even possible to improve slides that have poor colour balance.

The simplest way to duplicate slides is with a projector. But better results are obtained with special equipment.

Using a projector

This method involves projecting the slide and photographing the image.

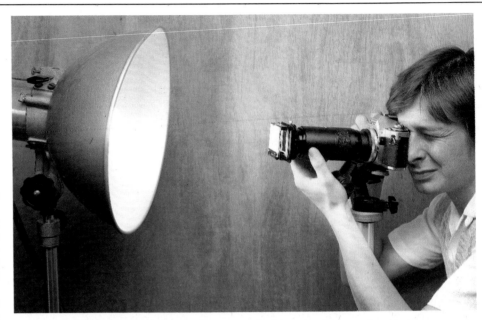

▼ This type of slide duplicator can be used to enlarge sections of a transparency. Using a suitable adaptor the zoom lens can be fitted on to the front of your standard camera body.

▲ The ideal set up for the amateur. Using the duplicator with an automatic SLR, tungsten lighting and tungsten balanced film allows you to exercise accurate control over the exposure.

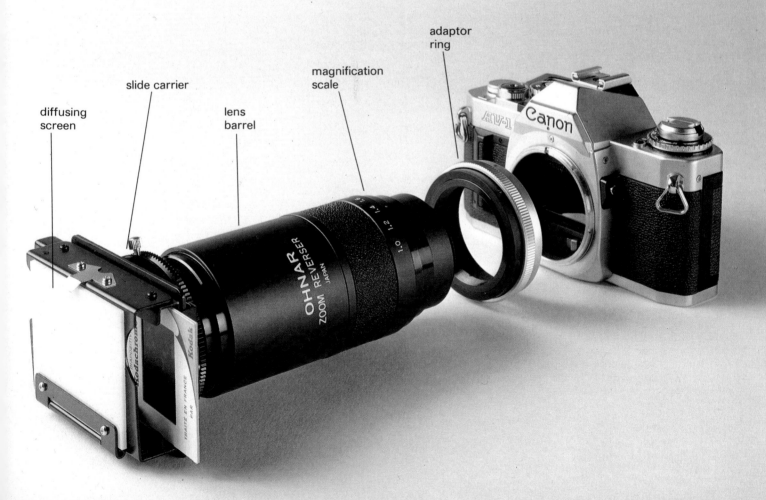

diffusing screen

slide carrier

lens barrel

magnification scale

adaptor ring

Use a slide projector and a suitable
screen— beaded or shiny surfaces should
be avoided. A matt white screen is best,
but if you don't have one a sheet from a
large sketch pad will do.

● Set up the projector and screen in a
darkened room and arrange the camera
on a tripod as close as possible to the
axis of the projector beam. If the focal
lengths of the projector and camera
lenses are about equal, the camera can
be positioned alongside or directly
below the projector. Avoid using a
shorter focal length camera lens than
the one supplied with your projector
since this will mean moving closer to the
screen and producing some distortion.
However, you can use a longer focal
length lens to allow you to move farther
back or to enable you to duplicate
selected small areas of the picture.

● You will need tungsten balanced
film and an 80A filter to correct the
colour balance. Choose a high speed
film, otherwise exposures may be too
long; it is best to avoid time exposures
since the ventilation system of the
projector may introduce a slight vibra-
tion that will impair the sharpness of
the image.

● To calculate the exposure needed,
use an exposure meter to take a re-
flected reading from the projected image
on the screen. To be sure of success
bracket your exposures.

Duplicating attachments

There are several relatively inexpensive
camera attachments that provide you
with all you need for slide duplicating
except a light source. Some are simple
slide holders with a diffusing screen that
fits directly on a normal lens. Other
devices are more versatile; they may
include a zoom macro lens in the outfit
which allows the selection of a portion
of the image to be duplicated. These
attachments are used in conjunction
with an SLR camera.

Nearly all good quality lenses produce
acceptable results. Most lenses do not
allow you to focus down to close dis-
tances, so you will need an extension
tube, bellows attachments or a macro
lens. Macro lenses are designed to give
good definition right across the frame at
the close focusing distances used when
duplicating slides. Another possibility
is to use reversing rings to mount the
lens so that the rear element faces the
image being copied.

Light sources

There is a great temptation to use day-
light as a light source, but the variation

There are many reasons
why it can be impossible
to frame your subject
in the way you would like
when you are making the
original exposure. If
you are using negative
film cropping can take
place during enlargement.
Until recently the
amateur was denied the
same possibilities when
using reversal film.
Here the subject was
inappropriately shot as
a horizontal picture
(left). Cropping while
duplicating allows a
more suitable vertical
frame to be created
(above).

in its intensity and colour throughout the day make consistent results very difficult to obtain.

The simplest light source to use is tungsten, primarily because the colour balance is constant and the exposure is easy to calculate. The disadvantage is the heat produced by the bulb. This can be overcome by using a dimmer switch so that the light is turned on full only when necessary.

Electronic flash has the advantage of providing illumination close to daylight in colour balance. Flash units are also portable and cool to use. One disadvantage is that you will need some auxiliary lighting—a desk or table lamp —to allow you to set up and focus. Getting the exposure right can also be a problem, and at least one film must be used on an experimental basis before the right exposure for your set up can be ascertained.

Using tungsten lighting. With a movie light or a photoflood in a suitable fitting, use a clamp or similar device to position the light source behind the slide in its holder. To prevent overheating, place the light source at least 2ft (60cm) from the slide and use the dimmer switch to reduce the light intensity to a comfortable level while setting up.

● Work with a tungsten balanced film and an 81A correction filter over either the camera lens or the slide.

● To take an exposure reading, place the meter cell close to the slide on the camera side and measure the light transmitted. Alternatively, remove the slide and take an incident light reading. Again, to be sure of success, bracket exposures. Cameras with through-the-lens metering are a great advantage as the exposure is automatically calculated.

Using electronic flash. The distance between the slide and the flash unit depends on the power of the unit. For most compact units, which have guide numbers of 100 or less, with an ASA 100 film position the flash about 2ft (50cm) from the slide. With larger units use a distance of about 3ft (one metre).

● Since this form of lighting is similar in colour balance to daylight, use daylight balanced film.

● Exposure is difficult to assess unless you have an electronic flash meter. Do a test by making a series of exposures from f5.6 to f22 at one stop intervals. Keep a record of your exposures and flash distances so that you can repeat them accurately. The processed test strip will reveal the aperture setting which produces the best results.

Practical aspects

Most cameras 'see' slightly less than appears in the final image. This means that your duplicate may have an unsightly border round it unless you take steps to correct this. Your first few duplicates will soon tell you how much larger the image should appear in the viewfinder to remove the border. In general, an extra ¹/₁₆in (2mm) all round is the most you need to allow.

Controlling contrast. You will notice that there is a tendency for the contrast of the image to increase with duplication. There are ways of overcoming this. The easiest method is to pre-flash the film. This gives the film a low intensity, uniform exposure that lowers maximum density and shadow contrast. (As you will need to expose the

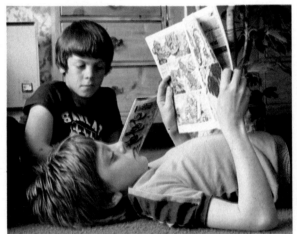

same section of film twice in this technique you should check your camera instruction booklet to see how to do this with your particular model.) An exposure without the slide in position, of about 1/100 normal is generally adequate. You can produce this easily by using a neutral density 2.0 filter over the camera lens and making an exposure without the original in position at the same setting used for making the duplicate.

Altering colour balance. Colour balance is another feature that may need changing. To do this, make the duplicate using selected colour compensating filters over the camera lens or between the light source and the original. Don't use more than three filters over the camera lens or defini-

Shooting informal portraits in the home can easily result in an unpleasant colour cast on your original slide (left). Light is reflected from highly coloured fabrics and surfaces in a way that is difficult to detect with the eye. Variations in processing can also produce casts. To overcome this problem make a duplicate with colour compensating filters over the camera lens or the light source (below).

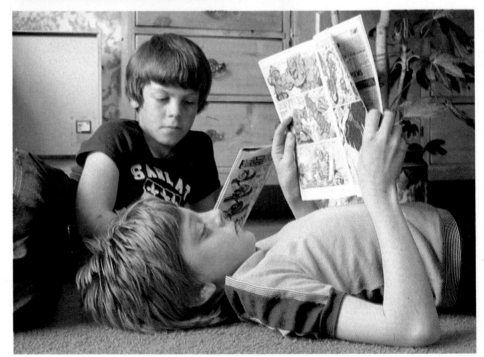

tion will be impaired. However, within reason, you can use any number of filters between the light source and the original.

To decide which filter is needed, view the original and duplicate side by side under the same viewing conditions. Decide which colour is in excess by viewing the duplicate through various colour compensating filters until the most appropriate is found. Concentrate on mid-tones, particularly such sensitive areas as flesh tones or neutral colours. Ignore the fact that the highlight areas may appear over-corrected or shadow areas under-corrected.

Any filters used will also have an effect on the exposure. The change may be small, but with several filters the increase necessary may be as much as

one stop or more. You will have to make allowances or recalculate the exposure with the filters in place.

It is also possible to use duplicating techniques to create entirely new images — for example, by combining two or three slides to create a montage, or adding strong filters to create unusual effects. When used in this way there is no such thing as 'correct', only what you feel is right.

▼ Colour casts are very noticeable when the subject features flesh tones and large pale areas (below left). Some films are especially prone to such faults, and corrected duplicates can be the only way of obtaining a natural appearance in the finished transparency (below right).

Electronic slide copiers

There are several commercial duplicating units available that give a selection of sophisticated controls. Such units generally use electronic flash for illumination and some have auxiliary flash to give a measure of contrast adjustment. Among other controls, units often have attachments that take correction filters and metering devices to give accurate exposures at varying magnifications. Although relatively expensive, these copiers do simplify the duplication of a variety of originals. They are particularly useful if you regularly need to produce a lot of duplicates.

Glossary

Words in *italics* appear as separate entries.

A

Accelerator The chemical in a *developer* which speeds up development, usually an alkaline salt, such as sodium carbonate or borax.

Acetic acid An acid commonly used in diluted form (2%) for *stop baths*—the processing step that follows the developer. It is also used in acid fixers.

Acid A substance with a pH less than 7. An acid neutralizes an alkali (a substance with a pH greater than 7). Stop baths are acidic to neutralize traces of developer, which is alkaline. Acids typically feel 'coarse' and the stronger ones, such as sulphuric or nitric acid, can cause serious burns.

Acid fixer A *fixer* which includes an acid, usually acetic acid.

Acid hardening fixer An acid fixer that contains an ingredient, usually alum, to harden the film or paper emulsion. The film or paper is then less susceptible to scratching.

Actinic light Any kind of light that causes a chemical or physical change in a substance. When photographic materials are struck by actinic light of sufficient quantity they produce an invisible, often referred to as a *latent*, image which is made visible by the developer.

Acutance A measurement of image sharpness which is dependent on the film emulsion and the developer. A laboratory test determines acutance from how rapidly image tones change between light and dark on going across a 'knife-edge'. Images of high acutance show high contrast across edges and appear sharper than images containing the same subject detail but with low acutance. Special high acutance developers make images appear sharper but, unfortunately, images produced this way also appear grainier (show a peppery effect).

Additive colour A method of mixing light where virtually any colour (except the pure spectrum colours) can be produced by adding various proportions of the primary colours—blue, green and red. The additive colour mixing system was used for early colour photographs, such as Autochrome and Dufaycolor and is used today in colour television.

Agitation The technique of moving or stirring a solution to ensure even and consistent processing. The amount of development or other processing, (for example, fixing) that occurs depends partly on the degree of agitation. (However, time, temperature and chemical formulation are also important.)

Air bells Small bubbles of air which stick to the surface of the emulsion on films and printing papers, and stop the developer acting on the emulsion.

Alkali A substance with a pH greater than 7. Alkalis are used in most developers and give the solution its 'slippery' feel. The stronger alkalis, such as sodium hydroxide (caustic soda),

should be treated with care as they can cause serious burns.

Alum A type of chemical often used as a *hardener* in fixers. The most common ones are potassium alum and chrome alum.

Anti-halation backing A thin coating of dye, pigment, or carbon on the back of the film which helps to prevent light from reflecting back to the light-sensitive emulsion. Without the backing, all bright lights in a scene would have a strong 'halo' of light around them.

Archival processing Processing of black-and-white films and prints to ensure that they can be kept in collections for a very long time without deteriorating.

ASA American Standards Association (former name of American National Standards Institute). The sensitivity (speed with which it reacts to light) of a film can be measured by the ASA standard or by other standards systems, such as DIN. The ASA film speed scale is arithmetical—a film of 200 ASA is twice as fast as a 100 ASA film and half the speed of a 400 ASA film.

B

Barium sulphate This chemical is the main constituent of the baryta coating which bonds the paper base to the light-sensitive emulsion on non-RC (resin-coated) photographic paper. The barium sulphate gives the paper its whiteness.

Base This is the support on which photographic materials are coated, and may be paper or a clear plastic (that is, film) such as cellulose triacetate. Base is also a general name for alkalis.

Baseboard The board on which an enlarger stands. An enlarger which does not have a baseboard big enough to contain large images can often be made to give large prints by swivelling the head round the column through 180°. The image is then projected on to, for example, the floor. With the enlarger head in this position, it is usually necessary to place a heavy weight on the baseboard to counterbalance the enlarger head.

Bas-relief This is a photograph that has a 3-D appearance and resembles a subject that is strongly lit from the side. To make a bas-relief print, a negative and a positive of the same image are sandwiched together, slightly out of register, in the negative carrier of the enlarger.

Bleach A chemical bath that reacts with the black silver formed by the developer in one of two ways; either by converting it back to its original silver salts, or by dissolving the silver completely. Most colour processes use the type of bleach which regenerates the original silver salts. Some black-and-white processes also use bleach, for example, sepia toning.

Bleed This refers to a picture that has no borders, with the image extending to the edges of the paper or page.

Blocked up This refers to an area of a negative which is heavily over-exposed

(and/or over-developed), and when printed gives no details in the lighter parts (highlights) of the scene. Sometimes it is possible to regain these highlights by reduction of the negative with *Farmer's reducer*.

Blocking out The technique of painting parts of the negative with an opaquing solution to block out the image in the treated areas. It is used to remove unwanted backgrounds which will then appear white on the final print. This operation requires considerable skill.

Brightness range The brightness difference between the darkest and the lightest parts of a scene (or image). This range depends on the reflectance of the various objects in the scene and on the nature of the illumination. On a sunny day with few clouds this range may exceed 1:100, but the same scene on a dull day may have a brightness range of less than 1:20. With careful exposure and film development, both of these conditions can be accommodated by the film.

Bromide paper A popular type of black and white printing paper which gives a neutral or blue-black image colour. It gets its name because the emulsion used is silver bromide. The other main type of black and white paper is *chlorobromide* (for example, Bromesko, Ilfomar) which gives a warmer (browner) image colour.

Buffer Chemicals which help to maintain the pH (acidity or alkalinity) or chemical constitution of a solution, and so keep the solution activity constant. They are normally used in developer solutions to help give consistent processing. Examples are borax/boracic acid and sodium carbonate/sodium hydroxide.

Burned out A term used when the highlights of a print or slide have no detail and appear as a white mass. This usually occurs when the negative is severely over-exposed and/or over-developed (see *Blocked up*).

Burning-in A printing technique where extra exposure is selectively given to parts of the image. In black-and-white printing burning-in darkens tones and modifies contrast (when using multicontrast papers); it is particularly useful for bringing out highlights. In colour printing, burning-in can modify both tone (density) and colour.

C

Cartridge A light-tight container in which lengths of film are sold. Normally these are made of plastic and come in two sizes—a 126 size and a 110 size.

Cassette A metal or plastic light-tight container which holds various lengths of 35mm film. They are smaller and simpler than cartridges, and some types may be used more than once.

CC filters 'Colour compensating' filters which are used in enlarging colour film to modify the final overall colour balance of the print. Their various strengths are indicated by numbers usually ranging from 05 to 50. For example, the weakest yellow filter is 05Y and the strongest magenta filter is 50M. These filters may be combined to

give a complete range of colour correction.

Characteristic curve The curved line on a graph which describes precisely how the photographic film or paper responds to light. These characteristic curves, sometimes called D log E curves, are used by photographic manufacturers for quality control.

China crayon (also known as a china-graph pencil or china marker) can be used to write on film without damaging the surface and is easily cleaned off when required.

Chlorobromide paper A photographic printing paper which consists of a mixture of silver chloride and silver bromide emulsions. When developed these papers give a warm-toned image, as compared with most bromide papers which produce a neutral or blue-black image tone.

Circle of confusion All out-of-focus points of a subject appear as circles (of confusion) on the final photograph. These circles are 'seen' as acceptably sharp if their diameters are below a specified limit. This limit depends on factors such as viewer's eyesight, viewing distance, and the type of subject.

Clearing bath The general name given to any processing step which is designed to remove or chemically neutralize any potentially harmful chemicals which are carried over by the film or paper.

Clearing time The time required in the fixer for the film to go from its initial milky appearance to a clear film. To ensure that fixing is complete it is normal to leave the film in the fixing bath for twice the clearing time. The clearing and fixing times depend on the formulation of the fixer, temperature, agitation, and the amount of use the solution has already had.

Cold cathode A type of fluorescent tube which runs at a low temperature and is a suitable light source for diffuser enlargers. Compared with condenser enlargers, there is some loss of definition and contrast. Cold cathode light sources are mainly used for large format enlargers.

Colour balance The overall colour cast of the film or print. Normally a film or print is balanced to give grey neutrals (such as a road or pavement) and pleasing skin tones. The colour balance preferred by the viewer is a subjective choice, and this is the reason why there is a variety of colour films available; each one having its own colour characteristics.

Colour head An enlarger head which includes built-in movable coloured filters to alter the colour of its light. The correct filtration for the colour negative or transparency being printed is dialled in. Most colour heads produce a softer light than a conventional black-and-white enlarger. A conventional enlarger, however, can be used for colour printing by placing coloured filters in a simple filter drawer positioned above the condenser.

Colour negative A type of film which

is used primarily to give colour prints; although colour transparencies and black-and-white prints may also be produced. The colours of a colour negative are complementary in colour and hue to the original subject colours. For example, a light blue appears as a dark yellow and a dark green appears as a light magenta. The characteristic orange appearance of all colour negatives comes from the built-in corrector which improves overall colour fidelity.

Colour reversal A colour film or paper which produces a positive image directly from a positive original. Thus a colour reversal film gives a colour transparency directly from the original scene and a colour reversal paper (for example, Cibachrome or Ektachrome paper) gives a positive print directly from a transparency. Most colour reversal materials are identified by the suffix 'chrome'.

Colour sensitivity The response of a photographic emulsion to various colours (wave-lengths of light).

Colour temperature Different white light sources emit a different mixture of colours. Often, the colour quality of a light source is measured in terms of colour temperature. Sources rich in red light have a low colour temperature—for example, photofloods at 3400K (Kelvin)—and sources rich in blue light have a high colour temperature—for example, daylight at 5500K. Colour films have to be balanced to match the light source in use, and films are made to suit tungsten lamps (3200K) and daylight (5500K).

Compensating developer A developer which acts more vigorously on the less exposed areas of the film and less actively on the more exposed areas. The net result is a reduction in negative contrast. At best, this compensating effect is only small, and is most found when very dilute developers are used with a minimum of agitation.

Complementary colours These are pairs of colours which, when mixed together, give a grey (neutral). For example, a grey is formed when yellow and blue light are mixed together; therefore, yellow is complementary to blue and vice versa. Other complementary colours include green and magenta, red and cyan.

Condenser A simple one-element lens which causes light to converge. These lenses are used in many enlargers to focus the light source on to the back of the enlarger lens. Their position or strength (focal length) may be varied according to the film size being enlarged.

Contact printing In this type of printing the film is held in contact with the printing paper and no lens is needed. Contact printing can be used for making prints from large films—4 x 5in (10.2 x 12.7cm) and larger—or when contacts are required for inspection or records.

Continuous tone Any photographic material which is capable of producing a continuous range of tones from white to a maximum black. A continuous tone

material shows subtlety of tone throughout its range, from rich shadows, through mid-greys, to delicate highlights.

Contrast The variation of image tones from the shadows of the scene, through its mid-tones, to the highlights. Contrast depends on the type of subject, scene brightness range, film, development and printing.

Contrast grade The number which indicates the contrast of photographic paper. The scale of numbers usually runs from 0 through to 5, with the most contrasty papers having the highest numbers. Negatives having a low contrast—referred to as soft negatives—are printed on to high-number paper grades such as 3 to 5, normal negatives should print best on grade 2, and high-contrast (hard) negatives on grades 0 and 1.

Contrast index A Kodak system designed to standardize negative printing characteristics. If a photographer develops all his films to the same CI, then he should obtain prints of similar quality on similar paper grades, provided that other factors, such as lighting and subject matter, are also standardized.

Copper toning A chemical process which changes the image colour of black-and-white prints. Depending on the activity of the toner and the time it is allowed to react, a range of tones from warm brown to red may be obtained.

Cropping The selection of just a portion of the original format of a negative or print so as to modify the composition.

Cyan A blue-green colour which is complementary to red. It is one of the three subtractive primaries; the other two are yellow and magenta.

D
Darkroom A room which is sufficiently dark to enlarge and process photographic prints; and to handle, without fear of premature exposure (fogging), other photographic materials.

Daylight colour film A colour film which is designed to be used in daylight without or with electronic flash or blue flash-bulbs. This film type can also be used in tungsten or fluorescent lighting if a suitable filter is put in front of the lens or light source.

Density The ability of an area of a paper or film to absorb light. Areas of high density absorb a lot of light and appear black, whereas low-density areas absorb only a small amount of light and appear closer to white (theoretically having a density of zero). A density increase of 0.3 represents a doubling of light-stopping ability so a 1.3 density area absorbs twice as much light as another area of 1.0 density.

Density range The difference between the minimum density (D min) of a print or film and its maximum density (D max). Typical density ranges are 0 – 1.8 for black-and-white and colour papers, 0 – 1.2 for black-and-white and colour negatives, and 0 – 3.0 for colour slides.

Developer A solution which converts the latent image on exposed film or paper to a visible image. A black-and-white developer produces a black silver image, while a colour developer generates both a black silver image (removed in later steps) and a coloured image consisting of three dyes (yellow, magenta and cyan).

Developing by inspection This technique, whereby the paper or film is viewed periodically under a suitable safelight during processing, allows development to be terminated at exactly the desired time. Development by inspection is only practical for papers and some slower films.

Developing tank A container in which film or paper is developed. The film is loaded on a spiral (reel) which is then placed in the tank. Most tanks allow processing in normal lighting, once the photographic material has been loaded into the tank which must be in total darkness.

Diapositive A positive image which is designed to be projected or viewed by transmitted light. All transparencies are diapositives.

Dichroic filter A filter, usually made of glass, which transmits certain colours and reflects all others. Its actual colour depends on the material coated on the glass. Dichroic filters are favoured for colour enlargers because they are resistant to both fading and heat.

Dichroic fog A magenta-green stain (colloidal silver) which can form on a developing film if it is transferred directly from the developer to the fixer without first going through a wash or stop bath. In practice dichroic fog is very rarely seen. Once formed, it is impossible to remove.

Diffraction When light rays pass close to opaque surfaces, such as the blades of a lens diaphragm, they are scattered; this phenomenon, known as diffraction, results in a loss of image clarity. Therefore, lenses which are stopped down to small apertures (f16 and smaller) begin to lose quality. Most lenses are at their best when stopped down by about three stops from their maximum aperture; at this aperture most aberrations are at a minimum and diffraction has not yet started to deteriorate the image.

Diffused image An image which has indistinct edges and appears 'soft'. Overall or partially-diffused images can be produced in the camera by using special lenses and filters, or by shooting through various 'filmy' substances such as Vaseline, transparent adhesive tape and fine stockings. Images may also be diffused during enlarging by placing a diffusing device between the enlarging lens and the paper.

Diffuse light source Any light source which produces indistinct and relatively light shadows with a soft outline. The larger and more even the light source is, the more diffuse will be the resulting illumination. Any light source bounced into a large reflecting surface (for example, a white umbrella, white card, or large dish reflector) will produce diffuse illumination.

Diffusion enlarger An enlarger which illuminates the negative (or transparency) with diffuse illumination, as opposed to condenser enlargers which pass more directional light through the negative. Diffusion enlargers produce images of slightly lower contrast and sharpness; when printing with black-and-white the contrast can be increased by the use of higher contrast papers. The effect of any scratches or other marks on the negative is minimized when a diffusion enlarger is used.

DIN Deutsche Industrie Norm. A film speed system used by Germany and some European countries. An increase/decrease of 3 DIN units indicates a doubling/halving of film speed, that is a film of 21 DIN (100 ASA) is half the speed of a 24 DIN (200 ASA) film, and double the speed of an 18 DIN (50 ASA) film.

D max The maximum density of a processed film or paper. The D max is the darkest part of the image; its value depends on exposure, development, and the type of photographic material.

D min The minimum density of a processed film or paper. The D min is the whitest part of a print or transparency and should be very close to zero. Negatives have a higher D min than positive images and provided their value is not too high, the quality of the final print is not affected.

Dodging The technique used during enlarging which reduces exposure in certain parts of the image by blocking the light. A dodging tool is moved gently above those areas of the picture which require lightening (or darkening if printing from a transparency) while the remainder of the image receives the full exposure.

Double exposure The process of exposing two separate images on one piece of film or paper. This is a relatively simple procedure when enlarging and when using most medium and large format cameras, but can be quite difficult with most 35mm cameras.

Double weight paper The thickest (heaviest) photographic paper normally obtainable. Many types of photographic paper are available as single and double weight, the latter being preferable when handling large print sizes. Resin-coated (RC) papers are normally only available in a medium weight; this is halfway between single and double weight.

Drying marks Marks sometimes formed while the processed film is drying; these may show up on the final print. Usually drying marks are located on the film base side and are normally removed by careful rewashing or gentle rubbing with methylated spirit or a proprietary film cleaner. To avoid drying marks use a wetting agent in the final rinse and ensure that the water is clean.

Dry mounting A method of mounting a print on to a thick card or other support, which uses a tissue of shellac sandwiched between the print and the board. The three are bonded together in a heat press (dry-mounting press).

Duplicate (Dupe) Any copy of a

photographic image (negative or transparency, black-and-white or colour) which is as close a match to the original as possible.

Dye transfer process A professional technique of producing prints and display transparencies of extremely high quality, and which have excellent keeping properties (especially resistance to fading). Because of the high cost it is seldom used by amateurs.

E

Easel Also known as an enlarging easel or a masking frame. It holds the photographic paper flat while an enlarged image is projected on to it. The easel also controls the size and squareness of the print borders.

Emulsion A photographic emulsion is the light-sensitive layer (or layers) which is coated on to the film or paper base. It consists of silver halide salts suspended in gelatin.

Emulsion speed See ASA, ISO and DIN.

Enlargement This usually refers to a print (positive) made from a smaller negative (or transparency).

Enlarger A device which projects an image, usually of greater size than the original negative or transparency, on to photographic paper or film. Enlargers consist essentially of a light source, condenser(s) to control the light, a negative (transparency) holder, an enlarging lens, and some method of varying the negative-to-lens and lens-to-paper distances.

Enlarging lens A lens which is specially designed to give excellent results at the relatively short lens-to-paper distances used in enlarging. A good enlarging lens is essential for high quality prints.

Exposure The result of allowing light to act on a photosensitive material. The amount of exposure depends on both the intensity of the light and the time it is allowed to fall on the sensitive material.

Exposure latitude The maximum variation of film or paper exposure from the 'correct' exposure which still yields acceptable results. For example, most colour negative films have an exposure latitude of −1 (one stop under) to +2 (two stops over). Exposure latitude depends on the actual film in use, processing, the subject and its lighting, and what is considered as acceptable to the photographer.

F

Farmer's reducer A solution of sodium thiosulphate (hypo) and potassium ferricyanide that is used to lighten the whole or parts of a black-and-white print or negative. The two chemicals are mixed just prior to use. It is essential to test the effect of Farmer's reducer on a spare print before applying to 'good' prints.

Fast films Films that are very sensitive to light and require only a small exposure. They are ideal for photography in dimly lit places, or where fast shutter speeds (for example, 1/500) and/or small apertures (for example, f16) are required. These fast films (400 ASA or more) are more grainy than slower films.

Ferrotype plate See glaze.

Film A thin, flexible, transparent material that is coated on one side with a light sensitive silver halide emulsion. It is sold either as rolls or variable widths and lengths, or in sheets.

Film base The material on to which the silver halide emulsion is coated—the two main types being acetate (cellulose triacetate) and polyester (for example, Estar). The polyester type is stronger and dimensionally more stable but is more difficult to work with.

Film speed See ASA, ISO and DIN.

Filter Any material which, when placed in front of a light source or lens, absorbs some of the light coming through it. Filters are usually made of glass, plastic, or gelatin-coated plastic and in photography are mainly used to modify the light reaching the film, or in colour printing to change the colour of the light reaching the paper.

Finegrain developer Any developer which produces a relatively finegrained negative—usually this is accomplished without the loss of film speed. Most modern developers are of the finegrain type—for example, D-76, ID-11, Acutol.

Fixer Solution which makes a photographic image permanent by dissolving all the remaining light sensitive silver halides. Most fixers contain a fixing agent (usually sodium or ammonium thiosulphate), an acid, and a hardening agent to toughen the processed emulsion.

Flat image of low contrast, which may occur because of under-exposure, underdevelopment, flare, or very diffuse (soft) lighting.

f numbers The series of internationally agreed numbers which are marked on lenses and indicate the brightness of the image on the film plane—so all lenses set to f8 produce the same image brightness when they are focused on infinity, the f number series is 1.4, 2, 2.8, 4, 5.6, 8, 11, 16, 22, 32 etc—changing to the next largest number (for example, f11 to f16) decreases the image brightness to ½, and moving to the next smallest number doubles the image brightness.

Focal point The point to which light rays coming from a point on the subject are focused by the lens.

Focusing The act of adjusting the lens-to-film distance so that the subject is sharply focused.

Fogging The act, usually accidental, of all or some parts of the photographic material being developed as a result of something other than exposure to the image. Fogging can be caused by light leaks, chemical contaminants, radiation, static discharges, and mechanical stress.

Fog level The amount of non-image density which occurs when a film is developed, fog level being the photographic equivalent of 'noise' in a hi-fi system. The fog level depends on factors such as the degree and type of development, and the age, keeping conditions and type of film used.

Forced development This occurs when a film (or paper) is developed for longer than the recommended time. Films are force developed when either they have been underexposed, intentionally or otherwise, or when higher than normal film contrast is required, such as when the subject is of low contrast.

Format Refers to the size and shape of image produced by a camera, or the size of paper and so on.

G

Gamma A number that indicates the degree of development that a film has received. The more development a film receives the higher is the value of gamma and the higher is the image contrast. Most negative films are developed to a 'normal' gamma of about 0.7—this usually being a suitable degree of development for printing average subjects on to grade 2 (normal) black and white paper. The value of gamma is found from the Characteristic curve—see also Contrast index.

Gelatin The 'binder' in which silver halide grains are suspended—this light-sensitive emulsion being coated on to the film or paper.

Glaze A glossy surface that results when certain fibre-based printing papers are dried face-down on a glazing plate or ferrotype plate.

Glazer drier For drying glazed (glossy) paper. See Glaze.

Glossy drier. See Glazer drier.

Glossy paper A photographic paper surface that is ultra smooth and produces the greatest range of tones from white to a deep black—other paper surfaces produce a less dense black. Glossy colour papers produce not only the largest tonal range of paper surfaces but also the purest (most saturated) colours. A glossy surface is obtained automatically from resin-coated (RC) papers, but 'conventional' papers need to be glazed to obtain a high gloss.

Gradation The range of tones, from white through to black, in a print or negative and how these tones relate to one another. For example, a long soft gradation indicates a large range of tones that gradually change from one to the next.

Grain The random pattern within the photographic emulsion that is made up of the final (processed) metallic silver image. The grain pattern depends on the film emulsion, plus the type and degree of development.

Graininess The subjective measurement of the grain pattern. For instance, fast films when greatly enlarged produce images that are very grainy, and slow films give relatively 'grainless' images.

Granularity The objective measurement of grain that is obtained from a microdensitometer (measures density of very small areas) trace across a processed film. Granularity figures for one film can be directly compared to those of another film.

Grey scale A series of grey patches joined together ranging from white through light, mid- and dark greys, to black. Usually the differences between adjoining patches are either visually equal or are of equal density increments (eg. 0, 0.3, 0.6, 0.9 etc). Grey scales are very useful for detecting contrast and colour changes.

H

Halation This is the result of light passing through the light sensitive emulsion, then through the film base, and finally being reflected back from the other side of the film and re-exposing the emulsion, but in a different place from the original exposure. Halation is largely removed in modern films by an antihalation backing which absorbs the light before it can return to re-expose the emulsion. Where very bright lights, such as street lamps, are present in a scene, halation still occurs and produces a bright circle around the central lamp exposure.

Half-tone process The procedure that converts a continuous-tone image, such as a photographic print or slide, into one that contains only black (or coloured) dots. The various tones of the original image are represented by dots of various sizes—small dots in light areas, large dots in shadow areas. Half-tone pictures are used in most printed publications and are easily identified in newspaper photographs by the obvious dot pattern.

Halides A group of compounds that consist of fluorides, chlorides, bromides, and iodides. Silver halides (chloride, bromide, iodide) are the light sensitive salts used in photographic emulsions.

Hard A slang term used in photography to mean 'high contrast', such as hard papers (grade 3, 4, 5), hard negatives.

Hardener A chemical that causes a photographic emulsion to dry hard and be therefore less susceptible to damage from scratching. Hardeners are usually incorporated into fixing solutions.

Highlight mask An intermediate negative or positive that is used in some duplicating processes so that highlight contrast is retained in the duplicate.

Highlights Those parts of the subject or photograph that are just darker than pure white e.g. lights shining off reflecting surfaces (sun on water, light shining through or on leaves). The first parts of a scene or photograph to catch the eye of the viewer are likely to be the highlights—it is therefore important that they are accurately exposed and composed.

Hue The colour of an object is described in terms of its brightness (light or dark), saturation (purity), and hue—the hue being the colour name, e.g. red, blue, green.

Hydroquinone A developing agent used in many black-and-white developers.

Hypo The common name given to sodium thiosulphate, a chemical used as a fixing agent in a number of fixer formulations. The fixing agent dissolves any remaining silver halide left in the film or paper after development.

Hypo clearing bath (eliminator) A solution used after fixing and a short wash, to reduce the overall washing time. It reduces the washing time of conventional double-weight photographic papers from 40 minutes to about 10 minutes. A hypo clearing bath has little use for films and resin-coated (RC) papers, which have fairly short washing times anyway.

I

Image An artificial representation of an original scene.

Image fall-off This term refers to the deterioration (fall-off) of an image in either definition or brightness, or both, towards the edges of the image produced by a lens. Image fall-off is only noticeable on lenses of poor quality or extreme design, such as very wide angle lenses.

Infectious development A type of development in which an initial, relatively slow reaction is followed by rapid 'infectious' development in these image areas. The chemical by-products of development act as catalysts for further development. Infectious development occurs with very high contrast materials such as 'lith' films.

Integral tripack This refers to the emulsion structure of modern colour films and papers which consist of three basic emulsion layers coated on top of each other. One layer is sensitive to blue light only, another to green light and the third to red light. These three layers are sufficient to analyse and then reproduce the colours of the photographed scene.

Integrating A term used to indicate an averaging or mixing of light. For example, an incident light reading attachment on a light meter receives light from about 180°, mixes the light, then produces an average reading. Most colour printing heads have an integrating sphere which mixes and diffuses the printing light.

Intensification The technique of adding density and/or contrast to an existing black-and-white negative which is too light to produce satisfactory prints. Chemical intensifiers cannot produce detail where none originally existed, but they can 'rescue' an otherwise unprintable negative.

Irradiation The loss of image definition caused by the scattering of light as it goes deeper and deeper into the photographic emulsion. Irradiation is greatest when the emulsion is thick and, to a degree, the silver halide grains are large; therefore faster films show the greatest loss of definition due to irradiation.

ISO International Standards Organization. The ISO number indicates the film speed and aims to replace the dual ASA and DIN systems. For example, a film rating of ASA 100, 21 DIN becomes ISO 100/21°.

K

Kelvin A temperature scale which is used to indicate the colour of a light source. Reddish sources, such as domestic light bulbs, have a low colour temperature (about 2800K); and bluish sources (e.g. daylight at 5500K) have higher colour temperature values. The Kelvin scale equals Celsius temperature plus 273, thus 100 degrees C equals 373K.

L

Lamp housing The unit into which an enlarger light source is fixed. The shape and size of the lamp housing has an effect on the evenness, temperature, and character (whether point or diffuse source) of the enlarging light.

Latensification The amplification of the latent image before it is processed to a visual image. Latensification can be achieved by chemical or light fogging of the film. This technique is difficult to control and is capable of only a x2 (one stop) increase in film speed.

Latent image The invisible image, produced by exposure of photographic film or paper to light, which is made visible by development. The latent image, when kept at low temperature and low humidity, can remain relatively stable for months and even years.

Latitude When used in connection with films, latitude refers to the amount of under- and over-exposure permissible to achieve acceptable images. Exposure latitude depends on type of film, subject, lighting and the visual quality of the final result. Colour materials, especially slide films, generally have less latitude than black-and-white films.

Light-tight Any container, room etc. which is not penetrated by light. In photography it is essential that developing tanks, changing bags, cameras and darkrooms are light-tight.

Light trap Any arrangement which excludes light from a container or room but still allows entry of chemicals, air, etc.

Lith developer A developer solution used to process lith (lithographic) films.

Lith film A film emulsion of very high contrast which is made principally for the printing industry. It is also used in a number of unconventional photographic processes such as bas-relief, solarization, and posterization.

Local control A term used to describe techniques which change print density and/or colour in local selected areas. There are three main types of local control: 1. shading—which locally reduces the printing exposure and gives lighter tones when printing negatives (darker tones when printing slides); 2. burning-in—which gives darker tones (lighter tones from slides) by increasing exposure in the area concerned; and 3. colour dodging—which changes colour locally by shading the area with a colour filter.

M

Magenta One of the three subtractive primary colours on which modern colour photography is based; the other colours being yellow and cyan.

Magenta is a purply colour produced by mixing equal quantities of red and blue light.

Magnification A term used to indicate the size of the image either on the film or on the final print. A magnification of x1 means the film image and the subject are the same size.

Mask Any device which obscures or modifies selectively one part of an image. Masks are used to alter the tonal scale, colour or content.

Masking frame See *Easel*.

Matt Any surface which is relatively non-reflective and can be viewed without getting specular reflections ('hot spots') from light sources.

Maximum aperture The widest or largest aperture available on a lens.

Metol A developing agent used in many developer solutions. Metol is also known by several brand names including Elon (Kodak). See also *MQ*.

Midtone Any tone which is neither dark (shadow) nor light (highlight). Whether a particular part of a scene reproduces as a midtone depends on the object's reflectance and the amount of light shining on it, the characteristics of the photographic materials used, and processing.

Monobath A black-and-white processing solution which both develops and fixes the film. Providing the monobath is between 64.5°F (18°C) and 75°F (24°C) the actual time (within reason) the film is in the solution is not critical; the film is then washed as for conventional processing.

Monochrome A monochrome picture is the one which has only one colour; the term is normally applied to black-and-white prints or slides.

Montage The combining of two or more separate images to produce a new composition. A montage can involve several techniques including multiple camera exposure, collage (paste-up), multiple printing, and sandwiching of film (negatives or slides).

MQ Any developer formulation which contains both metol and hydroquinone as the developing agents.

MTF Modulation transfer function. A sophisticated system which can be used to measure the recording ability (definition, sharpness) of lenses, films, etc. The MTF instruments produce a series of readings which are often plotted on a graph to give an MTF curve—this needing to be interpreted by experts to have any real meaning.

N

Negative A general term which is often used to describe a negative image on film, whether it be in black-and-white or colour. See also *Negative image*.

Negative carrier The unit which holds the negative (or slide) in the correct position between the enlarger light source and the enlarging lens.

Negative image Any image in which

the original subject tones (and/or colours) are reversed.

Newton's rings A series of ring-like patterns which are found when two surfaces do not quite meet. They can occur in photography when slides are bound in glass, or when glass negative carriers are used for enlarging.

O

One-shot solution A processing solution, usually a developer, which is used once and then discarded. Its advantage over reusable solutions is more consistent results; its disadvantage is slightly increased cost.

Opacity The ability of a material to 'stop' light going through it. See also *Density*.

Ordinary emulsion An emulsion which is sensitive only to UV and blue light. Most black-and-white enlarging papers have ordinary emulsions and can therefore be used under yellow-orange safelights.

Orthochromatic emulsion An emulsion which is sensitive to UV, blue and green light. It can be handled under a dark red safelight.

Overdevelopment Development which is longer than the recommended time. Overdevelopment causes increase in contrast, graininess and fog level, and a loss in sharpness. Occasionally over-development can be used to good advantage when lighting is dim (see *Push processing*).

Over-exposure Exposure which is much more than the 'normal' or 'correct' exposure for the film or paper being used. Over-exposure can cause loss of highlight detail and reduction of image quality. See also *Pull processing*.

Oxidation The effect of oxygen (air) on some chemicals. Some processing solutions, especially developers, are oxidized through contact with air and therefore become less active. If such solutions are to be stored for any time they should be kept in air-tight containers.

P

Permanence of photomaterials The ability of films and papers to keep their original images over a period of time. Permanence is affected by temperature, humidity, exposure to light, the type of material and how it is processed. See also *Archival processing*.

pH A scale used to measure the acidity or alkalinity of solutions. Solutions with a pH above seven are alkaline and below acid.

Phenidone A commonly used black-and-white developing agent. See also *PQ*.

Photogram A picture produced without the aid of a camera. A photogram is made by placing objects of varying opacity on to a sheet of photographic film or paper and exposing with a suitable light source.

Positive image An image which corresponds in colour and/or tone to the original scene.

Posterization A printing technique

which produces an image having two or more (but not usually more than five) tones or colours. The posterized image has large areas of the same tone or colour, and resembles a poster.

PQ Any black-and-white developer having phenidone and hydroquinone as its developing agents.

Pressure plate The plate, usually made of metal, which holds the film both flat and in the correct position for exposure or projection.

Printing frame A frame used in contact printing to hold the negative and photographic paper in contact while the exposure is made.

Pull processing A slang term which means to underdevelop a film or paper intentionally. This technique is used when films are over-exposed.

Push processing The opposite of pull processing—the overdevelopment of films or papers which have been under-exposed.

R
Rapid fixer A fast-acting fixing solution. Most rapid fixers use ammonium thiosulphate as the fixing agent.

RC paper See *Resin-coated paper*.

Reducer A photographic reducer is used to decrease the density of a negative or print. There are a number of formulations, one of the most popular being *Farmer's Reducer*.

Reel See *Spiral* and *Developing tank*.

Rehalogenization The chemical process of converting metallic silver back to silver halide. Rehalogenization takes place in the photographic bleaches used for most colour processes.

Replenisher A solution which is added in small quantities to a processing solution to keep it up to strength.

Resin-coated paper Photographic paper which has a plastic coating on either side of the paper base, the emulsion being coated on top of the plastic layer. RC papers are more convenient to process and dry than conventional papers but have poorer long-term keeping properties.

Restrainer Another name for an antifoggant—a chemical which keeps the level of fogging of a film or paper down to an acceptable level.

Reticulation A 'cracking' of the photographic emulsion which occurs when it receives a temperature shock (for example, hot developer in a very cold rinse).

Retouching The addition to, or removal of, parts of the image. This can simply be the repairing of slight blemishes (dust or hair lines) or complex airbrushing to alter the image completely. It is possible to retouch negatives or positives, in either black-and-white or colour.

Reversal material Any film or paper

which gives a positive directly from a positive (for example, slide film or Cibachrome paper), or a negative directly from a negative.

Roll film A film which is loaded on to a spool and protected by backing paper. The most common roll film size is 120.

S
Sabattier effect The result of giving an image-exposed film or paper a short 'fogging' exposure about halfway through development. If the balance between the image and fogging exposure is correct, the final picture will contain areas of both negative and positive image. The Sabattier effect is also known as pseudo solarization.

Safelight A coloured light which does not fog the photographic material being used. For example, a yellow-orange safelight does not emit blue light, and is therefore suitable when working with materials sensitive only to blue light (e.g. most enlarging papers).

Saturation The purity of a colour. The purest colours are spectrum colours (100% saturation) and the least pure are greys (0% saturation).

Scattering of light The bending of light caused by interaction of light waves with small particles of matter. Scattering occurs in the atmosphere and within photographic emulsion.

Sensitivity of emulsion The response of an emulsion to light, referring to both the spectral response (i.e. which colours cause exposure) and the film speed (how much light is needed to cause exposure).

Sensitometry The precise measurement of film and paper sensitivity.

Separation A separation of the of the original scene or image into two or more component parts. The term usually refers to tri-colour (blue, green and red) separation of an original colour slide or colour negative. The three colour separation negatives or positives can later be recombined to give the original colours of the transparency or negative.

Shading See *Dodging*.

Sharpness The subjective evaluation of how clearly fine detail is recorded.

Shoulder The upper part of a film or paper's characteristic curve. For negative materials, the shoulder represents the highlights of the scene; for slide and other positive materials it represents the shadows.

Silver halides The group of light-sensitive compounds used in photographic emulsions. Silver chloride and silver bromide are used in papers; silver bromide and silver iodide are used in films. See also *Halides*.

Slide A colour or black-and-white positive image on film designed for projection. Also known as transparency.

Slide copier Device which produces a duplicate slide. Also, it is often possible to crop, alter colour, and combine images on to the same frame. Slide

copiers range from simple lens attachments to sophisticated professional units.

Sodium hydroxide Strong alkali (high pH) which is used in some developer formulations—mainly those used for high contrast work. It should be handled with care as it can cause serious chemical burns.

Sodium thiosulphate The chemical 'hypo' which is the fixing agent used in many fixer solutions.

Soft A slang term which is applied to both unsharp images (soft focus) or a lower-than-normal contrast material (soft printing paper grades).

Soft-working developer Any developer which produces lower contrast than a 'normal' developer. It is useful when photographing very contrasty subjects.

Solarization Production of a partial positive image when a negative material (and vice versa) is grossly over-exposed. This phenomenon should not be confused with the *Sabattier effect*.

Spherical aberration Lens fault which causes loss of definition and spreading of highlights. It is reduced by stopping the lens down. Many early 'portrait' lenses were intentionally not corrected for spherical aberration to give a pleasing 'soft' image.

Spiral See *Developing tank*.

Spotting See *Retouching*.

Stock solution Any solution which can be stored and used as needed in small quantities. Many stock solutions are either diluted or mixed with another solution(s) just prior to use.

Stop Another term for aperture or exposure control. For example, to reduce exposure by two stops means to either reduce the aperture (e.g. from f8 to f16) or increase the shutter speed (from 1/60 to 1/250) by two settings. To 'stop down' a lens is to reduce the size of the aperture.

Stop bath A solution used to terminate the action of a developer. A stop bath is weakly acidic to counteract the alkalinity of the developer.

Straight line portion The centre portion of the characteristic curve where the film or paper responds proportionally to an increase or decrease of exposure. For example, each doubling of exposure results in the same density increase for the negative material being used.

Subtractive synthesis The method of producing colours by subtracting colours from white light. The subtractive colours (primaries) usually employed in photography are yellow (subtracts blue), magenta (subtracts green), and cyan (subtracts red).

T
Test strip A series of different exposures on one sheet of paper or film to help determine the correct exposure, and, in the case of colour materials, the correct colour filtration.

Tonal range The comparison between intermediate tones of a print or scene, and the difference between the whitest and blackest extremes.

Toner Any chemical or set of chemicals which alter the colour of a black-and-white image.

Tone separation See *Posterization*.

Translucent Transmitting diffuse rather than image-forming light.

Transparency See *Slide*.

Tungsten halogen lamp A special design of tungsten lamp which burns very brightly and has a stable colour throughout its relatively long life. Its main disadvantage is the extreme heat it generates and its greater cost.

Tungsten light A light source which produces light by passing electricity through a tungsten wire. Most domestic and much studio lighting uses tungsten lamps.

U
Ultra-violet radiation Invisible energy which is present in many light sources, especially daylight at high altitudes. UV energy, if it is not filtered, causes excessive blueness with colour films.

Underdevelopment Less-than-normal development for a film or paper. This can be caused by low temperature, short development time, insufficient agitation, or exhausted developer.

Under-exposure An exposure which is less than the film or paper needs to give a 'normal' reproduction of the scene. See *Push Processing*.

Universal developer Any developer formulation which can be used for both film and paper processing, usually employed at different dilutions for each.

Uprating a film See *Push processing*.

V
Variable-contrast paper A black-and-white printing paper which has a range of contrasts depending on the colour of the filter used when enlarging. One box of variable-contrast paper replaces several boxes of different grades.

Vignetting The masking of the edges of an image. This can occur when a lens hood or filter intrudes into the subject area, or when a negative is enlarged through a shaped cut-out.

Visible spectrum The part of electro-magnetic radiation which is visible to the human eye. The visible spectrum stretches from blue, through green, to red.

W
Wetting agent A chemical which is often added to the final processing rinse to promote even drying, thus avoiding drying marks.

X
X-ray Electro-magnetic radiation of short wavelength. An X-ray photograph is a 'shadowgraph' produced by passing X-ray radiation through the subject to be recorded by a special photographic emulsion.

Index

Addresses

The following are addresses for some of the US and UK manufacturers and distributors of products mentioned in this book. Should you have any difficulty in obtaining these products, write to the manufacturer for lists of retail outlets in your area.

US Addresses

Acufine Inc.
439-447 East Illinois Street
Chicago, IL 60611

Agfa-Gevaert, distributed by
Braun North America
Agfa Products Div.
55 Cambridge Parkway
Cambridge, MA 02142

Arkay Corporation
228 S. First Street
Milwaukee, WIS 53204

Autone, enquiries to
John Bushen & Co Ltd.
75 Kilburn Lane
London W10 4AW
United Kingdom

Berg Color-Tone, Inc.
P.O. Box 16
East Amherst, NY 14051

**Beseler Photo Marketing
Company, Inc.**
8 Fernwood Road
Florham Park, NJ 07932

Colourtronic
9716 Cozy Croft Avenue
Chatsworth, CA 91311

Durst, distributed by
Unitron Instruments, Inc.
Subs EPOI
101 Crossways Park West
Woodbury, NY 11797

Eastman Kodak Co.
343 State Street
Rochester, NY 14650

Edwal Scientific Products Corp.
12120 South Peoria Street
Chicago, IL 60643

Ethol Chemicals, Inc.
1808 North Damen Avenue
Chicago, IL 60647

Fuji Photo Film U.S.A., Inc.
350 Fifth Avenue
New York, NY 10001

Ilford U.S.A., Inc.
West 70 Century Road
Paramus, NJ 07652

Jobo see Soligor/Jobo

Kodak see Eastman Kodak Co.

E. Leitz, Inc.
Link Drive
Rockleigh, NJ 07647

Luminos Photo Corp.
25 Wolfe Street
Yonkers, NY 10705

Minolta Corp.
101 Williams Drive
Ramsey NJ 07446

Omega, distributed by
Berkey Marketing Cos., Inc.
25-20 Brooklyn-Queens Expwy W.
Woodside, NY 11377

Paterson, distributed by
BNA Photo (Braun North America)
55 Cambridge Parkway
Cambridge, MASS 02142

Philips, distributed by
Hindaphoto
26 Marlborough Ct
Rockville Centre, NY 11570

Photocolor, distributed by
Satter, Inc.
4100 Dahlia Street
Denver, CO 80207

Phototherm
110 Sewell Avenue
Trenton, NJ 08610

Saunders-Omega, see Omega

Soligor/Jobo, distributed by
AIC Photo Inc.
168 Glen Cove Road
Carle Place, NY 10705

Tetenal Neofin, distributed by
Kalt Corp.
2036 Broadway
Santa Monica, CA 90406

Unicolor, distributed by
Photo Systems, Inc.
Unicolor Div.
7200 Huron River Drive
Dexter, MI 48120

Vivitar Corp.
1630 Stewart Street
Santa Monica, CA 90406

UK Addresses

Acufine
Phago Photographic
259 Preston Road
Wembley, Middlesex

Agfa-Gevaert
27 Great West Road
Brentford, Middlesex

Autone, distributed by
John Bushen & Co. Ltd.
75 Kilburn Lane
London W10 4AW

Barfen
Photochemical Ltd.
Barfen House
Chatsworth Road
London E5

Berg, distributed by
Kenro Photographic Products
High Street
Kempsford, Gloucestershire

Beseler, distributed by
Rollei
Denington Estate
Wellingborough
Northamptonshire NN8 2RG

Colorvir, distributed by
Marchant Photographic
Unit 7
Willesden Trading Estate
Acton Lane
London NW10 7PB

Durst, distributed by
Eumig
14 Priestley Way
Eldonwall Trading Estate
London NW2 7TN

Fuji Film Processing
PO Box 33
Stevenage
Herts

Hauck, distributed by
De Vere (Kensington)
Thayers Farm Road
Beckenham
Kent BR3 4NB

Ilford UK Sales
1 Berners Street
London W1P 4DP

Jobo, distributed by
Introphoto
89 Park Street
Slough
Berkshire SL1 1PX

Kaiser, distributed by
Bush & Meissner
136-144 Granville Road
London NW2 2LD

Kentmere Ltd.
Staveley
Kendal
Cumbria

Kodak
PO Box 66
Kodak House
Station Road
Hemel Hempstead
Hertfordshire HP1 1JU

Leitz
48 Park Street
Luton
Bedfordshire LU1 3HP

Melico Darkroom Equipment
Medical & Electrical
Unit 5, Spencer Court
7 Chalcot Road
London NW1 8LH

Mitchell Products, distributed by
Phototopia
Hempstalls Lane
Newcastle under Lyme
Staffordshire ST5 0SW

Omega, distributed by
Berkey Technical
22 Concord Road
London W3 0TQ

Paterson
2-6 Boswell Court
London WC1N 3PS

Philips
PO Box 298
City House
420-430 London Road
Croydon
Surrey CR9 3CR

Photocolor Chemicals,
distributed by Phototechnology
9 Cranborne Industrial Estate
Potters Bar
Hertfordshire ENS 3JN

Saunders Equipment,
distributed by
Keith Johnson Photographic
Ramillies House
1-2 Ramillies Street
London W1V 1DF

Soligor, distributed by
Mayfair Photographic
Hempstalls Lane
Newcastle under Lyme
Staffordshire ST5 0SW

Tetenal, distributed by
Introphoto
89 Park Street
Slough
Berkshire SL1 1PX

Unicolor, distributed by
Mayfair Photographic
Hempstalls Lane
Newcastle under Lyme
Staffordshire ST5 0SW

Vivitar
Vivitar House
Ashville Trading Estate
Nuffield Way
Abingdon
Oxfordshire OX14 1RP

Photographic credits

Alan Bedding 8
HAG 6
Anne Hickmott 4,5
Malkolm Warrington/Eaglemoss 2,3

Equipping a darkroom
Steve Bicknell/Eaglemoss 22,24,25,27
Michael Busselle/Eaglemoss 42,43
Barry Lewis/Eaglemoss 12,13
Melico Ltd 41
Mike Newton/Eaglemoss 38(left),39
Joe Partridge/Eaglemoss 31,40
Con Putbrace/Eaglemoss 11
Dennis Walkingshaw/Eaglemoss 37
Malkolm Warrington/Eaglemoss 18-21,26,32,
 34,38(right)

Black-and-white developing
Tony Boxall 62
Michael Busselle/Eaglemoss 64,65
Bill Colman 50(bottom)
John Garrett 52
Barry Lewis/Eaglemoss 54-61
Con Putbrace/Eaglemoss 45
Anthea Sieveking/ZEFA 50(top)

Basic black-and-white printing
Michael Busselle/Eaglemoss 84,85
Tim Cook 89
Eric Crichton 91(top)
Ricardo Gomez-Perez 91(centre and bottom)
Ilford Ltd 82(bottom),83
David Kilpatrick/Eaglemoss 80
Barry Lewis/Eaglemoss 93
Philippa Longley 78(bottom left),
 79(bottom right)
Alasdair Ogilvie/Eaglemoss 71
Frank Owen/Eaglemoss 76,77,78(top left,
 79(top right and bottom right),
 79(top left, top right and bottom left)
Paterson 92
Con Putbrace/Eaglemoss 67,69,70
David Reed 95
Peter Sutherst/Eaglemoss 88
John Sims 87
John Swannell 81
Tony Timmington 74
Alison Trapmore/Eaglemoss 72,75
Malkolm Warrington/Eaglemoss 82(top),86

Colour developing
Steve Bicknell/Eaglemoss 97,100
Malkolm Warrington/Eaglemoss 102,103

Basic colour printing: negatives
Steve Bicknell/Eaglemoss 111
John Garrett 115
Kodak Ltd 120,121
Derek Watkins 116,117

Basic colour printing: slides
Steve Bicknell/Eaglemoss 130
Michael Busselle/Eaglemoss 126,127,131
Bill Colman 125(centre)
Fred Dustin/Eaglemoss 129(top)
Lawrence Lawry 129(bottom)
Peter Myers 125(bottom)
Dennis Walkingshaw 128
Malkolm Warrington/Eaglemoss 123
Ian Yeomans/Susan Griggs Agency 125(top)

Corrective techniques
Christopher Angeloglou 139
Steve Bicknell/Eaglemoss 132,140,152
Steve Bicknell and David Pratt/Eaglemoss
 153,154,155
Michael Boys/Susan Griggs Agency 157
John Garrett 147
Louis Jordaan 143,151
David Kilpatrick/Eaglemoss 136,137
Barry Lewis 141,142,144,145,146
David Reed 133(bottom),134,135
Homer Sykes/John Hillelson 133(top)
Jack Taylor/Eaglemoss 148,149,150

Simple creative darkroom techniques
Colin Barker 172(bottom)
Alan Bedding 172(top left and
 top right),185
Steve Bicknell/Eaglemoss 161(bottom)
Clive Boursnell/Eaglemoss 174
David Burrell/Eaglemoss 163
Valerie Conway 160,179(top)
Ralph Court 175
Amanda Currey 161(top),162,182,186,
 187(top),188,189
Peter Goodliffe 171
HAG 176,177,180,183
David Nicholson/Eaglemoss 164-169

Paterson 170
Bob Pullen 184
David Reed 187(bottom)
Jack Taylor/Eaglemoss 173
Doris Thomas 178,179(bottom),181

Advanced creative darkroom techniques
Richard Brook 212
Amanda Currey 191,192,193,196(top left)
Roger Darker/Eaglemoss 216
Gary Ede 213(bottom)
Anne Hickmott 214,215,217(top)
Graham Hughes 210
Heino Juhanson 213(top left and top right)
David Kilpatrick/Eaglemoss 198-201,
 203,204,206-209
David Kilpatrick 202
Howard Kingsnorth/Fred Dustin 217(bottom)
Martin Riedl 197
Jack Taylor 196(top right and bottom)
Colin Tout 194
Malkolm Warrington/Eaglemoss 190

Posterization
Steve Bicknell/Eaglemoss 222(top)
Anne Conway/Eaglemoss 223
Fred Dustin 221(top right),230(top
 and bottom)
Phil Gibbs 221(bottom)
Anne Hickmott 219,222(bottom),225
Heino Juhanson 218,220,221(top left),
 226,231
Heino Juhanson/Fred Dustin/Eaglemoss
 227,228,229 (bottom)
Lawrence Lawry 229(top)

Display and storage
John Kelly 240(top centre)
David Kilpatrick/Eaglemoss 238,239
Naru/Adrian Ensor 237
Kim Sayer 240(top right)
Homer Sykes 240(top left)
Malkolm Warrington/Eaglemoss 232-236,241

Duplicating
Michael Busselle/Eaglemoss 246
Peter Goodliffe 247
Homer Sykes/Eaglemoss 245
Malkolm Warrington/Eaglemoss 244

Art work credits

Drury Lane Studios 1

Equipping a darkroom
Drury Lane Studios 14-17,28,29,34-36,42,43
Jim Marks and Nigel Osborne 30,31
Peter Sullivan 33
Technical Art Services 10,11

Black-and-white developing
Drury Lane Studios 51,63
Kevin Maddison 48,49
John Thompson/Kevin Maddison 46(bottom),47
John Wells 46(top)

Basic black-and-white printing
Drury Lane Studios 72-74,87,90,94
Peter Sullivan 67-69

Colour developing
Drury Lane Studios 98,99,101,104,105

Basic colour printing: negatives
Drury Lane Studios 113-115,118,119

Basic colour printing: slides
Drury Lane Studios 124

Corrective techniques
Drury Lane Studios 141-143,145,147,152,153

Simple creative darkroom techniques
Drury Lane Studios 162,166,167,174,176,
 178,179

Advanced creative darkroom techniques
Carol Collins 193
Drury Lane Studios 195,196,200,211,216

Posterization
Drury Lane Studios 224,225

Display and storage
Drury Lane Studios 242,243